The Paradox of Paternalism

UNIVERSITY PRESS OF FLORIDA

Florida A&M University, Tallahassee
Florida Atlantic University, Boca Raton
Florida Gulf Coast University, Ft. Myers
Florida International University, Miami
Florida State University, Tallahassee
New College of Florida, Sarasota
University of Central Florida, Orlando
University of Florida, Gainesville
University of North Florida, Jacksonville
University of South Florida, Tampa
University of West Florida, Pensacola

The Paradox of Paternalism

Women and the Politics of Authoritarianism in the Dominican Republic

Elizabeth S. Manley

UNIVERSITY PRESS OF FLORIDA
Gainesville / Tallahassee / Tampa / Boca Raton
Pensacola / Orlando / Miami / Jacksonville / Ft. Myers / Sarasota

Publication of this paperback edition made possible by a Sustaining the Humanities through the American Rescue Plan grant from the National Endowment for the Humanities.

COPYRIGHT 2017 BY ELIZABETH S. MANLEY
All rights reserved
Published in the United States of America

First cloth printing, 2017
First paperback printing, 2022

27 26 25 24 23 22 6 5 4 3 2 1

A record of cataloging-in-publication data is available from the Library of Congress.
ISBN 978-0-8130-5429-2 (cloth) | ISBN 978-0-8130-6942-5 (pbk.)

The University Press of Florida is the scholarly publishing agency for the State University System of Florida, comprising Florida A&M University, Florida Atlantic University, Florida Gulf Coast University, Florida International University, Florida State University, New College of Florida, University of Central Florida, University of Florida, University of North Florida, University of South Florida, and University of West Florida.

UNIVERSITY PRESS OF FLORIDA
2046 NE Waldo Road
Suite 2100
Gainesville, FL 32609
http://upress.ufl.edu

This book is a part of the Latin American and Caribbean Arts and Culture publication initiative, funded by a grant from the Andrew W. Mellon Foundation.

Contents

List of Figures viii
Acknowledgments ix
List of Abbreviations xv

Introduction: Gendering the History of Dictatorship and Transnational Politics 1
1. Advocating Suffrage and Sovereignty: Pan-American Feminism and the Rise of the Trujillato, 1922–1942 29
2. Defending the Home against the Chaos of Communism: Women, Regime Politics, and the Cold War, 1942–1961 61
3. Intimate Violations: Gender, Family, and the *Ajusticiamiento* of Trujillo, 1944–1961 93
4. Neither Russia nor the United States: Women and the Search for Legitimate Democracy, 1961–1965 121
5. First to Liberate Women's Lib: Negotiating the Politics of Mediation during Balaguer's *Doce Años*, 1966–1978 156
6. *Sangre sin Revolución*: The Gendered Politics of Opposition through the *Doce Años* 190
Epilogue: International Women's Year and Dominican Transnational Feminism under Authoritarianism 219

Notes 243
Bibliography 291
Index 311

Figures

1.1. Logo of Acción Feminista Dominicana 41
1.2. Carmita Landestoy, circa 1934 45
1.3. *Voto de ensayo*, test vote 49
1.4. Doris Stevens and Minerva Bernardino departing for Ciudad Trujillo 53
2.1. Meeting of the Sección Femenina of the Partido Dominicano 81
2.2. Members of the Sección Femenina of the Partido Dominicano at the National Cathedral 81
3.1. Women protesting the disappearance of regime opponent Jesús de Galíndez in New York, 1956 106
3.2. Women in New York protesting Trujillo, 1960 109
4.1. Protest by the Federación de Mujeres Dominicanas 139
4.2. Women's demonstration at Puerta del Conde 148
4.3. April Revolution graffiti, 1965 152
4.4. Woman driving a tank, April Revolution 153
5.1. Joaquín Balaguer and his sister Emma Balaguer de Vallejo 161
5.2. Governor of Santiago, Lilia Balcácer de Estrella 178
5.3. Governor of Samaná, Altagracia Acosta de Bezi 179

Acknowledgments

AS I WAS COMPLETING THIS MANUSCRIPT the incomparable Dominican feminist revolutionary Magaly Pineda passed away after a long battle with cancer. Magaly was a fighter in the April Revolution and a feminist icon; her legacy is unparalleled. In many ways it was Magaly and the women with whom she surrounded herself—in the Dominican Republic and internationally—who sparked the flame for this project. Not only did Magaly represent her nation at countless global conferences and start the first feminist collective in the Dominican Republic, but she served as a model par excellence of the struggle for equality to everyone she met, young and old. She said, on the social media platforms she trumpeted, "To have commitment, perseverance, a sense of wonder, and to link personal processes with the political, that is a feminist principle. The personal is political. You have to be revolutionary in the house, on the street, and in the bedroom." I could not have begun this project without the atmosphere of struggle and hope for greater equality everywhere that she began in the Dominican Republic. I have been enriched by the stories of so many women like Magaly who, despite a national history that might wither many, have kept a sense of wonder about what the world could look like if we all continue to be revolutionaries in every part of our lives.

Other than the little information I knew about the 1970s feminist movement, when I began this project in the early 2000s I had precious little knowledge of the Dominican Republic or its history. Over this time I have come to love the country, its people, and its many paradoxes. My initial research on a tiny aid project for rural schools led to a much larger endeavor on the role of women in the twentieth-century body politic; I could have barely envisioned the incredible support from scholars and friends I would receive along the way. While this book has been a long time coming, it has benefited significantly from the consistent mentorship, insight, love, and

guidance of so many people. I will make an attempt here to thank some of them for their help and absolve them of my sins.

At Xavier University of Louisiana I am consistently inspired by my hardworking and dedicated colleagues who care deeply about our students and still manage to find time to support research and writing. In the history department I have felt nurtured as well as free to pursue my own path as a teacher-scholar. Steve Salm and Jonathan Rotondo-McCord have been extremely supportive of my scholarly work as leaders and friends and have helped me to squeeze in as much time as possible to dedicate to this book. Sister Barbara Hughes generously offered her assistance in the final stages of the project, and Gary Donaldson, Sharlene Sinegal-DeCuir, and Shamsul Huda round out what might be the one of the most collegial departments in academia. Outside the history department, Robin Runia and Megan Osterbur committed significant portions of their limited time to reading this manuscript and providing valuable feedback; more importantly, they have become incredible co-teachers and even better friends. Meg's dedication and perseverance are a constant inspiration and her friendship has been sustaining to me in more ways than I can enumerate here. Elizabeth Yost Hammer has created a nurturing environment of teaching, learning, and scholarship through the Center for Advancement of Teaching and Faculty Development; I am so thankful for her encouragement and guidance. My students have provided me with the inspiration to continue the difficult work of combining a high teaching load and research; they remind me daily why looking beyond the standard narrative is so important. I am particularly grateful to Victoria Watson, who provided crucial assistance in the final stages of this book.

As a graduate student at Tulane University I was extremely lucky to be a member of a small and supportive cohort of graduate students and to be guided by some extremely committed faculty members. Justin Wolfe was and is a caring friend and remarkable mentor. He taught me to think about the big picture and, more importantly, to persist in the face of a sometimes challenging career path. Rosanne Adderley and Trudy Yeager, in very different ways, modeled what it means to be a strong woman in academia. Rachel Devlin and Daniel Hurewitz pushed me to think more critically about gender and identity; Daniel particularly was instrumental in helping me learn what a good teacher looks like and the importance of not using five-dollar words when much simpler ones would suffice. The camaraderie of

Marc Eagle, David Simonelli, Mike Ross, Keira Williams, and Gregg Bocketti at various points provided levity, and Liz McMahon helped me through some of the most excruciating transition points. I am also indebted to Guadalupe Garcia for helping me brainstorm the title of this book. Fiscal support from the Stone Center for Latin American Studies, the John T. Monroe Fellowship, and the Newcomb College Institute was crucial in moving this project along.

As I have transitioned into my role as teacher-scholar I have come to think ever more about the mentors I had as an undergraduate and how to serve my first-generation students as they did for me. Ann Farnsworth-Alvear pushed me to pursue Latin American studies despite my limited Spanish, and her encouragement to dive into primary sources on my paper on Evita clearly directed me toward the ultimate path I took. Julie Franks and Michel Gobat convinced me I could succeed in graduate school, something I would never have imagined without their encouragement. Just as I am never sure of the efforts I make on behalf of my students, they may not have known how important their words were to me; luckily, I have this tiny window to set the record straight.

Historical research in the Dominican Republic can be a challenging and surreal endeavor at times; I am grateful to a number of people who helped me chart a path through new waters. In the Archivo General de la Nación (AGN) in Santo Domingo, I am one of the last of a certain cohort who owe a huge debt of gratitude to Eddy Jáquez. His indefatigable efforts on my behalf, searching up and down for *legajos* no one had seen since they were first deposited in the archives, made this book possible. Under the new leadership of Roberto Cassá the archives have undergone significant positive transformations. I am extremely grateful for the assistance of Quisqueya Lora Hugi, Alejandro Paulino, Raymundo González, Salvador Alfau, Aquilies Castro, and Ingrid Suriel through my many trips to Santo Domingo and the AGN. Thanks also go to Lisa Carrasco, Sorange Castillo, and Victor Lugo in the Fototeca for help with images. Further, I was blessed to meet and interview several of the women included in this study, and I cannot thank them enough for their time and candor. Josefina Padilla, Magaly Pineda, Margarita Cordero, Grey Coiscou, Cristina Díaz, Teresa Espaillat, Lourdes Contreras, Milagros Concepción, Patricia Solano, Sagrada Bujosa, Liliana González Vda. Jiménez, and former governors Lilia Balcácer de Estrella and Virginia Pérez de Florencia all contributed their

strength to the advancement of women in the Dominican Republic, albeit in vastly different ways; it was an honor to talk with each one of them. Over my years of research I have been fortunate to meet wonderful people in the Dominican Republic whom I call good friends, among them Manuel Vargas, Joan Díaz, Edna Lerebours, and especially Arlyn (Buloya) Jiménez and Nathalie Ramírez San Miguel.

As a scholar of the Dominican Republic I am grateful to the small but powerful and committed cohort of people who work on Hispaniola. Much appreciation and love to my previous collaborators April Mayes and Ginetta Candelario, with whom I share the bond of countless hours in the archives and long collaborative conversations. Also thanks go to Robin (Lauren) Derby, Kiran Jayaram, and April Yoder for reading drafts, providing feedback, and generally being extraordinary colleagues! Maja Horn and Lorgia Garcia-Peña were there almost from the beginning and have provided me with support, places to rest my head, laughs, and commiseration at nearly every turn. Both have become wonderful friends and confidants. Most importantly, Neici Zeller has been my lodestar. From the first meeting we had in her office in Santo Domingo to our regular catch-ups today, she has been a constant source of inspiration, insight, and *cariño*. Words do not suffice, but as ever, I will try.

This study benefited immensely from research at Harvard University's Schlesinger Library and the University of Florida's Smathers Library; I thank both institutions for their generous travel grants. I was also privileged to be included in Fisk University's United Negro College Fund/Mellon Teaching and Learning Institute "Productive Feminist Scholars, Producing Feminist Scholarship" seminar; many thanks go to Adenike Davidson for leading the seminar and Beverly Guy-Sheftall for providing inspiration. The opportunity to present parts of the manuscript at numerous conferences over the years improved the study, facilitated new personal and professional relationships, and would not have been possible without the support of travel grants from the Dean's Office at Xavier University's College of Arts and Sciences. At the University Press of Florida I would like to thank Stephanye Hunter for her attentive shepherding of this project and Marthe Walters for her production guidance. Many thanks go also to Scott "W" Williams for some fabulous last-minute image editing. Kristen Weber, in addition to being practically family, tackled the index with the dependable dedication she commits to all things. The two anonymous readers for the University Press

of Florida made this book considerably stronger through their generous commitment of time and intellectual rigor; I thank them for encouraging me to think about the larger patterns and implications of this work.

Throughout this entire process I have had the incredible fortune to live in the city of New Orleans surrounded by a dense network of chosen family. Shel Roumillat began this journey with me a decade and a half ago and remains a constant source of inspiration, an unflagging supporter, and an enviable ally. It is an honor to continue to share this city's riches with her and to get to see her children, Leo and Ruby, grow into true New Orleanians! James McAlister provided shelter real and figurative for so much of this journey; I am completed indebted, and I hope to continue to make my New Orleans dad proud. Thomas Adams has provided an ear on things academic and not; he has been an incredible friend, source of laughs, and travel companion for the past decade and a half, making this journey much more enjoyable. And a number of friends I must thank for just being sources of joy and encouragement, including Ron Rona, Niki Fisk, Evan Ehrhardt, Meredith Dudley, and Nikki Lebrasseur.

My sister Carolyn McCormack constantly astounds me with her strong and thoughtful mothering and nourishes me with her friendship; I am grateful to her and the opportunity to see her raise two wonderful boys to believe an equitable world is possible. Carolyn brought Butch, Maxwell, and Seamus into our world, and they have made it so much richer. Jennifer Manley has been an unflagging source of motivation and love and is my closest confidant; with JenJen and KK I am pretty sure I won the sister lottery. Finally, my parents, Patricia and Frederick, have, by their own examples, taught me the value of hard work and adventure. I cannot possibly repay the debt, but I hope I can demonstrate my gratitude in the little things.

Abbreviations

1J4	Movimiento (Clandestino) 14 de Junio
ADPDH	Asociación Dominicana Pro-Derechos Humanos
AFD	Acción Feminista Dominicana
APFD	Asociación Patriótica Femenina Dominicana
CFMPD	Comité de Familiares de Muertos, Presos y Desaparecidos
CNM	Consejo Nacional de Mujeres
CONAPOFA	Consejo Nacional de Población y Familia
CSW	UN Commission on the Status of Women
FMD	Federacíon de Mujeres Dominicanas
IACW (CIM)	Inter-American Commission of Women (Comisión Interamericano de Mujeres)
IADF	Inter-American Association for Democracy and Freedom
JR/JD	Juventud Revolucionaria/Juventud Democrática
LIREMU	Liga Revolucionario por la Emancipación de la Mujer
LWV	League of Women Voters
MLD	Movimiento de Liberación Dominicana
MPD	Movimiento Popular Dominicano
OEF	Overseas Education Fund (LWV)
OAS	Organization of American States
PD	Partido Dominicano
PR	Partido Reformista (Balaguer's party)
PRD	Partido Revolucionario Dominicano
PRSC	Partido Revolucionario Social Cristiano
UASD	Universidad Autónoma de Santo Domingo
UCN	Unión Cívica Nacional
UFIA	Unión Femenina Ibero-Americano
UN	United Nations
UPD	Unión Patriótica Dominicana
VRD	Vanguardia Revolucionaria Dominicana

Introduction

Gendering the History of Dictatorship
and Transnational Politics

IN EARLY JUNE 1961 citizens of the Dominican Republic began a process of national mourning and subsequent memory revision that would last into the twenty-first century. Rafael Leónidas Trujillo Molina, the dictator who had reigned with a heavy hand over their country for three decades, was assassinated on May 30. The country's major newspapers—all formerly controlled by Trujillo—immediately reported the news of a citizenry drowning in grief.[1] While many Dominicans secretly rejoiced in the days following the assassination, the period's chaos and conflict underscore the strength of the paternalist model solidified by the Trujillo regime over his thirty-year reign. Having styled himself as a fatherly—even Godlike if also consummately masculine—protector of the Dominican nation and its moral firmament, the loss of Trujillo's physical presence sparked anxiety and confusion for government functionaries and the general populace alike. On June 3 the *New York Times* reported the funereal events being held at the National Palace in Santo Domingo and in Trujillo's hometown of San Cristóbal, noting that thousands had been turned away due to emotions getting "out of hand."[2] Women, however, seemed most at fault. One reporter noted, "As the procession passed, some women hurled themselves down at the roadside, shrieking and beating their heads on the ground." Almost as an afterthought, the reporter added that "many men wept also."[3] The images of thousands of *campesinas* grieving the loss of their beloved "Generalísimo" dominated the many stories about the immediate aftermath of the assassination in the Dominican Republic and beyond. Particularly when viewed from the United States, these stories were accompanied by a scornful tone denigrating the deluded state of such women who wept for a vicious

dictator. And while Dominican papers initially eschewed judgment of the women they described as "in agony," such crying, grief-stricken, female figures dominated their coverage of the wake, funeral, and interment. Beyond the basic questions of political succession, larger concerns regarding the protection of the Dominican family, home, and nation were at stake in the demise of the self-styled father of the nation. Regardless of tone, the marked presence of women in the process of national mourning points to the strong ties between the regime and the nation's female population at the time of Trujillo's *ajusticiamiento*, as Dominicans have widely called the assassination, to the present.[4]

Beyond these immediate media portrayals, later accounts of Dominican public memory of the assassination of Trujillo demonstrate a much more celebratory attitude, even if the continued presence of the Trujillo family often prevented its expression.[5] Nearly a half century later, activist and writer Grey Coiscou Guzmán recalled her quite public elation upon hearing of the assassination.[6] Involved in the underground opposition to the regime, she was less than patiently awaiting the dictator's demise. In fact, by her own accounts she kept a festive, fire-engine-red dress hidden at the back of her closet specifically for the much-hoped-for day. As she recounted, she donned the dress and headed for El Conde, the central thoroughfare in the colonial city. Along with some of her compatriots, Coiscou reported, she sang and danced to the merengue "Mataron el chivo" (They killed the goat).[7] Coiscou recounted a story not of mourning but of active repudiation. Given the chaotic political conditions that followed the assassination, including a vicious manhunt for the dictator's killers, most Dominicans kept their celebrations secret. While Coiscou's memory offers a contrasting depiction of the strong ties between the regime and the protection of women and families that most citizens sought to purge and forget, both sides of the narrative reveal intense links between the dictator and female engagement with the Dominican state.

Whether seen from the perspective of the jubilant dancers or through the eyes of the wailing mourners, the death and funeral of dictator Rafael Trujillo presents a window on women's diverse engagements with the Dominican state and its paternalist model that lasted from the earliest years of the Trujillo era well through 1978 with the end of the regime of his successor Joaquín Balaguer. For some, the ritualized patriarchy of authoritarianism offered a predictable protection of the traditional family. For others, the

calculated organization of bureaucracy, coupled with the regime's staunch defense of traditional gender roles, provided opportunities for personal political advancement and the establishment of a national women's movement. And for still others, the intense surveillance of everyday life and suppression of political opposition represented a threat to the survival of the Dominican family at large and a reason to join the ranks of the resistance. Regardless of women's individual investments or the practicality of political choices under strict authoritarianism, for nearly half of the twentieth century, dictatorial leaders Rafael Trujillo (1930–1961) and Joaquín Balaguer (1966–1978) mandated the terms of political involvement for the Dominican populace and marshaled thousands of women into the public arena of politics.

From the ascendancy of Rafael Trujillo in the late 1920s to the conclusion of Joaquín Balaguer's three presidential terms in the late 1970s, Dominican women engaged in local and national politics, operated within complex inter-American relations, and employed the most current global political discourse to further their diverse personal and political agendas. Not only were they invested in the social and civic well-being of the nation and often particularly the status of female citizens, but they employed a transnational model of political activism to pursue their goals. In this book I argue that women's engagement across the political spectrum proved a vital component in the successes and failures of twentieth-century Dominican authoritarian regimes. Through conservative political circles and the maternalist discourse they engendered, many women created viable avenues to formal participation at national and international levels, paving the way for a more active female population and, consequently, a more stable national regime.

During this process, Dominican women also demonstrated the fragility of traditional gender expectations and the strength wielded by those who could point out a regime's failure to maintain the link between expected standards of behavior and national security. Not content to operate on merely a local or even national platform, women became part of a larger discourse about the nature of citizenship, national sovereignty, and global engagement. By the end of the 1960s various groups began to selectively import ideas of feminism from western models and reformulate their own relations with existing political parties and the state. As a result, by the mid-1970s a uniquely Dominican feminist movement emerged that cannot be understood without a fully dissected analysis of the years of dictatorship

and resistance that preceded it. From the years preceding the Trujillo era through the end of Balaguer's regime in 1978, during multiple periods of rule and of transition, women were central to the politics of authoritarianism and political opposition through public displays of support and displeasure, active interventions into the discourse of nation and family, and inter-American discussion and debate on the role of the female citizen. In this book I examine the practices of women in national and transnational political arenas and the gendered nature of the politics of dictatorship and transnationalism in the twentieth century. I analyze the ways in which authoritarian politics relied on certain gendered ideals of participation and how a relatively select group of middle- to upper-class Dominican women served as the central actors in a prolonged political drama.[8] While I make no claims on any significant class or racial diversity among them, I argue that it is nonetheless important to focus on their words and deeds through these difficult periods of authoritarianism, regime transition, and U.S. intervention because they ultimately formed the foundations of a late twentieth-century feminist movement, helped stabilize and destabilize authoritarian regimes, and established the terms of transnational feminist activism.

In *The Paradox of Paternalism* I offer a model for understanding women's political mobilization and the paths to twentieth-century feminist activism through authoritarianism. This study demonstrates that in working through dictatorial regimes and transnational networks, Dominican women built the foundations of a solid and practical women's movement. In addition to contributing to the longevity of authoritarian leadership as well as its eventual demise, their efforts situate squarely the rise of women's liberation throughout the global South in the complex networks of inter-American activism and the maternalist politics of conservative rule. Throughout the study I argue two main points. First, as a result of the Trujillo and Balaguer regimes' efforts to uphold the Dominican Republic's international reputation as stable and to project an image of a progressive and progressing nation, women found and expanded spaces of global and transnational activism that advanced basic political rights and paved the way for the feminist movement. Second, while the paternal constructs of rule upheld by Trujillo and Balaguer did advance women's roles in certain arenas of society and politics, they also paradoxically enforced a superstructure that maintained a traditional understanding of women's innate abilities as maternal public

figures. Both of these narrative strands are central to the development of a distinct feminist movement in the 1960s and 1970s as well as to the hurdles women activists continue to face as they confront a highly patriarchal and conservative Dominican state.

Just as the regimes of Trujillo and Balaguer cemented certain gendered practices in the Dominican state, many women were active participants in the discussion that dictated such constructs. Throughout this half century in Dominican history, women of various political proclivities undertook a complicated performance of female citizenship that centered on several authoritarian tenets of the time: democracy, anticommunism, progress, and national sovereignty. Knowing full well the shifting international demands on a small island nation in the so-called American lake, they successfully demonstrated their ability to perform as proper citizens who understood and interacted with the demands of twentieth-century modernity. They carefully negotiated the paradox that Maja Horn points out relative to the regimes' construction of a "starkly hierarchical organization of Dominican society and politics that was overwritten by an emphatically egalitarian discourse" and ultimately undergirded by an extremely masculinized language of rule.[9] While most certainly the constraints on public discourse limited the terms of discussion, many women maintained a commitment to what it meant to be a cosmopolitan female citizen. Although their end goals ranged widely, their efforts explain much about the structure and function of authoritarian rule, the on-the-ground realities of democratic and anticommunist image-making during the Cold War, and the problems and possibilities of feminist transnational and solidarity work.

Paternalism and the Gendered Politics of Authoritarianism

When Trujillo came to power in 1930 and solidified a model of paternalist politics, he at once justified his oppressive tactics for the good of the populace while he concurrently moralized his role as protective father figure. The Trujillo state constructed a relation to its constituents that was at once based on binds of "protection and obedience" but also grounded in unequal "hierarchies of gender."[10] Mary Renda's argument regarding U.S. paternalism over Haiti during the occupation applies to the Dominican context during dictatorship. She insists that such paternalism must not be dismissed by scholars as mere rhetoric but rather understood as a regime's

"assertion of authority, superiority, and control expressed in the metaphor of a father's relationship with his children."[11] Trujillo, the self-proclaimed "Father of the New Fatherland," served as the "disciplinary father" yet actively engaged Dominican women in what historian Lauren Derby terms the "vernacular politics" or everyday incursions of the state into civil society by the regime.[12] In contrast to the women who appeared in the regime's official displays of paternal authority as a foil to the dictator's masculinity, many active female politicians adhered to traditional gender norms within the household yet maintained complex careers in multiple levels of the regime's bureaucratic structure of paternal control.[13] As Trujillo actively asserted, these women were acceptably modern precisely because they fused their maternal duties to their commitment to his vision of the democratic (and later anticommunist) Dominican state. In the years that followed the end of the Trujillo era, or Trujillato, women continued to assume roles in politics through the model of paternal protections even as it became more and more counterproductive to their goals of full political and social equity.

The use of maternalism—as a complement to the regime's paternalism—to scaffold conservative regimes is far from a new concept, and as research on Nicaragua and Chile illustrates, Latin American authoritarian regimes actively recruited women to solidify a number of crucial "mother-centric" national projects in the early to mid-twentieth century.[14] Maternalism, as both political approach and public discourse, focuses on the social needs of women and children and creates spaces for women to participate in the construction of state programs and policies.[15] The engagement of women in the public arena of politics through programs aimed at assisting children and families was a tactic of the Trujillato and other Latin American regimes, and it often led to suffrage and various concrete advancements by feminist movements across the region.[16] Unsurprisingly, from its earliest years, the Trujillo machinery dedicated significant effort to promoting and expanding the stable home and family through these programs, and it enlisted women to do much of the heavy labor involved in this project.[17] The patterns of paternalism and maternalism established by the regime were intended to reassure the peasantry that it would be cared for, and they were accompanied by no small dose of compulsion. However, the argument that only Trujillo knew what was best for the Dominican people created a unique relation between the nation's leader and its female population. While Trujillo ostensibly sought to implement policies and pro-

grams suitable to protect Dominican women and guard them from harm, many women responded by interacting with regime politics and inserting themselves into ongoing public debate. The corresponding paradox of Trujillo's—and later Balaguer's—style of paternalism is twofold: in these exchanges over the proper protections for families and mothers, women became important and visible players in the public arena of politics; and as the messengers for maternalist policies, the *feministas trujillistas* and later *balagueristas* served to reproduce the regime's paternalism in their small towns and provinces, on the national stage, and even in some international arenas.

Following the assassination of Trujillo in 1961, the shifting political ground gave way to several years of crisis and ultimately, armed U.S. intervention. The political lessons learned by women on both sides of the dictatorship proved vital during the period of transition as they actively engaged in debates over the best direction for the newly liberated nation-state, and many even physically intervened in defense of its sovereignty. In the half decade that followed the demise of Trujillo, women continued to challenge the state—either understood as the occupying United States in 1965 or the revolutionary and transitional governments in between—that constructed its role as the paternal protector of women and children. While there were exceptions, many activist women during the U.S. occupation realized that male militants expected them to concurrently contribute to the struggle and maintain their traditional domestic duties in the theater of civil strife. Concurrently, more conservative female political activists viewed their most valuable contributions to the struggling state through their maternal roles as caretakers, nurses, and educators.

In 1966 Joaquin Balaguer, Trujillo's former speechwriter, titular leader (1960–1961), and closest aide, assumed the presidency and proceeded to rule the nation for the next twelve years. Balaguer's period of rule, often dubbed the *doce años* (twelve years), demonstrated many of the same hallmarks of the Trujillato, as the label *continuismo* indicates. While not the same kind of father figure styled by Trujillo, Balaguer served as a purportedly progressive protector seeking to shepherd the Dominican nation into a more modern period. In focusing on the peace he could bring the mothers of the nation, Balaguer brought women even more predominantly into official political spaces. Specifically, he made the unprecedented decision to appoint exclusively women to the posts of provincial governor. Yet while

the Balaguerato sought to demonstrate its progressive model of women in politics, regime officials continued to reinforce the maternal role of its female functionaries serving as the consummate caretakers and mediators of a nation moving forward. The many female politicians of the *doce años* assumed their roles as national conciliators in earnest and helped to modernize the state's paternalism by putting on national and international display their ability to function at once as effective party operatives and nurturing provincial mothers.

Much like during the Trujillato, an active underground female resistance to the Balaguer regime developed and engaged the principles of maternalism and the defense of the Dominican family and nation from the late 1960s through the 1970s. However, the terms of the public debate surrounding Dominican sovereignty had changed, and women adapted to this new discourse. Like their conservative counterparts, women of the resistance knew that the regime's emphasis lay in the display of democracy and development. In seeking to demonstrate that Balaguer's purported "revolution without blood" was in fact just the opposite, blood without revolution, this diverse group of women sought a more radical revolutionary set of changes that would ultimately equalize gender relations. For them, a model truly built on the principles of democracy and development offered promises far beyond the token appointments of female governors and pointed to a revolutionized social order that would incorporate women as equal partners. By the end of the twelve years of Balaguer, though, women across the political spectrum began to realize that even through their transnational activism and despite their ideological differences, their defense of the embedded model of paternalist politics was seriously handicapping their efforts at full civil, social, and political equality.

Transnationalism and the Historiography of Dominican Women

Regardless of political affiliation or ideological bent, women's activism during periods of dictatorial and authoritarian rule is inevitably a challenging endeavor. Creating figurative and literal space for issues subordinate to the aggrandizement of the state, even for those in favor of the regime, held the possibility of becoming a serious liability or, at the very least, proving fruitless. Even prior to the rise of Trujillo, Dominican women saw the advantages of looking past their immediate national contexts to find leverage

for their positions, advance their standing as public figures of note, and demonstrate their ability to comprehend complex issues of sovereignty and international diplomacy. Particularly with the solidification of a dictatorial regime in the 1930s, a Santo Domingo–based feminist cadre recognized the importance of creating linkages across the hemisphere with other feminists groups in order to transcend the political limitations of the regime and demonstrate their international savvy to Trujillo.[18] As a result, their work focused on local conditions yet sought out a transnational exchange of ideas, solidarity, and best practices. While the women working for and against these dictators may not have described their own efforts as "transnational," they often creatively thought across the national boundaries such leaders sought to solidify.[19] For these Dominican women, the technical assistance of their international counterparts, the global peer pressure exerted by the demand to sign—and abide by—certain treaties or resolutions, or simply the state's desire to join a list of "firsts" drove many of the advancements of their growing personal and public agendas, the feminist movement, and the overall place of women in politics.

While transnational activism often has been pegged to the flow of information associated with globalization, such extranational engagement has existed in the Americas since the birth of the Atlantic world. Whether associated with the dispersal of revolutionary egalitarianism of the Haitian Revolution or tied to the fervor for radical economic change at the onset of the Cold War, Latin American citizens—elite and non-elite alike—have utilized transnational exchanges of information to fight oppression, agitate for rights, and create networks of solidarity.[20] Like José Martí's vision of a united America, transnational scholarly approaches to the region hold revolutionary potential and yet raise myriad theoretical complications. Shandhya Shukla and Heidi Tinsman argue that looking to an alternative (transnational) paradigm allows scholars to see a "relationship that on the one hand has been profoundly structured by imperialism and on the other has given rise to the political and cultural formations that may undermine the calcified boundaries between nation-states."[21] Viewing the Dominican Republic as more than just geographically and figuratively under the United States and rather entwined in a more complex web of inter-American engagements highlights the impact nonstate actors have in the drama of foreign relations.

Transnational feminism, more specifically, centers on the activism of

individuals outside of state structures with the end of improving conditions for women globally and locally. In a study of Russian women's activism, Valerie Sparling, Myra Marx Ferree, and Barbara Risman describe international organizing techniques between Russian and U.S. women; they define transnational feminism in a more recent context, arguing that as a phenomenon of globalization, it is a type of social movement employed "as a means of naming the values, discourses, and objectives that bind [women's advocacy networks] together."[22] While the Dominican case supports transnational feminism as a social movement in the way described by these authors, it also illustrates that such organizing has been in place since at least the beginning of the twentieth century. Karen Offen finds that transnational feminist activism has deep roots and that the creation of a historic line between international and transnational activism among women is not only arbitrary but serves to discredit participants' conscious understanding and articulation of the networks they themselves have created.[23] Within the context of the Americas, transnational feminism has a particularly rich historical record, and scholars have begun to actively interrogate these interconnected webs of activism.[24]

For the women who toiled dutifully under authoritarianism in the Dominican Republic, these transnational feminist pathways presented a myriad of opportunities. Through the relationships they forged with women in the Inter-American Commission of Women (IACW), the League of Women Voters, and various pan-American women's organizations, Dominican activists managed to advance their agendas through the state, organize leadership and empowerment-building programs nation-wide, and generally cut a wider swath for themselves in the public arena. Especially as women moved more rapidly into positions of political power under Balaguer, the transnational arena became central to their efforts to respond effectively to the demands of Cold War developmentalism and maintain their maternal image. While the relationships they built, particularly with their North American counterparts, were not uncomplicated, neither were they as clearly imperialistic as we might imagine. Micol Seigel points out that often these encounters were "uneven" in that Dominican women entered into them at distinct economic and social disadvantages, yet more often than not they managed to negotiate through them in ways that were beneficial to themselves, their agendas, and their constituencies.[25]

Operating within an even more conflicted space than their conserva-

tive counterparts did, women of the opposition throughout the period of this study found transnational feminist networks central to their ability to work against the oppressive regimes of Trujillo and Balaguer and for the creation of a more equitable and sovereign Dominican state. Given the tensions of the Cold War, their efforts to create what Jocelyn Olcott terms "feminist counterpublics" served to push discussions of basic human rights toward the forefront of the public discourse.[26] Through their engagements with solidarity movements in various forms, women within the opposition challenged the international community to stare directly into the destructiveness of authoritarian rule and not avert its eyes.[27] Given that several of these networks were based in the United States, some with clear ties to governmental agencies, the vision of an uncomplicated anti-imperial leftist feminism gets blurred. Yet, as Jessica Stites Mor argues, it was precisely the local actors who had strategically located themselves within transnational networks of solidarity that "shaped Cold War struggles into languages of anticolonialism, socioeconomic rights, and identity that transformed political subjecthood" and challenged the basic geopolitical assumptions of the period.[28] These networks of feminist solidarity serve as a window onto the (in)stability of authoritarian regimes in the face of international pressures and the role Dominican women played in directing a political agenda that demanded equality and fair play. Working in support of anti-imperial, anti-authoritarian, and antisexist agendas, these groups of U.S. and Dominican activists served at once to complicate an authoritarian mirage of democratic politics and contribute to an international gaze that would prove to be at a minimum unsettling to the state's patterns of paternalism.

Dominican transnational actors demonstrated that global engagement was a variegated process of interchange. Certainly, many efforts at political change and feminist advancement failed precisely because of the imperialist positionality of North American counterparts, often so humorously seen in their total naïveté to the realities of Dominican life.[29] Yet it is not my goal in this study to ask if such solidarity and transnational networks worked per se but rather how they created exchanges of information that substantially affected the political and social agendas of their Dominican counterparts. Margaret McFadden illustrates in her work on nineteenth-century international women's activism that the "golden cables of sympathy" served much larger ends than their immediate impact might indicate.[30] Ultimately, the creation of dense networks of feminist

and human rights activism enabled the growth of a robust Dominican feminist movement in the late 1970s.

Taken as another form of transnational engagement, U.S.-Dominican solidarity is a central element in the successes and failures of women living under authoritarian rule. Within the growing body of work on women's political activity in Latin America, scholars have begun to pay attention to the intimate connections between gender and global interactions among nations. The involvement of women in international relations at all levels is a key component in an understanding of their mobilization and the strength of more informal networks of foreign interactions.[31] In the end, transnational feminism, as a theoretical construct describing an amorphous collection of collaborations, cooperations, and exchanges among individuals and groups from different countries with the end of achieving greater rights for women has been a tool of feminist activists across the globe and particularly in the Americas for decades. Dominican feminists, well aware of these possibilities, sought to secure the greatest advantage for themselves given the often oppressive weight of authoritarian rule and U.S. imperial ambitions. In this book I examine the inherent irony that while the regimes of Rafael Trujillo and Joaquín Balaguer exerted tremendous effort to shore up the lines of Dominican nationhood, they wittingly and unwittingly engaged women in a political discourse that imagined communities far beyond those limits in ways that had tremendous impact on the stability of the nation-state, the function of state-to-state interactions, and the strength of feminist activism.

In reconstructing the narrative of the pre-dictatorial growth of a transnational feminist movement and the gender politics of nearly five decades of authoritarian rule through this study, women across the ideological spectrum surface, playing a central role despite a popular narrative that says otherwise. Michel-Rolph Trouillot argues that the silences that occur in the past are a product of a multilayered process, one complicated by the violent thirty-year dictatorship and its twelve-year continuation under Balaguer.[32] Creating a new "usable past" after authoritarianism entails a process of what James Wertsch calls "narrative repair."[33] As in the case of the Franco dictatorship, this process is impacted significantly by the past "abusive and repressive use of the concepts of nation and patriotism" of the regime.[34] In the silences surrounding women's political engagement with the authoritarian state, the seemingly usable elements of the near half

century of authoritarianism have entailed depicting women predominantly as angelic, motherly victims who testified to the oppressive nature of the regime or as single and dangerous co-conspirators who carried blame for the viciousness of the state.[35] Looking beyond these one-dimensional archetypes one finds that individual activisms, regardless of affiliation, were built upon a foundation of feminist action and engagement from the earlier part of the century and utilized the regime's deliberate yet unintentional mobilization of women in various ways. Since the turn of the twentieth century, Dominican women have taken careful advantage of these political openings and pressed their advantage as nurturers and caretakers—often channeled through transnational networks—for social and political advancement however they envisioned it. They have intervened regularly in the public life of the nation, transcended the domestic sphere, and contributed to the meaning of politics and the rule of law. Giving voice to their activism not only breaks some of the silences but adds a layer of gendered narrative repair by confronting the involvement of women in politics prior to and during the long stretches of authoritarian rule.

The mythification of women in popular representations of the Dominican past does a disservice to the historical record, both for understanding the contemporary role of women in the Dominican state and its international agenda and for a more thorough comprehension of the legacies of dictatorship. Unfortunately, the effort to reconstruct a painful period in the national narrative has enacted symbolic violence on women and groups similarly marginalized that serves to replicate the actual violence that surrounds the Trujillato and Balaguerato. Dominican journalist and feminist activist Susi Pola pointed out in 2014 following the nation's independence celebrations that the failure to recognize women in crucial moments in the country's history, a form of "latent violence," serves only to perpetuate myth, ignorance, and inequality.[36] The construction of violence is central to the dichotomous martyr versus whore vision of women in the Trujillo regime and is inextricably linked to Dominican female sexuality. Lizabeth Paravisini-Gebert finds in her study of women in recent Dominican and Haitian literature that the histories of both nations "have left deep lasting scars on the bodies of Dominican and Haitian women trying to survive and thrive in political systems where women's bodies have been subject to rape, torture and dismemberment as a method of political control."[37] She exhorts readers to look to the "possibilities of transcending a history of

political abuse that has left its indelible imprint on the bodies of the women of Hispaniola."[38] The continuation of this symbolic violence exerted upon Dominican women of the past is evidenced by the novels of Julia Alvarez, Junot Díaz, and Mario Vargas Llosa. Díaz' *The Brief Wondrous Life of Oscar Wao* and Vargas Llosa's *La Fiesta del Chivo* perpetuate the myth that Trujillo used sexual coercion as a dominant form of social control and was only interested in women so far as they could provide him with sexual pleasure.[39] Dominican national insistence that the shocking 1960 murders of the three oppositionist Mirabal sisters by the Trujillo regime was the definitive beginning of the end of the regime affirms the power of sexual violence in the narratives of the dictatorship and, particularly when coupled with the pervasiveness of Alvarez's version of the tale, further inscribes violence and loss onto the bodies of women.

Public understandings of Dominican history have favored facile categorizations of marginalized groups in service to the grand narrative of nation. Women, like Afro-Dominicans or the landless poor, appear when needed to reinforce the triumphs of the Dominican people or as evidence of the nation's failures due to the power and corruption of isolated individuals. The absence of women in Dominican popular histories is a product of this tendency and its creation of these dualistic categories.[40] When they appear, their images serve as an easy substitute for a more substantive treatment of gender.[41] As with other marginalized social and economic groups, the role of prominent women has been viewed almost exclusively as contributing to the success or failure of a usable national identity, or *dominicanidad*.[42] The majority of the narratives that do address women's presence in the Dominican past are often little more than lists of prominent figures and their accomplishments.[43] Most commonly, these books trace chronologically the Dominican women who have established themselves in society in some way. While a number of women appear in the public sphere, the effect is the same: a laundry list of "firsts" that says little of either the context in which these women were struggling to establish themselves or the changes their struggles engendered. In the end these narratives, although highlighting women's contributions to the nation, simply place them within the male-centered periodization using the same requisites for public and political importance employed for male figures and do not interrogate the effects of a masculinized political culture or national narrative.[44]

In recent years some scholars have attempted to reconfigure the existing

popular historiography in order to chart more comprehensively the path of women's politicization in the Dominican Republic. Their studies build upon the work of Dominican scholar-activists like Margarita Cordero, Magaly Pineda, and Ángela Hernández who throughout their careers have steadfastly refused to accept standard historical categories that exclude women and have worked to refocus the Dominican narrative onto issues in which female participation changed political, social, and economic realities.[45] The founding of the Center of Gender Studies at the Instituto Tecnológico de Santo Domingo (INTEC) in the early 1990s proved an important turning point in academic assessments of gender and the past and spurred an interest in university and graduate level gender studies on and off the island. Subsequent scholarship has built upon the center and its conferences as well as previous work by Dominican feminist scholars to begin to correct the imbalances seen in popular understandings of the past.[46] Much of the most recent work has explored women's diverse engagements with the Dominican state to uncover what Elizabeth Dore and Maxine Molyneux term the "changing modalities of state/gender relations."[47]

The role of women as integral players in the Trujillo regime has recently been given greater scholarly attention. In her intricate treatment of the inner workings of the dictatorship, Lauren Derby highlights the ways Trujillo used women in his life "as a foil for [his] multiple masculine identities" and how "each female relationship revealed a different facet of his power."[48] Early histories of the dictatorship summarily dismiss women's political involvement with the regime which Derby roundly refutes, yet her work does not center on the women who operated within the party machine.[49] Neici Zeller argues that female presence within the regime was significant even if it was, in the end, itself highly symbolic.[50] What Zeller's work makes wonderfully clear is the manner in which the women of the regime carefully negotiated the shifting terrain of the Trujillato. Similarly, April Mayes points to the early feminist movement in the Dominican Republic to highlight the way Trujillo "leaned on activist women" to turn his nationalist ideas into "daily practice."[51] Mayes focuses specifically on the discourse of *hispanidad* in the regime's engagement with feminist activists in its first years. Ginetta Candelario emphasizes that this nascent development of feminist ideology in the Dominican Republic was intimately linked to the involvement of women in the transnational arena.[52] Building on these strands of research I contend that women's interactions with the Trujillo regime and its na-

tionalizing discourse were symbolic and highly practical and transcended single-issue politics and national boundaries to connect to larger themes of citizenship, sovereignty, and the viability of authoritarianism.

Like the earliest studies of the Trujillato, the extant literature on the *doce años* of Balaguer either dismisses women's activism outright or positions it as merely a "strategy of the right."[53] Likewise, little scholarly work on the role of women during the April Revolution of 1965 to reinstate a democratically elected president that brought a U.S. military intervention or on the resistance to Balaguer proposes a gendered analysis of the changing patterns of the paternal state or the implications of U.S. imperialism. I seek in this study to build on the existing corpus of women's oral histories and journalistic accounts that bear witness to women's active engagement with contemporary understandings of sovereignty and state power during the 1960s and 1970s.[54] I employ a broader temporal frame to encompass the Trujillato and the *doce años* in order to chart the changing patterns of authoritarian paternalism and its unexpected relation to the development of transnational feminist activism. The book contributes to two growing categories of gendered historical analysis: by actively considering the role of conservative women and their contributions to the regimes of Rafael Trujillo and Joaquín Balaguer, I interrogate the ways the paternal politics of authoritarian leaders inadvertently fostered a practice of internationalism among feminist and women's groups; and in combining this analysis with an assessment of the women of the resistance and the left, I emphasize the importance of maternalist understandings of female citizenship across the political spectrum to the processes of state building. While the regimes of Rafael Trujillo and Joaquín Balaguer effectively helped to politicize an ever-enlarging group of women through the politics of paternalism and fostered an embedded understanding of the fatherly state and the mothering female politician, they also served as the catalyst for the creation of diverse female engagements with broader understandings of national identity, Dominican sovereignty, and women's rights that would echo into the twenty-first century.

Envisioning Dictatorship and Inter-American Politics

Recent studies of dictatorship have begun to reassess the strength and longevity of such personalized and often military-based governments through

an examination of non-elite actors, their relations to the apparatus of the state, and the general mechanics of exchange between state and citizen. Older scholarship on dictatorship in Latin America has mostly emphasized the violent, repressive, and fantastical elements of dictatorial rule, reinforcing popular images of dictators as power-obsessed madmen.[55] Trujillo and less so Balaguer have been evaluated through this lens in their characterization as megalomaniacal, eccentric, and ultimately power-hungry and corrupt leaders of a backward nation. As Richard Turits accurately notes, such cartoonish depictions do little to advance our understanding of long-standing regimes that clearly could not have maintained their positions through mere force.[56] They serve to reinforce the misconception that Caribbean history is not worth serious study, given its constant tropes of corruption, tragedy, and madness.[57] By incorporating concepts of popular consent, recent work on dictatorship across Latin America has begun to explicate more fully the construction and maintenance of power by long-running authoritarian regimes.[58] Jeffrey Gould points out that in Nicaragua, the Somoza regime relied heavily on the support of the rural working class to maintain its position.[59] Turits demonstrates in the case of the Dominican Republic that beyond the use of force and intimidation, Trujillo actively attended to the concerns of the rural landowning class.[60] While neither Trujillo nor Balaguer relied as heavily upon working-class support as a leader like Perón in Argentina, their active attention to at least a portion of the agendas of the rural and working poor solidified a base of their long-standing power and worked against the possibility of a countryside-based toppling as seen in Cuba.

As self-constructed men—and by extension, fathers—of the people, Trujillo and Balaguer acted to consolidate support of these groups, with uneven success, yet also knew that consent for their regimes came through various channels. Through what she terms the "choreography of consent," Lauren Derby details the many public rituals and projects used by the Trujillo regime to draw in the support of the people on "a more murky quotidian terrain."[61] These types of activities—particularly those that involved women and the working poor—were essential components of the success of Dominican politics of paternalism. However, particularly under Trujillo, the Dominican state actively cultivated an expanded citizenship that not only extended greater civil and political rights but encouraged involvement in newly created bureaucracies at local and national levels. The combina-

tion of consent from this newly mobilized group and certain levels of coercion helped to maintain the Trujillo regime and Balaguer's *doce años*. Women, as part of this expanded citizenry, served to support and legitimize the façade of democratic consent constructed by both leaders.

The example of Evita—who exemplified Peronism's benevolent and maternal face—reinforces the importance of women to the everyday interactions between citizens and the state that upheld the structure of authoritarianism in Argentina.[62] As the public visage of a healthy home and nation in the Trujillo and Balaguer regimes, women served as ideal participants in such state spectacles but also functioned as the liaison between the national and the local. Ever cognizant of their role in maintaining the nation's image as modern, progressive, and developing, Dominican women used their positions in the transnational arena to further their varied feminist agendas. Whether performing democracy, anticommunism, or development, women operating in the political arenas of Dominican authoritarianism served as a public display of their respective leaders' progressive politics and willingness to conform to the inter-American diplomatic terms dictated by the United States. From the Good Neighbor Policy through the Cold War, women for and against dictatorial regimes across the region have contended with varying degrees of U.S. pressure and leveraged the dictates of foreign-local interactions for individual and collective advancement.

Recognizing the shifts in U.S.-Dominican relations from the late 1920s through the late 1970s helps chart the course that female politicians navigated through the Trujillo regime, the tentative transitions into and out of democracy in the early 1960s, U.S. occupation in 1965, Balaguer's twelve years of *continuismo*, and ultimately to negotiated elections of 1978. Their activism highlights the structure and function of authoritarian regimes but also points to new ways of understanding relations between the United States and its southern neighbors. For approximately the first half of the Trujillato, relations between the two were negotiated through the policies of the Good Neighbor. Central to this policy of nonintervention, as Eric Roorda argues in the Dominican Republic, lay the demonstration by Caribbean and Central American dictators that they "maintained common enemies with the United States: first, the fascists, then the communists."[63] By demonstrating progress and stability, leaders like Trujillo cultivated the façade of that commonality. For women of the regime, their advancement as citizens and involvement in the everyday politics of the nation served as

an image par excellence of the modern nation. Conversely, the very fabric of the dictatorship seemed to tear slowly as women of the opposition demonstrated across the Americas that the Trujillato could no more maintain its stability than it could protect the nation's homes and families. As the post–World War II era brought on new realities and struggles with dictatorial regimes, Trujillo sought to demonstrate to the U.S. government that while he may have been, in a notorious phrase, an "SOB," he actively promoted the performance of democracy, showcasing himself, at least, as the United States' SOB. The Cold War presented numerous challenges for Dominican women as they worked in the international arena and fought to prove or disprove that the Trujillato was a fit example of a stable democratic regime. As with other nonstate actors across the region, the battles of the Cold War over democracy and communism proved to be as relevant in the politics of the everyday as they were in top diplomatic circles.[64] As members of the Federación de Mujeres Dominicanas (FMD, Federation of Dominican Women) demonstrated after the fall of Trujillo, the discourse of democracy would remain a cornerstone of international activism from the *ajusticiamiento*, his death, through the arrival of U.S. Marine forces in 1965. Cold War politics in the post-1965 era proved to be a complicated mix of *continuismo* and a new set of discourses on egalitarianism and development that Dominican women deployed in various ways depending on their relations to their regime and their particular feminist agendas.

Historians have begun to chart these interventions from the everyday into the grand narrative of the Cold War in Latin America, but the study of women in this process continues to lag behind despite their clear and public alignment with the ideological battles of democracy, communism, and national capitalist development. Despite—or perhaps because of—what Jadwiga Pieper Mooney calls the "deep sexist consensus" of the Cold War, Dominican women demonstrated that quotidian interventions in the local political arena, coupled with transnational activism, served to destabilize more traditional understandings of dictatorial manipulation of global political relations.[65] In looking to the formal politics of elections and political posts as well as the informal network building across communities and national boundaries, in this study I seek to amplify more traditional definitions of the political in foreign relations studies while demonstrating the ways in which looking to women's interactions with authoritarianism alters our understandings of its structure and function.

Dominican Feminism, Authoritarian Feminine Politics, and Maternalism

Throughout this study female politicians, resistance fighters, and government officials have participated in a wide array of activities that both support and challenge the state's understanding of women's roles in society, the role of maternalism in a paternalist political structure, and the social and civil balance of power between men and women. In addition, the relations between public female actors and their understandings of themselves as state participants have ranged widely. Many of the women who resisted the first U.S. occupation (1916–1924) and fought for greater educational and civic rights began to label themselves as feminists; among these was the ambitious journalist Petronila Angélica Gómez, who began her magazine *Fémina* in 1922. Through the mid-1940s many female activists called themselves "feminists" as they worked toward greater contributions and involvement of women in social, civic, and political life. With the solidification of the Trujillato, many participants in the regime began to espouse the label *damas trujillistas* as they turned their efforts to more public assistance–oriented programs, though they maintained the importance of their contributions to the nation. Offen contends that scholars should look to feminism as all efforts that make "claims for a rebalancing between women and men of the social, economic, and political power within a given society, on behalf of both sexes in the name of their common humanity."[66] While the solidification of the Trujillato significantly curtailed the self-labeling of feminism, the women of this study continued to work toward a type of redistribution of power between men and women even if the new lines fell very much along naturalized gender divides. Still, as they mostly eschewed "feminism" as a label, I have framed their activism along their own terms to more justly encompass the way they viewed themselves publicly.

Understanding politics and the function of the twentieth-century state in Latin America through the lens of gender has been a project undertaken by scholars for the past several decades; many studies have offered drastically transformed images of state and nation by examining closely the actions of women in the public arena and through discourses of maternalism. Much of the earliest scholarship focused on movements for legal and political reform, while more recent work has transcended a selective focus on feminist movements to explore the myriad interconnections between

female citizens and state dictates regarding proper feminine roles and behaviors.[67] As many Latin American women's groups have embraced the maternalist tendencies of a naturalized vision of gender and found ways to press its advantage, scholars have interrogated what engaging maternalism has meant for the Latin American state as well as its relations with female and male citizens. Through what Mooney refers to as the "competing uses of motherhood,"[68] Dominican women from the beginnings of the Trujillato to the end of the *doce años* consistently pushed against the often rigid ideals established by state and society for them as mothers. Rather than accept them as given, many of the nation's most politically active women sought to challenge and reshape these difficult prescriptions but also to demonstrate that in their maintenance, women deserved a much larger role in the political process.

Across Latin America recent studies have addressed the centrality of women and specifically maternalism to authoritarian regimes.[69] Margaret Power demonstrates with her analysis of the women who opposed the socialist government of Salvador Allende in Chile that women were integral to the installation of military dictatorship.[70] Sandra McGee Deutsch illustrates that women of the right in the Southern Cone during the first half of the twentieth century staunchly upheld their roles as mothers and patriots in service to various highly conservative agendas. Deutsch points out that this type of "rightist maternalism" is markedly different from the progressive maternalism depicted in most of the scholarship on Latin American women,[71] yet in the case of the Dominican Republic such conservative feminism and women's achievement of suffrage went hand in hand. The conservative women of the Trujillo and Balaguer regimes upheld notions of proper femininity and patriotism while they concurrently reinforced the argument that they were compelling political actors in their own right. This narrative highlights an alternative model of women's political empowerment and tells us much about the relation between authoritarian regimes and their female supporters. Further, as scholars are noting, taking a more critical eye to female activists and the state during periods of civil strife and revolution following dictatorship reveals a narrative beyond the single thread of the glorified female revolutionary. Johanna Moya Fábregas argues that in Cuban history and through the revolutionary government, female independence fighters, or *mambisas*, promoted female activism and facilitated "the public's acceptance of women's participation in revolutionary

programs."[72] However, their model of "self-sacrifice and abnegation" also served to "set a precedent for Cuban women" to continue their dual roles as patriotic mothers and revolutionaries.[73]

Independence fighter María Trinidad Sánchez assumes the symbolism reserved for the Cuban *mambisas* in Dominican history, as she literally gave her life for the cause, dying by firing squad and clutching her skirt around her legs. Several studies attest to the valor of Trinidad Sánchez and her compatriots, and other scholars have looked at the bravery of the women who fought the U.S. occupation, the Trujillato, and the Balaguerato.[74] However, unlike the cases of Chile, Nicaragua, Argentina, and Brazil, the scholarship on the conservative women of the Trujillo and Balaguer regimes has only begun to scratch the surface.[75] Mayes argues that the historic reluctance—even dismissiveness—of such conservative women's movements results in a divided historiography and a reticence of contemporary feminists to address authoritarian women as part of their own history. Mayes contends that these two historiographies separate the study of "exemplary Dominican women and feminism" and the relatively ungendered treatment of authoritarianism.[76] Like Mayes, I am seeking to connect authoritarian states and women's activism in the Trujillo era, but through this study I also link these two entities through the twelve years of Balaguer to make more explicit the connections between the paternal politics of authoritarianism, women's engagement with the state, and the Dominican transition to more democratic practices in the late 1970s.

Scholars have increasingly recognized how an extended period of women's mobilization across the political divide has contributed to the growth of a second-wave feminist movement or to the development of democratic transitions across the region. In her recent analysis of the Nicaraguan first-wave feminist movement and the Somocista women's movement, Victoria González-Rivera asserts that her approach to look at them jointly helps shed light on "some of their similarities and the shared 'demons' of the two different groups and ultimately to better understand the lasting legacies of the pre-1979 period."[77] Here I argue similarly that the Trujillo women's movement and the feminist activists of the resistance and the 1965 revolution shared the common demon of the paternal protections of the Trujilloist state. Whether they were fighting to defend or dismantle the regime, the legacy of paternalism structured a particular political approach that foregrounded women's innate maternal contributions to the Dominican

home and national family. In addition, the growing body of literature specifically focused on gender and democratization illustrates that women are central to the move toward more democratic systems. Elisabeth Friedman contends that gender is "embedded in the process of the transition to democracy."[78] In her study she finds that women, despite their efforts, were actually hindered in their ability to become involved in the democratic transition in Venezuela. Conversely, Sonia Alvarez argues that the rapid changes in women's roles following the demise of the military dictatorship in Brazil led to women's massive participation in the country's transition to democracy.[79] Just as Joaquín Balaguer ceded presidential power to negotiated elections in 1978, Dominican legislators passed fairly sweeping new regulations granting greater rights to women. The fact that the two happened concurrently was not a coincidence, and the significance of female participation in the political process across the twentieth century demonstrates the relevance of the Dominican case to periods of transition and regime change regionwide.

I contend in this book that the participatory experiences gained by women under authoritarian regimes and the various responses to the politics of paternalism led to the involvement of women in transitional periods of rule and ultimately the redevelopment of feminism in the 1970s. Although women of the left were often motivated across Latin America to join second-wave feminist movements precisely because of the contradictions created by authoritarian regimes, the movement of conservative women into formal political spaces in periods prior to transitions aided in the coalition building that would help make such movements politically possible. By the late 1970s in the Dominican Republic, both sides came to recognize that while they had made great strides in advancing the political agendas of their respective parties or programs, the neglect of larger issues of gender egalitarianism left them seeking a potential avenue for the democratization of Dominican society that included even greater equity. As evidenced by their efforts into the present, the legacies of authoritarianism, however, remain a powerful and constricting force in all efforts toward that greater good.

This study begins by examining the rise of a feminist movement in the 1920s that was intimately connected to the struggle for sovereignty under the first U.S. occupation. I argue in chapter 1 that this mobilization of women into the public sphere as teachers and workers provided the foun-

dation from which the Trujillo regime engaged women in the politics of the dictatorship through the rhetoric of maternalism and appropriate modernity. Shortly after assuming the presidency in 1930, Trujillo formally acknowledged the nascent Acción Feminista Dominicana (AFD, Dominican Feminist Action) and began fostering a special relationship with its membership while the women themselves continued actively nurturing relations with the inter-American community. Their work in the pan-American arena exerted a level of pressure on the regime for change but also inserted them as key leaders among a group of burgeoning female politicians and helped garner suffrage in 1942. More importantly, their work solidified the model of maternalism and proper modernity that would anchor their role as the foil to Trujillo's masculine public image as well as the performance of democratic politics in action.

For the next several years, the Dominican Republic witnessed the official incorporation of women into Trujillo's party structure through their roles as nurturers and caretakers as well as the expansion of female leadership under the new Sección Femenina of the Partido Dominicano (referred to alternately as the Women's Section and the Women's Branch of the Dominican Party) and the flurry of activities planned to celebrate the purportedly enlightened politics of the Trujillato. For the remainder of the regime, Dominican women carved out spaces for themselves in state and party structures and in the international arena; they ultimately demonstrated their indispensability to the dictator in their capacity as skilled politicians by directly employing the regime's own discourse of democracy and anticommunism. Chapter 2 charts the activism of the cadre of elite women from the granting of suffrage through the end of the Trujillo dictatorship and examines their national and international efforts. I address the shifting of feminine leadership that began after suffrage, given the difficult compromises this group of activist women confronted under the harsh rules of dictatorship. As representatives of the Dominican nation, the now-dubbed *damas trujillistas* positioned themselves as the ideal symbol for the tranquil home and the perfect prop for a regime struggling to present itself in a democratic light in the midst of World War II. Despite the reorganization of the Sección Femenina of Trujillo's official party, these women doggedly pushed for continued spaces of engagement with the regime. On the one hand they continued their activism within the inter-American arena, while on the other they worked to create new clubs and groups that linked the

international component with the local rhetoric of democratization and anticommunism. I argue that female participation continued to be central to the functioning of the regime's international reputation and domestic welfare programs but that this same involvement would also serve as a catalyst for many other women to challenge the deployment of this maternalist vision and subsequently join the resistance movement.

Chapters 3 and 4 examine resistance to the dictatorship through the lens of gender as well as the roles women played in reshaping the nation following the death of Trujillo and U.S. neocolonialism continued in the form of the 1965 Marine invasion. Across these twenty-plus years, Dominican women sought to remake the nation around the often conflicted discourses of maternalism and full female participatory citizenship. As documented in chapter 3, Rafael Trujillo was "brought to justice" by the bullets of six men in May 1961, yet Dominicans acknowledge that it was precisely the regime's murder of the Mirabal sisters the previous year that initiated its demise. Scholars and citizens have yet to truly deconstruct the three sisters' martyrization other than as the most horrific of many horrific acts that ultimately spurred individuals to action. By looking at women's resistance activities on the island and in exile as well as the rhetoric that surrounded mothers and wives within the movement, I contend that it was precisely the increasingly intimate violations of women and traditional gender roles that doomed the regime of Trujillo. I argue for not only a physical inclusion of women in the narrative of antidictatorial politics but also a consideration of the role of traditional familial and feminine "protections" in the upending of a thirty-year regime. Women pointed out—to both domestic and international audiences—the failure of the regime to protect femininity and national morality, and as a result, that led the way to the regime's demise.

Following the fall of Trujillo and the departure of his family, Dominicans sought to rebuild the electoral process through a plethora of new political parties and candidates; women were central to the attempted democratization of the nation. Chapter 4 addresses three interrelated strategies employed by women to reconstruct the body politic in the face of drastic political transition, a second U.S. occupation, and general social upheaval. Dominican women again called on the rhetoric of motherhood and maternalism in support of a return to domestic tranquility and for a nation free of dictatorial politics and foreign meddling. Political participation by women served to demonstrate a re-envisioning of the nature of Dominican politics

through their burgeoning support of full gendered equality. And as now long-term members of a number of inter-American organizations, they called for continental solidarity to return sovereignty to Latin American nations plagued by foreign intervention, particularly their own. Seen especially through oral histories of women involved in the 1965 resistance, the hopes for a truly equal participatory democracy and national sovereignty were present equally with a pervasive cynicism that their male compatriots were not prepared to accept such change despite their revolutionary discourse. In sum, the brief period between the fall of Trujillo and the rise of his longtime crony Balaguer held the potential for maternal politics as a form of national healing as well is its limitations for creating true gender equity.

In the last two chapters I return to the politics of authoritarianism, looking at the policies and practices women enacted during the twelve-year rule of Balaguer (1966–1978) that ultimately led to a greater focus on a national politics of gendered equity. In chapter 5 I analyze the multiple strategies of negotiation employed by the women governors who were assigned to a difficult job in a seemingly powerless post. For the loyal women of the *doce años*, understanding and embracing their roles as mothers and caretakers of a "new democracy" was central to their place as official politicians of the regime. I argue that the women governors maintained their positions and used their leverage as mediators between the local and the national to obtain resources for their constituents and recognition for themselves. The role of international activism, as highlighted in previous chapters, was an equally important tactic for the *balagueristas*, particularly in the ways the governors worked with the League of Women Voters' Overseas Education Fund to create networks of involved and politicized women. Utilizing multiple forms of participation legitimized the positions of the women in the politics of the Balaguer regime and ultimately vastly expanded female political participation. Yet in the end, it was also still a model centered on the fundamental and essentialized differences between men and women, deftly tied to an internationalized vision of woman as peacemaker, and anchored in a highly authoritarian regime.

Despite the efforts of the Balaguerato to portray itself as a progressive and developing state, many activist women found Balaguer's promises of peace exacerbatingly empty. In the late 1960s and the 1970s women across political lines began finding both authoritarianism and socialist

opposition to be failing in bringing about true gender equity. Chapter 6 addresses the ways in which many activists interrogated the role of government in the regulation of individual women's lives and families. Women built community associations and interest groups to demand accountability from a government that had labeled itself "democratic," particularly in terms of the protection of mothers and families. Challenging the regime's argument for a "revolution without blood," they described the government's agenda to national and inter-American audiences as "blood without revolution." I contend that women continued to mobilize within the opposition through the discourse of motherhood and family in a way that was especially salient given their general marginalization within the larger structures of the left. Yet the period was also a time of growing realization that the politics of maternalism could only accomplish so much. Coupled with an ever-deepening awareness of the tools and tactics of international second-wave feminism, many women began publicly challenging a model of political participation that constructed their roles as nurturers and caretakers.

The Paradox of Paternalism concludes with an assessment of the gendered politics of the final three years of the *doce años* within the context of the increasing attention on global feminism and the democratic transition from Joaquín Balaguer to Antonio Guzmán in 1978. As one of the last years of the twelve-year reign of Joaquín Balaguer, 1975 was also International Women's Year. Particularly during these last three years, female opposition activists found fertile ground in the platform of global feminism from which to push for change in the business-as-usual model of *continuismo* practiced by the regime. Their increasing disappointment with their male counterparts in the opposition pushed forth a more active and gender-conscious agenda. Although the shifts were subtle, a clear difference in tactics manifested itself as women advocated a more aggressive platform of feminist rights. As a result, clear cross-party alliances formed among women and led to the legislative reform relative to women's rights that occurred shortly before the brokered transfer of power from Balaguer to Antonio Guzmán's Partido Revolucionario Dominicano (PRD) in 1978. Through these transformations the grounding of modern Dominican feminism can be seen as linked to its early predecessors of the 1920s while also embedded in the fifty years of engagement with authoritarianism and transnational activism.

Throughout the thirty-year dictatorship and twelve years of authoritarian rule that followed in the Dominican Republic, women were fundamental to the paternalistic politics of Trujillo and Balaguer. Participation at the local, national, and international levels allowed women to uphold the status quo while also pushing for large-scale change in the political environment that would eventually result in a democratic transition in 1978 and the regrowth of a feminist movement. In *The Paradox of Paternalism* I maintain that the ways women participated politically in official and unofficial spaces is crucial to any understanding of authoritarianism as well as regime transition and democratization within a larger, transnational context. Besides explaining how women mobilized maternalism in service to politics, the study demonstrates how this involvement laid the foundations for the redevelopment of a feminist movement in the Dominican Republic in the 1970s through its thoughtful political participation in international networks and local contexts. Throughout the period of the study, Dominican women took part in a battle that was waged through the everyday yet played out in highly visible public and often transnational arenas. In the end, I argue, the impact of women's political mobilization on the apparatus of authoritarian rule can only be fully understood through an analysis of women's participation on all levels and all points of the political spectrum. The paradox of paternalism, then, becomes most clear as women of varying political ideologies at once engaged with the protective and paternal discourse of the regime while actively undermining its conceptual weight with their regular involvement in the public arena of politics.

1

Advocating Suffrage and Sovereignty

Pan-American Feminism and the Rise of the Trujillato, 1922–1942

COMMENTING IN THE INAUGURAL EDITION of her magazine *Fémina* in 1922, San Pedro de Macorís resident and feminist Petronila Angélica Gómez wrote that in such an "hour of adversity" as her nation faced, women not only merited an intellectual position in society but were crucial to creating a viable future for the Dominican state. "This humble magazine," she noted, would serve as a small tribute to women's place as actors for "the good of liberty and culture of the country."[1] From her call to arms in 1922 through the beginning of the Trujillo regime in the 1930s, a feminist movement developed in the Dominican Republic that demanded recognition for the role of women in raising future citizens, debating issues of nationalism and sovereignty, and engaging with issues of transnational import. The hour of adversity of which Gómez spoke was indeed a serious one, as the U.S. Marines had been occupying the country since 1916. While this moment marked a crucial point in the advancement of women's rights in the Dominican Republic, it was deeply entrenched in events of the previous twenty years and would prove foundational in situating the movement politically and socially as it adapted to the dictatorship of Rafael Trujillo.

The years that preceded Gómez' clarion call and Trujillo's rise to power in the Dominican Republic brought women into the public sphere in various ways. Between 1900 and 1930, the efforts of liberal-minded education reformers, an eight-year occupation by U.S. Marines, a growing middle class, urbanization, and a nascent women's movement combined to significantly increase the presence of women and young girls in education, social reform, and even protest movements. A consistent theme in national debates about women's public presence during these years was how

the modernizing state could make room for the "modern" Dominican woman while maintaining its structure of paternalistic protections. Ultimately the much sought-after connection between acceptable modernity and proper womanhood through the model of the secular schoolteacher would provide the ideal platform for Trujillo's politicization of women. He would continue to mobilize the group of activists through a project of nation building precisely because they had managed to demonstrate their support for Dominican sovereignty and tradition while upholding select traits of western progress and emphasizing their maternal contributions. As a result, the regime's construction of a new vision of paternalist politics and masculine identity was at once unique but also built upon the previous years of transformation of women's roles in the state.

Dominican feminists who operated within the transnational arena during the first twelve years of the Trujillato built their work on several decades of previous women's activism yet adroitly adapted to new national political discourse and a changing global environment. Within the larger context of pan-American relations, the 1930s and early 1940s demonstrated a shift in interactions between Caribbean nations and the United States.[2] The formulation of the Good Neighbor policy represented the efforts of U.S. diplomats to offer the carrot rather than the stick in its relations with Latin American states. For their part, many Caribbean nations sought to prove their advancement and progress in the pan-American arena, and no one excelled at this display more than Trujillo.[3] Dominican women understood the stakes of this geopolitical posturing from the very inception of the Trujillo regime.[4] Their efforts were inextricably linked to the regime's reliance on its international reputation and its practiced façade as a democratic nation. International activism for Dominican women—specifically affiliation with the Inter-American Commission of Women—became an important element in the women's movement in the early 1930s with the rise of the dictatorship.[5] Enabled by the desire of the dictator to present the country in the most favorable and democratic light, Dominican women were able to use the international arena to press for changes at the local level, even if that space was still much encumbered by the presence of an overwhelmingly authoritarian and paternalist regime. The *feministas trujillistas* employed the rhetoric of egalitarian rule to assert their place in the theater of democracy that Trujillo had begun to act out locally for the international stage. Enacting

publicly what the international community expected of the modernizing nation-state was key to the longevity of the regime as well as to the advancement of women's political rights. Politically active women, by this point well versed in international politics, assimilated the discourse of democratization into their everyday discussions of feminism and the Dominican state.

Although Trujillo vacillated in the type of assistance he offered women of the "feminist movement," he, in his words, "had never hesitated in backing the just cause of the woman."[6] Dominican feminists, in turn, learned to carefully deploy their just causes with strategic intent. Feminism, for those women who accepted the regime's political parameters, was not an attempt to reformulate the philosophical underpinnings of a paternalist dictatorship but a struggle for recognized equal rights and participation in political life as it was. The idea that women brought an element of tranquility, peace, and justice to the boisterous world of politics remained a constant touchstone for women's continued participation in the government of Rafael Trujillo but also served as a foil for the regime's more violent underpinnings. Rather than endorsing full equity between the sexes, women reminded the regime of their importance as mothers, educators, and peacemakers.[7] This tactic, fully supported in the dictator's plan for the nation and his vision of a virile yet fatherly masculinity, enabled their entrée into politics and served as the continued foundation for many women's increasingly public positions in government and politics.[8] This vision of feminism delineated a specific place for women in the public sphere as moral guardians and social conservators, allowing them to contribute to the progress of the nation under a dictatorship according to their particular skills and capabilities. Locally and internationally, Dominican women found fertile ground in which to cultivate the idea that they provided "el freno suave" (the smooth brake) to a political system that could get unruly and potentially even uncivilized when managed solely by men. In the end, by proving themselves as skilled, networked, and nonthreatening agents in the nation's show of democracy, the women active prior to and during the first decade of the dictatorship of Rafael Trujillo made themselves central to a carefully orchestrated national and international reputation, garnered concrete political gains like suffrage, and allowed for their continued engagement with the politics of the Dominican state through an intense period of transition.

Dominican Feminism and Politics before Trujillo

Prior to World War I and the U.S. economic and military occupation of the Dominican Republic in 1916, Dominican national politics consisted of several small elite groups competing over social and economic supremacy. The assassination of dictator Ulises Heureaux in 1899 and the chaotic years that followed made room for a group of liberal political thinkers who sought to direct the nation's progress.[9] Although forced to cede control of the nation's customs revenues to the United States in 1907, the liberal constituency was able to implement an agenda of modernization through the rule of Ramón Cáceres and other caudillo rulers.[10] One of the keys to the project of progress lay in liberal, positivist education, which encouraged secular environments and modern teaching techniques. Much like the concept of citizenship at the time, the elite's plans for education were highly exclusionary. While generally praised and given significant capital by the late-nineteenth century residency of Puerto Rican positivist intellectual Eugenio María de Hostos, the project still only managed to incorporate a small percentage of mostly upper-class women into the nation's embryonic school system.[11] Nor was the project an endeavor that received full support. Teresa Martínez-Vergne demonstrates that for the first twenty years of the century, elite society faced a paradox: how to incorporate such elite women into the larger concept of nation while limiting their avenues of participation.[12] As she notes, "Bourgeois women were entrusted with the task of raising the new generation of citizens" and, it was often argued, should be educated but not so as to encourage the abandonment of their expected duties of home and family.[13] Women were seen as lacking the full capabilities to participate in the intellectual world, particularly when it meant combining these new tasks with the sacred duties of the home. The delicate balance for women between the home and the life of the mind was not a concern unique to the Dominican Republic. As several scholars have indicated, Latin American liberal elites were keenly aware of what they viewed as women's innate connection to teaching—as mothers—and the need to selectively educate and employ them as "agents of secularization and modernization."[14] A number of Dominican women, having been trained as *normalistas* (primary school teachers) at the end of the nineteenth century and claiming the role of cultural transmitters, worked for expanded education for women and for greater opportunities to contribute to civil society.

One woman played a central role in the advocacy of female education in the Dominican Republic precisely because she carefully fused liberal education with a dedication to motherhood and vigilant attention to the nation and its progress. Despite her death several years before the turn of the century, Salomé Ureña de Henríquez, poet, essayist, mother, and patriot, wrote extensively about the need for public education for young women.[15] The symbol of women's education for this period, she started the Instituto de Señoritas (Young Ladies Institute) in 1881, a secular school for young women that ran nearly continuously for the next forty years and significantly expanded educational opportunities for young women of the middle and upper classes.[16] She and her husband maintained a close relationship with Hostos, who worked to establish normal schools across the region and was a particular advocate of education for young women, believing that ultimately all learning begins with mothers.[17] Building on the momentum created by Hostos and other Dominican liberal reformers, Ureña successfully pushed for greater educational opportunities for the young women of the *gente de primera* (elite).[18] Though she ceded leadership of the school to two younger women in 1896 and died shortly thereafter, the group of elite women who continued the liberal tradition of female education in the Dominican Republic created a dense network of *normalistas* who would advocate for an ever-expanding role of women in the progress of the nation in the coming decades. Historian Neici Zeller contends that it was the creation of a network or "sisterhood" of teachers that facilitated women's entrance into the political world and would create a platform of activism for decades to come, including during the difficult occupation years.[19]

Despite a liberal constitution established in 1908 under President Ramón Cáceres, the country's inability to pay on its foreign debt forced it into the position of a semiprotectorate of the United States, which then effectively controlled the Dominican economy and sent Marine forces in 1916.[20] U.S. administration entailed strict fiscal limitations and attempted to reformulate Dominican ideas of civic culture and modernization against which many Dominicans chafed. They continued to direct their own ideas of positivist change through agricultural, educational, fiscal, and infrastructural ventures. The modernization project Cáceres and his followers endorsed, while limited by U.S. oversight, sought to reconstitute citizenship and, according to Martínez-Vergne, chart a "discourse of progress."[21] While many of the elite's liberal ideals found echoes in the policies of the U.S. occupa-

tion, the occupying forces invoked widespread indignation over the total denial of sovereignty.[22] Lauren Derby and others have argued that the United States ostensibly sought to create a "civic culture of democracy" and used schools, roads, banks, and U.S.-styled military government to achieve those ends.[23] Through economic and military measures, the occupation weakened the previously dominant Cibao-region leadership, solidified the political elite in Santo Domingo, and affirmed the importance of sugar as the nation's primary export crop.[24] In addition to strict economic and political controls instituted by the U.S. government, occupiers sought to teach western-style citizenship to their Dominican charges. Turits points out that many of these changes, particularly the encouragement of sugar production, engendered a highly nationalist response among the liberal elite.[25] Reacting to the modernizing and often materialist tendencies of the occupation, many of the Dominican lettered class—men and women—sought both an assertion of national sovereignty and a return to more traditional gender divisions of labor that extended to a critique of women's expanding social roles beyond the home. Concurrently, many middle-class and elite women continued to demonstrate that the modern woman was a benefit rather than a detriment to the nation's quest for sovereignty.

The women who entered into the public sphere during the occupation and the several years that followed provided the foundation for the feminist movement that solidified in the two major urban centers of Santo Domingo and San Pedro de Macorís as well as the reconceptualization of the so-called modern woman. In San Pedro de Macorís, Petronila Angélica Gómez began calling for a greater feminist consciousness with her publication *Fémina*.[26] Five years later a group of women in Santo Domingo inaugurated a cultural and social club for women called Club Nosotras.[27] Branches of the group sprung up quickly in other towns and cities. *Fémina* and Club Nosotras focused on what their founders saw as modest social and cultural goals such as education, art and music awareness, and female intellectual advancement. Gómez and the women of Club Nosotras drew their ideas for women's roles in society from literature emanating from Europe, predominantly Spain, and the Americas, yet they were also fiercely committed to building a sovereign Dominican democracy. Suffrage was initially not the primary target of their efforts, although it certainly was part of the larger discussions of female intellectual capability and civic duty. They defined themselves as feminists, working as women for the betterment of

Dominican society. Gómez asserted in an article defending feminism that "the transfer of feminine activities to the social world does not mean that a woman has to abandon the home, but rather, expand [her skills] to the shop, factory, warehouse, school, municipality, and national government."[28]

This early feminist collective, despite being the object of attack by elite men who feared, among other things, the adverse effects of U.S.-style modernization, did not fall in line with the occupation, as one of the main objectives of the loosely structured movement was the return of national sovereignty. Records of female opposition, especially evident in a weeklong 1920 protest called the Semana Patriótica, demonstrate elite women's own fear of the continued effects of foreign domination and their desire to use the opportunity to reconfigure the image of the modern political woman.[29] The Junta Patriótica de Damas was allied with the anti-occupation Unión Nacionalista Dominicana; junta members' concern was to "protect the Dominican people from the danger of becoming prostituted [to the United States]." They assisted with fund-raising and appeared publicly throughout the week demanding the return of Dominican national sovereignty.[30] Despite an evident elite male desire to use the errant female as a scapegoat for the occupation, women participated in the resistance and solidified the reality that they were moving into the public sphere through work, society, and politics.[31]

Women within the feminist core sought to expand upon and highlight the ways their endeavors outside the traditional domestic sphere brought honor and advancement to the nation.[32] From within the pages of *Fémina*, Gómez and others praised the efforts of the newly graduated and freshly licensed in the professions of pharmacy, law, teaching, and the arts.[33] In 1927 *Fémina* offered space—and its editor's opinion—on a transnational debate over women and the working world. Reprinting the article "Feminismo y trabajo" (Feminism and work) from Spanish feminist Carmen de Burgos that originally appeared in New York's *La Nueva Democracia*, Gómez invited renewed debate over issues of women outside the domestic sphere.[34] Burgos contended that maintaining the argument that women should not work outside the home perpetuated the practice of female enslavement. To be a feminist was not to oppose the ideas of the home or maternity but simply to support the assertion of rights for women.[35] Writer Delia Weber responded that the women within Burgos' Liga de Mujeres Ibéricas e Hispano Americanas (League of Iberian and Hispanic American Women)

were creating discord despite ultimately seeking the same ends. Weber attempted to assure her readers of the Dominican feminist middle ground.[36] As summarized by her colleague Carmen G. de Peynado in the same issue, they simply wanted for the Dominican woman "more rights and protections under the law than [she] currently has."[37] In the end, working women proved essential to the feminist cause when they were able to demonstrate that they could balance their contributions to a greater national good with the maintenance of their maternal roles within the home.[38] Despite the difficulty of that balance, more and more women were finding entrée into the worlds of work and politics.

By the 1920s, Dominican feminists were actively engaging in the transnational arena and using their international participation to demonstrate their importance to the national project of modernization. Gómez served as the model for global networking when she formed an official Dominican affiliate to the Spain-based Liga on May 10, 1925, although she had been working with the international group since late 1922.[39] The transnational organization, formed by Mexican feminist Elena Arizmendi and Burgos, sought to serve as a balance to the predominance of Anglo-Saxon ideals in the pan-American women's movement and create solidarity among women's rights activists around the idea of a shared Hispanic identity.[40] The formal creation of a Comité Central Feminista Dominicana (Central Dominican Feminist Committee) to work with the Liga legitimized Gómez' efforts shortly before Abigaíl Mejía, a young activist mobilized during several years among feminists in Spain, returned to Santo Domingo and began the social and cultural women's group Club Nosotras.[41] Contributors to *Fémina* were highly conscious of the importance of their relationships to international women's organizations. Similarly, Club Nosotras engaged global ideas by inviting foreign speakers to discuss topics related to its focus on women's advancements in art and culture.[42] The women of the *Fémina* collective in San Pedro de Macorís and Club Nosotras in Santo Domingo demonstrated the importance of local discussions of women's rights and advancement set within a context of a more international debate.

Dominican women, however, assented to internationalism on their own terms, demonstrating their marked ability to negotiate the rules of political engagement for the modern woman and for their investment in Dominican sovereignty. At the request of the Pan American Conference of Women, the U.S. military government selected lawyer Ana Teresa Paradas to represent

the Dominican Republic at the 1922 League of Women Voters–sponsored meeting in Baltimore. Paradas rejected the invitation.[43] Two other notable members of the feminist cadre and teachers, Ercilia Pepín and Mercedes Amiama, did the same. Two members of the feminist group publicized their reasons for abstaining from the conference and chided the assembly for not demonstrating solidarity with the Dominican Republic.[44] Printed in *Listín Diario*, anti-occupation activists Julieta P. de McGregor and Alicia G. de Cestero directed their letter to the delegates in Baltimore to "affirm publicly, in the name of Dominican feminism, oppressed and afflicted," that pan-Americanism would never exist so long as any of its members lived "under the yoke of an unjust armed occupation" as existed in the Dominican Republic. In their words and deeds, the early leaders of Dominican feminism demonstrated careful attention to the work-home balance and the primacy of national sovereignty to justify their place in the modernizing state.

Given this level of engagement, the modern Dominican woman conjured by the public imagination in the 1920s looked, on the surface, distinctly different from the generation of Ureña de Henríquez' disciples and elicited elite concern over the solidity of the paternalist model. Several male intellectuals decried the changing gender norms wrought by the eight years of occupation that had brought significant legal changes for women and confirmed existing fears about women in the public sphere. Modernity, which had once been held up as a tentative ideal if executed properly, was now one of the most serious concerns of military occupation and resulted in what Derby terms a "crisis of masculinity."[45] Coupled with the loss of sovereignty, the new rights afforded Dominican women exacerbated men's fears about their inability to provide the necessary paternal protections to uphold a powerful and independent nation. Historian Bruce Calder argues that there was a "male backlash" in response to the years of corrupting examples set by North American occupiers and their wives.[46] As other scholars have argued, a fear of women and specifically their physical presence in the public arena was written into many of the dominant political and social tracts of the day.[47]

Yet despite male fears, women continued to resist publicly the imperialist and potentially corrupting influences of the United States. While the efforts of these women may have borne no fruit in geopolitical terms and certainly caused anxiety over the stability of the traditional gender sys-

tem, they were a clear display of the conviction Dominican women carried relative to the negotiation of national independence and their role in the political agenda. In the face of these shifting debates about the future, Dominican women sought to affirm their contributions as women to national sovereignty and progress. The goal of creating a democratic civic culture had involved, for U.S. occupying forces, the reform of marriage and paternity laws as well as civil rights regulations regarding women.[48] Educational reform instituted by the U.S. Marines had created more opportunities for female recognition; as a result, the country's first female lawyers, doctors, and pharmacists began practicing in the capital and other cities in the late 1910s, and women began entering public careers centered on traditionally female skill sets such as education, philanthropy, and the arts.[49] While generalized anxiety surrounded these working women as they stood at the center of debate about the presence of the modern woman in the public sphere, they outwardly resisted the notion that "modern" could be equated with compromised sovereignty, national subservience, or a degradation of Dominican elite culture through their regular writings and anti-occupation manifestations.

The Rise of Trujillo and the Solidification of Dominican Feminism

In 1924 the United States began the process of withdrawing its troops from the Dominican Republic, significantly altering the playing ground on which feminists would engage with politics. The most consequential figure to step into the political arena in the postoccupation period was a young National Guard–trained upstart named Rafael Leónidas Trujillo Molina. Scholars argue that Trujillo's rise to power was a direct product of the U.S. occupation and his training as a member of the National Guard.[50] As with other occupations during this same time in the Caribbean basin, the United States had established a National Guard as a way of policing the populace and building a loyal national force that could subjugate rival caudillo groups. The Guardia Nacional Dominicana provided an avenue for social advancement outside of the typical class hierarchies in the Dominican Republic, and Trujillo had rapidly advanced through the ranks to become commander-in-chief. He took charge of the nation through a coordinated military coup in February 1930 and quickly solidified his control over rival political factions.[51] His transition to power was facilitated in part

by the crisis of masculinity, and as such it provided the avenue through which he was able to assert his "new masculinity" while concurrently creating space for women to appropriately take up the mantle in service to *la patria*.[52] The change to the Dominican political arena was considerable, and women sought ways to delegitimize claims to crisis through a concerted engagement with Trujillo's new formulation of political participation and national sovereignty.

For Dominican feminists, the new regime portended both problems and possibilities as Trujillo began a profoundly gendered process of solidifying his bases of support and erecting the structure of the so-called Patria Nueva. Emilio Betances argues that Trujillo concentrated power over the nation through his efforts in four key centers of political leadership: focusing on the military that he already headed, establishing the Partido Dominicano (PD) as the sole party, installing loyal supporters in the National Congress, and building up government bureaucracy.[53] Certainly, one of the most significant components of this four-part approach was the attention Trujillo paid to the growth of mid-level bureaucratic posts dedicated to those formerly excluded from the political elite. Through organizations like the Partido Dominicano, Trujillo brought government to the people and involved them in unprecedented ways in public displays of governance. Derby argues that the regime ushered in "a new style of mass participation" that mandated a "political economy" of adulation but also developed a massive bureaucracy.[54] However, what most scholars have glossed over is the careful attention Trujillo paid to women as a potential source for this new bureaucracy. Sensing the potential strength of women as an element of government alliance, Trujillo carefully evaluated the burgeoning feminist movement and set his sights on the Santo Domingo–based feminist cadre. Not only did this tactic serve to fill the ranks with grateful employees, but it offered up an answer to the crisis of masculinity of the occupation years. Dominican feminists, stepping into the pathways of the professions and the formal political arena, could continue their roles as nurturers and caretakers of future citizens while demonstrating their public savvy in a controlled dictatorial arena.

As the Trujillo regime solidified its control over the country, Dominican feminists tightened their ranks, focused their existing agenda, and strengthened their position through continued transnational engagements. The Santo Domingo–based feminists, organized primarily by Abigaíl Me-

jía, formed the Acción Feminista Dominicana (AFD, Dominican Feminist Action) in 1931, a restructuring of its predecessor, Club Nosotras.[55] Founding members of the AFD, who organized in the capital but retained ties to other areas of the country, stated that they could no longer "remain indifferent to the signs of the times and the call of the voices of progress" and proceeded to spread their message and form subcommittees throughout the nation's provinces.[56] Their motto, "Libertad, Justicia y Amor" (Liberty, justice, and love), encapsulated their concern for women's rights couched in a rhetoric of proper femininity.[57] Various conference agendas revealed their belief that suffrage for women provided an avenue to greater national progress and refinement. Echoing earlier arguments, they supported a maternalist feminism that highlighted their inherent capabilities as women. The AFD letterhead read, "We will fight for peace, for the stability of the home, and we support civil equality for the moral, social, and intellectual betterment of women."[58] While their programs approached ways to educate and uplift the mass of lower-class women through a socially acceptable paternal frame, they also provided spaces for women of the middle and upper classes to be present in public life and participate in what they believed to be educational and civic progress.

Dominican feminists continued their quest for international engagement and recognition as the dictatorship took control. They quickly forged strong relations with the Inter-American Commission of Women and its chairwoman, U.S. suffragist Doris Stevens, and sought to use the organization's prestige and expertise to further their local agenda.[59] Formed in 1928 in Havana, the IACW was a pan-American collective intended to push for greater women's rights through the international stage; the Dominican Republic soon became one of the group's most active nations. Despite a relatively negligible presence at the first conference in Havana, Dominican feminists quickly aligned themselves with the group. By 1929 Petronila Angélica Gómez had established a relationship with the IACW and particularly with Stevens. After writing a brief article in *Fémina* about the commission's formation at the 1928 conference, Gómez forwarded several copies of her magazine to Stevens.[60] Members of the AFD, including Minerva Bernardino and Carmita Landestoy, would quickly follow Gómez' example. Soon after the AFD's formation in 1931 two of its founding members wrote to Stevens to report on the new organization, its goals, and its commitment to the IACW. As the "first feminist association founded in the

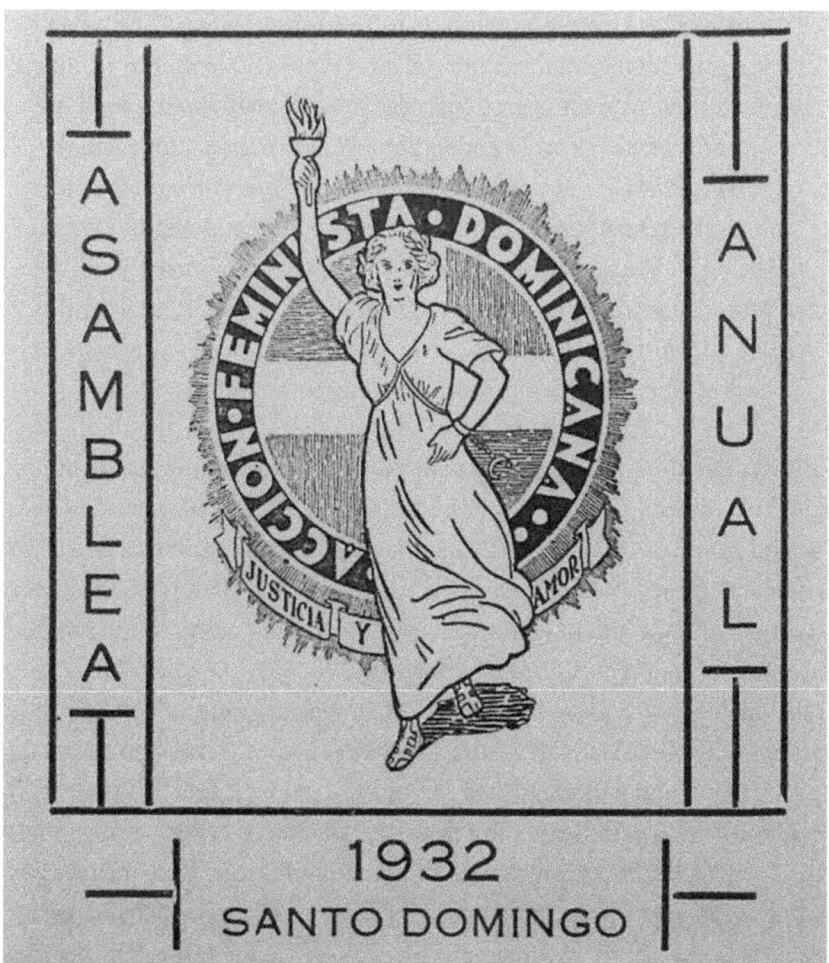

Figure 1.1. Logo, Acción Feminista Dominicana, "Liberty, Justice, and Love," First Annual Assembly, 1932. Courtesy of Doris Stevens Papers, 1884–1983, Schlesinger Library, Radcliffe Institute, Harvard University.

country," they argued that they had finally "awoken and were preparing to struggle persistently to achieve the longed-for triumph of our ideals."[61] This clear insult to Gómez and the *Fémina* cadre would not go unnoticed yet served effectively to streamline the nation's feminist collective and center it in the capital.[62]

In one of their first letters to Stevens the AFD founders argued for their vaunted position in Dominican society and justified their close kinship with the IACW, in effect setting themselves up for attention from the new regime and its desire for international approval.

> We think that so long as the Acción Feminista Dominicana, which is the genuine representative of the great mass of Dominican women since all the women of the country with the best aspirations have grouped themselves in its fold, is already in existence, this same Acción Feminista could create within its ranks the Committee which you desire to help the Commission in its work. Our Government and all other public and private institution[s], have recognized us as the representatives of feminism in the Dominican Republic, and for this reason, it will be easier for us to take steps of real value to the work of the Inter American Commission of Women.[63]

They utilized their relationship with the IACW to emphasize the importance of women's rights to the Dominican president and to streamline their overall agenda. Although their local focus continued to be on education and social programs, they reported to Stevens that the organization was "created with the aim of working at everything that related to the progress of women." In a report on their efforts domestically they mentioned their relationship with Stevens and the IACW in Washington as a point of pride. Stevens, they boasted, had written "very encouraging letters" to the young organization and had composed "a beautiful commentary" on their work in the IACW newsletter.[64] Similarly, they pointed out their many affiliations with feminist organizations in the United States, Puerto Rico, Portugal, Cuba, Argentina, and Peru. In its earliest years, the AFD recognized its collective strength as an organization as well as the favor that might be developed through the creation of transnational networks.

In 1932 Trujillo officially addressed the women of the AFD in a speech at the Ateneo (Athenaeum) in Santo Domingo and formalized their role in broadening his base of popular consent. He aligned the regime with the concerns of women and publicly took up the banner of this early feminist movement. In so doing he echoed the AFD's narrowing focus on political and civil rights and brought them in line with the official goals of the state. He concurrently emphasized the democratic nature of the regime, adding that Dominican society would profit greatly "if our women brought to the civic arena their refinement and their strength."[65] In establishing the importance of female participation in the regime to the moral guardianship and social conservation of Dominican society, he encouraged Dominican feminists' continued role in the international arena and provided the tem-

plate for their transforming political identities. To properly promote the democracy Trujillo sought to display, they would argue that their addition as citizens not only procedurally proved the regime's egalitarianism but also demonstrated his personally progressive and magnanimous nature. Women served to bolster the regime's image of nation as family while also fashioning a place for themselves in the public sphere as defenders of Trujillo. Political legitimacy under the regime for these women was necessary for survival. Further, in drawing these prominent women into institutional circles Trujillo provided for closer supervision, assessment, and mobilization for the years to come. This place would allow women to present a nurturing, progressive foil—domestically and internationally—to the regime's totalitarian reality. However, it also allowed women to participate in a wholly new way in public politics as authorized agents of the Trujillato, and they continued to do so through domestic and international channels through the first decade and a half of the regime.

From its establishment in 1928 at the Pan American Union Conference in Havana, the Inter-American Commission of Women provided political leverage for many Latin American women seeking equal political and civil rights through its focus on specific juridical concerns. As the case of the Dominican Republic demonstrates, the IACW, perhaps counterintuitively, was even more influential for the women of a dictatorial regime; members of the AFD jockeyed aggressively to maintain and publicize their relationship with the international organization. The competition for the much-coveted position of representative to the Inter-American Commission of Women heated up as it became clear that the representative to the initial conferences in 1928 and 1930 would not continue as the regime's official designee. When IACW Chairwoman Doris Stevens learned that the Dominican Republic only had one official (male) representative to the 1933 Pan American Union conference in Montevideo, she first cabled the AFD, asking "if the Government did not send a representative would the feminist organization itself not send someone?"[66] Upon receiving the cable, the AFD printed an appeal "in a box on the front page of the leading Trujillo city daily." Trujillo, sensing an international audience, moved to assign an unofficial female representative to attend the IACW sessions. Initially, the government selected AFD founding member Milady Félix Miranda to represent the Dominican Republic. However, when promised resources failed to materialize, a low-level education inspector named Minerva Bernardino

volunteered to travel with her own funds.⁶⁷ Clearly, the perceived benefits of the alliance between the IACW and Dominican feminists were high.

Following the 1933 conference, presence at the IACW's Washington, DC, office—be it physical or otherwise—proved a key tactic for the women of the feminist movement. Bernardino extended her international engagement with a trip to the IACW following the Montevideo conference. She volunteered on the committee to edit the commission's report from the conference and she also likely positioned herself to supply a summary of the proceedings to *Equal Rights*, the newspaper of the U.S. National Woman's Party, as her picture appeared three times in the eight-page circular.⁶⁸ Bernardino again volunteered at the commission's headquarters during 1935 and was offered part-time paid work in 1936. Another Dominican feminist and AFD member, Carmita Landestoy, also sustained an active interest in the work of the IACW. She made herself known to Stevens shortly after Montevideo, volunteered regularly, and followed up with several of her own trips to the U.S. capital during the mid-1930s.⁶⁹ At the headquarters of the Pan American Union she assisted in the U.S. ratification of the IACW's proposed equal nationality treaty; her youthful energy proved quite useful, as Stevens noted in a photo caption that she and several other Latin American women "worked tirelessly" to get the treaty ratified.⁷⁰ For Bernardino and Landestoy, close connections to a figure such as Stevens offered vastly expanded possibilities from the perspective of Dominican feminists recognizing the onset of an authoritarian regime and its reliance on an international reputation of progress and democracy.

While Minerva Bernardino and Carmita Landestoy continued to correspond actively with Chair Stevens and viewed her as a key component in their respective feminist struggles, they were not alone in their quest for recognition from the international feminist community. As seen in the period prior to Trujillo's recognition of the AFD, active feminists like Abigaíl Mejía and Petronila Angélica Gómez as well as professionals Consuelo González Suero and Gladys de los Santos sought to maintain solid ties of friendship and feminist solidarity with the IACW president. By 1933, trained pharmacist González Suero had signed up to be a member of IACW's research committee, while Mejía regularly wrote Stevens and sent her clippings of her feminist writings in local Dominican papers. Lawyer Milady Félix Miranda and doctor Gladys de los Santos eagerly responded to requests for information on women's rights for the IACW, and many oth-

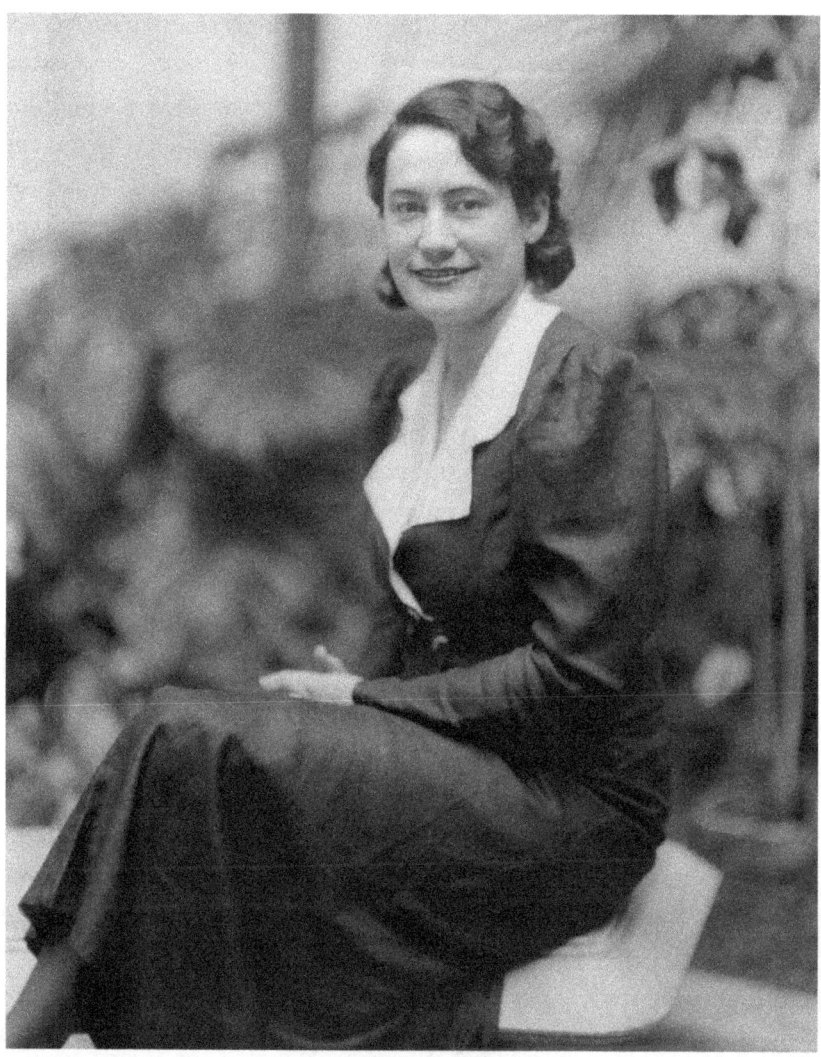

Figure 1.2. Studio portrait of Carmita Landestoy, circa 1934. Courtesy of Doris Stevens Papers, 1884–1983, Schlesinger Library, Radcliffe Institute, Harvard University.

ers sent clippings and reports on women's activism in the political arena, including reelection campaigns. Gómez, who had been corresponding with Stevens since the IACW's inception, continued their relationship, sending her copies of material from *Fémina* and friendly notes and even volunteering to work on the IACW's Committee on Petitions. In sum, the Dominican feminist group employed a highly cosmopolitan strategy as members worked to convince the regime of the importance of women's rights to its overall international reputation.

It was Bernardino who worked most aggressively to establish herself as the sole Dominican representative to the Inter-American Commission of Women and would reap the rewards Trujillo, soon to proclaim himself "Benefactor of Women's Rights," might bestow on such a figure. The stakes at this level of involvement were high personally and politically, as Trujillo gradually revealed his vision for the feminist movement. Some elements of the regime's platform were clear, linked closely to Trujillo's formal recognition of the AFD in 1932. Poet and veteran Pan American Union delegate Tulio M. Cestero stated emphatically at the Montevideo conference in 1933 that his country took pride "in proclaiming that Dominican women have rendered great services in the building up of their country, and that they have been and remain a principal factor in the country's moral and intellectual progress, and, therefore, that the equality of rights shall follow the rhythm of that progress."[71] As was the regime's style, high-ranking officials and the organizing skills of middle- and upper-class women together helped dictate the rhythm of progress. It was slow but certainly not without the influence of women like Bernardino who would subsequently demonstrate to Trujillo their strength in mobilizing future citizens in support of the regime and the purportedly progressive and democratic nation.

Through their public appearances in the United States and the Dominican Republic, their other international travels, and their emphasis on Dominican advancement in the realm of women's rights, the women of the AFD drew favorable international attention to the struggle for democracy and egalitarianism in their country. They actively advocated a model of feminism for the Dominican Republic that aspired to the U.S. women's example and at the same time fit Dominican reality. Overall, they sought to demonstrate to the nation's leadership that the Dominican Republic could serve as a model for women's rights in the Americas. The alliance between the Dominican feminist collective and the IACW changed over the first half of the dictatorship but remained a constant force in calling attention to the political and social status of women and the importance of that position in the construction of a believable democracy.

Nonetheless, Dominican feminists were highly aware of the fragility of their political situation and that their advances pertained to only a small percentage of the female population. In their correspondence with Stevens, Abigaíl Mejía and Gladys de los Santos referred to the new regime and

their need to curry favor and establish prestige with Trujillo. When they reported on AFD's first annual assembly, they asked Stevens to publish the president's speech in *Equal Rights* along with her own commentary and to submit a copy to the leader himself "with the hope that these declarations reach an international audience, something that would add much to our cause."[72] On a prior occasion, provocation by Stevens regarding their progress resulted in a statement on their political caution. Mejía explained that direct work on suffrage had not begun because "we are organizing diligently throughout the nation so that our petitions convey the most possible force."[73] Collectively they were aware of the influence they could create with the new regime if they were able to amass sufficient numbers, and they knew the Inter-American Commission could further emphasize the importance of these statistics. The fledgling feminist organization recognized the strength of the Trujillo regime but was certainly not above using bold measures to draw attention to their cause. In addition to the prestige of being recognized by the commission as an active and well-organized feminist group, AFD members used their connections with Stevens to more effectively lobby for increased opportunities for particular representatives or, in a few cases, greater speed in the passing of certain legislation. On two occasions Stevens wrote directly to Trujillo requesting that he favor Bernardino and Landestoy with positions in Washington so they could continue carrying out IACW work.[74] Ultimately, the AFD's relations with the Inter-American Commission of Women greatly strengthened its bargaining power with the regime.

The initial strength of the AFD gathered around the members' participation in the Inter-American Commission and a carefully orchestrated engagement with the Trujillo regime and its discourse on democracy and stability. As their programs, manifestos, and communication with Stevens indicated, the conservative nature of their feminism placed them as a powerful ally in Trujillo's nation-building project, which he sought in turn to showcase to the world. The program of their first annual meeting stressed women's education in order to prepare the Dominican woman for "when she would be called to cooperate in the realization of programs for the social good of her nation."[75] The well-being and democratic nature of the nation—seen through the eyes of the women and children who could contribute to such a project—was the essential element of the domestic platform of the AFD and ultimately its link between the global

and the local. Although it would continue to serve the collective well as the push for suffrage began in the coming years, it also would prove to be a divisive platform.

Performing Dictatorial Democracy

As testament to their political skills, the growing group of *feministas trujillistas* sought to demonstrate their allegiance to the Dominican leader as the clear answer to their lack of formal citizenship. In order to most clearly convey their readiness for political equality they drew actively on the national and international networks they had built during the first years of the regime and rallied women to support the cause of reelection. In January 1933 Abigaíl Mejía began the process of solidifying the direct link between the vote and the nation's advancement when she called for the AFD to support the reelection of Trujillo, even though women had not yet been granted the right to vote. She proclaimed that the group understood "that reelection is a duty, as it is from this high post that he will try to save the country, saving along with it the rights of the Dominican woman."[76] Bernardino flaunted her work for Trujillo's reelection when she attended the Montevideo conference, bringing with her a scrapbook of clippings and campaign memorabilia.[77] Shortly following an exchange between Mejía, Trujillo, and the AFD, Trujillo promised to grant women a "voto de ensayo" (test or practice vote) in which all the women in the country were to go to the polls on election day in 1934 and vote for or against their own suffrage.[78] The concession served as a plebiscite on suffrage as well as a demonstration of women's ability to show up on election day. Trujillo tasked the AFD with the chores of publicizing the event and mobilizing women to attend. AFD member Livia Veloz wrote that considerable energy was expended by members to get women to the polls in urban centers and rural areas. Trujillo granted them the small sum of one thousand Dominican pesos to conduct their work but made clear that the true test of suffrage would be in their ability to get women to the voting booths.[79] They set out to prove their political readiness and organizational capacity to the regime.

Ultimately Trujillo did not concede women's suffrage after the test vote, although women went to the polls in large numbers, proving the mobilizing and organizational power of the Acción Feminista Dominicana. With only a very short time to organize the event, the AFD drew 96,000 women

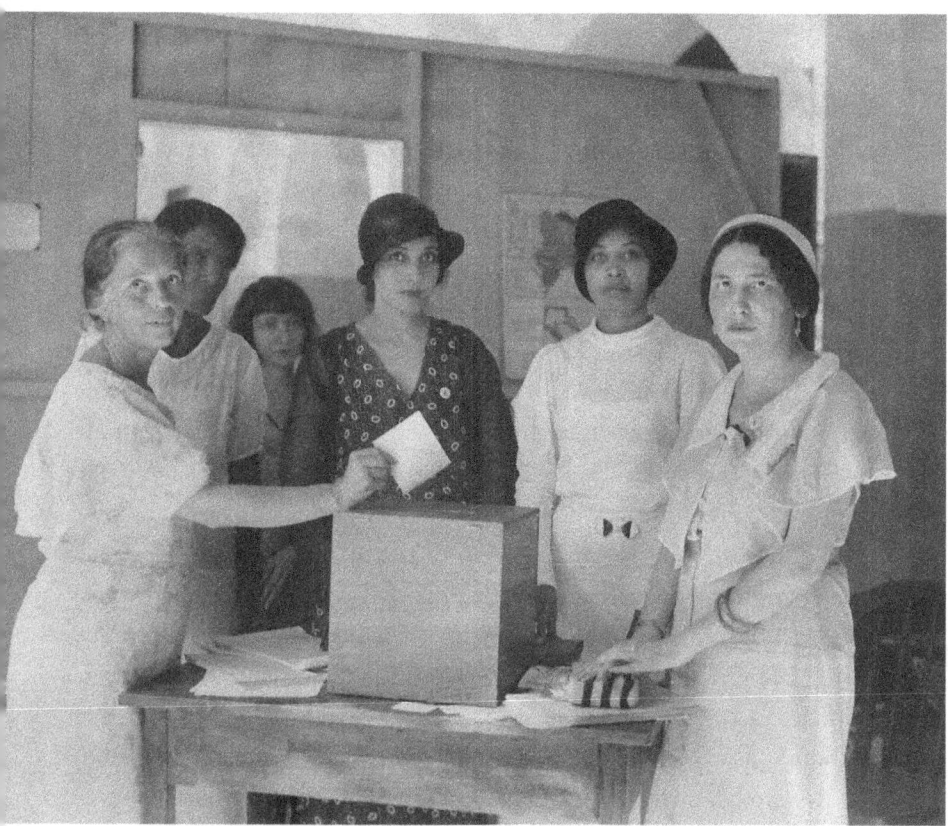

Figure 1.3. *Voto de ensayo*, Dominican women's test vote, 1934. Abigaíl Mejía is at the far right and Delia Weber directly behind the ballot box. Courtesy of Doris Stevens Papers, 1884–1983, Schlesinger Library, Radcliffe Institute, Harvard University.

to the polls. Only a handful voted against female suffrage.[80] Many organizers were surprised that Trujillo did not see the numbers as sufficient, and Bernardino commented with disappointment that inexplicably the president was unconvinced by this large turnout of female voters. In a letter to Stevens, Mejía complained that the number was almost half the 200,000 men who voted; the women who stayed home, she argued, simply did not have the means to get there, not that they were against suffrage.[81] Still, the 96,000 votes, while insufficient in the regime's eyes, were evidence that the AFD had gotten a large number of women behind the idea of suffrage and knew how to put together a campaign.

The significant number of women willing to venture out to polling stations indicates that Dominican feminists energetically promoted the idea of female political activity through their regional and local channels, yet the

four years following the failed test vote proved challenging for the feminist group. Balancing their support of an increasingly dictatorial regime with an international feminist identity proved fractious. Several letters from Landestoy and Bernardino to the IACW indicate that the years between 1934 and 1938 were difficult and ultimately fatal for the Dominican organization. In fact, although the linkages between the members of the AFD and the IACW remained intact, many ties within the AFD itself were severed. Several comments in the correspondence between Dominican feminists and with their international colleagues indicated that relationships between certain members were less than harmonious.[82] Abigaíl Mejía reported in a letter to Stevens that her biggest concern was with "adventurers" like Bernardino whom she accused of attaining positions that should have been "reserved for those who fight selflessly for the ideal."[83]

In addition, international opinion of the Trujillo regime had shifted briefly and provided yet another source of division among the women seeking to demonstrate the nation's progressivism and democracy to the world. Moving to solidify the Dominican Republic as a Hispanic rather than African-based nation, in 1937 Trujillo ordered the massacre of tens of thousands of Haitian and Haitian-descended individuals along the border the two countries shared.[84] While the U.S. government had supported Trujillo up to this point despite his increasingly dictatorial leadership style, reports of the massacre that reached the United States turned several key diplomats against him. The administration of Franklin Roosevelt, uncovering the truth behind the regime's public dissimilation, exerted pressure on Trujillo to conduct negotiations with Haiti, pay reparations, and ultimately withdraw from the upcoming elections. Eric Roorda argues that the massacre "threatened to damage the Roosevelt administration's Good Neighbor policy in Latin America by calling attention to dictatorship in the Caribbean," and so U.S. policymakers sought out quick damage-control measures without actually condemning the regime publicly.[85] While Trujillo and the Good Neighbor policy survived what a Dominican ambassador called "the little incident," the long-term effects on the ability to sell Trujillo as a truly democratic and progressive leader were surely felt among the Dominican feminist collective.[86]

The massacre occurred along the country's northwestern border with neighboring Haiti and initiated a discourse led by regime intellectuals of a Dominican identity purged of its African past and centered on its Spanish

and Catholic roots. It was patently ignored by the feminist group. Trujillo's announcement calling for the genocide purportedly occurred at the home of Isabel Mayer, a rising star of the *trujillista* cadre.[87] Mayer, who had been president of the Monte Cristi Club de Damas in the early 1930s, came from a prominent family in that border province. Over the course of the regime she would become a close ally of Trujillo, occupying the positions of provincial governor and senator. While Mayer likely knew many details of the massacre, they were elided in public discussions among the *trujillista* feminists until several years later, when Trujillo began to call on the new members of his party to help with the "Dominicanization" of the border regions. A 1940 editorial in *Listín Diario* encapsulated this willful ignorance: "Our women know perfectly well that only Trujillo is capable of safeguarding the peace, spiritual tranquility and happiness of their homes."[88] Ignoring what had occurred, many focused on how they could maintain their allegiance to the "Benefactor" and his work of peace, civilization, and democracy while helping to obfuscate the grizzly events of 1937.

In spite of the regime's stained reputation and Trujillo's ultimate renunciation of the presidential nomination in 1938, a significant proportion of the Dominican feminists chose to continue their display of support and political readiness. In May 1938 a group of women in Santiago organized a "voto simbólico" in favor of the reelection of Trujillo despite the fact that he was not officially running for office.[89] Newspaper reports indicate that of the 429,051 females fifteen years or older, 342,458 voted in favor of continuation of Trujillo in power, despite his having declined his party's nomination.[90] Tellingly, the ballot read, "With our thoughts and hearts in God, we vote for the Generalísimo Dr. Rafael L. Trujillo, Benefactor of the Nation, to continue in the Office of the President as he is the only leader who has granted consistent peace to the Republic and tranquility to the Dominican home."[91] The faction of feminists aligned with Abigaíl Mejía chose to abstain from these voting activities due to their purported dissatisfaction with the government's response to their previous efforts as well as, perhaps, to the massacre.[92] Conversely, Bernardino and others continued their work of aligning with the regime and the IACW, carefully selecting their allies and actions in the international arena and ignoring the damaging news from the nation's border region.

The AFD may have been facing dissolution, but many of its members continued building connections with the regime and the now prominent

inter-American organization to secure for themselves a place in the movement, however it might transform. Bernardino and Landestoy were firmly entrenched; Gómez had attained a place as a member of an IACW subcommission through Bernardino, and lawyers Félix Miranda and González Suero had performed invaluable research work for Stevens several years earlier. Gladys de los Santos and Mejía continued their correspondence with Stevens and the IACW with complementary copies of their own publications, while others informed the organization's director of the work being carried out in the realm of voting.[93] Bernardino, from her coveted position at the IACW, turned her attention to journalist Gómez in 1937 and focused exclusively on her work with the international organization.[94] Given the increasing solidification of the regime and its calculated attention to its public image, Dominican feminists demonstrated that the best and most stable allegiance to have in the new regime was to the support of the government's international reputation as a dependable democracy.

Still, the issue of citizenship for women remained unresolved, and many of the original feminist collective continued the efforts to enact democratic readiness. If Trujillo had delayed the issue of suffrage until the second voting practice could be held and he could be assured of the consolidation of a strong group of conservative professional women to carry out his nationalist agenda, the "Magna Apoteosis Femenina al Benefactor de la Patria" (Great feminine apotheosis to the benefactor of the nation) may have been the final push he needed to alter the existing legislation on women's rights. The apotheosis was held on the main thoroughfare in the capital on January 16, 1938. Each and every community sent a committee of distinguished women to parade in the event, which also included marching bands of every possible institutional group, Trujillo's party's advisory group, and the Red Cross.[95] The event was filmed, and AFD member Maria Caridad Nanita praised the demonstration as a huge success.[96]

Following the apotheosis and the "voto simbólico" of 1938, Trujillo began to make a more public show of his commitment to women's suffrage with the return of Bernardino with her celebrated guest Doris Stevens to the Dominican capital. The initial invitation extended by the Dominican government went to Stevens in her position as chairwoman of the IACW.[97] Upon hearing of her exclusion from the trip, Bernardino acted on her sense of indignation and procured for herself an official invitation. Additionally, Trujillo invited Stevens to advise a special congressional session specifically

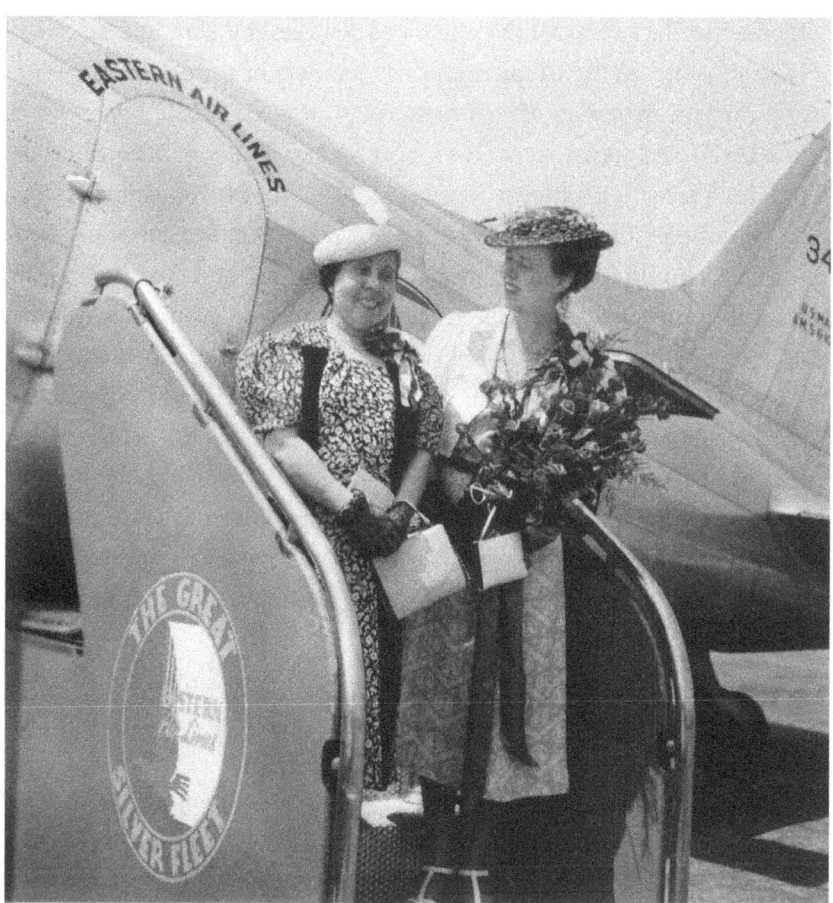

Figure 1.4. Doris Stevens and Minerva Bernardino departing Washington for the Dominican Republic, August 1938. Courtesy of Doris Stevens Papers, 1884–1983, Schlesinger Library, Radcliffe Institute, Harvard University.

allocated for the discussion of women's rights. Stevens wrote in her memoirs that she was the first woman to ever address the Dominican Congress. The August banquet attended by the two women allowed Trujillo to present a laudable plan to reform the constitution according to the recent recommendations of the IACW. Landestoy's new magazine *El Hogar* featured the important visit of Bernardino and Stevens with the publication of a photograph of the two women. The trip was a success, according to Stevens, as the Dominican government followed through on her recommendations: "everything that the government promised to do, it subsequently did."[98] Trujillo even appointed Bernardino to head the commission created to address the new reforms.

Following the success of the celebrated visit, several Dominican women moved to shore up their reputations as members of an international network; they organized an official national committee to support the work of the IACW and formalize their support for Trujillo's plan of equal rights. González Suero, in a letter to Stevens, reported on the November 5, 1938, formation of a Comité Dominicana de Cooperación Internacional (Dominican Committee of International Cooperation). At this first meeting the group established a series of principal aims and procedures. The women declared general meetings to be held weekly and planned to invite other feminists to join. The overarching goals of the committee were to study "the most appropriate means of obtaining ratification of [the] Equal Nationality Convention," to conduct a "comparative study of civil and political rights of men and women" through the established mandate of the IACW at its seventh conference, and to form a group to study potential means of carrying out Trujillo's instructions to Congress relative to the rights of women in the Dominican Republic.[99]

Given the highly publicized nature of the Stevens visit, Trujillo's formal address to Congress regarding legislative reform, and the continual efforts of Dominican feminists to align themselves publicly with the IACW and the regime, the nation appeared poised to grant women the vote for the 1942 elections. However, in order to fully display his magnanimity and openness to national debate, Trujillo concocted a public forum in the press in December 1940 that presumed to pit pro-suffragists against anti-suffragists. Set up in the capital-based newspaper *La Nación*, the single-issue forum asked that individuals offer their opinions as to whether it was an appropriate time to grant women the right to vote.[100] In yet another display of their support for the purportedly democratic practices of the dictator, Dominican feminists and activists stepped into the public sphere to advocate for greater rights for women, justified by their overwhelming and consistent display of political readiness and sophistication.

In carefully rehearsed responses, the Dominican public weighed in on the issue of civil and political rights for women. The answers fell much more to the affirmative than to the negative, and they were proffered not just from everyday newspaper readers but also specifically solicited from top-level government officials, their wives, and members of the feminist movement. The "free expression" of opinion encouraged in the open letter to the public was not ultimately the goal; praise of the now ten-year ruler

was a main element of every missive to the paper. Despite the practiced and formulaic nature of the responses, they were numerous and surprisingly nuanced. Making the public part of the suffrage decision, even if it had already been made, indicates the importance of female citizenship in the theater of democracy Trujillo sought to establish.

Several female writers supported women's preparation for the vote by citing examples of prior experience and practice in Dominican social life and international politics, although democracy was clearly the trump card. Many referenced the excellent performance of women in the prior test votes, and several noted their own and others' participation in the feminist movement. Prominent lawyer and AFD member Milady Félix (Miranda) de L'Official argued that the "brilliant and capable" work of women in the exterior "in Geneva, in Montevideo, etc." had more than established women's ability to perform respectably in the national political arena.[101] But the argument most common in all of the letters of support for universal suffrage, male and female, was that without such a constitutional amendment the Dominican Republic could not truly claim its place among civilized, democratic nations. Not only part of the "democratic spirit," full and equal suffrage was a requirement for the proper functioning of a sovereign and democratic state. Convinced that such a label was not in contradiction with the ten "glorious" years of rule by Rafael Trujillo, writers exhorted the government to follow through on its promise to grant women a true and legitimate vote. Celebrated feminist and then director of the National Museum Abigaíl Mejía opined that full suffrage was due precisely because she had been born "in a country that prides itself on being democratic."[102] A gentleman from Trujillo's own birth city stated more emphatically the connections between full suffrage and democracy: "the principle of democracy lacks integral significance and the operation of a democratic regime is incomplete when women are excluded—half of the social body—as a factor in the electoral process, which is the vertebral column of democracy."[103] The writers who connected democratic practice with women's political rights emphasized the need for immediate and full suffrage so that the Dominican Republic could assume its place among civilized nations and "the Era of Trujillo" could fulfill its promise of creating a true democracy.

Dominican feminists continued to press their advantage as a complement to the political arena, although now the public at large gave credit for this idea to Trujillo. As part of the grand plan of the regime, writers argued,

women voters and politicians would provide the "freno suave" (smooth brake) to the aggressive passions of male citizens.[104] Not only would they provide this "smoothing and beneficial influence" to male Dominican politicians, but would serve as a "model and example" before the "civilized world." Participants mentioned "our modern woman" and connected the nation's modernity and progress with future female citizens' abilities to apply their skills as wives and mothers to their positions in the political sphere. According to Rosa Smester of the AFD, a woman was "at the same time lover to her husband, intellectual sister, and mother to her children; moreover, she was the angel of the home. A quadruple role that Dominican women embodied as sane, spiritual beings, possessing a sense of family as well as a sense of society."[105] Smester argued that Dominican women would simply follow their maternal instincts into the political arena, and their participation in the body politic would make them better caretakers in the home. While highly essentialized, such characteristics had already granted many women entrée to the everyday practices of the dictatorial rule. By extension their very skills as wives and mothers would make all Dominican women ideal citizens.

Although women's suffrage was all but a formality by the end of the national poll, Trujillo convened the Chamber of Deputies to hear official pronouncements from women of the feminist movement on the issue. A group of female activists was invited to the ceremonious event that included several of the early AFD members: Minerva Bernardino, Delia Weber, painter Celeste Woss y Gil, Carmita Landestoy, Dr. Consuelo Bernardino (Minerva's sister), and writer Carmen Lara Fernández. The women who spoke before the special session—Bernardino, Weber, Landestoy, Isabel Mayer, and AFD member Clementina Henríquez, daughter of Salomé Ureña de Henríquez' brother-in-law—all emphasized the great work and uplifting example provided by President Trujillo in the historic gesture of women's suffrage. Bernardino, now representing the IACW as vice president, reinforced the influence of this model upon the entire continent; Weber in turn stressed the importance of women's potential contributions to the "vast and grandiose projects for liberty and national prosperity" of Trujillo. Although Weber and Landestoy reminded their listeners of the previous work of the AFD and the IACW in arriving at this point in history, their praise lay in the glorious, enlightened vision of the "statesman" who "had known to dignify the women of his nation."[106] Clearly, the efforts of the AFD during the

previous decade were in the rear view, and efforts of Dominican feminists could shift completely to the support of the regime with the full force of their newly acquired citizenship.

In 1942 Dominican women voted officially for the first time in national elections. Trujillo was back on the ballot formally. After a four-year hiatus in which he ruled through his hand-picked replacement, he reclaimed presidential candidacy, although only after he had done away with the vice presidential position.[107] The discussion among the feminist collective, however, had less to do with the candidates or lack thereof. Landestoy and Bernardino reported separately to Stevens on the joyous occasion, echoing the sentiments they had expressed before the Chamber of Deputies, praising Trujillo's progressive thinking, and ignoring the many constitutional laws violated to return Trujillo to the presidency. After over two decades of struggle, their focus centered on the precedent established by suffrage and the new public, political persona of Dominican women. The new female citizen was indebted, in their eyes, to both the enlightened perspective of Trujillo and the international alliances that had kept suffrage in the spotlight.

The connection between suffrage and Dominican feminists' cooperation with the IACW was clear in their postelection correspondence. Bernardino wrote Stevens, "How happy I feel with the results of the elections held in my country in which women took an active part and some were elected. As you know, that has been the greatest dream of my life. But the truth is Doris, that you will be forever linked to that great event."[108] The ideological vacuity of voting without choice seemed irrelevant or at least secondary to the roles women assumed in the Patria Nueva. Not everyone felt this way, of course, but dissenting voices were effectively muffled by the dictatorship and the clamoring praise of women like Bernardino and Landestoy.

Over two decades of activism had finally culminated in the achievement of suffrage, on which the AFD had centered its focus since nearly the inception of the regime. The women who maintained the struggle through their showcase of democracy, support for the regime, and international activism expressed pride in their new opportunity to contribute their maternal instincts officially to the political arena. They recognized that their allegiance to the IACW had been a key source of leverage and support for their efforts. In turn, the IACW was aware of the dangers of working with a dictatorship yet continued those efforts. Stevens begged, in a letter to a U.S.

colleague, not to quote her "as the authority in anything you say about dictatorships country by country. You will understand that we must work with whatever government is in power and can not at the same time call names publicly."[109] In many ways the members of the Dominican feminist movement followed a similar mantra. While more and more women would fall out of this contingent either through individual disagreements or personal principles, a powerful and highly connected core would continue to believe that the most effective way to create political advancement for women was through the channels of transnational feminism and within the iron fist of dictatorship, even if they had to redouble their efforts to do so.

THERE IS AN UNAVOIDABLE IRONY embedded in the defense of democracy by the newly enfranchised members of a solidified dictatorship. While they likely saw the inherent contradictions in their words, the *feministas trujillistas* focused instead on the potential benefits of entering into national and international conversations on democratic practices and egalitarianism. They argued that their inherent or essential characteristics as women positioned them to take part in the definition of their own nation, its international reputation, and its internal, albeit totalitarian, political structure. Their activism in local party politics, attendance at public demonstrations, enrollment in secondary and university institutions, and participation in national and international political processes mark the first half of the Trujillato and Dominican women's forms of activism in two distinct ways. In stressing their particularly womanly traits in these multiple political arenas the female activists forged an awareness of women as public and international actors in the unique space of the dictatorial power structure. And in emphasizing their indispensability to the regime's show of democracy, the women who engaged with the Trujillo regime made themselves truly central to the dictator's carefully orchestrated national and international reputation.

The Dominican feminists of the 1930s drew on the foundations laid by women entering education and civic life from the turn of the century. While the growth of an interconnected group of *normalistas* served as the base for the feminist movement, it was precisely their defense of Dominican sovereignty and their role as properly modern women that gave the collective its political significance. Responding to the crisis of masculinity brought

on by the U.S. occupation, early twentieth-century feminists argued that their new roles in public life allowed for a more balanced civic culture and a society that could cultivate the kinds of citizens crucial to a sovereign state. Their success in making this argument locally and transnationally would in turn draw the attention of Rafael Trujillo as he solidified his control of the nation. He would see the feminist collective as a key contributor to managing his international reputation as a democrat as well as to creating a foil to his more masculine style of politics.

Among the women who labored for greater rights during this period, transnational feminism was a central point of leverage that provided essential entry to political participation. Calling attention to their successes in the realm of women's rights, they worked effectively for the Trujillato and the many women who stepped into the public arena. Their work allowed a supposed statesmen like Trujillo to tout advancement and democratization in his regime, while it maintained spaces for the women involved in international organizations to translate global prescriptives into local contexts. As Trujillo worked to create an image of his nation as democratic, progressive, and yet familial and moral, politically active women served as the perfect example of national advancement as well as the ideal counterbalance to the brutish and corrupting tendencies of men. In this context, transnational feminism offered women a platform from which to project their contributions to the Patria Nueva. The relationships fostered within pan-American organizations during the first half of the Trujillato were not unilateral dictates from knowledgeable North American women to their less experienced sisters. Often ideas posited by organizations such as the IACW were foreign to the realities of a dictatorial Dominican Republic. The *feministas trujillistas* were fully aware of the challenges they faced at the local level, and they translated the directives from the IACW into a more palatable structure that the regime could adopt. In essence, this meant overlooking democratic concepts of true equity in exchange for a political organization that offered individual spaces for participation and a government that extolled the virtues and contributions of women as nurturing, soothing, and moral pillars of the nation.

Throughout the dialogue between the Trujillo regime and the various women's groups that looked to the regime for social and political change runs a variation of the theme of social conservation. The idea that women brought a more refined, calm, and educated perspective—"el freno suave"—

to the rough world of politics justified their entrance into such an atmosphere but also defined the roles they would play for the duration of the regime. Women viewed their contributions as distinctly different. In addition, they argued, their presence on the national political stage affirmed Trujillo's specious claims—at the national and international levels—that the regime was egalitarian in nature and should not be categorized as one of the dictatorial governments that would come to trouble U.S. and western powers with the onset of the Cold War in the later 1940s. Regardless of the realities of the claims of the dictatorial regime to egalitarianism and participatory politics, the *feministas trujillistas* capitalized on the dictator's desire both to stage a democracy for the world audience and to have the necessary participants to carry out its multiple acts. As the moral guardians of an increasingly violent regime, they would face an uphill battle in the subsequent two decades.

2

Defending the Home against the Chaos of Communism

Women, Regime Politics, and the Cold War, 1942–1961

IN 1942 A TRANSITION BEGAN in the Dominican Republic that would position the women newly registered in Rafael Trujillo's political party as the most vocal defenders for democracy and the stable family and against the dangers of communism. As the Dominican people and particularly its politically active women began gearing up to celebrate the nation's centennial in 1944, that shift became even more evident. Former *Fémina* contributor and feminist activist Carmen G. Vda. (*viuda*, widow) Peynado seized the opportunity to direct a message to the nation's "intellectual women" in one of the capital's prominent dailies.[1] She argued for the good fortune of Dominican women to live in a period when they no longer needed to hide their ambitions and men no longer feared their positions as teachers, intellectuals, or doctors. Accordingly, husbands, sons, fathers, and colleagues took women's opinions into account when considering issues not only of the home but also of larger social import. While the home offered refuge to men and women, she contended that "four walls, with nothing more than the monotonous and cold scenery of daily life, would harden anyone's soul." Women could and did enter the professional world without losing the "beautiful feminine qualities" that made them so vital to the family, even more so when they were educated. Peynado argued that women's advancements beyond the home were integral to the stability of the family and the nation. While over the previous two decades Dominican women had fought for civil and political rights as a bulwark to sovereignty and democracy, this new period of global instability demanded that women reformulate their importance to the polity and especially to the politics of the Trujillato. For Peynado, the "siglo de luz" (century of light) was also the "si-

glo de la mujer" (century of the woman) because it highlighted the efforts women had made under Trujillo to bring advancement and progress to the Dominican nation and its families. Her article demonstrated the subtle shift in discourse the women of the Trujillato would employ over the next decade and a half. Essentially letting go of a feminist vision that argued for their necessity as fully vested citizens, the politically active women of the Trujillato focused instead on their increasing importance as the guardians of the Dominican home and family.

In 1942 Dominican women exercised the right to vote for the first time and were quickly integrated into Trujillo's party machinery as engines of community engagement. In addition to the several women who were put up for election by the Partido Dominicano, women began filling the new positions created in its Sección Femenina (Women's Section), while thousands of others were swept up in the programs of social assistance launched through this new arm of the party. Party officials were eager to enroll as many women as possible to demonstrate female adherence to the regime. A significant number of women advocated for their new positions as full political actors by demanding a place in the party, organizing and participating in mass political demonstrations, and donating time and money to causes they believed Trujillo considered important. Their most significant roles, however, were as conciliators in national and international politics, defenders of the moral Dominican home, and staunch advocates for the democracy of the Trujillato. For two years they worked to organize at the grassroots of the Trujillato's social assistance programs and enact the performance of domestic stability and democratic progress.

By 1944 the remaining *feministas trujillistas* had become fully integrated in the everyday machinations of party politics and understood their role in upholding the regime's international reputation as the realities of the Cold War began to solidify. For the remainder of the Trujillato, most women in this middle- to upper-class contingent continued their new roles in the Sección Femenina, with various programs of *asistencia social* (social assistance), and through numerous local and international women's social and cultural groups. They promoted the mythic peace, prosperity, and stability of the Trujillo regime. Arguing that "no one has worked more intensely than Generalísimo Trujillo toward the glorious goal" of peace, the now-dubbed *damas trujillistas* maintained their role in the public discourse of the regime and, they argued, sustained the peaceful Dominican home that

served as the bulwark against the evil forces of communism.[2] For those aligned with the regime, the formalization of the politics of the Cold War provided ample material for public support of the dictatorship under the banner of domestic stability, democracy, and anticommunism. As a number of scholars have argued, such ideological battles were waged in arenas that reached well beyond government ministries and into the everyday lives of Latin Americans.[3] Active female supporters of the regime in the Dominican Republic took part in a larger conversation that circulated globally following the end of World War II, demanding particularly women's vigilance of an ideology that threatened the very core of western civilization.

The established positions of women in the political arena created by the Trujillo regime remained central to the narrative of democracy and stability during the second half of the so-called Era of Trujillo but not through the discourse of citizenship. Once the position of women in the political nexus of the Trujillato had been established through the regime's own propaganda and the work of women themselves, the focus of women's roles shifted to those of nurturing the proper Dominican family and sacrificing individual needs for the greater morality and stability of the nation. Casting their efforts through their work in *asistencia social*, they employed the language of democracy and anticommunism to establish themselves as the central cog in the stable Dominican family. In this role, sacrifice became a most essential element of their discourse, cementing their importance to the corporatist project of the 1940s and 1950s. The Trujillato relied on a political agenda that emphasized the collective over the individual. Similar to Getúlio Vargas in Brazil and Perón in Argentina, Trujillo publicly aligned with the forces fighting for democracy and individual freedom globally while simultaneously espousing a state project that demanded allegiance to a monolithic Dominican identity.[4] The women active in the regime were no small part of that public dissimilation. As such, the *damas trujillistas* continued to see the international context as a space to emphasize their importance to the national project. The rhetoric of anticommunism served to shore up their positions in politics in spite of a series of moves by regime officials to strictly delimit their public roles after 1944. Politically engaged women during these years depended on the fear mongering of the Cold War that facilitated their involvement in issues of national import through their centrality to the Dominican home, their purportedly natural defense against communism, and their dedication to the moral Dominican family.

The story of the 1940s and 1950s in the Dominican Republic, as Trujillo tightened his grip over the nation to a near choke hold, is complex and often tragically narrated.[5] Notwithstanding the many violent and reprehensible moves by the regime to retain its control over the country, the transition story of these women from *feministas* to *damas* demonstrates the rapidly shifting ground many individuals faced given the increasing intensity of the Cold War and the legacies of their particular style of activism. The exchange of basic civil and political rights for acceptance of the regime's authoritarian structure was not acceptable to all women in the feminist movement, but for those who chose continued engagement with the Trujillato the final two decades of the era presented a political arena in which individuals contended with a new set of international discourses of stability as well as the caprices of the dictator himself.[6] In some of the starkest cases of instability, women of older generations scrambled to maintain their positions while their sons and daughters schemed to rid the country of its dictatorial leader; at the same time, many upper- and middle-class women continued to actively use the regime as a ladder for social advancement at best or continued familial stability at least. The latter women's persistent loyalty to an often-capricious regime is testament to the difficult decisions they faced and their unwillingness to cede the advancements made in public and political arenas in the first decade of the Trujillato. In positioning themselves as the symbolic and moral center of the Dominican family writ large and offering themselves in sacrifice to the cause of anticommunism, the *damas trujillistas* demonstrated their centrality to the regime's image domestically and internationally. However, they also deftly shifted the script away from feminism and women's rights toward a solidly corporatist national project in order to maintain their influence in the political arena. In so doing they solidified a paternal discourse of rights that was embedded in the state's obligation to protect women, children, and families and would leave a legacy well beyond the Trujillato.

The Sección Femenina and the National Politics of Social Assistance

Just as some women viewed the regime as an avenue for political advancement through their newly granted citizenship, the Trujillo dictatorship recognized the value of suffrage and women's activism as mothers, wives,

sisters, and educators. Prior to the elections in 1942 but following the 1940 constitutional reform declaration, the regime began planning how to officially fold women into the party structure. The Partido Dominicano was effectively the country's only party for the span of the regime and served as a key channel for the incorporation of middle- and upper-middle-class men into bureaucratic positions; it would also direct women's political mobilization.[7] Party officials knew that this new base of female voters would provide a vastly expanded network for demonstrations, public assistance, and education work and they created a distinct branch for the new citizens. The work of the Sección Femenina del Partido Trujillista adscrita al Partido Dominicano (Feminine Section of the Trujillista Party attached to the Dominican Party) and variously referred to as the Sección Femenina or Rama Femenina (Women's Branch) illuminates the early party politicization of women under dictatorship and the formalization of their roles as the nation's maternal caretakers.[8] While regime officials encouraged certain women to take positions at various levels of government, many more women utilized the emphasis on maternity and morality to bolster their importance in the nation-building project and their roles as the protectors of the democratic Dominican family within the party.

Dominican women were acutely aware of the new possibilities proffered by party membership as well as the need to present themselves in a complementary and fully vested manner. Their words and deeds stressed the application of traditional feminine and heteronormative qualities to the progress of the nation; party women demonstrated at the local level how they might smooth over the more aggressive aspects of Dominican politics. Women eagerly exhibited their readiness for full participation in their letters to party leaders. Early agitation among female supporters of the regime encouraged the dictator to channel women's activities through a distinct section of the party structure. Following Trujillo's announcement of a constitutional amendment granting women full civil rights, several party functionaries in various locales wrote requesting direction in dealing with these new potential members. A junta president in the town of Restauración wrote to party leaders begging them "respectfully, to tell us if we can admit requests for inscriptions for women in the normal form as men in virtue of the equality of political rights that the Constitution has granted them."[9] Similar requests point to an overwhelming desire among women to assume places in the political bureaucracy among their male counterparts.

For men, such positions conferred a level of prestige and potential economic advancement; many women believed the constitutional amendment now made similar placements available to them.

Initially, the regime decided that the sham alternate Partido Trujillista (PT) would become the new and exclusive home of the *damas trujillistas* and envisioned it as a forceful show of the regime's egalitarian practices.[10] Between February and June 1942 local Partido Dominicano officials were told simply to enroll women in the Partido Trujillista.[11] On May 25 Trujillo directed a letter to the head of the PD formally requesting the formation of a Sección Femenina, and on June 9 it was created and provided with its own president.[12] Under the leadership of Carmita Landestoy, the Sección Femenina began organizing juntas and subjuntas in every major locality.[13] Male officials were exhorted by national leaders to provide the women with all possible assistance; as quickly as new members began drawing up organizational charts, there were plans for several grand events including a Primer Congreso Femenino Dominicano (First Dominican Feminine Congress) to celebrate Trujillo's granting of civil and political rights to women. Most local male officials responded enthusiastically to the prospect of the new recruits; they reported that they were in full support of women's efforts in their communities and would work actively with the women of the Sección Femenina.

By early fall 1942, after figuring out the proper structure and function of their organization, Landestoy and her provincial and subprovincial presidents set to work on the several projects authorized by Trujillo and the party leaders to showcase the new citizens as ideal engines of community engagement. Unsurprisingly, given their perceived inherent nurturing qualities as women, their work would be directed in support of Trujillo's new grand Plan de Asistencia y Mejoramiento Social, or simply *asistencia social*.[14] In nearly every community in each of the nineteen provinces across the country, members established women's committees to work on the creation of literacy schools, milk stations, sewing centers, school uniform drives, libraries, and lunch programs. Many women also volunteered on the Comité Pro-Visitadoras Sociales, the Comité Pro-Conversaciones Sencillas, or the Club de Madres (Committee of Social Workers, Committee for Simple Conversations, and Mothers Club) in their communities. Minimal funds for these committees came initially from party coffers, but officials expected women to contribute heavily to fund-raising.[15] Luckily

most active participants in the local committees of the Sección Femenina were socially well connected and as a result proficient fund-raisers. With each passing month there was a new call for more committees and volunteer work; except in the smallest of communities these groups were convened quickly and began working even if resources were lacking.

As the most prominent face of the new programs, Landestoy moved quickly to demonstrate that the Sección Femenina maintained the strict disciplinary codes of the governing Partido Dominicano and produced measurable results. A November circular published in the new bimonthly newspaper *La Mujer en la Era de Trujillo* (The woman in the era of Trujillo) established her rules for urban subjuntas that likely applied across the country. Each collective was to meet twice monthly and channel all reports through Landestoy's office. Nominated *encargadas* (section heads) were held responsible to enroll "mujeres trujillistas"—in other words, all women—in the party as quickly as possible and to get them involved in activities. Funds for the *desayuno escolar* (school breakfast) program were to be raised through house-to-house campaigns. In addition to the *desayuno escolar* program, women within each subjunta were expected to plan *charlas* (informal lectures) and other educational activities to teach other women about *ayuda mutua* (mutual aid) and Trujillo's enlightened Plan de Asistencia Social. In the circular Landestoy reminded participants that each woman had something to contribute and that activism consisted of more than just showing up. Their duties as members of the party, she asserted, "did not exist in mere words, nor in simple attendance at public acts of a political nature."[16] For Landestoy and the new party members, participatory politics now entailed demonstrating democratic practice and volunteerism in their everyday lives and communities.

Literacy was a high priority for regime officials in the early months of the Sección Femenina, and the women of the party obliged eagerly, as promoting it allowed them to model the progress of their nation and extend their reach into even the smallest communities.[17] Increasing literacy was an easily measured project that provided a facile platform for the enlistment of new female members of the party. Higher literacy levels, moreover, fit western models of progress in civilization and democratic citizenship. Regime officials lauded the plan as yet another example of Trujillo's omniscient vision for the country, while local *encargadas* demonstrated their readiness to begin courses and night schools for their communities.[18] For the most part, they

needed few resources to initiate the program. Local classrooms and even homes were utilized for courses, members of the Sección Femenina served as volunteer teachers, and qualified students proved easy to identify and enroll. Even the smallest communities reported beginning literacy classes for a least a dozen qualified candidates ranging in age from six to forty-six.

La Mujer en la Era de Trujillo reported on the early progress of the literacy program in the capital as well as the Sección's many other achievements in the realm of social progress. Director Andrea Morató Vda. Egea praised the direction of subjunta president Margarita Pou de Mejía in organizing the several literacy schools in Ciudad Trujillo, the dictator's new name for Santo Domingo.[19] She also commended the work of the volunteer teachers who helped guarantee that their students, "future mothers, will relate to their children, the future citizens, how Trujillo directed his beautiful plan for the government, offering to [the people] the bread of science and placing our country among the most civilized nations."[20] Like many others, Morató Vda. Egea connected the literacy program with the nation's level of civilization in the same way the regime's discourse sought out measurable advances in various projects to prove widespread national progress. Landestoy also triumphed the work of women toward *asistencia social* programs in her magazine *Prédica y Acción* (Sermon and action) and added her editorial opinions regularly to the more perfunctory progress reports. She weighed in on issues of pending legislation, marriage and childbearing, literacy, and pan-Americanism, always emphasizing women's key roles in the overall advancement of Dominican society.[21] Both publications praised the varied programs of Trujillo's *asistencia social* plan carried out by women to solidify the regime's moralizing discourse of *dominicanidad*.

The corporatist project of *dominicanidad* was racialized to construct a Hispanic, Catholic-based identity for the nation as well as centered in a discourse of class-based paternalism. The *damas trujillistas* demonstrated their ability to adopt to its rhetoric. One of the most prevalent discussions within the programs of social assistance centered on the needs of poor women and families. Presumably, the masses of poor and rural women throughout the country knew little of proper hygiene or nutrition and regularly put the nation's families at risk due to their lack of education. The *damas trujillistas* saw it as their duty to extend their knowledge and organizing skills to raise the level of Hispanic language and culture in poor neighborhoods and end the many practices deemed uncivilized that continued throughout the

countryside. Their efforts included educating women on proper hygiene during pregnancy, providing milk and food for destitute families, and encouraging the formalization of marriages. Although infrequently blaming the women themselves, they asserted a blanket indictment of poor and rural conditions on detaining the advancement of the Dominican nation as envisioned by Trujillo; they assumed the position of enlightened advisers in helping to elevate rural areas and, as a result, the nation as a whole to a place of true civilization and democracy.

The programs of *asistencia social* and participation in party politics provided an extensive platform for women to assert their nurturing influence in the arena of public policy and offered opportunities to many of the group's most prominent members to further their individual political standing. However, the programs coordinated through the Sección Femenina were not the only avenues available to women to praise the progressive and democratic work of Trujillo. In 1942 several women wrote to "el Jefe" himself to request permission to hold a national congress celebrating the one-year anniversary of women's suffrage.[22] The proposed women's congress was to be at once an homage to Trujillo and an attempt to demonstrate women's contributions to national advancement. While certainly offering requisite praise to the work of the regime and its leader, the authors of the request argued that the event would serve to make women, newly enfranchised, more capable of serving in the dictator's important national projects. The subsequent Primer Congreso Femenino Dominicano ultimately conveyed the gratitude of the Dominican woman to the leader who had granted them equality, yet it also demonstrated the ability of many new female dignitaries to organize and carry out a massive and well-received national homage to Trujillo and his progressive policies.[23] The three-day event was covered daily in the capital newspaper *La Nación*, even making the front page on its inaugural session. Delegates representing every province and more than eighty diverse social and cultural institutions across the country attended the event, demonstrating the mobilizing power of the *damas trujillistas*.

Every session in the three-day event was replete with the expected adulation of Trujillo and his glorious work for the cause of women's rights, but the more interesting message at the congress was the subtext. Running throughout the conference and concluding with a pertinent resolution was a discussion of the role of Dominican women in fomenting democratic

practices nationally and internationally. Trujillo alluded to this democratizing tendency when he discussed the importance of women as new citizens. More than just doubling the number of citizens, he argued, women increased the physical and theoretical strength of the nation in facing the most "intense crisis of humanity."[24] Women speakers at the congress stressed their role in defending democracy at home and abroad, engaging in a broader discussion of the global threats of war and fascism and belying the fact that they themselves lived in a dictatorial state. The congress' organizing committee called on the women of the Americas to "aid in the defense of the sacred principles of democracy with all their efforts, material or spiritual, and demand sacrifice for the cause of liberty." The plea, transformed into a formal resolution, was forwarded to Minerva Bernardino at the Inter-American Commission of Women. Fully aware of the regime's continued dependence on the terms of democracy to uphold its authoritarian measures, congress participants highlighted their work through the IACW and in their domestic contributions to the theater of democracy.[25] As women of the Americas, they felt it their place to point out that the "sacred rights of liberty" were the legacy of "democratic institutions" and that it was the "unavoidable duty" of the women of the continent to face any and all threats to such rights.[26]

Several of the presentations at the congress defended Trujillo's plan to Dominicanize the border region and instill Catholic and Hispanic values in the area's inhabitants. In several of the conference's subsections, including Education and Social Assistance, participants discussed the unique problems of the frontier.[27] In particular, some lecturers spoke to the need for female volunteers in border schools to collaborate in Trujillo's project to "nationalize the frontier zone." Octavia S. Vda. Valverde of Santiago argued that the nation's future depended on its "borders being fundamentally Dominican."[28] The work of the *damas trujillistas* was essential to this project, as the speaker proclaimed:

> We must, therefore, continue fighting the cultural "fifth column" and fortifying more and more Dominican culture and patriotic sentiment in that region. We must support everything that is Dominican and repudiate everything that is not. The language, customs, traditions, religion, entertainment . . . should prevail absolutely in the border area.

Volunteers from the Sección Femenina, Valverde argued, were crucial to helping teachers maintain that vigilance and might even be capable of publishing guides to help further this "patriotic purpose." In discussing the social work and school lunch program committees, a representative from the border town of Las Matas de Farfán contended that while work so far had aided in Trujillo's effort to Dominicanize the frontier, the region's misery and dire need demanded greater resources for maternity care centers and nutrition programs, especially in her town and several neighboring villas.[29] While generally avoiding the xenophobic and racist language that pervaded other discussions of the border region, the *damas trujillistas* asserted their class position and feminine skill sets in the work of *ayuda fronteriza* (frontier aid) to defend the region against the deleterious consequences of poverty and rural ignorance.

Despite the successes of the congress and the continued work of *asistencia social*, Trujillo's experiment in a relatively independent and female-headed Sección came to an abrupt halt in March 1944, demonstrating that perhaps its members had become a bit too vocal or that Trujillo envisioned a new role for the *damas trujillistas*. Landestoy was dismissed as the *encargada*, and the branch's central organizing committee was moved to San Cristóbal, Trujillo's hometown, and absorbed into the female section there. Although the work begun under Landestoy's guidance would continue, direct supervision would come from male party officials and women's membership would return to a more direct affiliation with the Partido Dominicano. The precise reason for Landestoy's dismissal is unclear, although party leaders had been unhappy with her since November of the previous year.[30] Despite male party members' professed support for the women's branch at its inception, they likely found the presence of female politicians in their midst increasingly unnerving. As officials dismissed Landestoy and reorganized the Sección Femenina, they signaled the regime's impending realignment of its paternalist discourse toward the altered realities of the Cold War.

The apparent disapproval by male officials of women's presence evidences their active participation in the everyday functioning of party activities. The women maintained offices in local PD buildings, corresponded actively with town and provincial officials, organized and carried out manifestations, fund-raisers, and school programs, and generally made themselves part of the everyday functioning of the local and national politics. The termination of Landestoy and reorganization of the Sección indicates two major issues

at play in the broader functioning of the regime. The administration saw the existence of an independent branch of the party as no longer necessary to demonstrate the democracy of the regime, and the incorporation of women into official politics had demonstrated women's ability to function as supporters of the regime and agents of community engagement with or without the support of a formal party structure. Streamlining the organization served to provide greater oversight of their activities without losing the strength of their support. Although the new formation limited women's participation at the national level, women continued their partisan involvement at the local and international levels and found new ways to contribute to politics as vanguard defenders against communism worldwide.

Century of Light, Century of Women

Marking one hundred years since the 1844 victory over Haitian occupation forces, the Dominican centennial offered the regime an ideal platform from which to reinforce the Hispanic, Christian, and anti-Haitian values that had come to serve as the regime's ideological base and a critical turning point in women's engagement with Trujillo's nation-building project. In the months of planning for the lavish event, the former cadre of feminist activists, along with new additions from high-level officials' wives and local Sección leaders, sought to demonstrate their continued usefulness to the regime's corporatist project. In addition to providing enthusiastic participants for the regime's public displays and key organizational and fundraising skills, they argued for their ability to sacrifice for the greater good and to serve as models of morality for the Dominican family both in and out of the home.

For women, the planning for the centennial began in late 1943 and highlighted the adroit fund-raising skills and new focus on morality and sacrifice that would characterize the collective that became key regime players after the reshuffling of the Sección in 1944. The *damas trujillistas* of the executive planning committee were led by Mercedes Soler Vda. Peynado, the widow of Jacinto Peynado, who had served as Trujillo's puppet president from 1938 to 1940.[31] The group presented two main objectives for the centennial celebrations at the inaugural organization meeting on November 3, 1943, in the capital: to present a medal of peace to Trujillo and to build a bust to commemorate Dominican independence fighter and mar-

tyr María Trinidad Sánchez.[32] At the very first executive meeting Senator Isabel Mayer and Congresswoman Josefa Sánchez de González each made generous personal contributions to the fund, others chose to demonstrate their support for the project through the press, and the committee worked effectively to collect large donations from prominent women.[33] However, a major part of the organizing and fund-raising burden fell to Landestoy and local party presidents who were responsible for collecting the much smaller but more numerous contributions from individual women across the country and mobilizing them to action.[34] By the conclusion of the drive the women had gathered enough money to build an elaborate bronze bust of their heroine María Trinidad Sánchez and create a gold medal and collar of peace imprinted with the shields of each of the nation's provinces. In message and execution, the *damas trujillistas* demonstrated their willingness to shift to the new discourse of the regime, and they would remain focused on world peace and sacrifice throughout the centennial celebrations. While certainly not complicated projects, together they demonstrated an acute awareness of the global realities of World War II and the necessary sacrifices of women during times of war and crisis as well as their ability to organize and gather funds in the name of national homage.

Dominican women continued to emphasize the significance of global political conditions and their strategic place as part of the regime's enlightened policies of democracy and peace. The first tribute, awarding a medal of peace to Trujillo, emphasized the support the *damas trujillistas* gave to the democratic practices of the leader in the face of global conflict. AFD member Amada Nivar de Pittaluga published an article entitled "Dianas del Centenario" in a prominent daily in which she argued that the "peace of Trujillo" was both vindication for the efforts of the independence fighters a century earlier and a model for the rest of the world.[35] She carefully situated the Dominican centennial celebrations in the context of larger global struggles for democracy. Unlike elsewhere, peace and stability reigned in the Dominican Republic due exclusively to the patriotism, incessant efforts, and "genius of Trujillo." She also argued that women especially desired such peace, as it was "stammered timidly from the lips of all mothers of the Universe." Nivar de Pittaluga placed women at the center of the purported Dominican peace as the most recent beneficiaries of his enlightened and egalitarian practices and the most appreciative subjects of Trujillo's work for democracy for the nation and for the home.

In the second tribute—a bust of the independence fighter and martyr María Trinidad Sánchez—the *damas trujillistas* placed themselves at the center of the regime's national project of democracy, peace, and *dominicanidad* through the metaphor of sacrifice. Trinidad Sánchez was the wife of an 1844 independence fighter who refused to recant her subversive actions and was subsequently assassinated. Giving one's own life in the struggle for national independence as she did, the *damas trujillistas* argued, represented the highest form of self-sacrifice in service to the nation.[36] Trinidad Sánchez' place as the symbolic mother and martyr of the Dominican nation was an apt representation of the role the women of the Trujillato constructed for themselves within regime politics.[37] Not only for her heroic actions did she garner such praise but specifically for the stoic nature with which she accepted her martyrdom. As Bernardino argued to her colleagues at the IACW, she was a "woman who never wavered before sacrifice, nor before that act of offering her own life, and who knew how to stand valiantly before the firing line that would take her life and immortalize her forever."[38] Trinidad Sánchez provided an ideal vision of sacrifice, and the act of memorializing her placed the *trujillista* leaders in a lineage of prominent historical figures. Landestoy summed up the dual efforts of the medal of peace and the bust of Trinidad Sánchez in her organizing letter to local juntas, describing Trinidad Sánchez as "the noble and selfless woman who shed her precious blood in honor of independence" and Trujillo as the nation's leader who had "established the unshakable foundations of a rule of peace, cementing the happiness and glory of the Republic."[39] In addition to celebrating the Trujillo regime for its achievement of unprecedented peace, the female participants sought to assure their own legacy in the historical memory of the centennial. Situating themselves as the descendants of such an illustrious martyr yet fortunate enough to live under the enlightened and democratic Trujillo, they highlighted their own sacrifice in service to the regime's corporatist vision for the nation.

Although women had organized events previous to these centennial celebrations, the *damas trujillistas* sought to demonstrate their commitment to an issue of national and international import. Just prior to the event Bernardino announced in a IACW newsletter, "Our sisters of the small and charming Dominican Republic will celebrate the Centennial of the nation's independence with grand and meaningful activities."[40] They focused on a discourse that at once held up Trujillo's international reputation as

purportedly democratic and peaceful while linking them to it as sacrificing mothers. The duality of their construction of the bust in conjunction with the awarding of the collar of peace highlighted their vision of democracy, national stability, and a uniquely feminine patriotism; their combination of female heroics with the more masculine decoration afforded Trujillo was undeniably strategic. As voting members of the polity, women did not just become additional citizens but rather brought an entirely new and mediating perspective to the world of politics. As their efforts throughout the next years would show, the *damas trujillistas* would continually employ an approach to politics that demonstrated what they could bring to the table as women but also that the Dominican family was incomplete without their contributions.

Demonstrating their commitment to the Dominican family, however, proved challenging in the face of various political and bureaucratic shifts in the mid-1940s. Shortly after the departure of Landestoy as the head of the Sección Femenina, Trujillo announced the creation of a massive Plan de Mejoramiento Social (Plan for Social Improvement) that was simply an institutionalizing of the existing programs of *asistencia social*.[41] The program was unofficially inaugurated on February 27, 1945, with an extensive distribution of clothing to the poor of the city.[42] The plan targeted the physical distribution of goods and services, but beyond that it represented an attempt to create "stability within the home" through the formalization of social assistance. According to Trujillo, the plan began with a restructuring of labor laws to protect the humble worker, progressed to the building of homes, and would finally expand to provide necessary services relative to health, education, and infrastructure. In his November 1945 speech to Congress laying out the program, Trujillo argued that the basic foundation of a stable social and political structure lay in the family, which, "lacking stability and healthy development, would make national prosperity impossible." He connected the various aspects of the plan with the requisites of a true democracy:

> Democracy emerges from prosperity, from physical health, and from the moral satisfaction of the individual and the family. Democracy is something organic, vital, and evolutionary that today can be based in nothing less than the best efforts of the government to make human life useful and valuable.[43]

Unlike the previous *asistencia social* programs, though, male-headed departments and foreign social work specialists would carry out the new plan. Party officials enlisted many of the women who had already begun such work under the Sección Femenina, but now their efforts were made an integrated and institutionalized part of regime politics. All projects were to be directed through established government ministries like Housing and Labor, rhetorically and logistically separating them from the previous work of the Sección Femenina. The *damas trujillistas*, however, would continue doing much of the day-to-day and face-to-face chores of the new program of social work and would be reaffirmed in their belief that emphasizing the moral family unit was still the most effective avenue to assert their presence in Dominican politics.

Although the women of the Sección were excluded from the top leadership of the new social assistance programs, they continued in a functional role as the direct administrators and struggled to remain central to the stable home as wives and mothers and the defenders of peace and democracy. As they had worked at many levels of the regime's social assistance programs in previous years, they clung to their roles as functionaries in the everyday workings of programs that encompassed concerns of health, education, motherhood, child rearing, and agriculture.[44] Between 1945 and 1950 the women of the Sección Femenina labored in many different areas of the later renamed Plan de Mejoramiento y Asistencia Social targeting the stable home and family. At a February 1945 meeting, Partido Dominicano head Virgilio Álvarez Pina offered thanks to the many women of the capital who had been working on such programs, and he promised even greater resources for their efforts in the upcoming year. Álvarez Pina committed, on behalf of the party, new sources of funding, engineers to assist in building homes for the needy, dentists and doctors for health programs, and increased resources for food assistance programs as he spoke to the female presidents of various social work, border assistance, school clothing, victory gardens, literacy, mothers clubs, school libraries, and school breakfast committees gathered at the Ateneo.[45] In response, the women promised to increase the number of participants in their committees and organize activities to raise funds independently for Trujillo's grand plans for the Dominican family.

The inauguration of a child care center and a school for domestic work later that year highlighted the allegiance the *damas trujillistas* maintained

for the programs of *asistencia social* and their work upholding the stable family.⁴⁶ However, the inauguration also made very clear the elitism that suffused the group of female activists. Congresswoman Josefa Sánchez de González opened the event with a discussion of the Escuela de Servicio Doméstico (School of Domestic Service) and Guardería Infantil Ramfis (Ramfis Day Care Center) as part of the larger program of "bien social" offered by Trujillo, on his birthday, no less. She argued that both institutions provided the resources so that women of the lower classes might find "a better way to live with decorum and be armed to defeat the problems of vice and misery." The school and child care center, Sánchez de González and other speakers implied, would make such women more capable mothers and homemakers while providing education and nutrition for the city's neglected children. In sum, the work promised "a happy future for the nation" and the elimination of any need for radical political change. Outside the capital, women relied on their local connections to call the attention of officials to the needs of their communities. They expressed their importance as mediators between citizens and regime officials and as a result their indispensable role as the maternal cogs in the dictatorial machine.

The continued work of the *damas trujillistas* in social programs allowed for a more direct link between the party and smaller, more isolated communities. Women like Ana Cavallo Vda. Ramírez in Barahona benefited from the increase in activity surrounding the Plan de Mejoramiento y Asistencia Social as she advocated for her province.⁴⁷ Entering politics initially as a local *encargada* for the Sección Femenina in 1944, Cavallo Vda. Ramírez became a vocal proponent of the social programs of the Trujillo regime in her home province. Barahona, on the southwest border with Haiti, was one of the six border provinces that were central to the dictator's plan of *ayuda fronteriza*.⁴⁸ Cavallo Vda. Ramírez made sure to stress the work that had been accomplished in her province, but she also proclaimed loudly the problems still evident in the area. A January 1945 newspaper article reported that many school uniforms, shoes, and blankets had been distributed to the needy by a commission headed by Cavallo Vda. Ramírez, a local priest, and the ladies of Acción Católica and that several thousand school breakfasts had been made available to schoolchildren. In her article "Lo que necesita Barahona" (What Barahona needs) Cavallo Vda. Ramírez detailed the urgent needs of her community.⁴⁹ She called for assistance with four major necessities of the region: a hospital, a maternity center, a mod-

ern school building, and a new home for the local Partido Dominicano. Of the dire medical concerns, the situation was painful and unavoidable, and the Sección Femenina in the area lacked the resources to address such large problems. In conclusion, she offered that such improvements had to be made so that Barahona could follow the "ritmo de progreso" dictated by Trujillo.

Drawing on the success of the centennial celebrations and keeping their efforts timed to the rhythm of progress through *asistencia social*, the women of the regime trained their focus for the next several years on reelection campaigns, the organization of a second women's congress, and maintenance of the Sección Femenina. While these events and activities provided them with numerous opportunities to engage in the everyday performance of the regime, they also proved to move them steadily into a more functionalist role within the dictatorial machine. Beginning in 1945 they campaigned for Trujillo's reelection in 1947 and stressed his vaunted position as the consummate democrat in a global arena filled with conflict, chaos, and potential revolution.[50] Bernardino, speaking from her international rostrum in 1945, reminded her listeners of the tireless work Trujillo had offered to the cause of women's rights and in guiding the Dominican Republic through a period "of chaos and misery experienced by the majority of the countries involved in the world war."[51] Having raised the country to a place "of perfect democracy," Trujillo deserved every Dominican woman's full support in the quest for reelection. Praise for the regime's peacemaking skills was evident on more local terrain as women began organizing in support of reelection.[52] The women of the barrio Punta de Garza in the sugar town of San Pedro de Macorís directed an open letter to Trujillo in *La Nación*, reinforcing the themes of peace and progress.[53] They assured the "supreme leader" of their support in the elections and their continued admiration of his work. More than one hundred women purportedly signed the letter. Given all that Trujillo had done to elevate women to a position of full citizenship, his reelection was at once distinctly a women's issue but also "a great necessity for the Dominican nation" and its families.

Reelection activities continued for the next two years and culminated with a highly symbolic manifestation in the historic Parque Colón in Ciudad Trujillo. Newspaper reports lauded the women organizers and argued that the success of the homage demonstrated the level of political and social advancement of women under the Trujillo regime:

This just recognition, brought to life by the women of the capital, reached extraordinary heights and was a lively demonstration of the high grade of culture and patriotic civic nature that Dominican women have achieved, all thanks to their experience in public activities and the class consciousness that they have acquired, all a direct consequence of their participation in national issues made possible by the illustrious Generalísimo Dr. Trujillo Molina through the modern social legislation that guaranteed their full enjoyment of civil rights.[54]

The highlight of the event was a parade that descended upon the historic park in front of the hemisphere's oldest cathedral in the early evening; the overall message was clearly about the peace and tranquility Trujillo had procured for the Dominican family.[55] As the women paraded into the park they were greeted by cannon fire; the elaborately decorated park was replete with thousands of chairs and welcoming banners proclaiming Dominican women's support for Trujillo's reelection. Like the imprint on the souvenirs offered at the earlier toast, the women claimed that "to reelect Trujillo is a patriotic duty." The presence of thousands of women in Ciudad Trujillo's colonial city marked the end of a historic two-year organizing effort, and the homage in Parque Colón demonstrated their leadership and mobilizing skills. Such practices afforded women the opportunity to participate directly in the affairs of the state and empowered them to serve as representatives of the regime in their hometowns. The event put on direct display their clear engagement with the international imperative for peace, women's maternal duty in that struggle, and the essential role that Trujillo should continue to play in connecting the two.[56] Yet it was also an extremely theatrical affair that made evident the minimized role women had come to occupy in the Trujillato.

Signaling female support for the regime that protected the Dominican nation and its families was a regular activity for the *damas trujillistas*. Isabel Mayer, the distinguished politician from Monte Cristi, employed the strong arm of "peace and progress" in her involvement in the construction of a colossal monument to Trujillo in Santiago, the nation's second-largest city.[57] The so-called monument of peace and progress stood seventy meters tall atop a hill in the city center, mocking residents' historical opposition to the regime. Several women wrote to *La Nación* to publicize their ideological and fiscal support for the project. Two letters were included in a March 1945

edition of the paper, noting each writer's enthusiasm for the monument.[58] One specifically expressed her hope that more women would contribute to the fund begun by the group of "distinguidas damas" as a tribute to all Trujillo had done for Dominican women and the nation. Isabel Mayer's speech at the commencement of construction on April 30, 1944, reinforced the role played by women as the ideological cornerstone of the nation's purported peace and tranquility but also as the fiscal ringleaders in a project that touted the regime's rhetoric of democracy and national advancement. As an extremely active *dama trujillista* Mayer was the ideal figure to lay the first stone in the construction of the colossal and imposing monument.

With Josefa Sánchez de González in the top position of leadership, the Sección Femenina continued to function under the direct supervision of the Partido Dominicano and evidenced the limitations placed on women's engagement with the party structure. Sánchez de González, or *doña* Fefita, as she was called affectionately, was responsible primarily for rounding up stray inscriptions in the party and policing participation.[59] By the early 1950s, with the *asistencia social* programs redirected through different government departments except the literacy and school uniform programs, Sánchez de González and her compatriots worked diligently to ensure 100 percent female enrollment in the party and women's continued participation in the programs that had been mined out to other departments.[60] The Partido Dominicano relied on Sánchez de González and the Sección Femenina to continue the work of the literacy programs, maintain high levels of activism among party women, and serve as watchdogs for improper political conduct among the masses. The *encargada* also looked for ways to improve female participation. The impulse toward active female political participation initiated in the early years remained an element of the Sección Femenina for many local women, and articles in *La Mujer en la Era de Trujillo* served to spotlight the activities of the organization in public displays and demonstrations.

Nonetheless, the activities of the *damas trujillistas* had clearly shifted by the early 1950s. The concerns of the women, now fully ensconced in the machinery of the Trujillo regime, centered on remaining public, active, and vocal members of the colossal machine. With female suffrage achieved and electoral activities focused on the practiced politics of reelection, the relevance of the *damas trujillistas* waned in the second half of the Trujillato. Regime bureaucracy slowly pushed them out of the more prominent

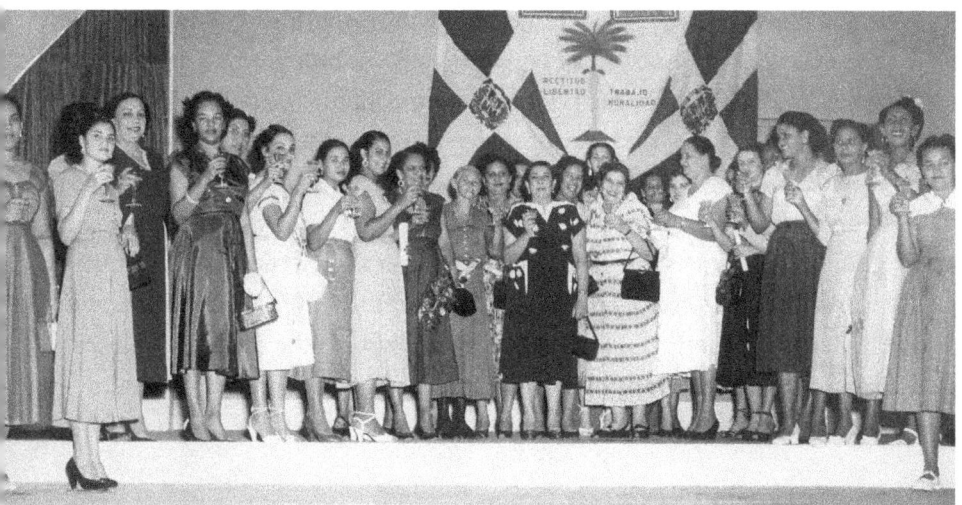

Figure 2.1. A meeting of the Sección Femenina of the Partido Dominicano in Ciudad Trujillo, circa 1955. Courtesy of Archivo General de la Nación, Santo Domingo.

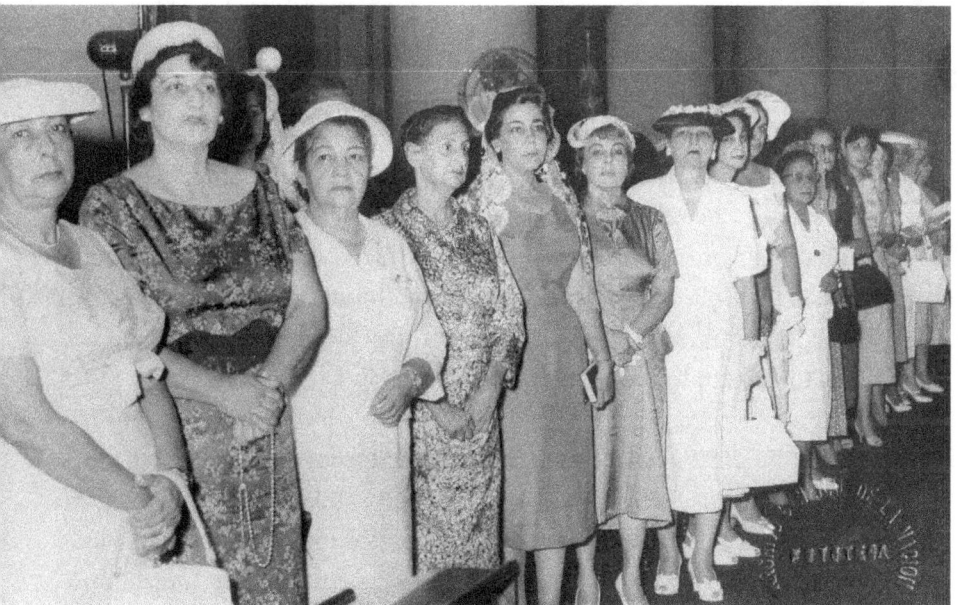

Figure 2.2. Members of the Sección Femenina of the Partido Dominicano at the National Cathedral, Ciudad Trujillo, circa 1955. Courtesy of Archivo General de la Nación, Santo Domingo.

positions in *asistencia social*, and the work of the Sección Femenina took a back seat to more pressing issues like economic reform and national development.[61] Still, the women who had so actively clamored for a place in national politics refused to give up their newfound prominence without

a fight. They assumed a functionalist role as the nurturing mothers of the body politic, continued to agitate for attention through the international channels established by the IACW, and found multiple activities into which to pour their public and patriotic efforts. As their activities clearly lacked the political import of the previous period, their engagement with the discourse of the regime became even more important. By drawing out the most salient elements of the regime's bid to maintain its domestic and international reputation as a democratic and peaceful nation, the elite women of the Trujillato continued to assert their centrality to the dictator's image as a stabilizing and moralizing force in an increasingly unpredictable international political context.

Women's Activism and the "Barbarous Theories of the Kremlin"

Through the late 1940s and the 1950s the women of the regime sought to continue their international engagement as well as their domestic efforts as a reminder of their importance in showcasing the nation's respectability and concern for global peace. With the end of World War II and a shift in world opinion toward the dangers of dictatorial regimes, the Trujillato began to refocus its attempts at international self-fashioning. While war efforts had garnered Trujillo at least the façade of a representative and humanitarian regime, new international assessments, particularly those coming from the United States, saw long-term authoritarian leaders as potential threats to stability.[62] Eric Roorda argues that the change in attitude had much to do with the contradictions inherent in Dominican relations with the Allies: "The parroting of democratic rhetoric by the grimly authoritarian Trujillo dictatorship injected unintended irony into the Allies' stock phrases praising freedom and international solidarity."[63] Predicting the transition, Trujillo officials eagerly reformulated the discourse of patriotic participation. Democracy remained a major touchstone, but "anticommunism" became the more potent term to justify the continued rule of Rafael Trujillo. The regime had flirted with a level of tolerance toward opposition parties in the wake of World War II, but the window closed definitively in 1947. A law enacted on June 4 prohibited all communist activity as well as any political organizing that challenged the "representative" government of the Dominican Republic. Rather quickly, the regime began characterizing opposition politics as communist. In an interview Trujillo argued that all

resistance activity ultimately was communist in nature because "no patriotic Dominican who loves his place of birth would try to overthrow its stable, beneficial government except Communists."[64] The scholar Jonathan Hartlyn points out that the end of the regime was marked by a decrease in discussion of national goals and a rapid increase in rhetoric surrounding the "communist threat."[65] Women of the regime, positioned as they were as the guardians of the home, saw themselves as the ideal watchdogs for the virulent threat of communist infiltration domestically and abroad. In the postwar period, this vigilance revolved around the terroristic language of the dangers of communism combined with the ongoing insistence that women served as the bulwarks of a moral home and family.

As the Dominican representative to the Inter-American Commission of Women and the nation's most prominent female international advocate, Minerva Bernardino echoed this discourse as she represented the regime at worldwide conferences toward the close of World War II. At the Inter-American Conference on Problems of War and Peace held in Mexico on March 6, 1945, Bernardino affirmed the foresight of her country's supreme leader in granting full and equal rights to Dominican women.[66] As she focused on the Americas-wide campaign for women's suffrage she stressed the importance of female participation in such issues of global concern as peace and progress. She offered tribute, at "this world-shaking hour," to the women who were "offering their lives and their sons' lives on the alter of a common ideal," while reminding delegates that "women possess all the virtues of the most high-minded citizenship; this, in addition to traditional recognition of the fact that as mothers, wives, daughters, and sisters they form the heart and soul of the family." Through her international appearances, Bernardino fostered an image of women as peacemakers and ideal citizens in a difficult world, while her Dominican compatriots angled to offer themselves as models of domestic tranquility and progress through transnational organizations.

Following the success of various domestic activities yet in the face of their waning party influence, the "distinguidas damas" of the capital sought out new transnational networks to bolster their activities in the local arena. In late 1944 several women convened to form a Dominican branch of the Unión Femenina Ibero-Americano (UFIA), a Mexico-based women's group.[67] The stated goals of the sister organization were the development of culture, an increase in international exchange, the cultivation of friend-

ship among members, and the contribution to the great work of "social improvement" of Trujillo.[68] Subcommissions sprung up in towns across the country and provided women with spaces to meet, offer lectures and readings, and promote their activities in the political arena. When they were praised by their compatriots in Mexico, the encomiums made their way into the national paper as a form of leverage and a reminder to the regime of the women's international presence. Affiliation with social and cultural groups like the UFIA offered prominent women an important venue to participate in the public arena during the second half of the Trujillato despite their reduced presence in party politics. Moreover, it allowed them the space to defend this new role. In September 1948 Delia Weber spoke to the distinguished female members of the UFIA in San Pedro de Macorís and offered advice on how to navigate a world of new complications and demands.[69] Weber said the new or modern woman faced a set of interconnected challenges that included defending her freedom, a "freedom that authorizes her with certain arrogance to maintain her dignity without undermining her beautiful gifts of femininity." She argued that the march of progress was inevitable and served as the "new light"; she called on women, as a distinctly enlightened component of public life, to contribute positively toward meeting the challenges ahead.

Besides their connections to the Mexican group, many Dominican women still looked to the trusted IACW for further support for their activities and as a way of maintaining their official status. Bernardino created a Comité de Cooperación Internacional (Committee of International Cooperation) to aid in her IACW work from the Dominican Republic in 1948. Party functionaries Abigail Coiscou, Margarita Peynado, and Consuelo González Suero were named members of the committee, although Bernardino drew on the support of many other women. Milady Félix de L'Official would soon assume Bernardino's place as the Dominican IACW representative to various international feminist conferences after Bernardino moved on to a post at the United Nations, while Amada Nivar de Pittaluga became the official Dominican liaison to the IACW. By formalizing the Committee of International Cooperation as the Consejo Nacional de Mujeres (CNM, National Council of Women) in May 1948 and declaring it the official IACW affiliate in Santo Domingo, Dominican feminists again linked legitimacy in the regime to international acceptance and reputation.[70] Although the CNM was merely a more formalized version of Ber-

nardino's earlier committee, Trujillo, having secured the election in 1947, officially appointed Nivar de Pittaluga as its president and sanctioned its work domestically and internationally. Bernardino declared to her international audience that it was comprised "of the most outstanding and influential feminine leaders of that country."[71] The group would work closely with Bernardino and the IACW while continuing to uphold Trujillo's Plan de Asistencia Social for all the world to admire.

Women were aided in their quest for political recognition by the regime during this period through the editorializing of many men who were equally interested in impressing government officials with their foresight, humanity, and awareness of the international context. Through the late 1940s and early 1950s, male editorialists, female writers, and the *damas trujillistas* combined to redirect the discussion of women in the regime from a focus on citizenship and the magnanimity of the regime to a linkage between the role of women in politics and the democratic nature and progressive outlook of the Dominican Republic. One male regime official, like his female international compatriots before him, connected the divine work of women in politics to the place of the Dominican Republic among the civilized nations.[72] He called for the combined publication of every speech of the CNM so that the collective voice of Dominican women might reach all of the Americas and convey the true progress of the Dominican nation in its struggle for right, justice, democracy, and liberty.

Reelection events again provided an ideal platform for women to expound on the themes of democracy, peace, progress, and above all, anticommunism. Women appropriated these concepts with vigor, ably connecting their role as citizens with the maintenance of such issues of worldwide importance. The CNM, headed by Nivar de Pittaluga, assumed the responsibilities for capital-based organizing during the next reelection campaign period of 1950–1952. Peace in the world and in the Dominican home were the touchstones of women's arguments for Trujillo's reelection. Their direct linkages between national progress in the Dominican Republic, democracy in the developing world, and the rule of Trujillo demonstrated keen awareness of the regime's national and international rhetoric. While an "election" could be risky, one speaker argued at a large demonstration in September 1950, "reelection" affirmed a nation's previous selection of a capable leader.[73] In no way did they see the lack of electoral choices as demonstrative of a lack of democratic principles. In fact, for them, their presence in

the electoral process affirmed the regime's true egalitarian and democratic nature. For the representative of San Pedro de Macorís, writer Lydia Pichardo Lapeyretta, to speak of anyone but Trujillo was to ignore "the salvation of democracy and the integrity of the Republic." Pichardo emphasized that Dominican women sought always to "conserve the social good, not only for herself, but for her children, her husband, and her siblings."[74] The sanctity of the Dominican home in a world of seeming chaos was the most blessed gift of the Trujillo regime. For many women the active female presence in the electoral pool not only allowed for total participation in the democratic process but brought a missing element to the Dominican political arena. By supporting the reelection of Trujillo they were affirming the continued security, culture, and progress in their nation and their homes. In other words, voting to reelect Trujillo, while highly emotional, was not a matter of individual choice but a corporatist endeavor designed to maintain the integrity of the Dominican family.

Public debate regarding the dangers of communism would escalate through the end of the decade and into the next, and the *damas trujillistas* clearly integrated the newfound loathing espoused by the regime for the "red threat" in their own discourse. Responding to the reports of leftist activism among young women during the brief period of political tolerance, Partido Dominicano president Virgilio Álvarez Pina spoke directly to the *damas trujillistas*. He exhorted Dominican women not to be seduced "by the tricks with which the misled communists hope to mine their good faith or gullible nature."[75] The *damas trujillistas* plunged themselves into domestic and transnational activities, arguing at every opportunity that the women of the Dominican Republic favored the continuation of Trujillo rule precisely because it was stable and encouraging of their role as defenders against threatening political ideologies. One of the greatest threats to peace and democracy was not, to them, the lack of choices but the specter of communism. By the early 1950s the challenge to democratic principles posed by the global spread of communism had assumed an importance in the Trujillo women's words and deeds. For subjunta head Nidia Battle de Paiewonsky, the reelection of Trujillo in 1952 represented a way to prevent the spread of communism and continue the country in its path to progress.[76] Battle de Paiewonsky's compatriot Pichardo Lapeyretta echoed her concerns regarding world influences. In her appeal for Trujillo's reelection, Pichardo Lapeyretta discussed her own country's "debilitating spells

of caudillismo" as well as "the terrible and threatening state of affairs in the world."[77] One speaker at the September 1950 rally affirmed the importance of democracy "in such crucial moments of opposing theories"; another described the period as the "crucial hour of world concern."[78] Trujillo's reelection was imperative, but in their estimation it was the women of the regime who truly protected the nation against the threat of communism. As the safeguards of the home and the providers of education, Dominican women stood as the first and last bulwarks against opposing political theories.

In the early 1950s, *La Mujer en la Era de Trujillo* served as another arena in which the *damas trujillistas* could bolster their importance in the anticommunist struggle. Morató Vda. Egea's publication reported regularly on legislation restricting the practice of "subversive" politics. On February 23, 1951, the editor printed with evident pleasure a piece on the recently declared state of emergency promulgated by Trujillo to combat the threat of communist aggression.[79] Her editorials in the newspaper showcased women's roles in maintaining peace and stability in the home in light of world upheaval. Through her diligent support of the work of Trujillo in the realm of anticommunism, Morató Vda. Egea sought to highlight the efforts of women who aligned themselves with the regime's motto of "work, peace, and liberty." The reach of this anticommunist rhetoric among women extended deep into the rank and file. In 1950 a teacher from San Pedro de Macorís wrote to officials in the Department of Education to inform on a fellow local teacher, Olga Arache, for dishonoring the population and the education system.[80] Not only was she generally disrespected by her students, but there was a naked picture of her circulating the neighborhood—and she was a communist. Signing the letter "Trujillista siempre," the teacher conveyed to officials the dangerous impact such subversive ideas had on the well-being of the Dominican nation and demonstrated the depth of anticommunist discourse among the *trujillistas*.

Throughout the 1950s, the ideals of anticommunism provided a platform for the women of the regime to prove their loyalty, service, and utility. In 1959 Thelma Frías de Rodríguez published a pamphlet that summarized many of the "truths" reiterated by the *damas trujillistas* in service to the regime. Titled simply "Ten reasons for my anticommunism," Frías de Rodríguez' publication offered testimony of her loyalty to the supposed ideals of the dictatorship.[81] In it she placed the Trujillo regime on the side of the democratic nations in the widening global polarization between national

well-being and worldwide moral danger. She tied her work in *asistencia social* to the more expansive good works of the regime. These efforts, she contended, elevated the standard of living in such a way as to fully block the dangers of the "barbarous theories of the Kremlin." Besides being a loyal and active *trujillista*, Frías de Rodríguez argued that her avid nationalism, strong religious convictions, humanism, individualism, and Americanism contributed to her stance against communism. However, she linked her identity as a woman and a writer directly to her ideological stance, claiming that pertaining to either of these two categories would automatically classify a person as standing with the democratic nations. First, women naturally hated war because they were life givers, and, Frías de Rodríguez contended, they readily joined the efforts of social betterment programs established by Trujillo. In rejecting war and supporting the home and family, Dominican women joined the efforts against communism ideologically but also practically as they helped elevate the standard of living.[82] Finally, as a journalist, Frías de Rodríguez argued that it was the circulation of a free press from the democratic nations—the Dominican Republic included—that most effectively warded off the threat of communism. The inherent contradictions of her writing could not be more evident, and yet her work exemplified the ideological linkages made by the *damas trujillistas* as they persisted in justifying their place in the regime and the body politic.

Regardless of these embedded contradictions, the work of the *damas trujillistas* continued apace. By the mid-1950s Amada Nivar de Pittaluga had amassed twenty-one subjuntas for the CNM in various interior cities and had assumed a prominent place among the *trujillista* women.[83] While Josefa Sánchez de González and the Sección Femenina proceeded with the behind-the-scenes work of female enrollment and *asistencia social*, credit for regime organization by women began to fall more heavily on the Consejo Nacional de Mujeres and its leader, Nivar de Pittaluga.[84] Ultimately, they assumed the public domestic face of the *damas trujillistas* while Bernardino and her colleagues kept working internationally for leverage. Many women evidently believed that their continued efforts through these various channels would be rewarded with even greater civic and social reform, yet little legislative change was made in the civil or political code after the mid-1940s.[85] In fact, some nominally protective legislation was actually rolled out to restrain women's ability to participate in the formal economy. Zeller points out that the labor code enacted in 1951 limited women's ac-

cess to salaried work even as the women themselves sought out the role of maternal protector of the Dominican family.[86] However, the women of the Trujillato maintained their quest for recognition in the political arena through their efforts in the day-to-day operations of *asistencia social*, their international engagement, and most importantly, their engagement with the regime's discourse of stability and anticommunism.

IN JUNE 1956 THE DOMINICAN REPUBLIC played host to the conference of the Inter-American Commission of Women, and the *damas trujillistas* made what would be nearly their last major push for public and political recognition amid a regime engulfed in its own contradictions. As Minerva Bernardino had served as the standing president of the IACW for the previous ten years, the selection of Ciudad Trujillo was an obvious choice, and the regime readily acquiesced. The event provided a venue for the regime to debut the developed and metropolitan Dominican capital, showcased the previous year in the Feria de la Paz y Confraternidad del Mundo Libre (Fair of Peace and Fraternity of the Free World), to the women of the Americas.[87] The conference was held on the grounds of the colossal fair in Ciudad Trujillo and drew on the grandiosity of the previous event. Female delegates from eighteen American nations attended, including a large delegation from the Dominican Republic and several UN representatives. As the regime was being challenged on several fronts by its own citizens and on the international stage, the conference provided an ideal opportunity to demonstrate the advancement of the country's women and hence the progress and modernity of the nation.

Dominican delegates to the IACW conference in 1956 knew of their indebtedness to the regime, and they expressed their thanks through their emphasis on the peace and stability of the Trujillato and their public and private roles as the vigilant protectors of that tranquility. Alternate delegate María Teresa Nanita de Espaillat, in a letter to the secretary of foreign relations, credited the "climate of peace and liberty" created by the government as key to the event's success. Bernardino herself pointed out that it was not mere chance that the conference was held in Ciudad Trujillo during the historic Año del Benefactor de la Patria.[88] Speaking at the opening of the conference, Trujillo discussed the "bitter days of trial" in which the world lived and argued that the "clear heart" of the woman, with her "pacifist

spirit" and love of the home, was the best defense in support of the most vaunted "spiritual values" he sought to uphold. Conference organizers extended back to Trujillo a "vote of applause and appreciation" in light of his "effective support of the cause of human rights" and "substantial contribution to the work of the Inter-American Commission of Women." They also said their successes at the conference hinged on the hospitality of the leader's progressive nation.[89] Including a tour of the nation's interior for all the delegates of the Americas, local conference organizers sought to showcase how essential they were to the peace and stability of the Trujillato.[90]

As the *damas trujillistas* were gaining more political experience at the national and international level—despite its practiced and pedantic form—they were also reiterating a traditional, maternalist discourse that lauded the caretaking and nurturing qualities of women. Julio Cesar Santana's praise of "la mujer dominicana" encapsulates the regime's long-standing elevation of women's traditional roles as nurturers and caretakers and their adoption of that role in the postsuffrage period. Santana reminded his readers of Trujillo's foresight in granting women full political rights in 1942, creating the opening through which Dominican women were able to "enter the arena of public life." Above all strong and sacrificing, women were made to "govern and educate." Through the brilliance of the supreme leader, such a reality had come to pass in the Dominican Republic: "Women are in the countryside, at the voting urns, in the classrooms, in the offices, in the social services . . . thanks to the man that no one can imitate though many desire to." According to Santana, women in the Dominican Republic were vanguards, acting freely in the public arena. Although the home was her "designated place," her capacity was to serve society "for peace, in work, for love, and in the home."[91] For Teresita Roja de Cantizano, a contemporary of Santana, the most noble and notable qualities of the Dominican woman were her love and sacrifice as a mother, her most important work the maintenance of the Dominican home.[92] The clear pinnacle of womanhood, maternity was described by regime sycophants as the veritable life force of the world. Similar praise came in various encomiums to the regime in its final years, all attempting to put a positive face on a government that few believed could any longer protect the country from the vicissitudes of international opinion or even of its own people. Yet the best efforts of officials and loyal female supporters in the last years of the 1950s come off as relatively hollow means to prove the anticommunist, progressive nature of

the dictatorship in light of domestic and international audiences growing tired of the regime's overwrought productions.

Ultimately the success of the *damas trujillistas* in the regime during the postsuffrage period was a precarious balance. Just as they used the regime to advance their individual careers and public agendas, they were at the mercy of international shifts as well as the dictator's whims. Toward the end of the regime, this reality became glaringly apparent as two distinct yet connected phenomena developed in the Dominican Republic, the growth of a youth and university movement in opposition to the regime and the waning importance of the *damas trujillistas* in politics as larger concerns for regime maintenance took center stage. The case of Isabel Mayer proves an excellent example of these two intersecting issues. Throughout the regime, she was considered an important and influential figure. She held the position of senator several times, served as provincial governor for Santiago and Monte Cristi, and was a key figure in many of the most important conferences and national celebrations held by the regime. Given her level of influence with the regime, she has been labeled a *celestina* by many Dominican historians; that is, several have alleged during the time and since that Mayer would fulfill any wish of the dictator, including procuring attractive virgins.[93] A foreign journalist described her as lonely and disillusioned.[94]

By the end of the regime Mayer had reason to look lonely and disillusioned. Her ex-husband's son as well as her own grandson were beginning a movement to overthrow the Trujillo dictatorship to which she had remained loyal for so many years.[95] As a result, Mayer soon found herself on the list of individuals whom the regime distrusted. She was called out in the famous "Foro público" in *El Caribe* for her revolutionary associations, and in January 1960, despite her many years of loyal service, she was removed from her political post.[96] To add insult to injury, that same month she was included on a list of individuals who were invited to form competing political parties for the upcoming elections.[97] The tactic, used in the past by the regime, was meant to force individuals to affirm their faith in the Partido Dominicano while concurrently reminding them of their past sins. Included on the list were prominent regime resisters. Mayer responded with an indignant letter and telegram stating unequivocally that she declined the invitation.[98] She wrote that she had been a member of the PD since its founding and would continue to remain within party ranks as long as she lived. She considered the party to be "the shelter for every pa-

triotic, progress-loving, and Christian Dominican" from the "Communist hordes" that threatened the world. She closed by reminding regime officials of her admiration of the party's founder and "father of the new nation," Rafael Trujillo, and of the enormous debt she owed to him. Having come from a position of such prominence, Mayer found herself in a relatively outcast state; her story echoes the larger patterns of women's political engagement with the Trujillo regime in its final years.

Through their everyday interventions in the public practices of political performance and anticommunist rhetoric, women asserted their importance in the second half of the Trujillo regime while constantly teetering on the edge of marginalization. They were forced to concede positions in social assistance programs and slowly pushed to the wings of Trujillo's show of democracy, but they continued to seek out avenues to prove their significance to the regime. By founding new organizations with linkages within the country and outside of it, the *damas trujillistas* created platforms from which to project their commitment to democracy and more specifically anticommunism. However, just as women like Isabel Mayer were being pushed from the political scene, the regime was rapidly neglecting its commitment to the stable and tranquil Dominican home through its persecution of dissidents. Despite their efforts to retain their positions, the *damas trujillistas* would be overshadowed by a new generation of female activists who found entirely different avenues for their participation. Many of the women of the Trujillato would fade from the political scene but their practices, methods, and public discourse would influence women's politics for nearly the rest of the century. In using their maternal gifts as the foundation of their inclusion in politics and the insistence that the Dominican state protect the sanctity of the family writ large, the *damas trujillistas* managed to cement their eventual marginalization from the public arena, the larger downfall of the regime, and the persistence of a maternalist model of female political participation.

3

Intimate Violations

Gender, Family, and the *Ajusticiamiento* of Trujillo, 1944–1961

ON THE AFTERNOON OF AUGUST 10, 1959, several dozen Dominican and Cuban women gathered in the streets of Havana.¹ Dressed in black as though headed to a funeral, they mourned the political situation in the neighboring Dominican Republic. Specifically, they targeted the dictator Rafael Trujillo, calling him the "Jackal of the Caribbean." As they paraded through the streets carrying placards and visiting newspaper offices, they focused attention on their specific struggles as women and mothers. Their posters read, "Dominican Women Support the Revolutionary Government"; "We Ask for the Expulsion of Trujillo from the OAS"; and "We Represent the Mourning of the Assassinations Committed by Trujillo." They told the Cuban newspaper *Información* that their actions symbolized "the mourning of our beloved Dominican people, every day more oppressed, humiliated, and enslaved by the crimes committed by the tyrannous regime of Rafael Trujillo." At once internationally savvy and domestically focused, Dominican women and their allies were central to the resistance movement that developed over the three-decade dictatorship of Rafael Trujillo. Drawing on the regime's own maternalist discourse of the nation as family, these female resister-activists consistently pointed out the failures of the Jackal to protect women, children, and the Dominican home; their vigilance was essential to the termination of the regime.

The story of the fall of the thirty-one-year regime has been told almost exclusively through the eyes of its male protagonists.² As the most visible members of the resistance that led to Trujillo's *ajusticiamiento*, Dominican men have taken near-exclusive discursive possession of the last years of the infamous dictatorship, with one major exception—the story of the martyred Mirabal sisters. However, women were far from absent from the

larger narrative of political transition that led up to the Trujillo assassination on May 30, 1961.[3] Dominican female activists demonstrated that the promises made by the leader—to protect the traditional family and national morality—not only were dubious but that through the direct violations of the regime their homes and loved ones were being evermore trampled upon. In an altered reflection of the regime's own gendered framework, these women demonstrated their skill in political engagement and created a discourse of resistance grounded in their specifically maternal contributions to civic life in the Dominican Republic, contributions that persisted well beyond the demise of the infamous leader.

For many Dominicans, the assassination of resistance activists and sisters Minerva, María Teresa, and Patria Mirabal in 1960 by the regime stands as the beginning of the end for the Trujillo dictatorship, yet the extant scholarship on the regime fails to fully interrogate this fact. This murder of three women activists was the breaking point of the regime precisely because it challenged deeply embedded beliefs of what the regime, even at the very minimum, could do for the Dominican people. Not simply because it was enacted on supposedly weak or defenseless women or because it was a tremendously shocking action even for Trujillo, the assassination of the Mirabals exposed the regime's failure to protect the sanctity of the home, embodied symbolically by women and mothers. As a result, it was an assault on Dominican national morality.

Moreover, while it is readily acknowledged that the assassination marked a significant turning point in Dominican history, the idea that women other than the Mirabal sisters participated in the resistance movement is only beginning to enter into the Dominican narrative. As Myrna Herrera Mora points out, many women were actively and valiantly involved in the revolutionary movements of the 1940s and 1950s.[4] Expanding the narrative beyond the three martyred Mirabal sisters highlights how women's activism, operating through local, national, and international channels and engaging the gendered discourse of conservative politics, is central to the toppling of authoritarian leaders. The historiography of the resistance has only begun to incorporate the contributions of women, and the martyrdom of the Mirabal sisters less than a year before the regime's dissolution further obscures the contributions of Dominican women to the end of the dictatorship. Yet in reality, as Trujillo actively created broken homes and orphans in his persecution of opponents, women more readily entered the movement

as engaged resisters, and Dominican society mobilized around these very intimate violations committed by the regime. Though the fall of the Trujillo regime was a complex process indebted to multiple forces, one of the most significant factors was the resistance movement's ability to highlight the regime's failure to maintain its promised link between traditional family values and national stability—and with the women who so vociferously made that failure part of the public debate.

Like similar resistance movements, the Trujillo opposition that developed in the Dominican Republic in the early 1940s and the 1950s sought to debunk the regime's own argument that it alone was best suited to defend the traditional home and family, and women were a central part of that movement. As the regime's pressures on the island mounted and the resistance transitioned into exile from the mid-1940s through 1961, women emphasized increasingly the need to bear witness against the abuses of the regime. Drawing on a legacy of feminine political engagement at the national and international levels, these female resistance activists knew that claims against the dictator needed to be made before both domestic and inter-American audiences and to focus on the home and family. As tensions on the island increased and international attention to the Dominican situation grew during the mid-1950s, some of the most intense resistance again developed at home. Many women who had not been forced into exile continued or renewed their commitment to revolutionary opposition work, while demonstrating a parallel dedication to defending the dignity of the mother and the family. These demands to protect women, wives, girlfriends, and children proved essential to the final push in the anti-Trujillo campaign.

Revolutionary Women and the Anti-Trujillo Movement, 1944–1950

Women's activism in the earliest years of the resistance movement found acceptance among many because it did not upend the traditional gender roles of mother, wife, and daughter; rather, early female resisters argued that the only way to preserve these formulations was through the termination of the rapacious regime of Rafael Trujillo. Given the growing presence of women at the universities of the region in the 1940s, several key female activists began clandestinely encouraging others to protest the increasingly violent tactics of the regime.[5] The group was predominantly middle- to

upper-class, educated, and from a few urban areas across the country. They utilized the democratic opening afforded by World War II to mobilize and came to serve as the inspiration for a larger group of women who would become the vanguard of the protest movement as it moved into the 1950s and 1960s.[6] The efforts of these women were foundational to the movement as it grew, and they conveyed the avenues to political participation available to women through the consistent defense of the stable home and family.

Grey Coiscou Guzmán, a young child in the 1940s, documented the memories of her mother, Rita Violeta Guzmán Gonnell, from the winter of 1944, and her words emphasize how women had come to revolutionary stances out of their anguish over destroyed families. Guzmán Gonnell recalls that "the resistance against the tyranny became more intense with the increase in losses of human lives. The mourning in many homes, as much in the interior of the country as in the capital, blanketed the bodies of mothers, wives, and children of those opposed to the regime."[7] Coiscou Guzmán's study, in providing the testimony of a self-proclaimed "faithful witness," helps reconstruct a movement that at the time was meant to go unrecorded or at least undetected. Though most of the voices are male, the tales of a few women do come through, proving if nothing else that the Mirabal sisters were not the only female figures in the struggle to end the dictatorship. However, what the memory of Guzmán Gonnell so pointedly illustrates is that women within the movement engaged in discussions of familial destruction as the primary justification for their resistance to the regime.

Although Coiscou Guzmán talks little about her own involvement in the resistance, the work of Josefina Padilla illustrates the role of women in pushing the regime's rhetoric in service of revolutionary change. Padilla, a young woman from Santiago, enrolled at the Universidad de Santo Domingo in 1943, which afforded her the opportunity to make contact with other young adults in opposition to the dictatorship. The timing was propitious, as 1943 was also the year the Partido Democrático Revolucionario Dominicano (PDRD, later the Partido Socialista Popular, PSP) formed in the capital and assumed its closed Marxist-Leninist ranks.[8] As a result, Padilla found herself amid many young adults who were questioning the existing state structure and authority and refusing to abide by the single-party system. The year following her enrollment at the university, Josefina Padilla joined the recently formed and clandestine Juventud Revoluciona-

ria (JR), initially the youth wing of the PDRD and the driving force behind the youth resistance movement. She remembers that it was a fellow student in medicine, Bolívar Kunhardt, who introduced her to the group, which she described as a "movement of youth trying to raise consciousness about the reality of the dictatorship" and attempting to inculcate their fellow students with the idea that there were other elements—"liberty, democracy, human rights"—essential to genuine national leadership.[9] She called it "an educational process," in reference to its search for alternatives to dictatorship and ways to fight it. The group organized in secret into three-person cells until the regime offered a brief window for legal opposition in August 1946. Their first documented collective activity was the distribution of pamphlets at the International Youth Congress during Trujillo's grand celebration of the nation's centennial in 1944.[10]

The small window created by the regime for political opposition in 1946 was a result of World War II. Global pressure for democratic governance reached even the smallest countries in Latin America, particularly those under the watchful eye of U.S. politicians.[11] Trujillo, according to Padilla, "wanted to appear democratic," and the quickest way to win that recognition was to publicly proclaim openness to opposing parties. The JR wanted to call the regime's bluff, to demonstrate publicly that its discourse of democracy and stability—paraded around by Trujillo's female supporters particularly—was devoid of substance. When the collective was given legal status in 1946, Padilla was the sole woman on its central committee. Upon this legal reorganization in October, members of the group, newly renamed Juventud Democrática, declared themselves to be "neither communist nor anticommunist" and professed commitment to the struggle for democratic principles. Padilla said her eleven co-leaders supported her work in the leadership collective and that there were a number of active women in other parts of the country including Santiago and La Vega.[12] Though hidden in the narrative much more deeply than their male counterparts, women participated in the organization and growth of the Juventud Democrática in both its clandestine and legalized stages and centered their activities in familial circles and hometown networks.[13] Although mention of their specific actions is limited, female participation did not go unnoticed by male activists.[14]

Josefina Padilla and another young woman, Carmen Natalia Martínez Bonilla, assisted the movement through their editing and writing of sev-

eral resistance newsletters, including *Juventud Democrática,* published bimonthly between November 1946 and May 1947, and *El Popular,* also published between 1946 and 1947. Along with Padilla, Martínez Bonilla was one of the most active female participants in the early youth protest movement.[15] Writing in the first edition of *Juventud Democrática,* Martínez Bonilla asserted that it was the aspiration of every individual to work toward a representative government and away from the condition in which the "voice of the people—the voice of truth—constitutes a moral threat to the force that oppresses it."[16] She valorized the effort and hope implicit among Dominican youth to combat oppression and injustice. Padilla, in the second edition of the publication, addressed Dominican women directly. She expressed her confidence that women would join the struggle for democracy, knowing that they too played a pivotal role in representative and just governance.[17] Padilla and Martínez Bonilla spoke regularly at various meetings, exhorting women to join the fight to redeem the nation and regain its liberties, rights, and sense of justice.[18] The female activists connected Dominican women's unfulfilled needs and desires with the failures of the regime while also expressing their personal dissatisfaction with the government for ignoring themselves and other women—the true *ciudadanas libres.*

Despite its self-proclamations of democratic governance and adherence to the reigning global opposition to fascism, the Trujillo regime quickly realized that its foray into political openness was leading to major disaster. Almost as abruptly as it had declared the legality of opposing parties, it changed course, punishing many of those political activists who had maneuvered into the movement.[19] The regime immediately shuttered public demonstrations, including pamphleteering and protest marches, as well as private organizing. Many individuals faced imprisonment, interrogation, and even torture.[20] Others took the lonely route to exile. When the Trujillo regime ended its experiment in early summer 1947, Josefina Padilla chose a form of exile; after first seeking asylum in the Mexican embassy, she brokered an agreement with the Dominican government that forced her into nearly a year of house arrest and daily reporting to the Mexican embassy.

Carmen Natalia Martínez Bonilla and her family were also among the many who paid dearly for their involvement in the resistance. A series of letters spanning several years of struggle for Martínez Bonilla and her family attests not only to her tenacious opposition, constructed around a

moral defense of her family's dignity, but also to the particularly gendered framing of regime opposition. Beginning in 1946, the young woman wrote to the Dominican government protesting the regime's unjust persecution of her family. The dispute, which would end in 1950 with the family's exile to Puerto Rico, began with the expulsion of her brother Andrés from the Colegio La Salle for belonging to the Juventud Democrática. Martínez Bonilla's critiques were patently provocative from the beginning despite her awareness of the repercussions that the regime visited upon dissenters. She demonstrated her awareness of the regime's failure to live up to its promises to protect the Dominican family and maintain the nation's moral rectitude. Although indirectly, Martínez Bonilla was clearly referencing the Trujillato's motto, an acronym for his initials that appeared on nearly all regime correspondence: "Rectitud, Libertad, Trabajo y Moralidad" (Integrity, loyalty, work, morality). The national situation, she argued, prevented an honest man from dedicating himself solely to his studies. A decent person such as her brother could "not remain indifferent in the face of such abject villainy." Unafraid of indicting the regime, she contended that his expulsion had exposed once again "the painful and tragic situation of this poor Dominican nation, forgotten by all, even those who claim to be the ministers of God and say they preach equality and love among men in His name." In the same initial missive fired at the director of her brother's school, Martínez Bonilla defended the Juventud Democrática with the regime's own rhetoric, calling it an organization "whose principles are to create better men for a better country, in support of our Constitution and within the most strict Christian moral codes."[21]

As the family's situation deteriorated and Martínez Bonilla received no response to her initial letter, she chose to write directly to Trujillo. In her February 1947 communication, she reiterated her concerns about Andrés and listed other injustices done to her father, another brother, and her sister. According to Martínez Bonilla, the national lottery had fired her brother José Antonio after two years of steady employment, and the Dominican telephone company had dismissed her father from his position. Her sister, Carmen, had been fired from her job at the Colegio Santa Teresita and her brother from a private company after ten years of service. The entire family had been evicted from their home. Her conclusion was that the family, unable to freely exercise "the basic right to work honestly and to live in a home—something to which all people aspire," had no choice but to aban-

don the country. She politely but firmly requested passports for the entire family, citing Article 10 of the Dominican constitution, which protected free transit for all citizens.[22] In choosing to write to the president himself, she implicitly cited the upper echelons of government as the originators of her family's multiple problems and ultimate inability to live and work honestly in their own nation.

The regime's reply supported Martínez Bonilla's claim that Trujillo and his regime protected only certain homes and families. The response was terse, explaining that the firings, because they had been undertaken by private businesses and the education system, fell under the purview of the secretaries of labor and education, respectively. The eviction issue was the concern of the Department of Housing, and any requests for passports were to be directed to the Department of Foreign Relations. The regime denied all allegations of involvement in the issues faced by the family and implied that the accusations against specific employees mentioned in Martínez Bonilla's letter could be attributed only to wrongdoing on the part of her family members. In her rebuttal, Martínez Bonilla stated what many knew but were afraid to voice, that is, while the stated officials should be responsible, it was ultimately the job of the president "to attend to the loyal execution of the laws." As a parting shot, Martínez Bonilla reminded her reader that while the Department of Foreign Relations should be the department making decisions about her family's passports, she well knew that it was "the President of the Republic himself who decides which persons will be permitted to leave Dominican territory."

On March 10, 1947, Martínez Bonilla wrote to the Department of Foreign Relations to again request passports for her entire family. She repeated her previous reference to Article 10 of the constitution, which guaranteed Dominicans the right to travel as honest and respectful citizens. Apparently, regime officials ignored her repeated requests. Correspondence from 1950 to the Mexican ambassador signed by the entire family indicates that the regime not only denied their earlier requests but escalated its persecution of the family, whom they had branded "enemies of the Government."[23] Finally, three years after Martínez Bonilla's initial request, the regime grudgingly and seemingly under international diplomatic pressure granted the family permission to leave. The Martínez Bonilla family headed to Puerto Rico, where they joined a large group of exiles and remained for the next ten years. These letters testify to the realities of the regime as it affected

many women and their families as well as the will among some women to stand up to the machinery of dictatorial rule. Never submissive, Martínez Bonilla refused to use the servile language expected in letters to the president. She understood the rights granted to Dominican citizens through the constitution and demanded nothing more or less than their full and fair compliance for her family. Her experiences make it clear that individual lives and livelihoods were being threatened but also that the regime's behavior tore at the fabric of the moral and Christian Dominican family.

Female dissidents and regime officials alike struggled with the discourse of gender, home, democracy, and morality. As Martínez Bonilla railed at the Trujillo regime, she expressed concerns about the sanctity of the Dominican home and family. Like the majority of her compatriots she did not seek directly to subvert gender norms through her activism. Josefina Padilla indicated support of a similar status quo when she rejected the idea that feminism was in any way part of her activism at a young age. Rather, these women relied on the discourse of democracy, morality, basic human decency, and family in what each argued was an important, if futile attempt to make the regime accountable to the Dominican home. By the late 1940s, in response to the resistance movement, the regime began to push the boundaries of its own paternal protections while it also struggled to maintain its position as moral guardian. Officials were aware of the danger posed by the involvement of women in the resistance. Virgilio Álvarez Pina, head of the Partido Dominicano, reminded Dominicans that Trujillo had transformed women into citizens. Writing in the newspaper *La Nación* he warned that the resistance groups were nothing more than a bunch of seditious communists and that individuals, particularly women, should guard against becoming victims of their "pernicious and dangerous" message.[24]

Padilla and Martínez Bonilla played instrumental roles in the development of a resistance movement during the early years of the Trujillato, and their lives exemplify how women came to ally themselves with such dangerous political activism. Avenues created during the Trujillo regime, often as a result of its own efforts, enabled greater numbers of women to enter higher education and encouraged a more active role for them in the public sphere. More women came to see possibilities for themselves within the political arena as resistance activists because they felt violated by the regime's claims of maternalism. Most importantly, Padilla and Martínez

Bonilla demonstrate that while women took a stand against the regime, issues of gender were galvanizing points in the resistance movement for all participants. Nonetheless, along with many others in the late 1940s, they realized that the battle to restore the nation to a genuine democracy would take much more time, and they retreated into exile only to seek other avenues to resistance a short time later.

Women Bearing Witness as Anti-Trujillista Exiles

Arriving in Puerto Rico in 1950, Martínez Bonilla joined a growing group of women exiles who were active in efforts against Trujillo. By the mid-1940s, groups in Puerto Rico, New York, Venezuela, and Cuba were organizing to bring an end to dictatorship in their native land. Although a varied group, these women demonstrate a deepening connection to the use of gender and transnational networks in the debate over dictatorship. Drawing on the solidarity of other Latin American women through writing, radio speeches, public demonstrations, and marches, the Dominican exile population invoked women as the spiritual center of the resistance and the hoped-for democratic future. The efforts of female exiles, along with those of their male compatriots and international supporters, scaffolded the most central critique posed by the resistance. In emphasizing Dominican women's quiet and heroic sacrifice, activists directly attacked Trujillo's inability to maintain the morality and dignity of the nation.

Exile groups began to consolidate around nuclei of resistance across the Dominican diaspora as early as the 1940s, and they employed periodicals and radio to highlight their particularly gendered national crisis. *Quisqueya Libre*, a Havana-based magazine of the Unión Democrática Antinazista Dominicana (Dominican Anti-Nazi Democratic Union) anchored by the regime's earliest dissidents, published a call to women in its first months of publication.[25] In September 1944, editors argued that Dominican women were particularly well placed to actively support the resistance through their connections to the home and the regime's failures in "food, housing, health, and public education."[26] The same issue included a reprint of an article by a Venezuelan female supporter titled "The Quiet and Heroic Sacrifice of the Dominican Woman."[27] In their introductory note, the editors proclaimed that the author was "doing justice to the Dominican woman, who, in her silence, carried one of the most heroic battles against

the treacherous barbarism" of the Trujillato. Carmen Clemente Travieso, identified as "the illustrious Venezuelan writer," argued that Dominican women, while living a "horrible tragedy," maintained the dignity of the home despite their situation, all the while following the "spirit of struggle and sacrifice that animates all Dominican women."

The magazine reproduced the radio address of a Cuban female supporter who lamented the suffering of Dominican women. The first in a series of "voces femeninas" that would be broadcast weekly by Cuba's Mil Diez radio, Graciela Heureaux de César's speech called attention to the "cry of the mother . . . of the girlfriend, or the woman desperately facing the absence of her beloved."[28] Heureaux de César emphasized the urgency of women's roles in the resistance and in the "reclaiming of public liberties," clearly indicting the regime and its inability to protect even the most basic freedoms. Like her Venezuelan counterpart, Heureaux de César assured her listeners of the solidarity of Cuban women, a pool from which Dominican women could presumably draw strength in their time of crisis.

While *Quisqueya Libre* did not boast its own female contributors, its editors made sure to demonstrate the significance of women's involvement in the resistance within the Dominican diaspora and across the Americas. Reporting on a 1946 conference of women in the United States, the editors thanked the attendees for their support on behalf of "the true Dominican woman who suffers the horrors of Trujillo."[29] While the women of the Dominican Republic purportedly suffered most the abuses of Trujillo, they could count on the support of an international audience of women, to whom they would continue to look through the 1950s for legitimization of their struggles. Dominican female activists directly and indirectly requested that the women of the Americas pay attention to their especially dire form of suffering.

The work of Altagracia del Orbe demonstrates the tactics used by women in exile to reveal the true nature of the Trujillo regime to the world and to call on the assistance of the women of the hemisphere. Del Orbe, wife of resistance activist Justino del Orbe, was not engaged in the opposition movement against Trujillo until she traveled to Cuba in 1952 to meet her husband. He had joined the Dominican labor movement in the 1940s and, after angering the regime, spent more than two years in prison, then fled to exile in Cuba.[30] Upon joining her husband with their four children there, she immediately became involved in the opposition movement.[31] As she

remembers, "I got caught up in the struggle; I *was* a militant and had a committee of Defense of the Revolution in my house." Del Orbe was not unlike many other women who joined the anti-Trujillo movement; her experiences as the wife and mother in a family classified as dissident moved her to action. Despite an upbringing that taught her that women were not political, del Orbe was curious about her husband's subversive activities even before they left the Dominican Republic. Upon hearing the activists' whisperings, she recalled, "It interested me, I liked it, but I didn't dare say I wanted to join the [Partido Socialista Popular]." Once settled in Cuba, she became active in the organizing efforts of the group. She was frequently present among distinguished male leaders, usually as the only female attendee at weekly meetings, and she organized other women in the movement and encouraged them to defend the dignity of the nation's mothers.[32] Women like del Orbe illustrate the continuity of women's involvement in the resistance and their deepening revulsion toward the regime's violations of its own professed patriarchal protections of the Dominican nation and family.

One of the most visible roles of exiled women was bearing witness through organized activities, and they did so before an international community, as wives, mothers, sisters, and daughters. Altagracia del Orbe addressed the abuses of the regime when she spoke out for female Dominican exiles in Cuba in an article titled "We Fight for the End of the Trujillo Regime."[33] Speaking for Dominican women, the author informed her readers that their common wish in commemoration of International Women's Day could be nothing other than "to see our country free from the ferocious tyranny that has oppressed and bled it for more than 30 years." The female exiles called on the solidarity of Latin American nations in a common struggle against dictatorship and for democratic freedoms. Moreover, they highlighted the total lack of rights and freedoms available to the women who, unlike themselves, still labored under the dictatorship in the Dominican Republic. As mothers, they pointed out, these realities were even harder to bear. "As a mother," del Orbe wrote in the article, "I wish for the triumph of peace from the bottom of my heart, and as a mother I am conscious that only peace will bring humanity the tranquility and well-being it desires." Expressing anxiety for children still in their native land, desire for the peace and well-being of their nation, and worry over the fate of other mothers like themselves, the female exiles in Cuba effectively put the Latin

American community on notice that they would not stand by and ignore the situation in the Dominican Republic.

In Puerto Rico, public demonstrations by exile groups often included women, and women were similarly active in resistance groups in other countries where disaffected Dominicans lived.[34] Several women joined a group of male exiles in 1950 to protest the Pan American Union's decision to hold a World Health Organization conference in Ciudad Trujillo. Signatories of the open letter to the press included Martínez Bonilla and her sister as well as former Trujillo functionary Carmita Landestoy, by then living in exile.[35] Upon her arrival in Puerto Rico, Martínez Bonilla also started writing for the publication *Boletín*, the voice of the Comité Puertorriqueño Pro Democracia Dominicana (CPPDD). Her first piece appeared on the front page of the June–July 1950 issue and was ominously titled "Democracy is in Imminent Danger."[36] She contended that while it was not yet time to discuss why Trujillo chose to inflict suffering on Dominican women it was time to realize that unless the forces of democracy stood up and found a way to overthrow the dictatorship, there might never be a guarantee of any democracy. She continued to write in service of the opposition through the end of the regime, calling on her knowledge of history and contemporary conditions in the Dominican Republic to highlight the ways in which the aggressive persecution of dissidents by the Trujillato was destroying the nation and its citizens.

Increased involvement among women is evidenced by several successful attempts to create women's branches of existing organizations, a move that supports the idea that female participants felt they had a distinct and essential perspective. While creating such branches had not been a practice of earlier resistance activists, organizers ironically mirrored the structure of the Partido Dominicano, which had created the Sección Femenina as a channel for women's activism. Early in 1959 Carolina Mainardi formed a Feminine Committee of the Partido Revolucionario Dominicano in Puerto Rico with fellow activist Mercedes Borel. The two women circulated their letter of invitation throughout San Juan, encouraging Dominican and Puerto Rican women to join their struggle against the "dean of dictators of America" and follow the example of a similarly organized group of New York City exiles.[37] The correspondence demonstrates the unique role women had constructed for themselves within the opposition. The organization, they stated, was comprised solely of "women who love liberty" and

who were willing "to face the most immense sacrifices in order to liberate our sons, husbands, boyfriends, and colleagues" from the clutches of the Trujillato. They called on Puerto Rican women to join them in making America a "continent of liberty, justice, and equality." Not only were female exiles demanding attention to a situation that violated the vaunted role of motherhood and the values of the traditional home, but they were also arguing that women were particularly obligated to sacrifice for the attainment of more just conditions.

In Cuba, Altagracia del Orbe headed a group of women who formed a female branch of their local resistance group, the Unión Patriótica Dominicana (UPD, Dominican Patriotic Union), and by September 1959 the women's group was actively seeking greater cooperation from fellow UPD members exiled in Puerto Rico. It is likely that this group's membership

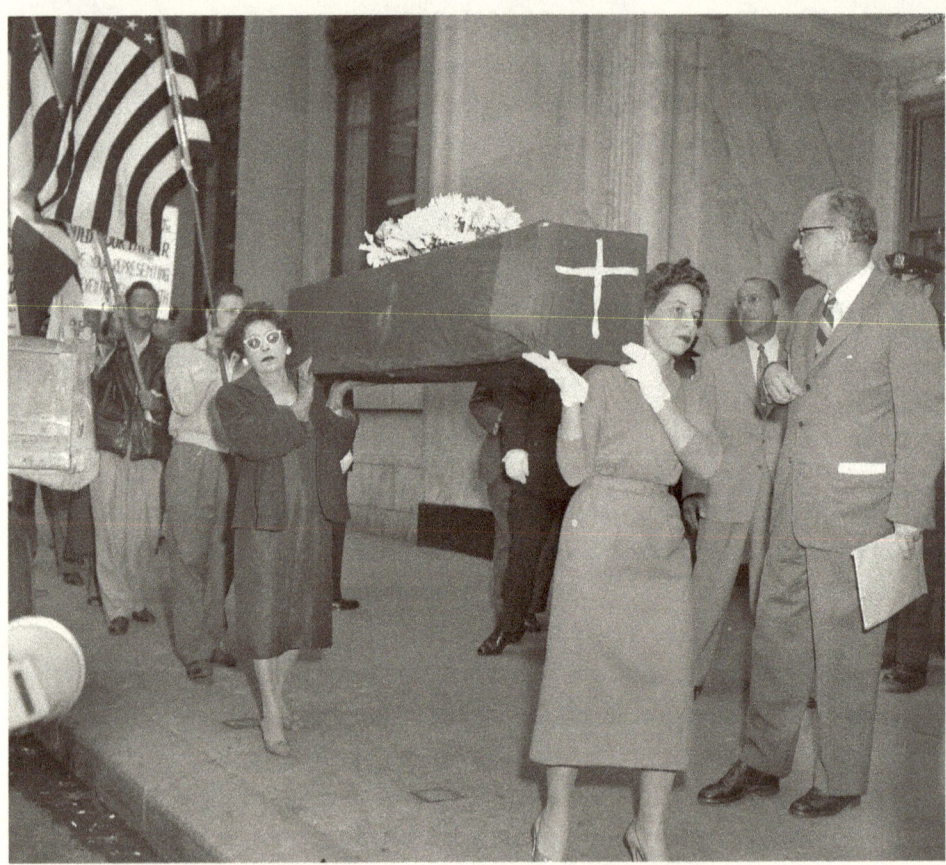

Figure 3.1. Women carrying a coffin in protest of the disappearance of regime opponent Jesús de Galíndez, New York City, 1956. Credit: Seymour Wally/New York Daily News, Getty Images.

grew significantly as a result of the participation of the husbands and children of female exiles in the ill-fated June 1959 revolutionary expedition from Cuba to the Dominican towns of Constanza, Maimón, and Estero Hondo to overthrow Trujillo. The expedition began on June 14 and lasted less than a week. The resistance movement that grew in Santo Domingo subsequent to the failed attempt took the name Movimiento 14 de Junio in honor of the effort. The women who remained in exile during and after the expedition expressed their concern for their loved ones publicly. A letter from Dominga Montesinos dated January 3, 1960, requested membership status in the UPD based on her "condition as mother of a member of the Dominican Liberation Army."[38] The August 1959 protest by the Sección Femenina in Havana attests to the women's strength as a collective.[39] Numerous papers covered their demonstration with pictures and short articles, and their public presence dressed in black demanded international attention to the egregious crimes committed against mothers by the Jackal of the Caribbean. In addition to demanding change in Santo Domingo and garnering support from their Cuban compatriots, they expressed solidarity with fellow exiles in New York who undertook a hunger strike in protest of the regime's crimes. Thus their presence as political mourners drew attention not only to the dictatorship but also its direct attack on women and families.

In Cuba in September 1959, the wives of the June expeditionaries and members of the Sección Femenina of the UPD wrote an open letter to Fidel Castro that was printed in the daily newspaper *Hoy*.[40] The writers hinted that Castro had decided to turn his back on the June expedition and that blame for its failure was in large part his, yet they then insistently denied "such slanderous accusations." They affirmed their faith in Castro as "a great democrat, friend of the Dominican people, and enemy of tyranny wherever it might be found." Despite the somewhat obsequious opening, the writers got straight to the point in the second half of their letter. Their immediate goal was obtaining weapons. They appealed to Castro's known support for social revolution and liberation, expressing confidence that as a "true revolutionary" he could not but throw his support behind their continued struggle against the dictatorship. The women of the UPD also used the letter to call on the support of their Latin American sisters as yet another resource in their cause as well as to gain the attention of North American diplomats.[41]

Less well known than Castro but a prominent North American political actor nonetheless, Frances R. Grant also received correspondence from Dominican women. In one particularly long, poetic letter, the unidentified female author nearly begged Grant, who was then president of the Pan-American Women's Association and active in the Women's International League of Peace and Freedom, to intervene on behalf of the beleaguered Dominican Republic.[42] "I need a channel, a North American channel," she wrote, adding that she wished only "to prevent bloodshed in Santo D[omingo]" and that "Trujillo must fall." Through as many channels as they could find, female activists sought attention to the crimes of Trujillo but also to the particular suffering of women.

As the stakes grew higher, female exiles continued working to protect their specific rights as women and mothers. In New York City in early 1960, more than two hundred Dominican exiles went directly to the office of Dominican consul Luis Mercado to protest against the dictator.[43] Officials allowed only seventy-five women to picket, and when a five-woman delegation entered the building, Mercado refused to see them. The women brought with them a list of all individuals incarcerated by the regime, requested the consul deliver it to the Dominican Republic, and asked specifically for information on their incarcerated children and husbands. The *New York Times* reported that in the end the list was left "with some minor employee at the consul's office." These women and others like them across the diaspora drew attention to their roles as mothers and wives as well as to their struggles as Dominicans to shed light on the regime's misdoings.

Another Trujillo dissident, well versed in the workings of the regime, added her voice to the clamoring voices of protest. Carmita Landestoy, exiled in 1945 after nearly a decade in service to the Sección Femenina, published a scathing indictment of the regime titled ¡*Yo también acuso!*[44] In it, she detailed the many abuses of the regime, particularly in reference to its purported claims to have given women full and equal rights as citizens. Calling it a "strange paradox," she argued that once the regime officially granted women their civil liberties, they ironically "no longer had the right to either express or write anything approaching the truth, nor to broach any fundamental issues."[45] Having been a vocal proponent of Trujillo's policies promoting the importance of female maternal contributions to the political arena, her claim that the regime denied all means of women's expression

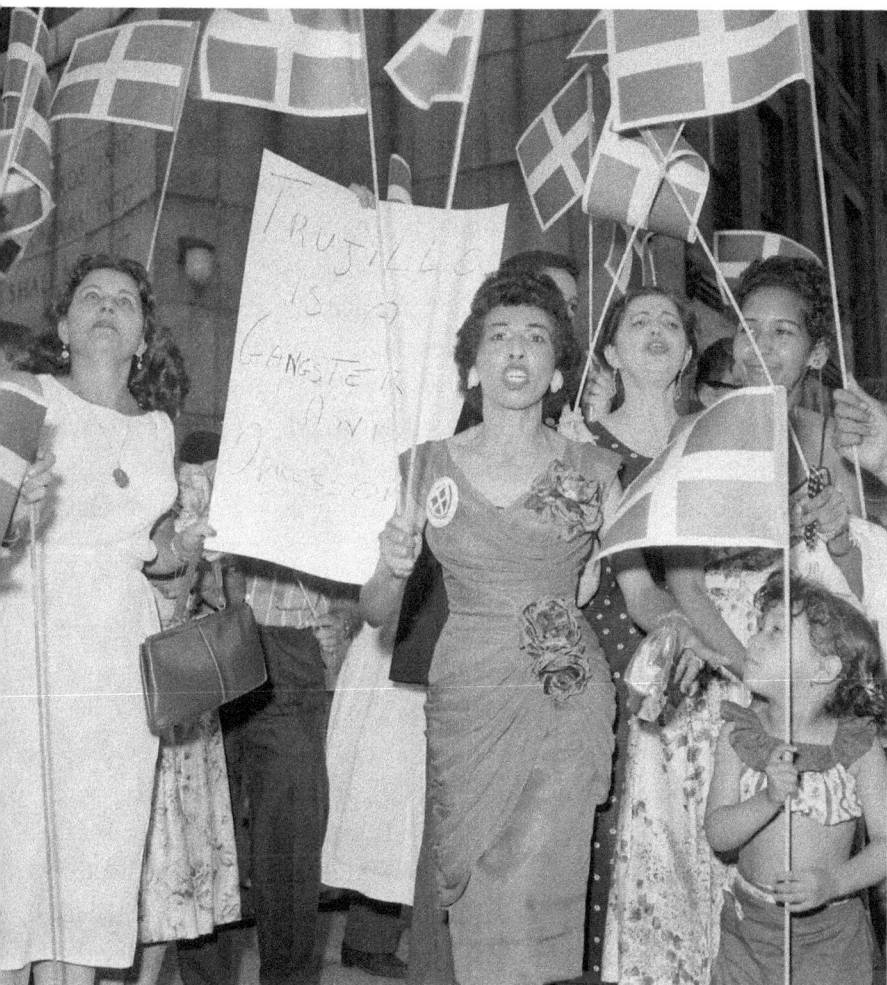

Figure 3.2. Women in New York City protesting Trujillo, August 16, 1960. Credit: Bettmann Collection, Getty Images.

argued strongly for the significant disjuncture between official policy and reality for the Dominican public.

In the writings and actions of women engaged in the *antitrujillista* movement in exile, an appeal to Latin American women as empathetic mothers and wives is the trope most frequently found. As a call to female exiles to unite in their struggles against dictatorship generally, joined with an exhortation to women in the region to identify with their anguish as mothers, wives, and citizens, their efforts combined two powerful discursive techniques—both used by the regime itself—to demand support in overthrow-

ing the Trujillo regime.[46] As a collective, they demanded that attention be paid to the true ideals of democracy, which they felt were withering rapidly under the many military governments in Latin America. Women in the opposition sought Latin American solidarity in their struggle for "the complete triumph of peace" and invited "mothers, wives, sisters, girlfriends" to unite in the cause.[47] Women of the opposition movement sought the attention not just of everyday Latin Americans but also of the diplomatic corps and other well-placed officials throughout the hemisphere. Their male colleagues found that the women exemplified the "traditional spirit of sacrifice of the Dominican woman" and actively conveyed the "pain of the Dominican tragedy" to others.[48] The women urged the American nations to "enact a robust isolation of and embargo against the Jackal of the Caribbean, the international symbol of tyranny," in hopes of ending the regime that brutalized the country and its families.[49]

Beyond picketing the Dominican embassies in their places of exile and publicly demonstrating their continued displeasure at the world's lack of attention to the abuses of Trujillo, some women stepped directly into revolutionary action. One woman served as a spy for the opposition movement, while another prepared to join the revolutionary forces. Others worked clandestinely to shuttle information, goods, and even weapons, making dangerous trips to transport funds to exiled family members. Their courageous actions foreshadowed the shift that would occur as the movement intensified back on the island.[50] However, the major contribution of women during this period of exile was their ability to engage the regime's own politics of gender across national boundaries. In demonstrating the Trujillato's inability to protect Dominican homes, families, and the integrity of women and mothers, these female activists provided the movement with significant momentum and solidified the discourse that would become vital in dismantling the regime. In essence, while many women became more radicalized in their politics, their arguments against the regime still hinged on a maternalist discourse of national stability and morality.

Women and the Movimiento 14 de Junio

In the Dominican Republic and particularly Santo Domingo, resistance activists remobilized in the early to mid-1950s. The post–World War II

period presented difficulties for the movement, given the totalitarian crackdowns that followed the brief moment of tolerance. The core of the revitalization lay in the Universidad de Santo Domingo, where, given rising female enrollment, women became key players in the renewed spread of anti-Trujillo activism.[51] One woman who became intimately connected with this movement was Minerva Mirabal. By the time she entered the university to study law in 1952, a fledgling resistance movement operating in the same cellular structure followed by the earlier Juventud Democrática was coming back to life. The reinvigoration of the movement highlights a transition to even stronger revolutionary stances among women and illustrates that young female activists had begun to denounce the regime's violations of its own professed gender norms with increasing frequency.

The efforts of Minerva Mirabal and her sisters María Teresa and Patria were not unlike those of other women active in resistance, but they stand out because of their martyrdom in the final years of the regime. Minerva Mirabal was born to middle-class parents in 1926; she and her three sisters grew up in a relatively rural area in the northeastern Dominican Republic. With the opportunities available to her and her sisters as children of a successful small-crop exporter, Mirabal was well educated and politically engaged, and she became a key player in the resistance movement that developed against Trujillo in the 1950s. She developed close friendships with several daughters of clandestine anti-Trujillo families while in grade school; these friendships, along with her education, served as the foundation for her later activism.[52] It was her years prior to university and the friendships she cultivated during this time that pushed her from merely thinking about social and political change to actively pursuing such possibilities. Although legally tolerated opposition had ended by the time Mirabal entered the university, her awareness of the political conditions of her country had begun earlier, during her school years in La Vega, and then developed more fully during her time at the Universidad de Santo Domingo.[53] The political awakening of Minerva Mirabal in her secondary school and college years mirrors the experiences of many other women of her generation. Included in that cadre of female students were other women who would become active in the opposition movement.[54]

The political maneuverings of the resistance following the brief legal period of Juventud Democrática were highly clandestine, but the arrest

of Mirabal in October 1949 along with three other women, presumably for opposition activities, garnered significant international press attention and marked the beginning of a decade of intensified resistance activism.[55] Precisely because they were women, the regime both underestimated their involvement and was wary of the effects of meting out harsh punishments for female dissidents. Officials questioned the women but then released them. Still, the regime continued its repression of the entire Mirabal family in hopes of halting the activities of its most political daughter, attempting to provide a cautionary example for other women who might consider similar engagement.[56] In the second year of her legal studies, the regime demanded that Mirabal write and perform a speech praising Trujillo as a condition of her continued enrollment at the state institution. After her 1955 marriage to activist Manolo Tavárez Justo, whom she had met at the university, Mirabal and her sisters became even more intimately tied to the small opposition movement operating throughout the country. Together Tavárez and Mirabal gathered support among individuals in his hometown province of Monte Cristi until regime pressure and her second pregnancy forced her to return to her family home in Salcedo. She continued her work in that region, securing contacts with the newly formed Acción Clero Cultural, a Catholic organization formed under the guise of regime support but actually a resistance group.[57] By 1959, several different nuclei of resistance had begun to coalesce into a national movement against Trujillo, and the groups of women who had gathered around the activities of Juventud Democrática and subsequently through the university played a large part in this unification.

In January 1959 at a small meeting convened by Minerva and María Teresa, their husbands, and several others, the group began formal organizing of a nationwide movement. María Teresa's husband, Leandro Guzmán, later reported that it was at this meeting that Minerva Mirabal expressed her understanding of the Dominican Republic's connection to other revolutionary movements in Latin America. As Guzmán remembered it, Mirabal argued that their country was equally prepared to overthrow the repressive chains of dictatorial rule. He recalled her words: "There could not have been a stronger sentiment in Cuba against Batista than there was here against Trujillo. I do not know why there they could create a revolution and overthrow tyrants, while here, with the same conditions, we cannot. . . . It is clear that if we organize against Trujillo, we can have success here too."[58]

In other areas, a similar optimism pervaded the work of women who had become involved in the anti-Trujillo movement, yet their efforts remained profoundly gendered. Miriam Morales, a native of Puerto Plata, began in the early months of 1959 to organize women into a collective that would eventually integrate into the group of Mirabal, Tavárez, and Guzmán. Her group collected money and medicine and constructed rucksacks that would be used by the planned guerrilla invasion from Cuba.[59] Much like women in other revolutionary struggles, their initial efforts coalesced around the auxiliary needs and their traditional, feminine skills of organizing, preparing food, and sewing.

In June 1959, one event drastically altered the course of anti-Trujillo activities in the Dominican Republic. A small group of insurgents, organized in Cuba and supported by the newly installed Castro government, launched an assault on the regime in the three towns of Constanza, Maimón, and Estero Hondo. Informed of the event prior to its occurrence, the regime quickly dispatched a counterattack and easily overwhelmed the group, which was unable to call upon planned support from the local peasantry. Turits argues that the continued "loyalty to the state among much of the peasantry" as a result of land tenure and other practices, particularly in the areas chosen for invasion, helps explain why the action failed so miserably in comparison to similar actions in Cuba and Nicaragua.[60] Regime officials captured the men of the insurgency and executed the majority. However, despite its lack of military success, the invasion caused a significant increase in support for the anti-Trujillo movement, following the regime's brutal treatment of those involved.[61] Activist Tomasina Cabral called the regime's reprisal "the detonator for the massive escalation of the resistance struggle to the national level was the assassination of so many good Dominicans and foreigners, now sons of glory, whose holocaust lit the sacred spark of rebellion latent in our hearts."[62]

By the end of 1959 the incipient national movement had both greater inspiration for its activism and a formal organizational structure. The influence of the January 1, 1959, triumph of the Cuban revolution, watched attentively by many of the group's participants, motivated the core committee; by January 1960 they had devised a basic set of principles and a name. They claimed the title Movimiento (Clandestino) 14 de Junio in honor of the failed invasion; two of the opposition's most active women

participated in its very first official meeting.[63] Minerva Mirabal collaborated with the small group that drafted the original declaration of principles. While Mirabal was not designated as an officer of the leadership group, historian Roberto Cassá argues that the group did consider her for a position "in recognition of her skills and role as a mentor." He contends that members excluded her and Dulce Tejada from positions of responsibility due to the high level of danger. Nonetheless, while Mirabal was not elected to the position of president of the group, participants later asserted that she had soundly rejected the idea that women should not participate in the movement.[64] Moreover, according to the testimony of several activists, it was Mirabal and not her husband who exercised true leadership for the group.[65]

Shortly after the group's official organization, regime officials caught wind of the resistance movement and mobilized quickly to put an end to its activities. Hundreds of resisters were jailed and savagely tortured by the regime, ostensibly to prevent further organizing and to force them to reveal the names of every participant involved.[66] This time, women were not exempt from the horrendous treatment meted out to organizers. On January 22, 1960, shortly after her husband's arrest, Minerva Mirabal was jailed for the third time, along with several other female activists.[67] In a collection of testimonies, two of these women recorded the brutal treatment they received from regime officials. In the January arrests, several of the more prominent female members were brought into the regime's notorious prisons La Cuarenta and La Victoria for interrogation alongside their male colleagues. Regime officials brought activist Asela Morel to La Cuarenta and paraded her in front of her fellow male activists, naked, handcuffed, and displaying massive bruises from their savage beatings.[68] Several other women including Minerva Mirabal were already in the single jail cell when Morel arrived. Tomasina Cabral, arrested on January 20, witnessed the beatings of her fellow detainees, and officials paraded her in front of their entire array of torture devices including the infamous electric chair.[69] For her, the worst sight of all was the congregation of regime officials preparing for continual rounds of torture. After "a wave of indecent insults and threats," her captors tortured her with an electric prod, with what she described as "evident pleasure."[70]

While Cabral offers the only direct testimony of physical torture, other participants have indicated that regime officials treated all the female

prisoners in an uncharacteristically savage manner. At one point, officials placed all five in a cell together with only a miniscule window, no circulating air, and a mere three cans for food, ostensibly potable water, and waste. Guards removed the women from their cell in the middle of the night for interrogations, transported them randomly from prison to prison, separated and placed them in solitary cells, allowed for no contact with family, and provided no information about their arrests. In another account Cabral described the food they had as a "cornmeal with something like pig ears or snouts, nauseating."[71] They witnessed the torture of companions who, in most cases, were their own husbands, brothers, and friends.[72] While scholars and novelists have widely decried Trujillo's sexual violation of young women, this level of depravity enacted on female dissidents represents two interconnected tactical shifts on the part of the regime that would definitively impact the path of the resistance: regime officials no longer considered women somehow less dangerous in their revolutionary activism, and they responded to female resistance in a way that highlighted how clearly they felt the women had violated the compact of paternal protections. On the one hand they treated female dissidents like all other revolutionaries for the first time; on the other, they took strategic advantage of women's purportedly gentler and nurturing natures through torture on display.

After what could only be considered the merest semblance of a trial, the women received penalties averaging thirty years in jail along with heavy fines.[73] However, the combination of international pressures and internal struggle weighed heavily on the regime, and in early February it released the women and many of the men to house arrest. The brutal change in the regime's treatment of women dissidents was shocking to the Dominican public and to an international audience as well. By making women targets of their draconian practices, the regime publicly and unequivocally violated its own declared gender norms. The "sacred spark" described by Cabral may have been lit by the 1959 deaths of the revolutionaries, but it was aggressively fanned to a flame by the treatment of these young women. The massive arrests and imprisonments carried out by the Trujillo regime drew significant national and international attention to the dictator's crumbling political drama. During this final year and a half of the regime, Trujillo's grip over the country, and even perhaps his sanity, began to slip precipitously. Responding to the arrests and

imprisonments, the Church, despite its strong support over the preceding thirty years, issued a pastoral letter condemning the actions of the government and demanding fair treatment for all Dominican citizens. The letter was read at every mass in the country on January 31, 1960, immediately following the arrests.[74] It was a major blow to Trujillo's power base—the Church had consistently supported his policies regardless of his blatant violations of human rights.[75] The United States also began to actively pursue an alliance with the opposition, although this effort was focused mostly on the resistance in exile. In addition, the Organization of American States (OAS) became increasingly concerned about the violations of human rights in Trujillo's brutal persecution of his opposition.[76] In response to the regime's actions and the increasing concern over dictatorship in the Caribbean, the OAS, the United States, and the opposition began communications regarding an appropriate response as early as February 1, 1960.[77]

Particularly among the families affected by the disappearances and imprisonments, most of whom were identified by many accounts with the upper classes, responses were surprisingly bold, public, and gendered, and women assumed even larger roles in these activities. According to missives from U.S. Ambassador Joseph Farland, a group of "women dressed in mourning" had been regularly using Church confessionals to pass along information about clandestine groups as well as to convey their concern for loved ones.[78] Trujillo's legal agent responsible for reporting on subversive publications and activities, Dulce María Sánchez de Rubio, expressed irritation in her correspondence to regime officials at the many groups, including those headed by women, that depicted the regime as authoritarian. According to her reports, the opposition Movimiento Popular Dominicano (MPD) periodical *Libertad* had published Juana Ramona Castillo's letter to the group requesting aid in locating her son, who had been detained for nearly a year without communication.[79] Ongoing public protest by youth groups and the MPD, especially in Santiago, proved a constant vexation to Sánchez de Rubio and other regime officials. Another *Libertad* article declared that "female organizations" as well as student and worker groups had been unable to organize since 1930 because of repression by the regime and that women in particular were growing eager for change. "Women and housewives," the writer argued, "have not had the opportunity to defend their interests nor to see

improvements on the part of the state relative to maternity, education, or child care."[80] While women were not frequently among the upper echelons of leadership, their involvement—and their protection—were key to mobilizing political activism at local and community levels.

In the last decade of the Trujillo regime, women from multiple socioeconomic levels enrolled in the resistance movement. Yet, more to the point, participants of both genders found the dictatorship's violations of maternalism and family its greatest point of weakness. The resistance used Trujillo's own rhetoric—protecting maternalism, education, mothers' rights, and families—as a vehicle for pointing out the regime's downfalls. Before 1959, many had been able to overlook the regime's farcical displays of democracy, but they found the regime's attacks on women and entire families in its final years untenable. Many asked themselves whether the dictatorship, unable to abide by its own gendered rhetoric, could do anything to protect the Dominican people. As the regime's own inconsistencies were pointed out more forcefully, many individuals joined the movement against the dictatorship either explicitly or implicitly, giving it the authority and weight it would need to eventually topple the regime.

In November 1960 the excesses of the Trujillo regime destroyed the politics of exchange that had maintained it for thirty long years. After the Church response to the massive arrests of 1959, Trujillo reportedly stated that he had only two problems: the Church and the Mirabal sisters.[81] When the regime moved to solve the latter problem by creating a sham automobile accident as the three women returned from visiting their jailed husbands on November 25, 1960, many believed Trujillo had sealed his own fate. By violating the norms of gender that he himself had so widely institutionalized, Trujillo set in motion the events that led to his demise. At the same time, his incensed response to the Church's objections brought on an extreme violation of his own terms of maternalism. Reacting in April 1961 to the adamantly oppositional stance of a church in La Vega, Trujillo reportedly sent prostitutes to create a spectacle in the cathedral and desecrate the sanctity of the institution.[82] According to a newspaper report, the women "of doubtful reputation" entered the church and "stopped the mass with their dancing of merengue and yelling 'Long Live Trujillo.'" Reportedly the prostitutes carried placards that read "In the Church and Everywhere, Long Live Trujillo" and "Down with Regime Traitors."[83] While it is unclear precisely who these women were or

where they came from, the intended effect of intimidation clearly missed its mark. If torturing female dissidents violated the internal guidelines laid down by the regime to protect women, sending supposed prostitutes to a mass and murdering three sisters and mothers went above and beyond what the Dominican public could accept.

AS MUCH AS THE DEATHS of the Mirabal sisters were a brutal and intensely emotional event for the Dominican public, the massacre of women completed the destruction of the gendered politics the Trujillato had created. The idea that women could be assassinated for their unrepentant role in public politics shattered ideas about purported propriety. While Trujillo's specific motivations for the murder of the three sisters lie in the realm of Dominican mythology, the result was incontrovertible. According to the *New York Times*, the New York–based Dominican Liberation Movement called the murders "the most abominable assassination in the 31-year history of the Trujillo dictatorship."[84] While the Trujillo-controlled newspaper *El Caribe* reported the deaths as an inexplicable accident, countless Dominicans considered the act the final straw in a series of horrific acts. Exile groups in New York picketed the Dominican consulate demanding action by the United States and the OAS.[85]

In addition, the massive arrests and assault on the Church provoked a response among mothers and family members who might previously have been apolitical. The testimony of Gloria Cabral de Macarrulla sheds light on the responses of many women to the crumbling control of the Trujillo regime.[86] Her nephew, Lisandro Macarrulla, was present in La Cuarenta prison during the period of arrests and torture. Cabral de Macarrulla visited her nephew every Sunday, bringing news from the family and kind words. Her memories serve as testament to the conditions borne by the prisoners but also to her own response to the regime's inhumane treatment of the country's youth. She had begun to collect crucifixes to bring to the prisoners, realizing that the objects brought comfort to her otherwise miserable family members and friends. By her count, she collected nearly two hundred. Although the objects were eventually destroyed by prison guards, her efforts stood as testimony to the growing radicalism of Dominican women and their continued dedication to maternal activities in their efforts to find an alternative to dictatorship.

The murder of the Mirabal sisters and the increasing violence during the final years of the regime, especially against women, provoked a visceral reaction among the Dominican populace. For many, the regime's total abandonment of its paternal protections—its charade of promoting the idea of nation as family and the blatant flaunting of its own standards for the proper treatment of women—demonstrated to the public that the regime was collapsing under the weight of its own perfidy. Acceptance by the public of a façade of democracy had been a consistent element in maintaining the regime; many understood their return for such acceptance to be the paternalistic protection of homes and families. As women and men pointed out repeatedly, particularly in the final years of the regime, Trujillo's persecutions and violations of women betrayed that compact.

Such violations of human life were not unprecedented, yet it was the steadily increasing assaults on the national family and morality that truly created the crisis. Rafael Valera Benítez, a member of the resistance, expressed a sentiment that echoed through the efforts of those who became involved in the movement. As he put it, the assassinations "had their roots in [the regime's] absolute devaluation of the life of women, and, worse still, children."[87] While the regime had indeed reached a point at which its value of human life was nearly nonexistent, even given its own justifications of stability and anticommunism, it was specifically the violation of its promises of gendered protections, as decried by men and women, that mobilized the Dominican public.

On May 30, 1961, a group of six men assassinated Rafael Trujillo Molina as he headed west along the oceanside highway en route to his Casa de Caoba retreat in San Cristóbal. The end may have come at the hands of male protagonists, but the process that led to that juncture was undeniably gendered. Carmen Natalia Martínez Bonilla argued that the end of the regime came as a result of

> an army of women, without any weapon other than the powerful weapon of the heart, the heart tempered by sorrow and sacrifice, the heart capable of conquering ancestral weakness, to resist danger and even attack it. A heart capable of the highest sacrifice, without asking glory, honor or recognition. A heart capable of offering to one's country the most precious treasure.[88]

Dominican women had become involved in the resistance in significant numbers, demonstrating not just their political capabilities but also their skill in reappropriating the regime's own discourse in service of the opposition. Trujillo worked meticulously to create a political role for women that allowed them to actively support his policies, and *trujillista* women were a major element in the success of such tactics. However, as the resistance movement grew and women became visible players in the drama that was unfolding against him, they brought evidence that the Dominican public was rejecting Trujillo's image of himself as the larger-than-life, generous protector of national morality, the Padre de la Patria Nueva. Dominican women spoke and acted in ways that brought an integral and distinct element to the functioning of democracy and domestic stability. Employing local, national, and international channels, they worked consistently to bring attention to what would become glaringly obvious to the population at large with the murder of the Mirabal sisters, that hollow promises of domestic and international stability would no longer stand on the legs of the regime's gendered rhetoric.

4

Neither Russia nor the United States

Women and the Search for Legitimate Democracy, 1961–1965

IMMEDIATELY FOLLOWING THE *AJUSTICIAMIENTO* of Rafael Trujillo, the Dominican Republic fell into a period of political uncertainty and chaos. While many secretly rejoiced, others feared the revenge that was certain to be exacted on the nation's dissidents by the remnants of the Trujillato and, more specifically, the dictator's vicious and capricious eldest son Ramfis. The five years that followed the assassination of Trujillo were marked by various plans to return the nation to political peace, sovereignty, and democracy. Embedded in all of these competing plans were three interconnected realities that emanated from the past decades of dictatorship: the now fractured nature of the Dominican family, the need to restore national morality, and the women who maintained the sacred center of the home. Through numerous political transitions over a brief span of time, women defended these apparent truths and their centrality to the process of democratization. They posited a maternalist vision of the transition out of dictatorship toward peace and sovereignty that drew on their predecessors' calls for inter-American solidarity and perceived threats of communist takeover. What set the activism and the concomitant political discourse of this period apart from the previous years of dictatorship was the vastly expanded political arena in which women operated and the new realities of a post–Cuban Revolution Cold War. The explosion of new parties created space for involvement through their female branches across a wide ideological spectrum and also opened up significant opportunities for female leadership. Women exploited the liberalizing press outlets to demonstrate their importance not only to transition politics but also to bigger concerns of sovereignty and the nation's position vis-à-vis the global contest between capitalism and communism.

As women entered into the national political debate in significant numbers, they advocated for greater public discussion regarding the reconstruction of the Dominican family. And as the Trujillo family raged against the perpetrators of his murder during the second half of 1961, citizens continued to emphasize the government's inability to protect the sanctity of the home as its agents imprisoned, tortured, and otherwise persecuted the wives, sisters, and mothers of the purported assassins.[1] As the nation awaited the departure of Trujillo's family, much public print space was devoted to individuals looking for disappeared family members and demanding government accountability for the crimes of the dictator. Once the family fled to Europe and Trujillo functionary Joaquín Balaguer stepped aside in early 1962, a series of events testified to national efforts to reverse the damage the paternalist regime had wrought on its familial structure, including bringing to trial the individuals accused of the murder of the Mirabal sisters. The nation watched its first nationally broadcast court case, and reporters covered each day of the trial in detail. Achieving justice for the murdered women was only part of a much broader agenda of healing the wounds the regime had inflicted on the national family. As women stepped up their political participation across various political allegiances in the electoral campaigns of late 1962, they made themselves active agents in the discussion of democratization and national sovereignty, a reality that would be confirmed with serious reforms in women's rights in the 1963 Constitution adopted during democratically elected Juan Bosch's brief term as president.

In the context of the rising mercury in the Cold War thermometer and the dangerous precedent set by neighboring Cuba, the discussion of a genuine democracy in the Dominican Republic was a significant topic for the future prospects of the nation. U.S. President Kennedy reportedly argued in 1961 about the Dominican situation, there were "three possibilities, in descending order of preference: a decent democratic regime, a continuation of the Trujillo regime, or a Castro regime. We ought to aim at the first, but we really can't renounce the second until we are sure that we can avoid the third."[2] Likely no Dominicans were privy to this discussion, but many certainly knew the realities of U.S. preferences and the need to skew away from outright communism and demonstrate the horrors of the Trujillato. Politically active women were aware of the heightened international pressures emanating most powerfully from the United States to democratize and to prevent another Cuba. They were not afraid to point out that what

was happening in their country was a crucial period of transition, one that could go dangerously wrong if not handled properly. They also constructed their particular interventions into Cold War politics as essential to charting a more democratic path for the Dominican Republic. Through this period they sought out international channels like the League of Women Voters, the Inter-American Commission of Women, the Pan-American Women's Association, the Women's International League of Peace and Freedom, and the Inter-American Association for Democracy and Freedom to demonstrate their commitment to the political agenda of containment and ultimately gain transnational support for their partisan goals. They proceeded into the murky waters of international relations both wary of the power that the U.S. could potentially exert over their nation and hopeful of such power's potential benefits.[3] For some women this activism took the form of ongoing anticommunist demonstrations, for others it demanded a rethinking of the Dominican Republic's place in the imperial Cold War contest. For all, however, it was an effort to draw on transnational alliances to participate in the transition to more legitimate democratic practice.

In the end it was much more the threat of economic instability than an actual communist agenda that resulted in another U.S. occupation in the Dominican Republic. After the overthrow of Juan Bosch in September 1963, just six months into his term of office, and the subsequent threat of a constitutionalist uprising in early 1965, President Lyndon Johnson dispatched more than twenty thousand Marines ostensibly to protect U.S. interests.[4] Much like what happened in the earlier occupation, many women stepped up to support the nation's sovereignty, but this time they did so with considerable political experience, a concrete understanding of their roles as citizens, and a vastly expanded awareness of a transnational second-wave feminist discourse.[5] The involvement of women in the 1965 April Revolution as guerrilla fighters punctuates this short period of political transition and democratization as many of them sought out equal stakes in the Dominican struggle for national freedom.[6] Many viewed their contributions as equally valid to men's yet often found themselves relegated to auxiliary roles in the struggle, marking a moment of awakening to the problems of a maternal approach to politics. The April Revolution and women's roles as guerilla fighters, as various scholars have pointed out, propelled many activists toward work for greater gender equity.[7] In other words, they would begin to contend that if the nation was truly going to transition to de-

mocracy, women's equal participation as citizens was a crucial point in the national political agenda.

While brief, the period between the fall of Trujillo and the assumption of power by his longtime functionary Balaguer in 1966 demonstrates the strengths of maternalist rhetoric and the significant cracks in the politics of the motherly defense of the nation. Many of the women who entered the new political arena of the postdictatorship maintained an active dialogue on the importance of their inherently feminine qualities to the nation's transition. Indeed, this maternal approach proved crucial to the process of collective healing yet also served to circumscribe women's political roles in ways that became more noticeable as the nation sought to defend its sovereignty and path to democratization. When coupled with women's engagements in transnational feminism, such limitations on women's equity pushed many activists to start rethinking their roles in party- and state-level politics. Numerous women who engaged with the nation's more liberal and socialist parties also began to interact with circulating second-wave feminism that posited a more radical approach to gender equity. In sum, while these five short years witnessed an explosion in the number of women in positions of leadership in party politics nationwide, they also gave way to a growing awareness of the limits of maternal politics.

Ridding the Nation of Dictatorship, Reconstructing the Dominican Family

With the political chaos that followed the May 30, 1961, assassination of Trujillo and its violent aftermath, many women found compelling reasons to get involved in the political arena, even if it meant merely publicly presenting their concerns about missing loved ones and familial stability. Within days the deceased dictator's son Ramfis returned from Europe; he assumed control of the country with Balaguer as his puppet and led the brutal torture and murder of individuals suspected of taking part in the plot against his father. Balaguer, as figurehead, contended with the international pressures that had been gradually building against the Trujillo government.[8] Although many believed Balaguer to be too deeply implicated in his former boss's politics to run the country after the November departure of the Trujillo family, Balaguer himself seemed to believe he could finesse both the Dominican public and the international community into

seeing him as capable of reconciling the country's many opposing factions. While he was wrong only in the short term, he managed to begin building a gendered politics of conciliation that many women utilized to insert themselves as part of the process of transition. From the *ajusticiamiento* through the internationally monitored elections in December 1962, Dominican women would assert the importance of familial—and especially maternal—reconstruction to the larger project of national recovery across a variety of political venues.

In the seven months Balaguer remained in his assumed post as president, controlling the nation's many new political movements proved difficult and public protest became increasingly problematic. Tough economic sanctions initially imposed by the OAS in August 1960 crippled the Dominican economy, and delegations from the United States and the larger inter-American community added pressure to an already difficult situation.[9] During the summer months many of the opposition groups formalized their organizations to publicly challenge Balaguer and press for elections. These groups varied widely in ideological formation and included the Marxist Movimiento Popular Dominicano (MPD), the antidictatorial Movimiento 14 de Junio (1J4, 14 of June Movement), the conservative Unión Cívica Nacional (UCN, National Civic Movement), the Partido Revolucionario Social Cristiano (PRSC, Christian Social Revolutionary Party), and the Partido Revolucionario Dominicano (PRD) led by longtime exile and resistance activist Juan Bosch. Activism also grew rapidly among the student population, particularly at the Universidad de Santo Domingo, soon to be renamed the Universidad Autónoma de Santo Domingo (UASD).[10]

As a result of the constant pressure from this growing opposition and the continuation of U.S. and OAS sanctions, the regime failed to maintain its grip on Dominican politics. In January 1962 Balaguer gave up his position, leaving the country to be led by an eight-member provisional council. With the assumption of control by the Consejo de Estado and promises of August elections, OAS sanctions were officially lifted, and the United States formally recognized the new Dominican government.[11] Between May 1961 and January 1962 many Dominican voices sought to convey nationally and internationally their ideas for the nation's future. Despite the somewhat Babelian nature of these months, citizen demands for government accountability and the protection of the Dominican family come through clearly. Women's voices were as diverse as their political leanings. They took on

positions that ranged from staunchly Catholic anticommunism to defense of their position as aggrieved mothers and wives to avowedly nonpartisan democratic activism, even as they all eschewed the idea of politics that they equated with the Trujillato. Above all, they demanded accountability from a government in the throes of transition, arguing that only a trained focus on family integrity would return the nation to a path of stability, and they asserted what they saw as their uniquely feminine gifts to attempt to bring peace to an uncertain time.

Dominican women were extraordinarily vocal in several venues in their attempts to assign accountability to the interim government led by Balaguer and to reconstruct their families destroyed by the Trujillato. Party membership served as one path to getting their voices heard. In one instance a group of women from the Movimiento 14 de Junio made a visit to President Balaguer at the National Palace to demand that he assist in their search for missing family members.[12] A sister of a disappeared activist related that she had begun her personal search the day her brother was taken in January 1960. She explained how her efforts continued and indeed intensified after the death of the dictator. She argued that simply because her brother's only crime had been his love of liberty and free expression, she was compelled to continue her search. Joining a group of female 1J4 activists, she secured an audience with Balaguer, who promised to allow the women to visit all the places where individuals had been held under the Trujillato. With this assurance, the woman began her search again in the company of the women of the 1J4. While their exhaustive tour yielded little concrete information, it was clear that Balaguer had a vested interest in addressing the needs of such aggrieved women and families. He would continue to grant such audiences over the span of his leadership. Still, letters to the press demonstrated that the process of rebuilding the nation's destroyed families had only just begun.

A political group that formed immediately after the assassination, the Unión Cívica Nacional, also provided a crucial platform for women to express their displeasure at Balaguer's leadership. Its leaders contended that he had failed to take accountability for the atrocities committed in the previous several years and that his government needed to address the nation's broken families. A number of letters that appeared in the organization's publication *Unión Cívica* testify to a growing participation among women in the public debate about a difficult past. In early September 1961, women

from Santiago publicly praised a senator who had criticized the government's inaction concerning the deaths of two young men on the streets of their city.[13] More than a hundred women signed the letter in the name of "the women of Santiago, distraught and overwhelmed with grief over the tragic death of the young men of our community." They celebrated the senator for having spoken out against "the recent abuses that have taken place in the country." His work in favor of the "outraged Dominican family," the women wrote, was patriotic and Christlike. About the same time, a large number of women in Santo Domingo publicly criticized the Catholic Church for not being more aggressive in dealing with Balaguer's "Trujillismo without Trujillo" regime.[14] They claimed that despite its earlier stance against the regime, the Church had since remained silent on the many abuses being committed against Dominican citizens.[15] Despite struggle and pain, they wrote, "the Dominican woman remained unswervingly impassioned by her faith in God." Still, they had failed to receive any answers to their innumerable questions posed to officials about the Church's stance on Balaguer. They maintained that their suffering empowered them to speak "for all the mothers, all the sisters, all the daughters, and all the wives" in the country who were similarly afflicted, and they beseeched Church officials to use their influence to defend basic human rights, which, they contended, were being scandalously trampled upon by government officials. They reasoned that the country was in danger and the situation was grave because once awakened and ready to reclaim their rights, the people would "require prompt and intelligent direction [from government] to avoid outbursts of violence." The threat of another Cuba was real to them, and the hundreds of women who signed the letter contended that it was the Church's responsibility to act on their behalf and demand a change in national leadership.

Other women sought transnational assistance in finding imprisoned husbands, brothers, and sons and stressed the importance of familial reconstruction to national stability. U.S. Ambassador John Bartlow Martin reported meeting several young women seeking his aid with the current political conditions and their own personal traumas.[16] The first woman, who had spent months searching for her husband after his arrest, had finally found him but was unable to see him. She beseeched Martin to report what was truly happening to the international community. She contended that nothing had changed, that the country was ruled by a "different boss; junior, not senior" and that "all this talk of democracy [was] a big show."

She alluded to the threat of violent uprising among the Dominican people to compel Martin to move more forcefully against the current government. She said, "If it doesn't happen now, it will happen later and be worse," clearly referring to political transition that, she transparently indicated, could result in a government structure highly unfavorable to the United States. The second woman Martin recalled reported to him that her brother had been killed during the recent Ramfis rampage. She told Martin that "mail was still being opened, the press censored, there were shootings nightly in the streets, and beatings; the regime was putting on a show of democracy for the OAS but nothing had changed." Savvy, she claimed to know that "Americans feared chaos, and perhaps a Communist takeover" and suggested they move quickly because conditions were far from an operational democracy. Beyond their own personal tragedies, these women sought a transnational audience and urged Martin to advocate on their behalf for a true transition out of dictatorship.

The women who visited the U.S. ambassador and the female letter writers and petitioners sought the removal of Balaguer and the remnants of the Trujillato, but they also sought a more transparent response to the destruction wrought by decades of dictatorship. While they may have been skeptical about their chances, they continued to publicly decry the government's abuse of their homes and families, and they were supported by many male voices.[17] As the editors of *Unión Cívica* argued in the introduction of yet another letter from an aggrieved female citizen, they found it difficult to believe that the current president, "dictator Balaguer," would respond to individual requests for change.[18] Still, they reprinted a letter written by Dulce María Simó Delgado because her words reflected "the shared pain of numerous Dominican homes." The content of the letter, like the article's title, "Where Is My Husband?" explicitly exposed the direct links between familial integrity, democratic practice, and government accountability. On the political situation immediately post-assassination and the disappearance of her husband, Simó Delgado asked, "Is this JUSTICE, DEMOCRACY, CIVILIZATION, OR A COUNTRY OF SAVAGE AND ILLITERATE BRUTES? Where are the RIGHTS OF MAN, our Magna Carta, or the most basic sense of HUMAN LIBERTY? Mr. President, Where is my husband? Where is the father of my children?"[19] Her husband, Fulvio Amado Abreu y Rodríguez, had disappeared in December 1959, reportedly taken to the infamous La Cuarenta prison and tortured. Simó Delgado knew noth-

ing of his status. In fact, she signed the letter with the caveat that she did not know whether to call herself by her married name or as a widow. Like her fellow aggrieved women, Simó Delgado demanded transparency and basic human rights. In contrast to their treatment by Trujillo and his bands of willing henchmen, state accountability to families like hers was a precondition for the nation's transition out of dictatorship and toward a more civilized society.

Dominican women continued the public campaign for the reconstruction of the family as they joined new parties and advocated for women's partisan political activism in the ramp-up to elections. When Balaguer finally relinquished power in January 1962, the Consejo de Estado assumed control of the Dominican government and announced elections for August 1962. As a result, all existing parties and groups began to mobilize their forces, including their now very active female members and branches. While the interim government stumbled and elections were postponed until December, the various groups continued their election campaigns in earnest. Their political platforms ranged wildly, yet from 1J4's focus on ending latifundio and imperialism to the PRSC's slogan of Christian revolution, all sought a way to scrub away the stains of dictatorship while constructing a plan for full participatory citizenship, albeit across a broad spectrum of ideologies.

Various *ramas femeninas* and *asociaciones femeninas* formed in municipalities across the country pertaining to the UCN, PRSC, PRD, and Movimiento 14 de Junio (1J4). Women were exhorted to join the partisan fray, and they heeded the call in large numbers.[20] Across the spectrum, the focus on female contributions to the upcoming elections was both practical and strategic and drew on a model of women's political participation that was indebted to the activism of female resistance fighters and the public arena opened to women through the Trujillato. In a call to UCN women, Elisa de Zayas Bazán excused them for their previous inattention to the concerns of politics but insisted that in this "hour of heroic decisions, hour of truth" each woman had a responsibility, "for love and for duty, to place your grain of sand to build the foundations of liberty where tomorrow we will erect our majestic and serene holy mother: the Homeland."[21] She exhorted fellow female party members to join with men in the struggle to return to the country its liberties, denied for so many years under the dictatorship. She asked rhetorically if any woman could possibly remain indifferent during

such a "crucial moment" for the country, recalling the earlier cries of the AFD. In outlining duties for mothers, wives, daughters, sisters, and girlfriends, Zayas Bazán upheld traditional female roles of nurturer, educator, and caregiver and encouraged sacrifice and courage in her readers but also urged them to become part of the public debate over politics. For Zayas Bazán and the women of the UCN, utilizing the rhetoric of maternalism that had been so adeptly channeled by the Trujillo regime was strategic and in line with the party's larger platform, and they continued to effectively deploy it to garner attention for government accountability, democracy, and the bereaved Dominican family.

The UCN paid particular attention to the role played by women in the upcoming elections. In a campaign advertisement in late September they promoted the official opening of their campaign with a women's convention in homage to "the noble and selfless Dominican woman."[22] The party promised to bring peace and tranquility to the nation's families, to restore honesty in government, and to create "happy and dignified homes." At the convention in early October they drew on the skills of party women from across the nation to support their platform to bring democratization and dignity to Dominican governance.[23] One delegate declared that the UCN sought justice for the past crimes that had caused so much grief for the nation's mothers, wives, and sisters and relied on women to help the country become neither Russia nor the United States, "but an authentic autochthonous Dominican revolution." According to the female speakers, women, as "the greatest moral and political force of our people," were essential to the party's efforts to create "the path to happiness."[24] In the UCN's "crusade for honesty" women played a crucial role as the great moralizers of the nation.

The UCN was not the only party to provide a platform for its female members to join the campaign for a more accountable and honest government, although it was arguably the most conservative. Josefina Padilla was one of the women who turned to the politics of reconstruction following the assassination of Trujillo; her previous experience as an activist propelled her to a place of significance in the electoral campaign of 1962.[25] Although she initially joined the UCN, she had become disillusioned when the group transitioned to a political party and moved toward the right in an attempt to protect its members' business interests. Padilla joined the PRSC and, at the party's national assembly, was chosen as vice presidential candidate for the upcoming 1962 elections, with former university classmate

and colleague Alfonso Moreno as the presidential candidate. Their slogan was "With Alfonso and Josefina, the Revolution Advances"; their platform offered no concrete promises save the commitment to work for the reconstitution of morality and the Dominican family.

Speaking regularly to the press as a spokeswoman for the party and particularly its female members, Padilla reminded her listeners of the party's plan to lead the nation on a path between the terrors of communism and the evils of imperial capitalism. She reasoned that while the nation faced many problems, it was crucial for women to take their place in the struggle for "the moralization of public administration."[26] As she and Moreno traveled the countryside hosting meetings they described as "family style," they painted themselves as the ideal candidates to reconstruct the Dominican national family. Padilla publicly proclaimed that the PRSC truly cared about the family as the moral center of society because it was the only way to move the nation forward—toward a Christian revolution—that would avoid the dangers of communist subversion and the capitalist corruption of political and economic institutions. Despite its Christian leanings, the PRSC was not unique on this point; nearly all of the major parties involved in the 1962 elections sought a third way, as described by Padilla, and depended on women to execute the moralizing component of the program.

Not all of the parties, however, broadcast their messages of maternal healing in quite the same conservative fashion as the UCN and the PRSC. The PRD, counting the presence of some of the nation's most established female activists, spread its message of inclusion and healing in a slightly more subtle manner. Thelma Frías de Rodríguez, as the head of women's affairs for the PRD, reached out to the International Institute for Political Education to help support the building of a rural youth education program, indicating the intimate connection that continued between women's issues and education.[27] All of the major political collectives on the left of the political spectrum also relied extensively on this discourse of women as natural teachers to enlist and engage female members. For example, the women of the 1J4's Asociación Femenina called on female constituents' presumed proclivities as teachers and implored women to send books to create "a library of general education" that would aid in the efforts of the movement and generally in the creation of "a better world."[28] Expanding knowledge, they posited, would increase societal demands that restitution be made for the familial destruction wrought by the Trujillato. Activist

Teresa Espaillat contended that the 1J4, given its martyred founders and revolutionary resistance base, had an incredible ability to mobilize women, particularly through these past atrocities.[29] Espaillat recounted her participation in a march held on June 14, 1962, in commemoration of the combatants who died in the failed invasion against Trujillo three years prior. As she recalls, each woman carried the name of one of the men who died as they headed toward the National Pantheon. Tomasina Cabral and Emma Tavárez Justo, sister of Manolo, also had been members of the movement in its clandestine stage and continued to recruit others during the election period. At a meeting prior to the elections, Cabral reminded members of the collective that they were the "protectors of the ideals" of the martyred Mirabal sisters and that their work moving forward was to continue advancing those ideals.[30] Another highly active female member of the 1J4 was Carmen Josefina "Piky" Lora Iglesias, who had become involved in the group through her friends at the Universidad de Santo Domingo in the early 1960s.[31] For the women of the 1J4 the program of national liberation was revolutionary, and yet it still hinged crucially on their sacrifices as wives, mothers, sisters, and daughters.

While party histories have generally excluded women from the narratives of its activities, their presence at conferences, demonstrations, and meetings is incontrovertible.[32] Across the partisan spectrum, Dominican women confronted the politics of dictatorship without a dictator and drew on a relatively consistent script of women's maternal and sacrificial contributions in the creation of a just and democratic society. They focused throughout the campaign on the necessity of the candidates to attend to the grave damage inflicted by the Trujillato on the nation's families and the crucial role they could play as women in the recovery process. Above all, they were attentive to the value brought to the political arena through their sacrifice to the nation. As noble and selfless Dominican women, they argued for a path to national recovery that neither strayed into dangerous communist territory nor was slavishly devoted to U.S. capitalist ideals. In other words, they sought to create an ideal and distinctly Dominican democracy.

From the fall of Trujillo to the elections of December 1962, women played significant roles in election campaigns and consciousness raising but also instigated new avenues to demonstrate the centrality of their maternalist vision for national healing. For many women of differing partisan alle-

giances, the return of anti-Trujillo activists still in exile immediately prior to the elections presented a platform to express the sacrifice of Dominican women and the demands of familial reconstitution. In September a series of protests and demands confronted the Consejo de Estado's blocking of the return of the former activists. Many women, including Angela Ricart, president of the Fundación Heroes de Constanza, Maimón y Estero Honda (Foundation for the Heroes of Constanza, Maimón and Estero Honda), joined the call for change and transparency, "motivated by the desire to contribute to the peace of the Dominican family and the establishment of democratic normalcy."[33] Later in December a large demonstration was held at the National Palace to again demand a response from the government, this time with protesters holding signs that read, "Black is the color of the grief of the mothers of the exiled Dominicans" and "The dutiful woman demands the return of the exiles."[34] While little progress was made to remove restrictions for exiles until after the elections, female activists continued to make clear how central their suffering was to the process of national reconciliation. One of the clearest displays of the debate over the reconstitution of the Dominican family writ large and the crimes of the Trujillato was the summer's long and extensively publicized trial of the accused murderers of the Mirabal sisters and their chauffeur.

The Mirabal Trial and Continued National Rehabilitation

The trial of the accused Mirabal murderers was one of the most significant events during the period from the appointment of the Consejo de Estado through the election and presidency of Juan Bosch. While it offered little closure on the murders themselves, it expressed the nation's desire to move beyond the legacy of the dictatorship even if few agreed on the direction potential new leaders should take. At the core of the trial and its massive dissemination across television, radio, and print outlets were the issues of transcending the atrocities of three decades of dictatorship and whether the state was capable of reconstituting the nation's families and morality. Reporters for *La Nación* and *El Caribe* covered each day's testimony during the summer of 1962, and the details were projected over several radio stations and a television station. Every excruciating detail was made available to the Dominican public, and significant print space was given to debating the trial's importance to national transition. Just as the murder had served

as a catalyst for significant political change, the trial offered an opportunity for national mourning and recovery and exemplified many of the aspirations for the future that would echo across the nation in the coming years.

On June 27, 1962, the public trial of the assassins of María Teresa, Patria, and Minerva Mirabal began in a courtroom in Santo Domingo. The trial was part of a special commission composed to address the crimes committed by the regime and its nefarious agents. The courtroom was packed to capacity, and the public loudly expressed distaste for the defendants.[35] Outbursts were common, including booing, jeering, and incantations of "to the wall, to the wall, for the guilty parties!" Initially, not all audience members felt such action was warranted, although as the days dragged on, the public became more impatient, precipitating several lectures from the presiding judge. When one of the defense attorneys complained about the less than decorous audience, the judge replied that in no way did they prevent him from mounting a defense and that he should "watch his language and observe the appropriate decorum." According to *El Caribe*, it was the first trial ever to be broadcast on Dominican television. As the newspaper reported, "the citizens of the capital are closely following the details of the cause via their radios and televisions."[36] While the trial began at the end of June, it was continued after a few days to the end of July then proceeded for the next several months on a daily basis with several extended continuances due to conflicts of interest among the accused and the discovery of new sources of evidence. The final decision was handed down at the end of November.

Implicated in the murder were five main assassins and seven additional conspirators, all members of Trujillo's secret police. Each of the five central defendants sought to either claim his own innocence or place blame on fellow participants. Initially, the defendants argued that although they did arrest the sisters and their chauffer, they drove them directly to the prison La Cuarenta, where they left them. Ciriaco de la Rosa argued that he tried to "avoid the disaster but could not," and his companion Ramón Lora Rojas contended that Rosa was the most vicious of them all: "To me he was the human representation of Satan; he was truly one of the devils of the Military Intelligence Service."[37] Each man sought to blame the others, but, much like the accused at Nuremberg blamed Hitler, the defendants all placed final culpability on the deceased dictator Trujillo. The orders, according to the defendants, had come directly from him, and there was no

possible way to avoid the horrible crime. The implication was that in the calculus of the regime, if one refused, he would be eliminated and another functionary would take his place. The court concluded that sufficient evidence existed to convict the five co-authors of the Mirabal murders and sentence them to prison for twenty to thirty years.

In spite of the relatively minimal sentences handed down to the Mirabal assassins given the calls for the death penalty, the trial itself continued the public debate about how to heal the wounds left by Trujillo. Beyond being a "decisive test of democratic advancement," the trial advanced the discussion of what it meant to heal the national family.[38] As three of the most mourned losses of the Trujillato, the Mirabals and their respective families sat at the nexus of this struggle over national reconstruction. Healing these wounds through proper democratic practice, based in the rule of law, was crucial to advancement. At issue was the violation of the sanctity of women and children but also implicitly the role women were to play in the new political arena, as the sisters had become symbolic of the political activism of the late Trujillato. That debate played a major role in the campaigns and later attempts by the victor to reconstruct the Dominican government and its constituency.

The conclusion of the 1962 elections brought former exile Juan Bosch of the PRD to the presidential palace. He won the presidency by a relatively large margin after campaigning under the slogan "Borrón y cuenta nueva" (Erase and start from scratch).[39] His assumption of the position was supported by the 1J4 and conceded by both the UCN and the PRSC. During his few short months as president, some significant changes were initiated regarding the legal status of women. Dominican women increased their commitments to various parties and movements up to and through the overthrow of Bosch in September 1963. In addition to the women who became active in the governments of Bosch and the subsequent Triumvirato, female activists continued to engage in politics through the opposition as well, similarly focused on the needs of national reconstruction and the creation of a third way between communism and exploitative capitalism. Despite increasingly heated debates over who could best govern the postdictatorial nation, women actively sought out cross-party alliances, moved smoothly into new partisan circles, and even engaged in radical resistance politics. Their participation would build all the way to the eventual invasion of U.S. troops and outbreak of civil war in April 1965.

In one of his first formal acts as president, Bosch began a complete overhaul of the Dominican constitution. Included in the reforms was a reassessment of the rights and privileges afforded Dominican women. In the constitutional reforms and his general campaign promises, Bosch sought to erase the vestiges of the Trujillo regime and begin with an entirely new foundation, focusing specifically on the concerns of poor Dominicans and the disenfranchised more generally.[40] Women played a significant role in the debate over Bosch's clean slate. The 1963 Constitution, despite its brief lifespan, established several important changes in the rights of women as mothers and spouses.[41] Specifically, the new constitution, approved by the Dominican Congress in April 1963, guaranteed women equal economic standing with their husbands and negated previous legislation granting men full control over community property within the union. The Bosch constitution also legalized divorce and removed all juridical distinctions between children born in and out of wedlock. While the traditional family unit continued to be the lodestar, Bosch recognized the more realistic challenges faced by women and sought to create more enlightened gender politics. Not surprisingly, these last two modifications—divorce and equal recognition of children—angered Catholic Church officials who had previously enjoyed the full support and cooperation of the government.[42] These changes provided an important marker in the advancement of democratic practices, and many Dominican women continued to seek out concrete avenues for participation during Bosch's brief presidency.

Many women established themselves among the ranks of the PRD, the 1J4, and other parties. Thelma Frías de Rodríguez won her bid for Senate as the representative of the National District and assumed the position of vice president of the body, while UCN member Elena Campagna de Read was elected to Congress from Santiago, as was Altagracia Fremia Germosén Canela. Despite the assumption of power by Bosch and the PRD in early 1963, the women of the 1J4 remained active in their search for national reconciliation. In June, on the fourth anniversary of the resistance expedition at Constanza, Maimón, and Estero Hondo, hundreds of women gathered in the colonial center of Santo Domingo dressed in green and black. Publicly expressing gratitude for the sacrifice offered by their fellow Dominicans in the struggle against dictatorship, these women also demonstrated their active involvement in the image of their party and their commitment to creating a more open and democratic state. A male activist called them

"defiant and glamorous" and claimed they epitomized Tavárez' call to "create a free nation or die trying."[43] Political rallies and meetings, whether by the 1J4 or other parties, allowed like-minded women to gather and discuss their political participation. Although party alignment among women ranged widely, often according to class or generation, many viewed the opportunities to participate in public debate about the future of the nation with similar enthusiasm.

By the time of the overthrow of Bosch in September and the transition of presidential power to a group of men called the Triumvirato, it was clear that everyday life for many women in the Dominican Republic included a high level of political activism. Ana Silvia R. de Columna pointed out in the initial installment of her column "Vanguardia femenina" a year later that "the Dominican woman also understands her great responsibilities in this time of national rehabilitation and the proof of this is her active participation in politics."[44] Among the most public manifestations of these supposed responsibilities were two groups at opposite ends of the political spectrum that formed prior to the election of Bosch and continued their domestic and transnational activism through his presidency and after. Both groups' political activism demonstrates the importance of linkages across national boundaries in elucidating concepts of democracy and progress at a crucial time of transition.

The Federación de Mujeres Dominicanas (FMD, Federation of Dominican Women) and the Associación Patriótica Feminina Dominicana (APFD, Dominican Feminine Patriotic Association) represent two opposing visions of the demands for Dominican democratization and the roles of women in that process. While both posited a continuation of previous tactics of maternal politics and transnational engagement, the FMD focused on the need for women's cross-partisan engagement and supported a liberal understanding of democratization free from the vestiges of dictatorship, and the APFD, shepherded by former *trujillista* Gladys de los Santos, centered its critiques on the dangerous nature of socialist thought. As the FMD began to show signs of feminist consciousness-raising and an awareness of global second-wave feminist thought, the APFD pushed a highly conservative vision for the role of women in the Dominican polity. While both groups argued for the centrality of women's participation in politics, their differences marked the larger division growing among female activists.

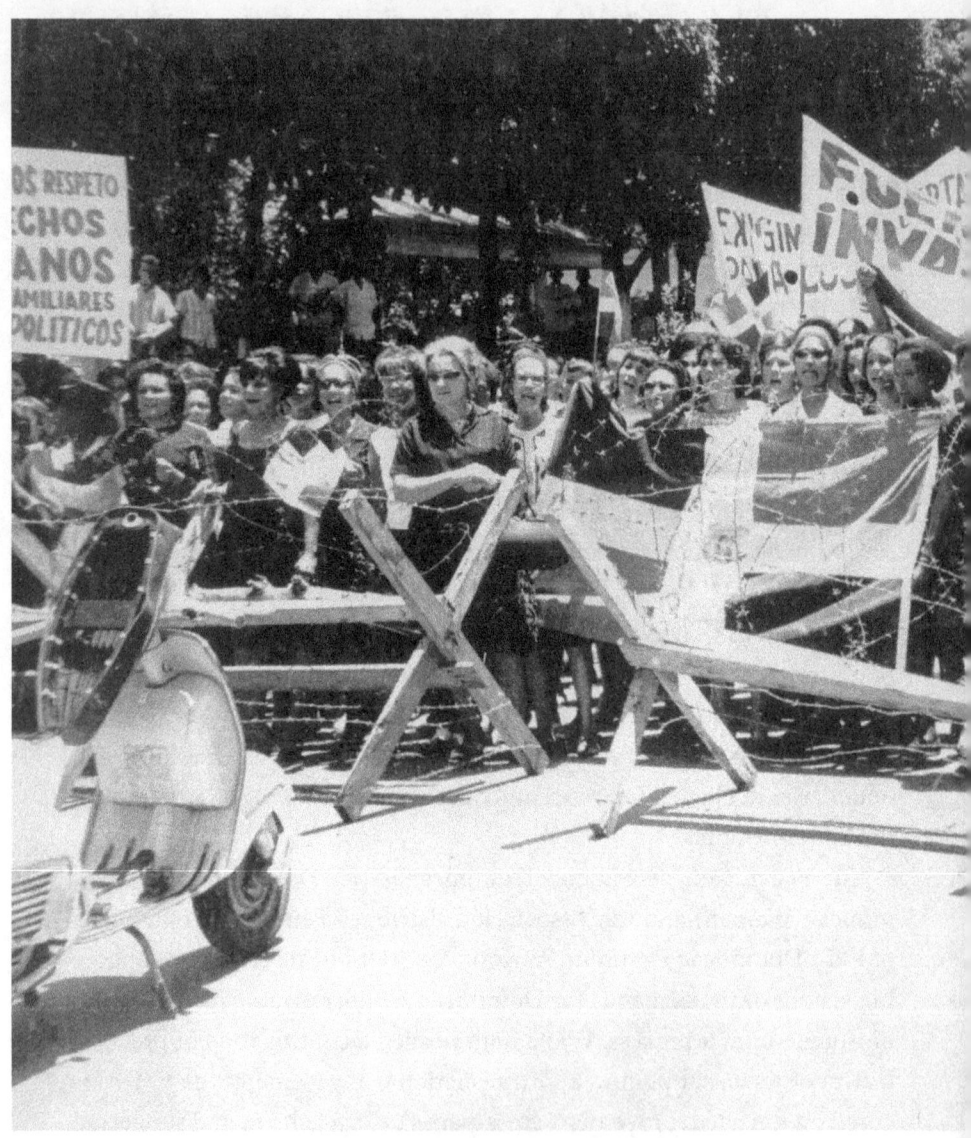

The FMD formed in late 1961 as a nonpartisan group focused on women's rights and the restoration of the Dominican family.⁴⁵ For approximately six years the group served as a loose affiliation of women of the more left-leaning parties and provided a platform for women to tentatively yet publicly advance political issues specific to their gender status. Ángela Hernández finds that the group lacked a theoretical framework for explaining the root causes of inequality yet was crucial for women of the period beginning to have a vision of who they were and what their connection was

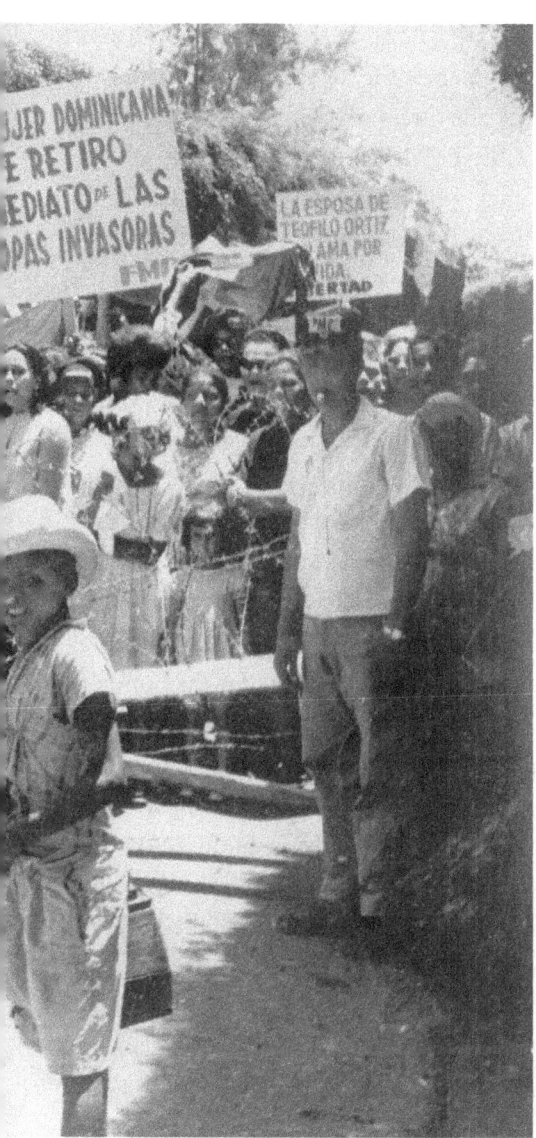

Figure 4.1. Members of the Federación de Mujeres Dominicanas protesting at the military cordon during the U.S. occupation of 1965, Santo Domingo. Colección Juan Antonio Thomen. Courtesy of Archivo General de la Nación, Santo Domingo.

to the collective.⁴⁶ Their efforts mark the beginning of a return to a claim of feminism within the political arena, yet they were still highly focused on maternalist visions of national rehabilitation. Scholar Moema Viezzer asserts that the group "played an important role in the democratic struggle in the country" and was comprised of "professional women of the middle classes, and students of more progressive political tendencies."⁴⁷ They took part in the many public marches, demonstrations, and strikes and voiced their concerns often in the press, marking their presence as women and as

a distinctly organized women's group.⁴⁸ They also worked actively to assist in development and training for women of the lower classes and drew on their skills and inherent qualities as nurturers to propel the group's agenda in the public arena. Significantly, the FMD served an important role as a springboard for many of the women who later would take on leadership roles in the feminist movement in the 1970s.

In their early public proclamations, the leaders of the FMD asserted their major concerns in this period of transition, confirming the larger pattern of maternal concerns for the process of *destrujillización* of the nation. They formed the FMD with the goals of protecting "the rights of women" and guaranteeing "the stability of the Dominican family given the grave damage it has suffered during the Trujillo tyranny and following the *ajusticiamiento*."⁴⁹ Not surprisingly, the topic chosen for the inauguration of its Santo Domingo headquarters was the ever-popular martyr María Trinidad Sánchez.⁵⁰ In a public statement from late 1961, FMD leaders addressed the ongoing destruction of the family through the regime's systematic expulsions of political activists. These deportations, confirmed by the hundreds of letters from aggrieved wives, daughters, and sisters, were not only a direct attack on the "tranquility and security of the Dominican woman" and the family but a threat to the very foundations of the rule of law.⁵¹ They demanded that Balaguer immediately reverse these deportations and vacate all charges against all who were illegally forced from the country, allowing them to return without fear. In addition, they recommended that the government immediately cease any and all "illegal and dictatorial" actions against political activists, as these were "at odds with the most elementary principles of humanity and the constitutional democratic system to which Dominican women aspired." Finally, they called on national leadership to intercede against any nation that "for any reason impedes or seeks to impede the return of Dominicans to their country."⁵²

The FMD, despite accusations from U.S. embassy officials that it was a known communist front and "clearly infiltrated by communists," kept the focus on national and international concerns that were, in its leaders' eyes, distinctly feminine or, more to the point, maternal.⁵³ From its founding to the beginning of the April Revolution, they focused on the ways in which the destruction of the Dominican home, a clear continuation of dictatorial tactics, put the entire nation in grave danger. Following the ouster of democratically elected President Bosch in September 1963,

FMD members asserted their desire for the complete reestablishment of democracy and their duty to "alert all the democratic forces of the nation, particularly the Dominican woman, who has shown so many demonstrations of the love of peace and liberty, to unite as a force to prevent the enthronement of another tyranny."[54] They sought to project their message beyond the Dominican government, joining other groups frequently to call on the United States and the UN to help defend the human rights that were regularly being violated by the government's "clearly *trujillista* tactics."[55]

On the opposite side of the political spectrum stood the APFD, led by longtime conservative activist, early feminist, and doctor Gladys de los Santos. De los Santos, who served in the Department of Health during the Consejo years, resigned her post upon the assumption of power by Bosch—whom she viewed as overtly communist—yet had not stopped her political activism and transnational engagement. Despite a distinct ideological perspective than that of the FMD, the APFD under de los Santos took a remarkably similar approach to political relevance. De los Santos explained to a U.S. friend that the APFD initially formed clandestinely during the Trujillo regime and reorganized in early 1962 to focus on issues of *asistencia social*. The group centered its work on building "home-schools" for orphans and poor children and was dedicated to teaching the "moral and human foundations that all women should know to be able to lead a dignified life" and to supporting national and international activities to benefit the cause of women.[56] While they maintained their core focus on aid to mothers and children and the prevention of prostitution, APFD leaders were well aware of the role they played in transitional politics, as they wrote in a letter to the secretary-general of the OAS in 1965.[57] They warned that the country stood in a dangerous place between two forces, one Christian and democratic, the other communist. They exhorted the OAS to ensure "true Democracy in the Dominican Republic." For the women of the APFD, the role of women in the new body politic was as the protective mother guarding against the dangerous threats from the Left. So for both the FMD and the APFD the ultimate goal in these first postdictatorial years was the construction of democracy through the reconstruction of the family, but the two groups demonstrate the intense divergence in that goal and the differing impacts of transnational engagement.

Notwithstanding calls for genuine democracy and initial popular support for a democratically elected leader, Juan Bosch lost ground quickly. Members of the UCN were active in their attempts to undermine Bosch's power, as were certain military groups, the Catholic Church, and a large portion of the business community. Economic assistance from the United States, along with rumors of such funds' misappropriation, were insufficient to build up the Dominican economy, which sagged under the weight of the former Trujillo family properties and efforts to expropriate businesses. Likewise, constant talk of the country's growing communist threat among U.S. officials, Catholic Church circles, and conservative parties did nothing to support Bosch's attempt to provide an open political forum. A two-day strike in September demonstrated that support for Bosch had entirely eroded; on September 25, 1963, a military coup overthrew the government and established a three-man junta of business leaders known as the Triumvirato.[58]

Despite the prevailing efforts to draw attention to particularly feminine concerns of transition, a number of women of the Left chose to actively engage in the more radical and aggressive tactics during the immediate postcoup period. In response to the September 1963 overthrow and undermining of the constitutionally elected government, the members of the Movimiento 14 de Junio attempted a rural insurrection centered on three "guerrilla focos" in November 1963. The movement was quickly shut down by the army and most participants were assassinated, but the attempt demonstrated the continued commitment to democratic governance by certain elements of the Dominican public. The move provided the country with its first modern female guerrilla: twenty-one-year-old Piky Lora. As the only female in the group to take to the mountains and recruit rural citizens to join the struggle against the unconstitutional government of the Triumvirato, Lora was extraordinary in her ability to negotiate the masculine world of armed struggle and revolution.[59] In her attempt to join equally the struggle for a more democratic government in her country, she was part of a larger group of female activists and a harbinger of things to come. After deciding to turn herself in, Lora was taken with the remaining fighters to jail in Santo Domingo and remained there for six months until she was exiled to Paris. Following her political convictions, Lora traveled to Cuba, where she was influenced by the ideals of the Cuban Revolution and received direct military training for guerilla insurrection, something, as

it would turn out, that would be quite useful in the near future. Risking a second exile, Lora returned to her native land in early 1965 just prior to the start of the April Revolution. During the period between the coup and the initiation of civil insurrection, other women would begin to see radical leftist politics as a more fruitful avenue to change in both politics and gender relations.

Challenging Patriarchy and Communism on the International Stage

Surrounding the elections of 1962 there was an important change in the leadership of Dominican women's international activism. Not only did new participants on the transnational scene seek to demonstrate women's importance to the politics of transition, but they shifted the discussion of Dominican governance from the stability of dictatorship to the dangers inherent in the path to democracy. No longer aligned with the ruling party, long-standing diplomat Minerva Bernardino was unceremoniously removed from her position as Dominican delegate to the UN.[60] The new delegate to the IACW and the United Nations was former anti-Trujillo activist Carmen Natalia Martínez Bonilla; she began her international tenure seeking the influence formerly held by Bernardino without its dictatorial ties.[61] Although only recently returned from a long exile in Puerto Rico, Martínez Bonilla was no stranger to transnational politics, and the IACW nominated her immediately to the presidency. While at the IACW from 1962 to 1965 she worked to construct programs that would help Dominican women and others throughout the region work toward more equitable democracy.

Besides her nomination as delegate to the IACW and the UN, Martínez Bonilla took Bernardino's place as ambassador to UNICEF in 1963 as well as to the OAS in 1964, and she began to build on her international reputation as an advocate for women's equity and democratization. During her tenure at the IACW she began a program of civic education that one publication called "one of the most important activities of the IACW." The Program of Inter-American Training Courses for Women Leaders was inaugurated at the University of Puerto Rico in 1966 and would continue for years to be a large-scale training program for Latin American women.[62] In proposing the five-year program, she emphasized that despite Latin American women's right to vote, the struggle for equity had only just be-

gun and that the organization needed "to dedicate the maximum effort, intellectual capacity, spiritual reserves, and love to the work of justice and vindication for the women of the world." The courses she proposed would help prepare women in the Americas to occupy political posts and any woman to "above all seek her rightful place in the public affairs of her country."[63] Two representatives were chosen from each nation for the original two-month seminar and offered scholarships to attend the program. Two young women active in community affairs, Quisqueya Altagracia Rivas de Liz and Vincenta Lamourth Lugo, were chosen as the Dominican representatives to the program; as part of Martínez Bonilla's design, they learned basic concepts of community, government, development, and international organization.

Assuming the presidency of the IACW afforded Martínez Bonilla an ample platform from which to project a renewed feminist approach to democratic politics that stemmed from her time outside the stifling atmosphere of dictatorship. Rather than simply arguing for more rights or privileges to be granted women, she contended that the entire patriarchal system needed to be restructured. It was not sufficient, she wrote, to grant women rights or teach them how to be citizens. Instead, it was necessary to

> totally break down the wall that, for centuries, women have faced, denying them opportunities, closing the path to their emancipation, opposing the full development of their capabilities. This hard wall was built with an amalgam of prejudices, habits, traditions, and customs, without any sense of social justice, and with an extreme selfishness... But nothing will shame us and we have begun to correct it, to repair the damage, to correct the error. I believe firmly that this is what we are doing, but there is so much still to be done.[64]

In destroying the wall of patriarchy, Martínez Bonilla dedicated herself to the possibilities inherent in inter-American cooperation. She insisted that through the inter-American system women were advancing daily, gaining their political rights, and contributing to public life, continental unity, and the preservation of peace and stability in the region. However, unlike her predecessor, she argued that such work was nascent; she claimed that women's efforts would contribute to creating a better life for all the peoples of the Americas and that advancement was dependent on voluntary action by women. She exhorted them to be *sembradoras* (sowers) of

the continent's future peace, well-being, and happiness and to contribute to the region's solidarity through their individual volunteer work. Her efforts point to the growing awareness among some Dominican female activists of second-wave feminist thought circulating in international circuits as well as, particularly for those who had fought against Trujillo, the gender equity hinted at by the Federation of Cuban Women.

Like Bernardino, Martínez Bonilla proclaimed the varied successes of Dominican women to the IAWC and created a network of international activists to back her efforts. She reported on the importance of the December 1962 elections, noting the significant contributions of women and the elected and appointed female officials.[65] Similar reports would echo her efforts to integrate a new group of women into Dominican leadership, including women like alternate IACW delegate Luisa Olivetta Contreras de Puig as well as teachers and businesswomen from smaller towns and cities outside the capital. Martínez Bonilla ably used the IACW to encourage organization locally. In one of her first speeches she advocated for the strength of national committees and, in respect to her own country, quickly reorganized the Dominican Committee on Cooperation with the IACW to reflect the newly prominent members of postdictatorial women's politics. She reported that the group included "representatives of different women's groups and plans for an intensive program of civic activities."[66] Martínez Bonilla boasted of the group's planned "short course of study and dissemination of the Universal Declaration of the Rights of Man, which will be taught with the assistance of the Women's Patriotic Association on Human Rights."[67] Like others during this period, Martínez Bonilla engaged a transnational discourse that linked application of human rights to men and women as a path to stability and democracy. Through all of her networking and program planning with the IACW, Martínez Bonilla maintained a focus on gender equality and solidarity to bring true democracy to the Americas.

Other transnational activists and politicians would use these same networks to warn the community about some of the biggest obstacles to Dominican democratization, although their perspective on such dangers would be far more conservative. As the president of the APFD, Gladys de los Santos sought out international alliances to strengthen her domestic efforts, and U.S. solidarity worker Frances Grant became a key figure in her work and the work of others. Although Grant, as a founder of the Pan-

American Women's Association, had been an active member of the international feminist circuit, by the late 1940s she had become better known for her work as a leader in the Inter-American Association for Democracy and Freedom (IADF).[68] For many politically active women during this period, the combination of Grant's established feminist credentials and trained focus on democratization demonstrated her to be the perfect ally, and they jumped at the opportunity to correspond with her, receive her support, and even shower her with praise when she visited several times during these years of transition.

Gladys de los Santos maintained a close alliance with Grant that legitimated her work locally. During her tenure as secretary of health under the Consejo government, de los Santos began a correspondence with the U.S. activist that would last into the 1970s. She regularly sent materials to Grant regarding her work with women and infant health, including the formation of a Comité Nacional de Asistencia Social in fall 1962.[69] She wrote to Grant regularly over the years, focusing consistently on the sacred duty to properly educate women to lead honorable lives and what she perceived as the communist threat that had begun with the election of Juan Bosch and continued throughout the 1960s. In an October 1963 letter she noted that the "red" danger had increased daily over the course of Bosch's government to the point that given a few more months, "a new Cuba" would have formed in the Dominican Republic.[70] For De los Santos, the relationship with Grant offered not only legitimation of her work with women's education but an international audience for her warnings of the dangerous potential of leftist thought and action.

As a result of the changed domestic conditions in the spring of 1965, Dominican women's international activism became restricted. Martínez Bonilla resigned in the fall of 1965, given the imperialist actions of the United States, and in November the IACW accepted her resignation with "sincere regret."[71] De los Santos continued her correspondence with Grant, but her letters were filled with gloom and apprehension over what she viewed as the dangerous control of the government by leftists. Still, in the period prior to the revolution, a number of women served to create and maintain strong international networks in their work advancing Dominican recovery and democracy, and for some this came with a shift in discourse toward a more gender-equitable and participatory democracy. Their efforts not only served to maintain a level of visibility for themselves within the national

press but also strengthened their credibility, honed their discourse of gender equity, and fortified the international attention on basic rights, justice, and the perils inherent to Cold War democratization in the postdictatorial period.

Women and the April Revolution

In April 1965 the tensions that had been building since the overthrow of Juan Bosch boiled over, and a small group supporting the return from exile of the constitutionally elected president began a countercoup. Using the radio and street insurrection techniques, the small group created the illusion of a larger movement and set off many alarms about a growing communist threat. As activists took to the streets, the standing government and U.S. diplomats expressed their intense concern over the stability of the island nation in the stark face of Cold War politics.[72] The government was unable to put down the popular insurrection on April 24, and U.S. Marines landed four days later. Though U.S. forces bore down aggressively on the protesters who had labeled themselves "loyalists" and "constitutionalists," the pro-Bosch group managed to retain control of a part of Santo Domingo known as Ciudad Nueva adjacent to the colonial center and close to the presidential palace. Many women would remain within this area or move back and forth across the cordon established by the U.S. Marines. The civil insurrection, or Revolución de Abril, provided a platform for Dominican women to collaborate in the struggle for the nation's sovereignty. Women like Piky Lora joined the movement, and for the first time women, *guerrilleras*, became visible members of an armed resistance. Through the struggle Dominican women called for a democratization that would entail full gendered equality and, as seasoned transnational activists, demanded continental solidarity to return sovereignty and peace to the Dominican Republic and other Latin American nations plagued by foreign intervention.

Although their experiences as part of the loyalist group have been in large part overlooked by male protagonists, the recollections of the female guerillas are documented in several memoirs and collections of oral histories. Margarita Cordero points out in her groundbreaking study of women in the April Revolution that most attempts to reconstruct female involvement in the civil war have mythified the roles of women much as the story

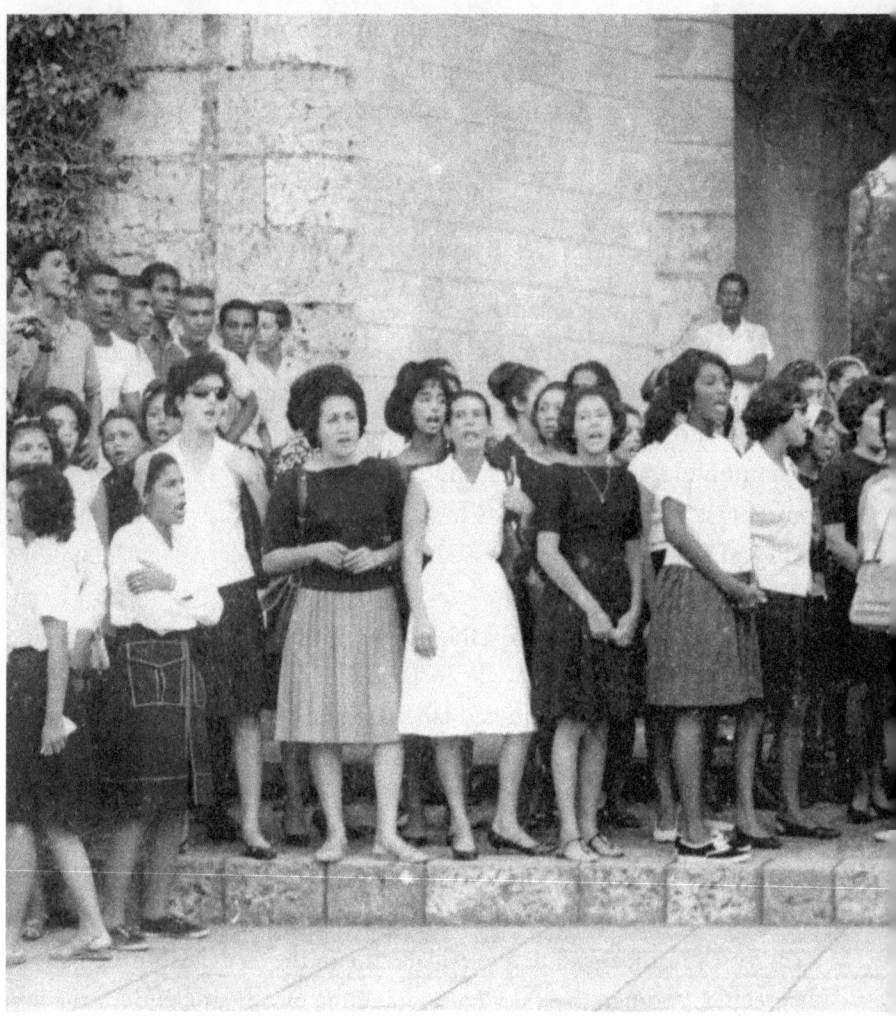

Figure 4.2. Women's demonstration at Puerta del Conde during the April Revolution, 1965. Colección René Fortunato. Courtesy of Archivo General de la Nación, Santo Domingo.

of the Mirabal sisters obscures the other women's roles in the resistance movement.[73] Cordero argues for moving beyond the retelling of the period as a parade of women to a narrative that attempts to explain their real struggles as part of the armed conflict.[74] Through the oral histories in Cordero's study and the other fragments of narrative that remain regarding women's involvement in the April Revolution, the period—seen precisely in these daily challenges—becomes more than a struggle against U.S. imperialism or the internecine fighting of contrasting political groups but reveals itself as a period in which ideas about gender equity—beyond a maternal and

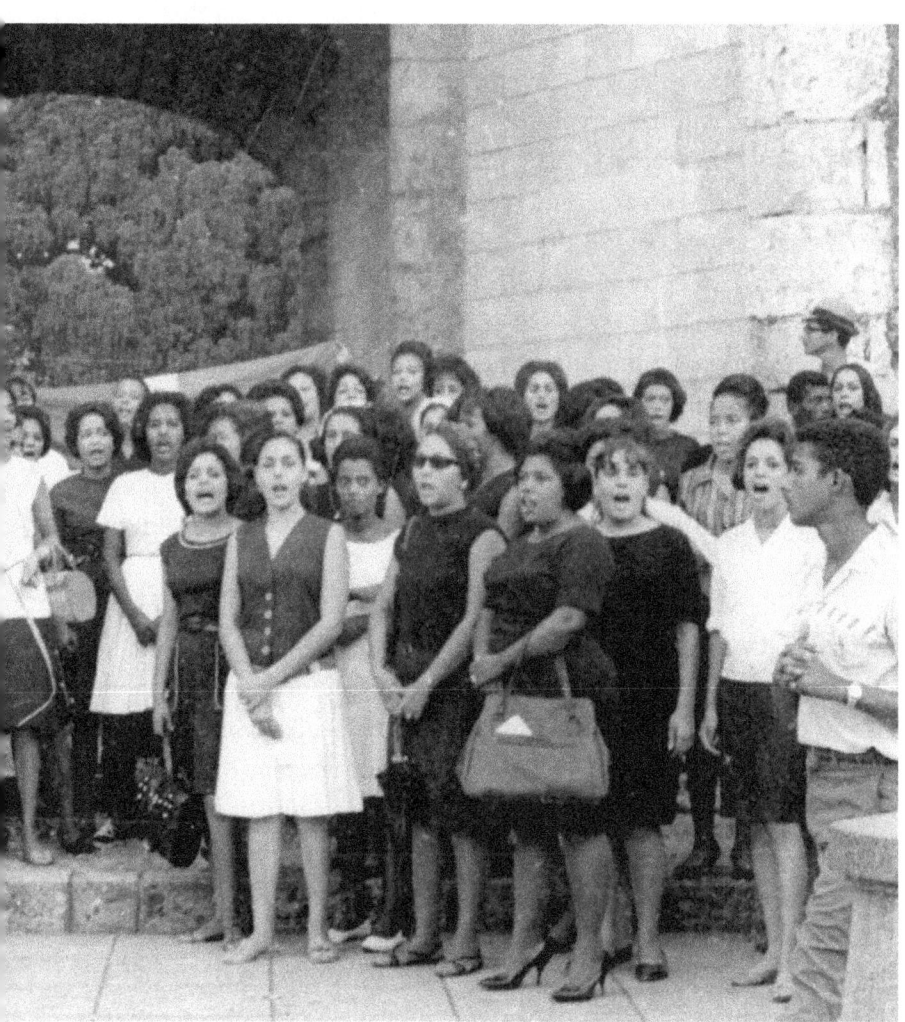

sacrificial model of participation—became an important element in the political discourse about the Dominican future and its readiness for democracy. What is significant about the April Revolution is that the involvement of women highlighted the striking imbalance in the opportunities available for political participation between men and women and the gender inequality of Dominican society. In reacting to the often sexist treatment they received from their compatriots, the women of the Left reconnected the problems of women's unequal access to social and political power with the challenges of democracy and national sovereignty.

The testimonies of women participants, most recorded in the early 1980s, demonstrate many of the unprecedented activities conducted by women throughout the several months' duration of the civil war. As the visual and written representations illustrate, many women involved in the conflict carried firearms and received military training. Through this training process women began to see the possibility for more active roles in the strategic and planning aspects of the movement. Participant Teresa Espaillat recalled that it was only because of the war that women received their military training and that most of the women who participated trained themselves "there in the fight itself."[75] While women rarely if ever saw armed conflict, their training in and outside the recently formed 24 de Abril military academy illustrates their willingness to enter equally into the struggle and the limitations imposed and exposed by the existing gender constrictions.

The military academy began to accept women in mid-June through a leadership decision seeking to boost morale and demonstrate a willingness to continue the struggle despite severe military defeats from U.S. Marines. As part of the plan, women were to be enlisted as students and teachers.[76] One teacher recounted that "there were so many women willing to fight" and, given the failure of other tactics, leaders decided that these women should be trained. As the only woman with prior military training and experience, from her time in Cuba, Piky Lora became a key instructor for the school's addition of women. She recollected that all the men respected her because they realized she had the capability to teach in such a setting. Not all the women involved felt so immediately respected. Sagrada Bujosa recalled that initially the men did not want to respect her but that eventually she found success through her work. Espaillat pointed out that several of the men in the leadership group believed that women "were members that they trusted, members regardless of their sex."[77] Still, many of the women faced regular challenges to their participation even as they daily acquired new roles and knowledge. It was precisely this training and experience that exposed women of the revolution to the possibilities of full gendered equity.

Women took seriously their roles as combatants in an armed conflict, found new skills they never realized they had, and gained satisfaction from missions completed. Recounting her experiences in the war, one woman nicknamed La Rubia said she was never apart from her rifle, that

it was her companion and her "everything."[78] Espaillat recalled several companions finding solidarity in the sense that "we are all combatants."[79] Brunilda Amaral recounted the details of her daily teaching at the academy, including the physical vigor of the job and her complete exhaustion, yet she said that at the end of the day she felt like "the happiest woman in the world" because she had fulfilled everything she felt was her duty.[80] The duty of defending the nation has been a touchstone of women's political participation since the nineteenth century across the Spanish Caribbean, yet this new physicality exposed the limits of the old model and demonstrated women's satisfaction with a more engaged defense of sovereignty.

Still, the incorporation of women into the armed element of the conflict began to create certain upheaval regarding participant understandings of their roles in the movement. Lora claimed that offering military training to women created problems for male constitutionalists because "the female members, once they began to train, wanted to abandon their traditional duties; as a result, there was no one to do them."[81] Up until that point, women had been fulfilling traditional and supporting roles as part of the insurrection: cooking, cleaning, doing laundry, nursing, and acting as messengers and fund-raisers. Many of the women initially had little problem doing these activities. Cándida Oviedo recalled her daily activities—cooking, cleaning, running errands—as simply acting on her belief that she was "adding her grain of sand in order to create change."[82] As they had during previous resistance periods, women also served as couriers to the interior, collecting funds and supplies for the struggle. Aniana Vargas served as one of the main liaisons to the interior. While she was undertaking a typically traditional role of procuring food for participants, she was also engaging in the dangerous work of supporting the constitutionalists under siege and beginning to see a new role for herself.[83]

At the end of the day, political education, mobilization, and critical thinking were central to these women revolutionaries' daily lives, even while they continued to reconstruct their traditional roles within the spaces of the war. Nearly all of the women in Cordero's study discuss the importance of daily conversations with fellow revolutionaries in expanding their knowledge of politics, imperialism, and the situation of armed struggle. Brunilda Amaral described how from these conversations and

collective activities she and her companions began to "see another side, things we did not know, or were unaware of." In the process, many began to see their social and political capabilities in a new way. Amaral said, "As a woman I felt good. I felt as though I could do the same job as any man."[84] Participant discussions of this period of struggle mirror the consciousness-raising groups of the feminist movement in the United States. Female revolutionaries came out of the April Revolution with a new sense of self. Teresa Espaillat argues that during the war participants began to see their lives from a new perspective:

> We took on the work in those five months of war with an intensity, with a passion, with a devotion; we saw, in the process, a way of life to which we aspired.... [W]e were realizing and believed that it should continue being that way.[85]

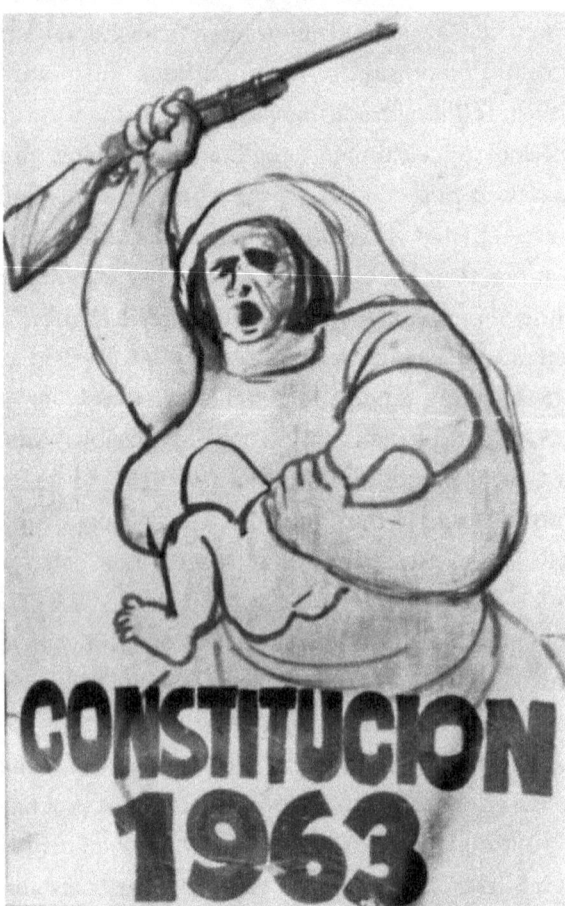

Figure 4.3. April 1965 graffiti of mother with child and rifle, referencing the 1963 Constitution. Colección René Fortunato. Courtesy of Archivo General de la Nación, Santo Domingo.

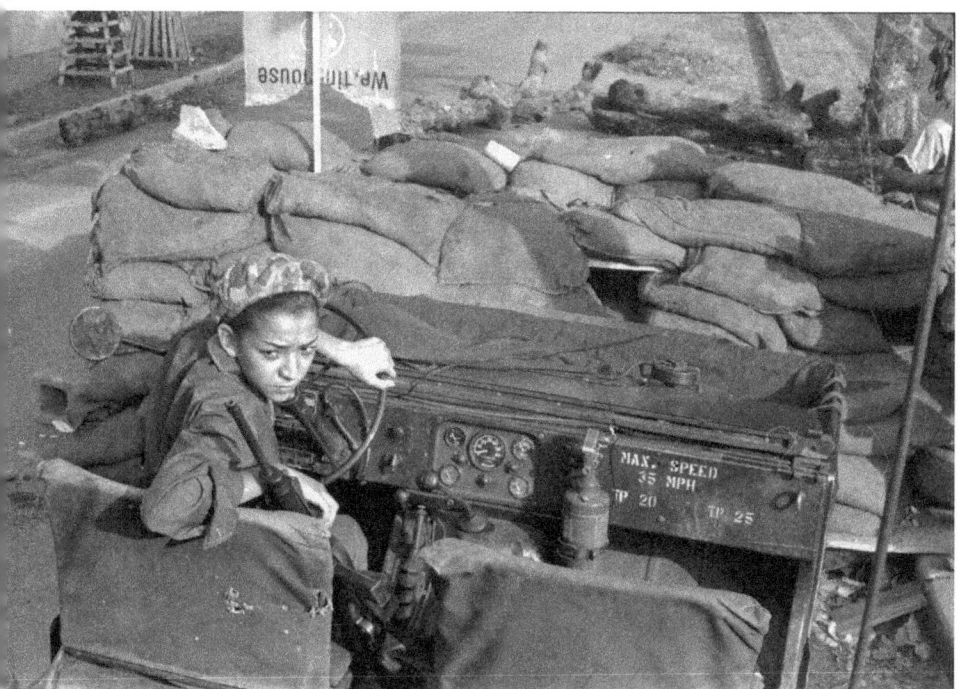

Figure 4.4. A woman revolutionary driving a military tank, April 1965. Colección Milvio Pérez. Courtesy of Archivo General de la Nación, Santo Domingo.

As female participants would soon discover, the return to daily life after the war presented them with something quite different than they had imagined, what Espaillat calls "an abrupt change" or "a sense of loss."[86] The loss they felt was of the possibilities for a more democratized and equitable political and social process.

For the women of the April Revolution, the transition back to daily life was difficult and for some filled with a sense of loss and disappointment. However, their political mobilization begun during this brief period of national crisis would carry over into their postwar lives. While they found different and new ways to be active in politics, several have remarked that they carried with them a sense of empowerment achieved through their time in the *guerra civil*. Many also realized that the goals of justice espoused by their respective movements gave no consideration to issues of gender equity. They would find likewise that their efforts were trampled by the negotiations and subsequent elections that followed the civil insurrection. After peace was brokered with the U.S. and inter-American forces in August, a provisional government was established, headed by UCN

member Hector García Godoy, and the new administration began to plan national elections. The women who had been so central to the constitutionalist struggle would remain active participants in the transitional political arena. They continued their efforts through their respective parties and the FMD, pushed for greater recognition of women's contributions to national politics, and intensified their agitation for democratization as they saw it imbricated in concerns of gender, equity, and feminism promised and denied during the April Revolution.

AS THE REVOLUTION NEARED A CLOSE and elections yet again loomed, two Dominican women wrote a pleading letter to the U.S. League of Women Voters (LWV). Throughout the revolution, Dominican women on and off the island had called for inter-American solidarity in support of national sovereignty. This particular letter, written by 1966 IACW seminar participants Quisqueya Rivas de Liz and Vincenta Lamourth Lugo, demonstrates the ways Dominican women continued to employ transnational connections to defend democracy and sovereignty through the period that lasted from the *ajusticiamiento* to the beginning of Balaguer's *doce años*. Rivas de Liz and Lamourth Lugo sought not the expertise of their North American counterparts in the league's Overseas Education Fund but rather some measure of political pressure.[87] The two women, who wrote "on behalf of the Dominican woman and of our country's interests," requested that the league "use all possible means within their reach to influence the holding of truly free elections sponsored by the U.S. and the Inter-American Peace Forces now in our country." They guaranteed that the April Revolution was not communist and argued that just as the Dominican people had risen up against the "extreme right" of the dictatorship, they would "remain on guard against the extreme Left." Having attended the multinational seminar sponsored jointly by the IACW and the LWV, the two women sought to use the organization as an avenue of protest and political aid. They wrote that their efforts in the field of social work made them particularly attuned to issues like "illness, poverty, social injustice." The two saw value in their relationships with the women of the LWV Overseas Education Fund as leverage for a more fair and sovereign electoral campaign. Despite ultimately not receiving the assistance they sought, their correspondence reveals key ways Dominican women waged political battles on their own territory

and extended their quest for equitable and democratic politics across the Americas.

The transnational arena was not the only battleground for women in the period between the fall of Trujillo and the beginning of Balaguer's regime in 1966 as women made their voices heard in the public debate over the future of the Dominican nation. Most often as mothers, sisters, and daughters but sometimes just as women, they asserted their concerns for a return to a just, stable, and civil society amid the chaos of these difficult years. The trial of the Mirabal assassins and its massive public dissemination attest to the primacy of this need for national familial reconstruction. Activist women focused on the need to repair the Dominican family that had been destroyed by the Trujillato and insisted that it was the only way forward for the nation. They justified their roles in this new discussion through their inherently maternal and caring natures. And as opportunities for women in politics formally and informally expanded, space grew slowly for a discussion of democracy that incorporated gender equality as a prerequisite for a true transition out of dictatorship and to democracy.

Not all or even most active Dominican women fully understood Martínez Bonilla's call in 1963 to break down the wall of patriarchy that was impeding female advancement in society, but through women's organizations like the FMD and various female branches of the now multiple political parties, many were beginning to understand the challenges they faced in the transition to democracy and the importance of global feminist discourse to this struggle. The women of the April Revolution who took to the streets and learned to make Molotov cocktails and shoot rifles during the civil war were realizing the important linkages between transitions to democracy, international politics, and the reshaping of their nation's patriarchal power structure. Still, the maternalism of the political arena—one of the most enduring legacies of the Trujillato—held sway as the most productive way to eliminate the remnants of the dictatorship. This approach would remain highly relevant for the women who would follow Joaquín Balaguer back into office in 1966 and prove increasingly problematic for the women who returned to active resistance to authoritarian leadership.

5

First to Liberate Women's Lib

Negotiating the Politics of Mediation
during Balaguer's *Doce Años*, 1966–1978

TOWARD THE END OF HIS LIFE, elder statesman Joaquín Balaguer faced an international press corps and was challenged with a question about his personal life. A young, female reporter from the United States wondered why the distinguished gentleman had never married. His answer, quick and witty, was that he had not "come across a woman quite like [her] in the path of his life."[1] The coquettish comment was at once complementary and dismissive and followed the manner in which he conducted his twelve years of political leadership between 1966 and 1978. Balaguer styled himself publicly as progressive in matters of gender politics, in this case flattering the reporter who posed a rather intrusive personal question. While he did remain single his entire life, during his *doce años* as president he made an impressive performance of the importance of women to his regime and placed them in significant political posts. He attempted to demonstrate to the world, as in his answer to the reporter, that he was forward-thinking when it came to matters of gender equity. However, rather than reenvisioning the role of women within their new positions, Balaguer actively emphasized a maternal politics that reified traditional gender concerns written onto the public sphere. Much like his somewhat empty reply to the woman, his vision for women in politics did not extend much further than naturalized roles fit carefully into seemingly appropriate public spaces. Yet his dependence on women to provide political stability throughout his twelve-year regime was unprecedented in Dominican history. Balaguer appointed many female government functionaries during the *doce años*, perhaps more than any government at that time in the hemisphere, and directed much of the regime's efforts at issues directly affecting women's everyday lives.

And while historians and political commentators view the many female governmental appointments of the regime as mere window dressing to an otherwise authoritarian and paternal regime, much like Balaguer's own offhand comment, the *balagueristas* managed capably to maneuver through party politics, international alliances, and local power struggles to ensure political advantage and experience for themselves and their extended networks of female colleagues. As much as Balaguer attempted to style himself the clever and worldly bachelor, he also effectively and paradoxically reconstructed a politics of paternalism that set him up as the benevolent and holy father with his female politicians as his hardworking and devoted handmaidens.

The politics of the *doce años* may have echoed Trujillo's maternalist policies but several elements of Balaguer's approach toward his female appointees and other gender-specific governing policies altered the structure of women's political involvement. The regime actively incorporated and encouraged women to become the politicians of mediation in the midst of a very public forum about the future of the country. Balaguer not only advocated for his all-female gubernatorial nominations before national and international audiences, but he argued that they served as the antidote to the current climate of political chaos and disagreement. They were key liaisons between the federal government and the local masses and facilitated Balaguer's clientelistic politics of apportioning goods and services to the peasantry. As the regime empowered women to act as mediators and conciliators, the new politicians in turn made strategic use of their positions in the party and in government to further their careers through the assertion that women inherently performed politics differently than men did. The numerous female politicians during the twelve-year regime—including governors, senators, congresswomen, mayors, secretaries of state, ambassadors, and volunteers for the Cruzada de Amor (Crusade of Love) aid program—assumed the roles of public officials by applying their experiences as wives, mothers, and ex-participants in a dictatorial regime, extending their involvement to international arenas and incorporating their trusted friends and neighbors in the process. By their own admission they did not believe that men and women should participate in politics in the same way, nor did they consider themselves feminists; they saw their contributions as an extension of the mediating and moralizing qualities of the domestic sphere brought into the political arena. As one foreign observer noted, they were

"*not* women trying to do men's jobs but women trying to do jobs better by being women."[2] This maternalist vision of women as mediators and peacemakers in a time of purported transition simultaneously relied as much on their naturalized skills as mothers as on their abilities to perform as aggressive and cosmopolitan politicians capable of smoothing out heated and difficult regional disputes. Their role as mediators was essential to the functioning of a regime that scholars have considered both a continuation of dictatorship and a transitional regime moving ever so painfully toward democracy.

At the base of women's importance to the Balaguer regime and its international negotiations in the context of the Cold War was the politics of clientelism enacted by the leader and his regional representatives. While the *doce años* were in many ways a mirror of the Trujillato, given Balaguer's critical involvement in the dictatorship, international demands for a new kind of stability coupled with a population overwhelmingly tired of iron-fisted rule necessitated a different style of leadership. After the rampant intimidation and electoral fraud of the regime, the country was far from what political analysts would categorize as a functional democracy. Yet Balaguer, much like Trujillo, understood that talk of stability, justice, cooperation, and equity went a long way in masking an authoritarian regime for national and international audiences. Political scientist Jonathan Hartlyn calls the Balaguer regime "neopatrimonial," arguing that it was a type of political regime that "crosscut authoritarianism and democracy."[3] While this description of the regime is apt, it also tends toward a generalization of what must be seen as a unique period of rule. Balaguer inherited much of his style from his predecessor, but he also constructed a new kind of paternalism that depended upon regular apportioning of goods and services to the poor and underserved.[4] This form of popular clientelism ensured that the less fortunate would continue to support his policies and vote for him on election day, and it was facilitated by the hundreds of women—in official and unofficial roles—who worked as the deliverers of the items that would guarantee Reform Party loyalty. In this formulation, Balaguer stood as benevolent father as his female proxies spread the maternal love and mediation necessary to maintain the stable Dominican family.

Balaguer's reliance on women in formal posts was in some ways unprecedented, but he followed a recognized path toward proving democratization. Mire Koikari contends in her study of Japan in the postwar oc-

cupation period that the gender imperialism of the Cold War created a complex web of expectations, at once spreading "discourses of femininity and domesticity . . . in the name of women's emancipation" and simultaneously subverting "the dominant structure of power" and contradicting "Cold War notions of women and domestic containment" in an effort to demonstrate true democratization.[5] Balaguer committed to proving himself an appropriately democratic alternative to both communism and dictatorship; the female governors constantly negotiated that middle ground, at once traversing it in perfect Cold War femininity and also wading through the more challenging terrain of subversive political behavior in an effort to prove domestic stability. As a result, the efforts of Balaguer's female politicians invite an analysis of the local contexts of women's political engagements in the Cold War, as their work highlights the complex negotiations between foreign demands for anticommunist stability and local concerns for national sovereignty and progress.

Whether as volunteers in the extensive charitable network Cruzada de Amor led by Balaguer's sister Emma Balaguer de Vallejo or as high-level international diplomats, provincial governors, or participants in U.S. NGO-led democratic leadership schools, the female politicians of the Balaguer government used the rhetoric of the regime as a tool to advance their own activism within the tightly defined position of their feminine roles. Fulfilling political positions more ably as women was the goal, yet in the process many women proved themselves highly capable of succeeding within the masculinized world of Dominican politics.[6] Negotiating a real place for themselves, this group of mothers, wives, and daughters was part of a key transition in the definition of a woman's place in the public sphere and the practices of Dominican politics. Seen particularly through the efforts of the all-female governor appointees, women of this period were forced to reconcile local need with national rhetoric. The *balagueristas* straddled several worlds. Like the women of the Trujillato, they were forced to contend with the regime's dictates of how to be properly political, but in working as the local representatives in many cases they injected specific area needs along with a more aggressive and decidedly unfeminine approach into the national debate. As a result, the Balaguer machinery more often than not saw that conceding to their demands helped grease the many links between the regime and the population at large.

Following the efforts of their predecessors, the female politicians en-

gaged with the Balaguerato found international linkages to be crucial in advocating for women's advancement, creating networks of support, and advancing their careers. Formal posts in the international arena remained a central tool for the women of the Balaguer regime, and they followed closely the return of Trujillo-era diplomat Minerva Bernardino to international prominence. However, a new form of transnational activism surfaced in the 1960s and 1970s. The Alliance for Progress initiated under President Kennedy as a new and proactive approach to fighting communism in Latin America provided the foundation for a transformed approach to women and development projects.[7] Following the dictate "to improve and strengthen democratic institutions," the U.S. State Department funded a number of programs to teach voluntary service and democratic leadership among women in Latin America.[8] In the Dominican Republic, this effort was led by the League of Women Voters and its Overseas Education Fund (OEF). Hundreds of Dominicans participated in programs aimed to train women "as professional consultants in the field of citizenship and to build within the electorate of Latin American countries served by such technicians an increasingly large group of women skilled in democratic practices."[9] Wendy Pojmann finds that for women in Italy during this same period, their decisions about "political participation did not exist outside of the influence of Cold War discourses and realities."[10] This was equally true for the many Dominican women, including the governors, who participated in OEF training programs; the problematic discourse of development leached into every workshop and session, yet these opportunities also provided networking opportunities and leverage for the women and their work in local arenas.

Assuming this new model of maternalism in politics in the late 1960s and the 1970s was not without its limitations and the work of the *balagueristas* as mediators between local, national, and international politics highlights the complex and circumscribed realities of female politicians under authoritarian regimes. Utilizing multiple avenues of participation, the women of the Balaguerato legitimized the positions of women in the formal political arena and ultimately altered existing models of female political participation, even if doing so highlighted the many gendered contradictions of the regime. It was a political model that validated women's distinctly feminine involvement and centered on the fundamental differences between men and women. Female participation was deftly tied to a vision of women

Figure 5.1. Joaquín Balaguer and his sister Emma Balaguer de Vallejo at an official event. Courtesy of Archivo General de la Nación, Santo Domingo.

as peacemakers while anchored in a highly authoritarian regime. It was a series of participatory practices that centered on the local, all the while reaching out to the national and international for leverage and negotiating the political rhetoric required at each level. Such a configuration brought an unprecedented number of women into the political arena as the regime's agents of peace and conciliation even while advancing a highly conservative and restrictive model of female participation.

Joaquín Balaguer, Continuismo, and Maternal Politics

After the 1961 assassination of Trujillo and the nation's subsequent years of political uncertainty and U.S. occupation, the 1966 election of Joaquín Balaguer ended a long period of political turmoil in the Dominican Republic and began a new and yet familiar era of authoritarian leadership.

Leaders of Balaguer's backing party, the Partido Reformista (PR), were well aware that responses to their electoral victory would range from relief to resigned acceptance or outright resistance. As a result, the politics of the Balaguer regime were a mixture of attempted reconciliation and continued intimidation. The government recognized the need to draw in a large constituency marginalized by the previous years' upheaval, and the rhetoric of rule was a careful combination of discursive peacemaking, active clientelism, and outright brutality. Coined *continuismo* by contemporary observers and later scholars, the Balaguer regime drew heavily on the tactics of the Trujillo but also attempted massive development projects meant to demonstrate a stable civil society and a solvent economy.[11] Without the military connections pivotal to the Trujillo regime, however, the Balaguer government depended on intense levels of repression of political dissidents, co-optation of the middle and upper classes, and distribution of necessities among the poorer masses.

Having risen to power through the Trujillato, Balaguer was well versed in the politics of international image making. Balaguer had been involved in the Trujillo regime since its inception in 1930. He initially worked as a speechwriter and diplomat and eventually became Trujillo's choice for vice president under the dictator's brother Héctor Trujillo as titular president in 1957. Over the course of the thirty-one-year regime, Balaguer held significant posts as secretary of education and foreign relations but also served as a close adviser to the dictator. Under pressure from the OAS, Balaguer assumed the title of president in 1960 and remained there until January 1962. The elections held in 1966 only served to drive home the importance of the global pressures on Dominican politics. Given the demands of the U.S. presence and OAS sanctions, political campaigning took place under extremely strained conditions. Balaguer was able to campaign freely throughout the country, while his main rival, Juan Bosch, was limited to radio addresses and media blitzes due to individual and party fears for his personal safety. As the candidate for the PRD and recently returned from exile in Puerto Rico, Bosch was barely able to leave his home in the capital neighborhood of Gazcue, while Balaguer managed a smart campaign of public speaking, grand promises, and goods distribution. Balaguer garnered 56 percent of votes cast and had the most success in rural areas; Bosch collected approximately 39 percent, with the remainder of votes going to the third candidate.[12] The election was marred by accusations of intimidation

and corruption, and Balaguer emerged well aware of the need to court public opinion of his leadership as the antidote to another Cuba.

A combined focus on government stability and economic survival along with healthy doses of intimidation and electoral fraud would carry Balaguer and his party through the next twelve years. Significantly, Balaguer's success in creating stability lay in the apportioning of needed goods and services to the poor and integration of the middle and upper classes in the social and economic spoils of such projects. His competitor Bosch had campaigned on his platform of a clean slate, while Balaguer depended on a continuation of the stability of the Trujillo regime without the dictatorial label. Also important was his promise that those compromised by their participation in the dictatorship would not be punished and in most cases integrated back into politics. Stability was also built on economic advancement and Balaguer relied heavily on U.S. aid and generous sugar quota, the encouragement of industrialization and the production of local consumables, and the redistribution of state-owned resources acquired throughout the Trujillo regime. The main component of the economic recovery plan, U.S. loans and grants, brought in $22.1 million between 1967 and 1978 and demanded strict implementation of approved development projects.[13] Such development programs focused on much-needed infrastructural and educational programs; they were supported by the slow privatization of resources previously held by the Trujillo family and were checked by strict austerity measures.[14] Continued success demanded that the regime prove to the United States that it was progressing away from the Caribbean strongman model while also steering clear of any socialist or communist leanings. Combined with the regime's ability to continue doling out contracts and various political appointments, as well as its continual rearrangements of the armed forces, Balaguer and the Partido Reformista kept themselves in a well-supported position vis-à-vis a large proportion of the Dominican population and U.S. policy makers.

Balaguer and his party made a direct appeal to women and their perceived desire for stability. One particular slogan during the 1966 campaign declared, "Mothers, I will give you peace."[15] Other campaign appeals called on women to participate in the construction of a more tranquil society by voting against the PRD and other revolutionary parties.[16] To incorporate women into the structure of the organization, the PR established a Department of Women's Affairs. Its purpose was to foster positive relationships

between female party members and national and foreign women's groups "of democratic tendencies."[17] The goals of the department were to collaborate with the multiple social assistance projects undertaken throughout the country and in general "elevate the condition of the Dominican woman." Specifically, the party involved middle- and upper-class women in the day-to-day practices of *reformismo* and through them provided charity and uplift to lower-class women and children. This work was supplemented by the semiprivate Cruzada de Amor managed by Balaguer's sister Emma. Although the discourse of the party's structure and platform affirmed the importance of women in the abstract, the regime created a real place for official feminine politics. Like his predecessor, Balaguer fostered a vision of the ideal Dominican family as a metaphor for the nation. The language of the regime and the party as well as their ongoing reliance on public assistance programs led by women helped create not only the fiction of full participation, stability, and development but also the idealized vision of the peaceful Dominican family.

In orchestrating the transition from several years of revolutionary struggle, the Partido Reformista had to grapple with significant national and international turmoil. Peace and conciliation provided the party with a formula with which to start the discussion about the future. The idea that women, an increasingly visible element in the body politic, could represent such change was desirable to the party. Balaguer declared "women of the humble classes" to be the "most important and numerous group" within the party. As its "standard of love and harmony," the party needed women, whose hearts were "anxious for the arrival of peace to [their] shaken land." He affirmed their centrality to the future of the nation in a 1966 campaign speech:

> Mothers have entered into public life to advocate for the establishment of a regime of security that will permit them to live without the anguish that one day might occasion a dead son in a street riot, or a husband or brother wounded by a stray bullet, or struck down by one of the many acts of terrorism that are staged daily on Dominican soil. That is why, I repeat, that across the country mothers who crave peace, beg for tranquility, and clamor for the establishment of a government capable of making blossom the flower of harmony in this field of weeds that Dominican life has become, are flocking by the thousands to our ranks.[18]

Envisioning women entering the "plaza pública" through the Balaguer regime was more than a mere campaign promise. The Balaguerista machine facilitated such an active entrance. In supporting the purported constitutionality of the presidency, upholding the moral mandate of the campaign platform, and creating the illusion of peace and conciliation in their respective provinces, the women governors and other female politicians provided Balaguer with much-needed legitimacy nationally and internationally.

Women still, as during the Trujillo period, were central to the idea of domestic politics. Adulatory homages—women coming en masse to praise the work of Balaguer and demonstrate their support for his reelection—were legacies of the Trujillo regime; still, a more active and aggressive kind of women's politics emerged during the twelve years. Female Balagueristas saw opportunities in the new government and its party beyond the segregated women's groups of the Trujillo era. Although they continued to uphold typically feminine roles as the moral guardians of the nation, they concurrently defended their positions alongside men in formal political structures. Their positions were at once naturalized—as soothing mothers of a troubled nation—and new, as they filled unprecedented roles as government officials, but always tactical, for the regime and the women who took them on.

Female Governors as Mediators for Peace and Progress

One of Balaguer's most significant and visible maneuvers in his bid for peace and progress was his nomination of women to high-profile public posts. After giving women, specifically mothers, a vaunted place in the campaign platform, he followed through on his rhetoric by appointing only women to the posts of provincial governor immediately after he assumed power in 1966.[19] The peace Balaguer had promised throughout the course of the campaign was built upon the Trujillo ideal of the nation as family, with women as the lynchpin of stability within that family. Although scholars have generally dismissed the appointments as typical Balaguer media spin, the appointees received a jubilant reception in national and international press outlets. News of the initial nominations and the swearing-in activities appeared in all the major Dominican dailies, and newspapers across the United States and Latin America reported on the unprecedented decision. In addition to articles covering the inaugural festivities, *Listín Diario* pub-

lished the actual decree naming each individual female governor. Through the press coverage Balaguer was able to publicly thank Dominican women for their endorsement in the 1966 election campaign.[20] The work of the female governors in their respective provinces would prove integral to the regime's relationship with the rural masses.

Twenty-six women were inaugurated as provincial governors on July 6, 1966. The act and the presence of women as provincial leaders were important to the Balaguer regime for several reasons. On the governors' inauguration day in the presidential palace, Balaguer said he believed that the appointees could be "the best vehicle for the politics of conciliation that the government wishes to realize." The regime's spin doctors portrayed the newly appointed female politicians as the ideal selections to carry out the peacemaking process at the local level. The underlying assumption was that women were not as polarized politically—either by the Trujillo regime or by the ensuing five years of turmoil—as their male counterparts, and they would serve Balaguer better than men could in smoothing over provincial struggles and unrest. Further, the multiple appointments portrayed the country as moving beyond the legacy of dictatorship. In Balaguer's words, the women governors "could demonstrate to the world that the Dominican people have the capacity to progress."[21] He insisted that the appointment of women would serve as a showcase for the advancement of the nation.

In October 1971 the *New York Times* printed a glossy, Sunday magazine–style advertisement from the Dominican Republic that affirmed the regime's plan for the female governors. A photo of the inauguration of the governors in 1966 appeared immediately below the opening message from the president, with an awkward caption: "The Dominican Republic was first to liberate Women's Lib."[22] "Liberating women's lib," as attributed to the Balaguer government, was a phrase clearly lost in translation, yet it highlights the core of the regime's gender politics. In freeing women from the purported radicalism of western feminism, Balaguer created space for them to participate in politics as the maternal peacemakers he needed to calm turbulent provincial conditions and create an image of national progress. Evidenced by the national and international press campaign, the governors took on two hefty tasks: creating political tranquility in often highly charged provincial arenas and convincing the international community that the Dominican Republic had moved beyond dictatorship to a more advanced form of government without resorting to radicalism. In

their positions as local leaders the women governors affirmed their importance to the regime in these two tasks. Their activities were depicted often as social labor rather than politics and as part of the project of conciliation or rapprochement of the campaign platform. As mediators between local constituencies and the national government, they implemented a brand of politics that enabled them as loyal party affiliates and empowered them as advocates of democratic practices.

Despite the regime's attempts to portray them as docile, conciliatory, and nonpartisan selections, the success of the governors depended on their being both partisan and highly politicized. The reams of correspondence they produced over the course of their tenures indicate that they struggled in the world of male-dominated politics but persisted and ultimately constructed a new style of women's participation.[23] Predominantly, they claimed authority over the kinds of feminine politics deemed appropriate to their roles as wives and mothers and made demands on the regime that reminded Balaguer of his continued indebtedness to the concerns of Dominican women. Yet they also demonstrated that they were equally adept at acclimating to the typically male-defined, cut-throat, clientelistic, and patronage-style politics that were at the core of the Balaguer government, constantly adjusting in their roles as the political go-betweens.

The women initially appointed were established members of their respective communities, and they assumed the charge of conciliation and mediation with seriousness. Of the pool of forty-eight women over the twelve years, eight were doctors and at least a dozen were teachers. Nearly all of the governors were married or widowed. One governor divorced her husband during her tenure. Overall, they were women of comfortable economic means with high levels of education. Many had lived in the capital and received a college education, while others had spent significant amounts of time in classrooms or other educational centers. They represented the middle- to upper-class family living in the small capital cities of their respective provinces. Their solid class status and stable family lives afforded them respectability even among non-Balaguerista families. Nearly all were women from highly politicized Reformista families, and as they themselves lacked officially defined political experience, many of them admitted being surprised by their appointments. In their comments to the press on inauguration day, the female governors expressed their desires to fulfill their positions in a nonpartisan manner and in a distinctly different political

style from their male counterparts. As the governor of the province of San Pedro de Macorís explained, she hoped to "open the doors of government to all, without regard to political party."[24] They replaced preelection rivalry with discussions of unification and rapprochement, particularly in provinces dominated by the oppositional PRD. Many made promises that only key provincial personnel would be replaced, if any at all, and that individuals would be judged on their merits and not by their political affiliations. They promised a voice for their impoverished provinces and spoke with confidence about the construction of schools, roads, bridges, hospitals, and other infrastructural needs. In serving as advocates for their local communities, the women governors demonstrated an early capacity to assume the rhetoric of the regime as a way to effectively gain resources for their constituents.

The principal duty of the provincial governors, first outlined in a 1950 law during the Trujillato, was to serve as representatives of the executive branch within the provinces, although they were given few resources to complete their tasks. The governors were to ensure compliance with the constitution and laws of the republic, contribute to the maintenance of public order, watch over the work of other local officials, organize provincial celebrations for all national holidays, inform the executive branch of the conditions of the province, and make suggestions for development and advancement within the region.[25] Legislation demanded annual reports detailing the general conditions of their provinces, with special attention to local communities, agriculture, public education, immigration and naturalization, demographics, labor, and children. The position also authorized governors to make recommendations to their superiors that "in their judgment, would encourage development in each area," although no promises were made as to compliance. Despite the regime's public proclamation of the importance of the women governors, they still faced difficult challenges and had few resources at their disposal.[26] National officials assigned the governors multiple menial tasks and were often blind to the severe challenges the women faced in the execution of their duties. Unlike mayors or town council presidents, the women governors had no exclusive budgets and were forced to deal with the central government for even the most miniscule expenditures. Requests for greater allocations of resources emerged consistently throughout their correspondence, and mundane daily tasks plagued their efforts.[27] The appointed officials seemed not to contest their

measly incomes and for the most part may not have needed them, but they made clear their fiscal concerns in other ways. They sought appointments of additional personnel for their offices, reminded upper-level officials that the governors used their own vehicles for provincial business, and in a few cases secured loans against their salaries to pay for provincial and personal needs. Due to their generally comfortable economic status, the governors projected an image of selflessness because their fiscal concerns consistently centered on their constituents. Almost daily they sought to fulfill their role as Balaguer's "vehicles of conciliation."

A report from U.S. women's advocate and consultant Mary Elmendorf echoes many of the ideals advocated by Balaguer and the women governors in their vision of themselves as mediators. Elmendorf's ultimate argument about the group of female politicians centered on the strength of female role models.[28] She noted that while not significantly powerful in a typical political sense, the women governors of the Dominican Republic felt as though they were vested with political influence and acted in a manner befitting such a belief. Elmendorf asserted that the most potentially powerful element of their appointments was their ability to approach traditional politics from a uniquely feminine perspective. Quoting President Balaguer, Elmendorf agreed that it was "these women who can be the best vehicle for the policy of conciliation which the government wishes to institute."[29] She argued that they fell into the category of a "new female image." That is, they seemed to be, as governors, "less aggressive, more interdependent—and more interested in people as their human resources."[30] Elmendorf's report underscored the ways in which the women governors used their positions for political leverage without altering their normative understanding of femininity and while still gaining resources for their constituents. As evidenced in their correspondence styles and press commentaries, many of the governors Elmendorf interviewed indicated that they did not consider themselves political and that in their eyes this made them more neutral selections. Their manner of approaching politics aligned closely with characteristics typically assigned women of their class and status: charm, diplomacy, subtlety, and oversight of issues of typically maternal concern. One governor noted, after reminding Elmendorf of her twenty-five years as a teacher and school director, that she felt it was her knowledge of the community that would allow her to create "harmony among the people."[31] Others told Elmendorf of the need to move beyond partisan politics and of

their respective roles in facilitating that process. As mediators, the women governors were charged with a massive project that demanded that they negotiate between the local and the national, operate within the charged world of provincial partisan politics, and supersede the typically masculine world of Dominican politics in order to fulfill their new roles as feminine peacemakers.

Seeking a second term as president in 1970, Balaguer compared women in the body politic to a heart within the human body, "affirming and ratifying all that the government did to sustain the peace of the Republic."[32] For the women governors, being the peacemaking heart of the body politic connected directly to their ability to bring resources to the provinces. Balaguer declared, "Our women have demonstrated themselves to be among the most ideal and capable public servants the current government has at its disposal." As the center of this national communication nexus, the governors carried the needs of the people to the president and then delivered results back to their constituents. Despite numerous challenges, they worked hard to fulfill their roles as mediators between the provinces and the president, advocates for their constituents, and beacons of the nation's progress and development.

Democratizing the Provinces

One of the most effective techniques used by the women governors in their role as local advocates was to remind the regime of the importance of the veneer of democracy. The officials demonstrated their ability to participate in a show of impartial politics in activities that ranged from their discussion of nonpartisan appointments to their handling of local school strikes. They employed a vocabulary of equality and indicated their awareness of the import of democratic ideals during the *doce años*. The regime advertised the female governors as moral guardians and peacemakers to project an image of egalitarian politics domestically and internationally. One governor said in a news article, "I will solicit the cooperation of everyone because I do not think government is for only one party. I am excited by the best wishes to govern my province with equity and will attempt to encourage its progress."[33]

At the local level, their most visible arena, this meant promising transparent hiring practices, emphasizing their concern for rural citizens re-

gardless of party affiliation, and most importantly, stressing the need for large-scale social and economic development. True to their commitment to democracy and its Cold War mirror, development, almost all the governors focused immediately and aggressively on issues of urgent necessity. Schools, roads, dams, potable water, electrical supply, office supplies, and transportation were most frequently noted in their letters and telegrams to the secretary of the interior and directly to Balaguer himself as well as in their weekly, monthly, and annual reports. Their concerns ranged from quotidian issues of demographics, appointments, and office supplies to complex queries into political intrigue, party strategy, and agrarian land reform. Nonetheless, all their correspondence was overwhelmingly focused on local development. Each governor discussed her problems in such a way as to make issues of local concern imperative to the success not just of the party but of national growth and progress. However, building, rebuilding, educating, and inaugurating were also vital activities for the group of governors hoping to prove to their constituencies the usefulness of a provincial leader engaged in the connected projects of local and national development. The women governors used their positions to direct and accelerate particular projects within their own provinces. Roads were essential in local areas that were isolated from provincial capitals and witnessing the effects of expanding industrialization. As one governor pointed out in her first annual report, keeping these channels of communication and transportation open was essential to national development.[34] Remodeling hospitals and expanding the medical system allowed governors to impress upon their superiors the importance of scientific advancement and progress, even for marginalized barrios and towns, to the larger national project.

Undeterred when the central government held up, held back, or denied funding, many governors looked to private investment and fund-raising committees to showcase their political savvy and commitment to development. For a road-building project in La Altagracia, Governor Italia Leopoldina Pion de Gómez reported nearly ten thousand Dominican pesos raised through "community support." Unwilling to stop with a single road and aggressively pressing her advantage as a skilled fund-raiser, she said local inhabitants demonstrated their support for work on a second road.[35] Fund-raising committees for local construction projects were common within the governors' networks of support. Rather than relying solely on the often

unpredictable "special funds" from President Balaguer, they looked to local businessmen and prominent citizens to financially and socially support the projects they viewed as crucial to the community.

In the execution of national development at the local level and the showcase of democracy nationally, the governors viewed education as perhaps the most essential tool at their disposal. One stated that local schools were of the utmost importance because they were "where the future men of the nation are forged."[36] Construction projects, while they signaled progress for the governors, were useless without an educated populace. Forged properly, they argued indirectly, the future men of the nation would carry forward the projects of development and plans of democracy for the party. As many of the governors were schoolteachers, they had a particular affinity for issues of education. At stake, the most outspoken of the governors contended, was the imperative of a viable and informed citizenry. As they naturalized their connections to youth and education, the women governors drew on a more universal rhetoric of educating for development and progress in order to gather resources for their local communities. Still, funds for education were scarce, and governors struggled constantly to draw attention to their local needs and appease students upset over such a dire and continual lack. The governor of La Romana wrote in her 1967 annual report that many of the five thousand children of school age in her province starved for the "bread of education" due to the physical deficit of resources.[37] She made sure to place blame on the appropriate officials, as she had, in her words, informed them on various occasions of the problems. Given the paucity of resources and local political disputes, governors were constantly attending to protests at local schools. Student strikes were irksomely commonplace; as a result, most governors mediated between the state and disgruntled students and staff, promising attention to local needs, allotment of resources and, in some cases, termination or reassignment of personnel. They reported on their inspections of schools as well as their attendance—to observe and mediate—during strikes. Opposition groups often led school protest movements, but the governors demonstrated a political even-handedness in educational negotiations less frequent in their other concerns. While they decried "agitators," they focused on students' lists of complaints accurately and followed through on their promises of improvement. The educational needs of the provinces provided a crucial platform from

which the female governors could gather resources for their constituents, showcase the progress and democracy of the nation, and prove themselves to be skilled and concerned mediators.

Promoting democracy and development in their provinces provided the women governors the opportunity to demonstrate the advantages of their style of maternal politics. For example, the collective concern of the governors for the youth of their respective provinces beyond the classroom highlights how ably they handled concerns so closely connected to their identities as mothers and caretakers.[38] The seemingly inconsequential issue of recreational sports appeared often in missives from the governors as they frequently requested resources for equipment, uniforms, and the reconditioning of local fields for youth groups. The governor of La Estrelleta wrote that this kind of aid was essential to "the physical and mental health of the Dominican youth."[39] The women governors consistently underscored their loyalty to the communities, the relatively small nature of their requests, and the benefits for the growth and development of the nation's young people. They viewed Dominican adolescents as their domain of expertise, and they demanded inclusion in decisions concerning related topics. In a similar manner, maternity hospitals and child-care centers received special attention from many of the female governors, with their formation often being initiated by a governor and her local supporters. The link was both intentional and naturalized, in the implicit suggestion that as women they had a closer connection to issues of childhood development, motherhood, and education. Highlighting the connection between feminine concerns and their jobs as governors allowed them to traffic in the world of masculine politics without getting trampled as relative newcomers to the political scene and at the same time keep a focus on national development and progress.

The governors and other women of the Balaguer regime knew their potential success also lay in avenues above and beyond the local. They complemented their work as advocates for social reform in their provinces with appeals for international recognition of their efforts in democratization and development. Internationally, female Balaguer officials drew collectively on the expertise of nonprofit organizations to bolster their work for democracy and used the leverage of their notoriety to implement the kinds of change they viewed as necessary for both their local constituents and their positions as female politicians. Through their participation in seminars led by

the U.S. League of Women Voters, the governors and many other politically active Dominican women incorporated the language of democracy and development in the day-to-day workings of local Reformista politics. The governor of La Romana told a visiting league representative that she was reluctant to take the position of governor but that Balaguer's commitment to democracy convinced her she had an obligation to his mission. As the center of Balaguer's public liberation of women's lib, the governors demonstrated their importance locally as mediators for democracy and development, but they also sought out an international audience to reinforce these claims.

Democratization, Development, and Transnationalism

While the work of the women governors speaks to a rupture in the maternal practices of local female politics in the Dominican Republic, women in office continued to rely on the long-standing tactic of international alliances to reinforce their efforts to prove the stability, progress, and democratization of their nation. They drew on an international feminist group's vision of democratic politics to advance their standing in provincial and national political circles. Through the League of Women Voters, an organization quite compatible with their version of feminine politics, they expanded their networks of support and cultivated leverage for their local projects of development. While the organization had worked with Dominican women prior to the 1966 nominations, it was compelled by the appointments to select the island nation as a central focus of its recently reconstituted Overseas Education Fund.[40] The events planned over the next several years incorporated the women governors into a series of "democratic leadership schools," and the governors in turn responded enthusiastically to the opportunity to learn more about U.S.-style democracy. These programs, spanning more than a decade, were popular and well received, as evidenced by the large numbers of women who attended from all regions of the country, including all of the female governors, and the return of many women to two or three courses. As the seminars offered no immediate material gain, they clearly afforded a level of political and social leverage for participants. The democratic leadership schools demonstrate the processes of negotiation between the lofty democratic ideals imposed on the Dominican Republic by the international community and the manner in which Dominican women attempted to forge their own transition from one heavy-handed dictatorship through another.

Propelled by requests in 1956 from the State Department for exploratory work in Latin America and a 1961 private donation earmarked for the region, the League of Women Voters began actively investigating the opportunity to spread its beliefs of nonpartisan democracy and civic education to women beyond the domestic sphere.[41] The Overseas Education Fund then quickly launched itself into the role of adviser to Latin American women. Early publications expressed the organization's collective belief that women outside the United States deserved the aid and expertise the organization had long offered U.S. female voters, but the assistance would not be forced.[42] By the mid-1960s the OEF had received more requests for aid from Latin American women's groups than it was capable of handling. The OEF's central tenet as it moved into its role as Latin American consultant in the early 1960s was a dedicated focus on volunteerism and civic education.[43] The league's outreach program in the region claimed to foster a multiplying ideal of volunteer work within individual communities that led to profound social change and avoided connections with partisan politics.[44] Ultimately, the league eschewed the word "politics" to signal that the best way to promote democracy was to encourage women to enter the public realm through the kinds of behaviors rendered appropriate to their gender rather than to engage in the typical masculine partisan fray.

By "politics" the league members were referring to partisan struggles like the problems that plagued the Dominican Republic. Their attempts to avoid those conflicts demonstrate the overall tenor of development that the U.S. government sought to implement and female governors found so useful in their daily work. In a short newspaper article a league representative demonstrated the organization's avoidance of partisan struggle and international diplomacy by saying the organization was "not very well geared to crisis action," in reference to the U.S. occupation.[45] In general the group's leaders argued that while the term "politics" could refer to participation, the OEF position was to avoid all references to parties and partisan struggle.[46] While on the one hand this focus on volunteer activities absolved OEF participants of involvement in the often contentious partisan politics in their host countries, it also allowed them to maintain the fiction that political activism could be nonpartisan. Activities, an OEF document indicated, were confined "to the whys and hows of government by the consent of the governed" and were illustrated through the techniques of participation in voluntary action.[47] As programs in the Dominican Republic show,

the organization's claims of civic education obscured the fact that all of the women in their programs were clearly aligned with a particular party and used the seminars to further their leverage as partisan activists.

Beginning in 1967, the OEF dove headlong into an extensive program of training in the Dominican Republic that focused on volunteerism and civic responsibility. Of the approximately 250 Latin American women who had attended the 1960s multinational seminars in the United States, only fourteen were from the Dominican Republic, although the country's own representative to the IACW had initiated the program and the league determined that the country was an ideal place to promote ideas of democratic civic culture. With the 1966 announcement by President Balaguer of the appointment of the women governors, the league began what would be more than a ten-year commitment to the women of the Dominican Republic. Before commencing the program the OEF sent consultant Mary Elmendorf, in partnership with the U.S. State Department, to research the problems faced by the new governors and evaluate the benefits of conducting in-country courses for the governors and volunteers.[48]

Elmendorf's consultation visit to the Dominican Republic focused on the role of the new women governors and the ways they and other women could further the democratization process through potential OEF seminars. Her report highlights the approach the OEF believed would make the collaboration with the women of the Balaguerato successful. Like them, the OEF leaders saw women as uniquely skilled at the peacemaking and conciliation central to democratization. Elmendorf met with nearly every governor in her home province and thoroughly documented the work of each individual she was able to visit. In addition, she met with several former participants of the OEF multinational programs and made extensive recommendations as to the role the organization should play in the development of democratic leadership skills for women in the Dominican Republic. Elmendorf concluded that "perhaps through these women governors we can have a new use of human resources through voluntary organizations working together toward economic, social and political development in a democratic way."[49]

As Elmendorf's report suggests, the OEF leaders believed they had a unique perspective allowing them to see seemingly nonpolitical behaviors as both central to democratization and concurrently divorced from partisan politics. They viewed charity and volunteer activities as a channel for

Latin American women to aid in the creation of a more stable and sustainable political sphere without engaging the perceived destructive element of Latin American partisan politics. Elmendorf, in her discussions of the women governors, commented repeatedly on their ability to listen and search for alternatives to existing problems and on their consummately feminine skill of conciliation. In a discourse that echoed that of the governors themselves, Elmendorf insisted that through an extension of domestic activities in the public sphere, Dominican women could affect policies and programs nationwide.

The OEF programs in the Dominican Republic were intended to encourage volunteer work and define appropriate paths to democratic practices, equitable participation and citizenship, and local approaches to national development. The Dominican female participants echoed these concerns but also sought to use them as a form of leverage in their more local efforts. Reiterating the themes of group work, cooperation, and self-help through role-playing exercises and small and large group discussions, the OEF leaders perceived the seminars to be successfully engendering social activism through communal and community-oriented work. Participants affirmed these goals through their own responses and subsequent community efforts. One participant, Illuminada A. de Perella, indicated her enthusiasm for volunteer work as she reported proudly to OEF on the progress of several groups in her area: "In Santiago . . . there are volunteers who work in different sectors. This account reports on part of the work which I am now accomplishing and hope to be able to continue, God willing, and to serve in all the places in which I can and will be necessary."[50] The kinds of courses offered ranged from three-day events in local provinces to weeklong, national-level retreats in the interior of the country. Participants arrived with varied expectations and even more varied backgrounds in the kinds of work the OEF sought to encourage. Almost exclusively, participants responded favorably to the work of the Overseas Education Fund in their country and reflected a desire to take the techniques used in the seminars back to their own communities. One called the program "a spark for lighting a flame for a process of development and democracy in my province."[51] Several women noted changes in their individual comportment. Two women reported post-course changes in their own homes, one saying that she learned "how to orient the home democratically" and the other going so far as to say that "even my family notices the difference." This kind of support for the program was

echoed by those who noted the need for more seminars like the ones they had attended. Several mentioned that more courses needed to be held "over a long period of time in the Dominican Republic"; one participant specifically targeted the need for educators to be part of such a group, while another stated that they should be made available to women with minimal opportunities to participate actively in their communities.[52] The frequency with which the terms "democracy" and "development" appear in the responses indicates that these were women already quite aware of the types of skills taught by the OEF and that they were really in search of leverage.

The expectations of Dominican women for the OEF courses reflected concern for national stability and their own individual advancement in the practiced democracy of the Balaguerato. Several women expressed their desire to be more aware, less restrained, and more confident. At the same time, several viewed the program as a way to create civic awareness, social stability, and communal cooperation. Participants seemed to be pleased with the outcome of the program and many stressed their liking of group work activities and their confidence in being able to apply seminar practices to solve issues of pressing local concern. A participant succinctly

Figure 5.2. Santiago Governor Lilia Balcácer de Estrella. The governor honors public servant Ángela M. Peralta during a service for International Workers Day, May 1975. Courtesy of Archivo General de la Nación, Santo Domingo.

noted, "Group work helps me to know the value of different ideas and the best ways for putting them into practice." The need to provide for member participation with equal rights and to accept the opinions of all democratically appears repeatedly among the lessons learned by OEF participants. One of the most common terms utilized by participants in answering their respective surveys was the word "awakened," evoking imagery of an existing yet hidden knowledge. Moreover, what was awakened was less often a general sense of civic duty but rather knowledge of the implementation of democracy. While it is true that the majority of these women were already involved in voluntary work, it is notable that they found the OEF to have brought such issues to the fore of their consciousness.

Through OEF-led seminars a substantial number of women found that there was much to be gained from the programs led by the U.S. women's organization. Although it is unclear the degree to which all the women were able to use their newly acquired knowledge within their communities and nation, they reported the multiple layers of confidence and expertise provided by their short coursework as well as confidence in the process of democratization despite the realities of the regime at the time. Significantly, the work of the women governors indicates the importance of the technical and

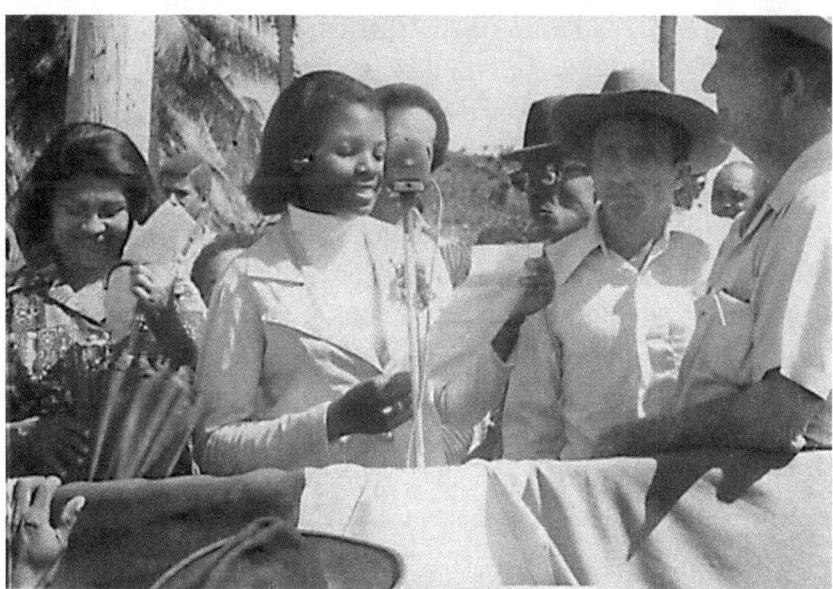

Figure 5.3. Altagracia Acosta de Bezi (*left*), governor of Samaná province 1966–1974. Courtesy of Archivo General de la Nación, Santo Domingo.

discursive skills taught by the OEF. While governors' use of the terms of democratization and development through civic activity rang false for all those not aligned with the Balaguer regime, their specific employment of these terms was part of a larger battleground among women struggling for rightful participation in the process of development within their country.

Forging a New Style of Politics

Finding success as the central mediating cogs in the clientelistic system and effective proponents of democratization, female officials discovered, hinged on their ability to portray themselves as a new kind of politician, one that was inherently moral and upstanding but also unafraid to confront the aggressive political sphere when necessary. Upon installation of each round of new or reappointed governors, the Reformista press affirmed the outstanding qualities of the chosen candidates and each woman's willingness to work for "el pueblo" to create change. All the women appointed were expected to fulfill multiple moral, social, and cultural qualifications, although such qualifications proved difficult to determine.[53] Seen clearly through their later struggles, perceived moral character remained of the highest importance in public assessments of the governor's successes and failures. Scrutiny of the governors increased as they implemented Reformista policy and faced various abuses from their constituency and other officials. The ways in which they faced these challenges varied, but all efforts were punctuated by the importance of their role as mediator. Local struggles demonstrated their ability to understand and communicate the needs of their communities to national-level officials, all the while maintaining proper morals and decorum. While male party functionaries behaved badly, were sometimes drunk, or got into the occasional fistfight, similar behavior was not part of the women governors' repertoire. Their position as the moral guardians of the regime demanded that in all but the most extreme cases they assume the role of peacemaker, putting aside their own personal needs or indignation for the greater good of the country. In the end each governor's classification as respectable depended heavily on the particular challenges she faced and the manner in which she meted out government policy; yet often in reality the governors were forced to resort to more subtly aggressive styles of politics than their predecessors.

In concerns of all natures—stereotypically feminine or not—the appointed female governors deftly tied issues of local concern to national-level political struggles and often used the survival of Balaguer's Partido Reformista as a veiled threat. Using the regime's clientelistic policies as leverage was common among the women governors. For example, in a 1967 annual report the governor of La Romana suggested implementation of an agrarian project and enumerated the political advantages in the context of the province's renowned communist agitators. She explained the details of the land distribution program as an important reward for a hardworking peasantry and the key to entering "a new stage of development." Her agrarian constituency demonstrated "strength and valor," she contended, "upon filling the polls with the Reformista vote when called upon to elect the man who should decide and rule their destiny."[54] Although she did not state directly that support for the party was flagging, the governor implied that a failure to attend to the proposed project could harm the currently strong allegiance to Balaguer among the rural areas of her province.

The governors focused even greater attention on the concerns of the party as election time approached. They coupled direct appeals for new and ongoing projects with scare tactics to remind senior party officials of the centrality of the rural constituency. Issues as small as prompt mail delivery and as large as roads and local industry merited a connection to national development. Women governors emphasized the fragility of local support. Not infrequently they reminded national officials to send the resources needed to physically carry out registration and polling tasks. Focusing on such concepts as progress, development, and fair elections during campaign years proved effective in pushing along a variety of projects and issues but also reminded government functionaries of the governors' importance to party allegiance. Their employment of the party discourse of clientelism demonstrates their willing execution of a more aggressive style of politics that drew on Balaguer's own rhetoric to demand real action for the rural constituency and to situate themselves as the most apt vehicles for the distribution of resources.

They also effectively employed party rhetoric in their regular communication. Terms like "bloodless revolution," "the Dominican family," "the spirit of cooperation, harmony, and understanding," "the enemies of public order," "the politics of rapprochement," and "the politics of social good" were the most commonly lifted from Balaguer and the PR and used in

the governors' everyday letters. Besides drawing on the scripts of the Partido Reformista, the governors relied on the well-honed practice of praise speech. Much of this entailed commending President Balaguer for his wise, charitable, and timely efforts in their respective provinces. The governors spoke not only for themselves but also for their constituents. The role they played as representatives of a constituency set this kind of praise speech apart from many of the adulatory addresses to Trujillo. More than slavish adoration, their statements reinforced the connection between local concerns and presidential stability. However, the governors were also proud of their own personal connections with the regime and used the terms of friendship to assert their legitimacy as party politicians.[55]

Appealing directly to Balaguer for aid in many of their more serious cases despite multiple telegrams from government officials reiterating the proper channel of communications demonstrates their willingness to ignore protocol to get the job done. They wrote to the president for aid in charitable acts as well as more complicated personnel disputes and development projects, seeking ultimately his direct intervention. When struggling with attendance at provincial events, particularly ceremonies Balaguer attended, the governors reported their problems directly to the president. Governor Aida Ivonne Rivas de Peña informed her superiors in October 1973 that all public employees had, despite her invitations, failed to attend an inauguration event presided over by President Balaguer.[56] Appealing directly to Balaguer, particularly as it went against official procedure, emphasized to the administration that the governors' concerns as high-ranking officials and party members were to be taken seriously.

Direct and repeated demands offered the best chance of success for the women governors and displayed their willingness to assert themselves if the case demanded. While their small requests for items like office furniture, new tires for their vehicles, or office supplies were often denied, they managed to command funding for provincial infrastructure development in impressive ways. Occasionally it took two or three requests, but the national government complied eventually with their demands for aqueducts, medical centers, roads, and educational centers.[57] One governor sent repeated telegrams to the secretary of the interior reporting on a total lack of working communication technology that prevented her from maintaining her regular duties.[58] Over the span of several months, the telegrams became increasingly insistent. The aggrieved appointee demanded that the problem

be remedied immediately, and eventually the proper department fixed the communication breakdown.

Despite their best efforts, many of the governors faced direct challenges upon their appointments from both Reformistas and non-Reformistas, and complaint letters accused them of wrongdoing ranging from "unscrupulous" political behavior to former involvement in the prostitution business. These challenges to the governors directly and their provincial authority demonstrate the contested political space assumed by the women and the ways they constructed their own visions of maternal politics. The governor of a frontier province in the southwest dealt with more than her share of challenges to her position as governor. Ana Valentina Roa de Moreta, a member of the original cohort of governors inaugurated by Balaguer, confronted political and personal threats in June 1969 when a local man attacked and physically threatened her in her home. According to the claim she filed with Balaguer and the secretary of the interior, the accused appeared at her door, shoved her to the ground, and stated, "You despicable woman, I have come to kill you." The male attacker was identified as the brother of a congressman who had himself been sending threatening letters to the governor. According to the governor's report, the attacker, the congressman, and the congressman's brother-in-law had been trying to stir up trouble for some time in an effort to discredit Roa de Moreta's political work for the party.[59] Not a full month later another man attacked her in her home, again at the behest of the congressman. Governor Roa de Moreta defended her legitimacy as a Balaguerista official and threatened to resign from her position. Several years after the 1969 incident an ex–party member proclaimed publicly that the province should be "governed by a man and not by a woman."[60] Although the investigation declared the man to be a drunkard and social parasite, the governor made clear her displeasure at this disruption of her work to create provincial peace and tranquility. In a letter regarding both events she described the reigning provincial jealousy surrounding her tenure as governor, an assertion substantiated by other reports indicating serious competition for the role of official representative of the party in her region. She requested to be reassigned to another type of political appointment. Despite her displeasure, she remembered to praise Balaguer, remind him of her loyal service to the regime, and affirmed her dependence on his government to continue to bestow her with the economic benefits of candidacy. She wrote that she was hopeful that

"Your Excellency will know to appreciate my economic situation with four daughters enrolled in the University," a situation made possible only with the aid Balaguer had always offered her.[61] Through these challenges to her position the governor staunchly defended her role as a high-level provincial authority with her demands for investigation by the armed forces, her discussion of the threats to her ability to carry out her work of conciliation, and her vehement avowal of her loyalty and service to the regime. Her case demonstrates the aggressive reactions to a governor's proclamations of defense of local campesinos and the Partido Reformista. Throughout the attacks on her person and her position, the governor defended the rights of her constituents to make a living and continue producing crops for the good of the country's industrial growth, and she returned the opposition's insults with her own subtle aggression.

Challenges to their persons and positions as the legitimate representatives of executive authority in their provinces were not uncommon and often pushed the governors to simultaneously cross and defend the invisible line of appropriate gender behavior. In the case of a bawdy discussion that flared up at her home in the province of Nagua, the governor reported firing her gun in the air twice to restore order, "in this way suffocating the heated discussion."[62] Although the governors were clear in their disdain for the frequent armed and drunken brawls that arose among male officials, the governor of Nagua made no apologies for using her firearm to reestablish necessary control. Another governor, working in Dajabón, reported in a terse telegram that a party meeting had turned into an assault on her person, and she solicited immediate aid from the armed forces to return public order to the provincial capital. According to the governor and party loyalists, several leaders began talking about the governor and her actions, "profaning her person," and orchestrating a protest in front of the provincial government building.[63] In another case the provincial appointee in Pedernales was attacked by constituents in 1969 on the grounds that she was being treated for mental illness. Her lack of tact, they claimed, was due to insanity. In what appears to be the only case in which the central government followed such a recommendation, the governor was shortly replaced. However, it seems her replacement had more to do with the political unrest reigning in the region in an election year.[64] There were a number of replacements in late 1969 and early 1970, immediately prior to the elections.

Conversely, the governors defended themselves verbally from attacks

that labeled them less than ideal representatives of the female sex. In a scathing letter to the vice president, Alejandrina Domenche de Mañe of Valverde wrote that as "an honest and decent women" she found her treatment by other party members painful after she had worked "tirelessly to gain supporters, not only in my town but also in the entire countryside where the majority of voters reside."[65] Although humiliated and insulted, she asserted that she had worked "with eagerness and dedication in her job" and administered "clothes, food, medicine, aid checks, sewing machines, land" for the party that was now tearing itself apart with internecine struggles. In conclusion, she renounced her membership and resigned from her position. Although somehow convinced to remain in the position into the next year, she denounced her appointment a second time due to continued lack of respect for her position. Another governor confronted serious attacks that cut to the core of the debate about the public woman. At inauguration activities in San Juan de la Maguana in 1970 the governor-elect faced accusations that she was nothing more than a "meretriz" (prostitute). The inauguration of Argentina Fuentes de Peña on September 12, 1970, during Balaguer's second term raised concern in her province stemming from local doubts about her status as a moral and upstanding woman. An internal memo dated four days after the inauguration declared that Fuentes de Peña had been the object of criticism from a large proportion of the community. Claiming her nomination to be nothing more than a mockery, local Lions and Rotary Clubs stated that they would extend no social invitations to the new official. Less damning, the memo noted, were several individuals who felt that she was a loyal Balaguerista but certainly not qualified for the job. The night before her inauguration, according to the memo, all the recently closed brothels reopened in celebration of her impending installation. Moreover, the official submitting the report indicated that many military personnel in the province held her in high regard. Given the accusations leveled at the military for supporting the practice of prostitution, the memo all but confirmed citizen complaints.[66]

This example, by far the most egregious of the many accusations leveled at the governors, struck at the heart of concerns about female officials, appointed or elected. Reformista leadership including Balaguer seemed to realize that the governors' success hinged on their ability to operate within the aggressive world of public, partisan politics, but the reality of this often unnerved male party functionaries and citizens, provoked accusations

of prostitution, and resulted in a more generalized anxiety over women in public spaces. As conciliators, governors like Fuentes de Peña negotiated between citizen demands for government accountability and morality and the logistics of following established law and maintaining their political power bases. The women governors understood the need to demonstrate the difference between the "mujer de la vida alegre" (prostitute) and the "mujer de la política" (female politician). Despite individuals who wished to label them as unfeminine and occasionally sexually deviant, the governors hung tightly to the mandate Balaguer established for them as conciliators. Whether attacked for their familial connections, in response to their rural policies or programs, or even because they were believed to be mentally ill or unfit to fulfill the positions, the female governors under Balaguer stood firm in their importance as local mediators and keys to the regime's policies of reconciliation and national growth.

Given the challenges the governors faced and their efforts to construct a new form of local politics, the importance of their work lies not in their individual accomplishments but in the collective success of women as politicians. In asserting their place in the arena of Balaguerista politics, a place of ambiguous gender expectations, the women governors enabled more women to bring the domestic into the political. Yet rather than merely enacting their domestic personas in public spaces, the women governors demonstrated that their roles were both more malleable than many believed and an integral part of the political process. Their influence can be seen through their constant discussions of democratic governance. The Balaguer regime would claim it was fulfilling a democratic mandate as vehemently as the opposition claimed it was undermining it. Regardless, some of the loudest voices on either side of the debate were women, and each brought distinct types of ammunition.

The all-female appointments under Balaguer were unprecedented in the way they changed local political dynamics. Despite challenges to their positions, including efforts to label them mentally unstable or engaged in the business of prostitution that harkened to Trujillo-era claims, they pushed forward to forge a new style of maternal politics. They executed their duties committed to issues of local concern without losing focus on traditionally feminine concerns. They addressed the issues that came before them cognizant of local need, and they expressed a particular expertise and confidence when approaching issues like education, adult literacy, childhood growth

and development, and maternity care. In challenges to their provincial authority, they acted upon some of the precepts of established gender codes, but at the same time defended their rights as politicians in ways that subverted previous understandings of maternal politics and went beyond the expectations of fatherly protections offered by Balaguer.

IN A 1968 REPORT TO HER COLLEAGUES at the OEF, the governor of San Cristóbal expressed the importance of the democratic leadership seminars for the newly inaugurated female officials and the participants' collective desire to apply the principles of volunteerism and development in their official duties.[67] Governor Mercedes Leger spoke for her fellow governors when she wrote, following the January "Role of the Woman in the Process of Development" seminar, that they "pledge[d] to put in place that which we have learned." Targeting pressing issues, she indicated that they were "enthusiastically concerned with the poor state of rural schools" as well as "trying to solve problems in the urban areas." Reporting to the secretary of the interior immediately following Balaguer's reelection in 1970, Leger noted that the work of the governors would continue to "follow enthusiastically and honestly in the footsteps of our beloved President Balaguer, who has given and continues to give testament to his singular ideal" of national development.[68] For officials like Leger working amidst the polarized realities of the Cold War, there were direct and crucial links between their work as local advocates, the skills gleaned through international development programs, and the regime's goals of national development.

As the "vehicles of conciliation" envisioned by the Balaguer regime, the *gobernadoras* and other female officials emphasized their link between the local and the national as the public faces of development and progress. They consistently and continually employed a discourse of democratic politics in their everyday dealings with local problems and national demands through the concept of development. One governor boasted in a report included in an OEF newsletter, "We have applied our knowledge of better democratic methods of life toward the assurance of the dignity of human life and we have demonstrated here, through tangible examples, that we are capable of the job."[69] For most of the governors, being capable of the job meant serving as advocates for local development in their provinces. Describing her upcoming agricultural initiative, the outspoken governor of La

Romana asserted that the project was "animated by the concept that man does not improve by giving but by loaning the means for others to use their own efforts to improve themselves and showing their descendants the path and system of progress."[70] Through their concern with the path and system of progress the women governors showcased their vision of Dominican development and their integral position in national growth in the postdictatorship. For themselves and their supporters, their role as mediators was crucial to the successes of the *doce años*. Their portraits adorned local and national papers as they stood in the midst of public works projects, newly instituted NGO initiatives, and charity events, and the images were of successful individuals happily making their way through a male-dominated political world. The governors personally made a point to send copies of photos to their superiors in which they were conducting meetings, delivering food and supplies, or talking with communities so as to reinforce their successes in the arena of Balaguerista politics.

In their role as participants in transnational seminars and training programs, international diplomacy, and postdictatorial image making, the women of the Balaguerato provided another essential link between the national and the global. They were the perfect foil to Balaguer's paternal and often oppressive politics as they demonstrated the nurturing and progressive policies of the regime while reminding the international community of the nation's growth and stability. In light of Cold War dictates, they helped the regime construct the fiction of representative and progressive democracy. At the same time, they constructed networks of similarly engaged women that supported and advanced their own local efforts. As a result, they built a new style of maternal politics that was at once dependent on women's local work as conciliators for Balaguer and a showcase of progressive democracy for international consumption.

The women governors saw their role as mediators in the local application of national party politics to be an essential element in the populist clientelism of the Balaguer regime, and they worked the role to their advantage. For the Balagueristas, their jobs provided a platform to practice politics as women in an extremely masculine arena. Regardless of the many challenges to their political authority, several of the governors deftly parlayed their political appointments into elected positions, demonstrating a level of prestige gained through their actions as the provincial representatives to the national government.[71] These women were aware of the politi-

cal capital gained through their work and used it to advance to different positions within the Balaguerista machine. They represent a minority of the larger pool of ex-governors, but their political education was shared by all the women who held the position. That is, they learned to negotiate the gendered clientelistic politics of the regime to benefit their local constituencies while advancing their own careers.

The female politicians and activists who served the Balaguer regime between 1966 and 1978 were much more than empty vessels into which Balaguer poured his clientelistic politics, and their active and politicized presence transformed maternal politics into a much more aggressive endeavor. Passive, resigned, and apolitical women would never have been able to effect the kinds of liaison and face work Balaguer needed in the country's rural areas. Women active in the everyday politics of the Partido Reformista were essential to the dual project of conciliation and control, and the legacy of this new form of maternalism would be evident in many subsequent efforts of women's mobilization. Still, the women who assumed the role of governor faced a deck that was stacked against them. As female politicians implementing an already suspect politics, they deftly maneuvered the very minimal space for conciliation that they were afforded. In their struggles to find a place for themselves in the politics of the Balaguer regime, the women governors established a precedent for political involvement with which women working outside the confines of official politics were forced to contend; struggles over the appropriate roles for women in politics and the maternal model would remain divisive and lasting legacies of the Balaguerato in subsequent years and in the reemergence of feminism in the Dominican Republic.

6

Sangre sin Revolución

The Gendered Politics of Opposition through the *Doce Años*

THROUGH THEIR DISCUSSIONS of democracy, development, and the "bloodless revolution," the women of the *doce años*—particularly the female governors—staked a place for themselves within the politics of the regime and its vision for the future. Their efforts paralleled the work of many women who looked to make social and political claims outside the realm of regime politics and who viewed Balaguer and the Partido Reformista as neither revolutionary nor bloodless. The running discourse of women's oppositional political activism during the Balaguer regime echoed the tone and tenor of the *balagueristas* but not their end goals. That is, while women of the opposition used the language of democracy and development, they envisioned an entirely different path of progress for their country. In drawing on an international discourse of human rights, they carried the legacy of the women of the April Revolution through to the mid-1970s. While much more limited in their arenas of public discussion, the women of the opposition continued to demonstrate how the basic human rights of individuals and families were essential to the nation's future. Unlike the party line held by the *balagueristas*, the politics of the women of the opposition took a variety of forms to address what they saw as the regime's violent, repressive, and often hypocritical stances. Some risked their lives and families' safety pointing out the regime's hypocrisies; others used solidarity, educational advancements, and openings in the press to instigate change at a broader level. Yet they all argued that the regime's tactics, what they termed "blood without revolution," violated international law, denied basic human rights, and most importantly, threatened the sanctity of the Dominican family.

Women, as during the Trujillo resistance years and the April Revolu-

tion, were key players in anti-Balaguer politics. As in their analysis of other periods, scholars have obscured or downplayed the women's work in favor of the heroification of male leaders and martyrs.[1] Nonetheless, through avenues outside more official political circles, women were active in changing the tenor of national politics through a rhetoric of maternalism, democracy, and government accountability. Women like anti-occupation activists Grey Coiscou and Magaly Pineda and opposition party militants Gladys Gutiérrez and Ivelisse Prats-Ramírez de Pérez all played central roles in the twelve-year struggle, and they were far from alone in their efforts to change the existing regime and to alter the manner of women's political engagement. Through their opposition activism non-*balaguerista* women pointed to the failures of the regime to live up to its promise of security. In demonstrating alternative models of democracy and development they began to realize the limitations of a maternal model of politics even when deployed from the left of the political spectrum. Over the course of a decade their tactics changed significantly and brought forth an altered women's politics that, while not completely discarding the forms and practices of maternalism, would concurrently embrace a nascent model of gender equity not seen since the first Dominican feminist movement of the 1920s.

Between 1966 and 1975 the Balaguer regime resorted to extreme levels of repression, and many women fought back by challenging the government's claims of security and protection for Dominican lives and families.[2] Women in the opposition formed groups like the *comités de amas de casa* (housewives committees) and the Comité de Familiares de Presos, Muertos y Desaparecidos (CFMPD, Committee of Families of the Imprisoned, Dead, and Disappeared) to demand accountability from a government that had labeled itself "democratic." Women also organized through distinct groups within opposition parties that had their roots in the 1965 civil war and U.S. occupation. They drew on an international discourse of human rights and solidarity for genuine democracy to defend against unprecedented levels of regime-sanctioned violence that struck at the sanctity of home and family. Though they often found their efforts blocked during the first half of the regime, they continued to emphasize their vision of national progress, peace, and stability and stress their concerns for a true and transparent transition to democracy.

Yet despite intense levels of repression, the *doce años* also ushered in significant changes for women in the public arena ranging from education to

job possibilities. Massive rural-to-urban migration, especially to Santo Domingo, and an ever-increasing level of foreign investment, primarily U.S., brought concepts of western modernity aggressively to Dominican homes and communities.[3] Jesse Hoffnung-Garskof shows how these economic and demographic changes were accompanied by a rhetoric of progress and modernization.[4] Educational opportunities for women expanded with the growth of private universities and the continued influence of the Universidad de Santo Domingo.[5] However, the period also brought visible increases in poverty and displacement, unemployment, and migration to the United States. With the high levels of urbanization, crime and prostitution became major problems confronting city dwellers.

Despite these changes, the legacy of violence toward women, the continued roles of women as caretaker and household manager, persistent paternal attitudes about women's place in society, and a vision of women's diminished social capacity continued to haunt female activists in the Dominican Republic. Given the contradictory and conflicted nature of these realities, many women of the opposition during the late 1960s and early 1970s began to challenge existing prejudices against women and reformulate a vision of feminine politics. Often using the university as a platform for activism, they began to demand a position of equality within the political struggle. Many of the women who utilized maternalism as a frame for their protest of human rights violations began to reformulate their understanding of widowhood and stress their skills and capabilities despite the absence of their marital partners. Parallel to these subtle shifts were gradual changes in the national approach to women's reproduction and family planning. The effort to construct a national plan for population control served as an important sounding board for feminist activism. In conceding to international development pressures, the Balaguer regime added a spark to an already engaged group of women that would result in the coalescing of a much more coherent and feminist women's activism after 1975. Most notably through the early 1970s, a new set of discussions emerged that would, for the first time since the 1920s, begin digging directly into the roots of oppression in the political, social, and civil lives of Dominican women. Like their predecessors, women in the burgeoning feminist movement sought influence and inspiration from international models of liberation yet ultimately desired a feminism that reflected the restrictions and realities of their own Dominican experience.

Protesting Unprecedented Violence

As many women of the opposition were eager to point out, the Balaguer years resembled much more "sangre sin revolución" (blood without revolution) than the promised "revolución sin sangre" (bloodless revolution). These women were not swayed by the rhetoric of development and modernization proffered by the regime, and they maintained an active voice in public discussions about national sovereignty and political progress. Many were directly connected to the constitutionalist uprising of 1965, anti-Trujillo resistance, or simply party participation outside Balaguer's Partido Reformista. Still others were galvanized by the imprisonments, murders, and disappearances of loved ones perpetrated by the regime in the late 1950s and early 1960s. Upon assuming the presidency in 1966, Joaquín Balaguer confronted a highly polarized population, torn by civil war and uneasy about the political bargains that had propelled their new president to his position. The main opposition party, the Partido Revolucionario Dominicano, faced serious political repression during and following the elections. Many of its major leaders were forced into exile or silence by Balaguer's party.[6] Similarly, members of less prominent and more radical parties like the Movimiento Popular Dominicano, the Partido Revolucionario Social Cristiano, or the Movimiento 14 de Junio faced even more intense opposition from the national government.[7] Unafraid to employ political terrorism, the regime regularly kidnapped, tortured, and assassinated political opponents. U.S. surveillance and the specter of communism blocked many groups from mounting viable campaigns against the regime. While opposition was constitutionally permitted, it was hardly tolerated and was often persecuted under the guises of anticommunism or counterterrorism.

The political repression of the early years of the Balaguer regime was an essential backdrop to women's participation in the opposition as they rallied to protest the unprecedented levels of violence. According to a report published by the Asociación Dominicana Pro Derechos Humanos (ADPDH, Dominican Association for Human Rights), between July and December 1966 there were a reported 36 assassinations, 16 disappearances, 31 injuries, 277 imprisonments, 27 beatings, and 70 search raids, all for political reasons.[8] The numbers were even greater when the entire year was tallied. Solidarity activist and ardent U.S. socialist Norman Thomas forwarded information to his U.S. colleagues passed to him by Martha Mar-

tínez, head of the ADPDH. The civil liberties violations, "practically all of them connected with the politics of the country," numbered 129 deaths, 26 missing, 168 wounded, 336 jailed, and 130 beaten.[9] Despite or perhaps because of being the victims of these abuses, the Dominican Left was unable to coalesce into a more cohesive opposition front, yet individual groups and parties continued their efforts despite repressive government measures. Women, while infrequently holding the highest leadership positions in opposition parties, were involved in mobilizing activities, often through designated women's branches or social assistance programs. Through the late 1960s and early 1970s, women participated in the efforts of their respective organizations and in women's and human rights groups that formed in response to the aggressive actions of the regime. They sought to create the social changes they felt would eventually effect a more radical revolution than the one proposed by Balaguer. Women of the opposition undertook a variety of activities to call attention to abuses of the regime while also promoting social and class-based structural change.

Following the 1966 elections the sense of disappointment among Dominicans was palpable, and women coalesced around the new regime's perceived economic and political aggressions. Not only had the U.S. presence fomented civil war and helped prop up a former Trujillo official in the presidency, but Balaguer's return to power portended even greater levels of repression and social control for members of the political Left than had been seen in the years immediately following the *ajusticiamiento*. Opposition activists credited Balaguer with the formation of a paramilitary group called La Banda in 1971 that drew in young boys to terrorize and punish dissenters. The supposedly anticommunist and antiterrorist group worked to further fracture the efforts of the opposition outside of formal state sanctions.[10] At the same time, the nation was undergoing economic crises brought on by internationally imposed austerity measures that were exacerbated by periods of civil unrest. Women as much as men were concerned with these political and economic developments and sought to express their disappointment and anger in all ways politically possible. For the first two years of the regime, the women of the Federación de Mujeres Dominicanas managed to maintain a presence in the public sphere, calling attention to the regime's lack of democratic freedoms, the remnants of authoritarianism throughout the education system, and the need for women to enter into the public discussion about the nation's future. They carried the legacy of

female engagement from the April Revolution into the Balaguer years and formed the nucleus of women's activism for the remainder of the regime.

Maintaining the focus on issues of traditional women's concerns, the FMD looked to support other groups that centered on democracy and the Dominican family. Protesting the massive layoffs at the Central Romana sugar company in La Romana, the mothers, wives, and daughters of the aggrieved workers staged a march and were led in their efforts by the FMD. Called "Red La Romana" by members of Balaguer's reform party, the area was known for its leftist tendencies. According to police reports, the march was planned by "Communist collectives" that intended to "use women and children to obscure their Machiavellian plans, looking to sacrifice one or several of them in order to have a motive they can use to raise public opinion against our government."[11] Like U.S. officials, the Balaguer regime viewed the FMD as a communist front, yet in reality its efforts focused much more narrowly on the needs of the women of the opposition. While its activists certainly used women and children to raise public opinion, they argued more conservatively that the central focus of government policy should be the establishment of democratic freedoms to ensure the sanctity of the national home and family.

Women of the Left across multiple opposition parties continued their activism through their respective women's branches after the FMD dissolved in 1968 due to internecine struggles. Eulalia Flores, the secretary-general of women's issues for the PRSC, declared that women had no choice but to remain political. In a newspaper article Flores contended that in the "current heartbreaking situation being experienced by the country," Dominican women had no alternative but to "organize ourselves to create a political force capable of demanding our rights as human beings."[12] She insisted not only that the nation needed women to create change in the "old order under which the Dominican Republic was dying" but that the PRSC was the only party capable of realizing change in the social structure. In a thinly veiled reference to Trujillo-style politics, PRSC leaders insisted that while other politicians had used women for their own base interests, their organization genuinely sought to foster independent and engaged female citizens. Still, like that of their male counterparts, women's activism encountered intense resistance from the government.

Women organizing in the opposition were a clear threat to the Balaguer regime. In a memorandum from the National Police dated April 1, 1967, five

women were accused of organizing meetings "of a leftist nature" in a local salon in the border province of Monte Cristi. No less, the five were teachers in a local elementary school who, according to the chief of police, dedicated more time to their meetings than to their teaching.[13] Similarly the National Police reported immediately to the administration upon intercepting letters relative to an early spring national convention of women of the Rama Femenina of the PRD discussing the "persecutions, imprisonments, and deaths PRD members and other democratic and constitutional fighters are suffering."[14] As evidence of the regime's careful monitoring of opposition, the letter was sent straight up the administrative chain to Balaguer. Knowing the danger of open violence against women and children and attentive to their own reputation as defenders of the Dominican family, agents of the regime carefully monitored women's groups and sought to prevent the organizations' successes in less violent ways than enacted in the last years of the Trujillato. Despite efforts to paint some of the women's work as communist, the government's inability to fully shut down activism among women allowed a number of fledgling groups focused on human rights and basic needs to survive the repression of the Balaguerato.

In some urban areas, particularly around Santo Domingo, organized resistance formed through groups of "amas de casas" (housewives) to protest the repression against unions and the elevated costs of basic foodstuffs. The efforts of these housewives groups presented a serious concern for Balaguer. When a *comité de amas de casas* planned an event in August 1972 in Santiago, local officials quickly alerted their superiors. Enrique Pérez y Pérez, major general of the military, forwarded the plans directly to the president.[15] According to his reports from Governor Lilia Balcácer de Estrella of Santiago, the groups planning the event there and at "other locations in the interior" were not actually seeking a reduction in prices or an augmentation of salaries but really the creation of "an atmosphere of restlessness and anxiety among Dominican families making it difficult to realize the reelection of His Excellency."[16] The governor added to her missive that the situation was potentially explosive and even revolutionary. Looking to make her report as threatening as possible, she added that rumors were circulating that the event was being organized by Gladys Gutiérrez de Segarra, who had confirmed the death of her husband, activist Henry Segarra Santos, in the prison where he had been held for political opposition. Gutiérrez was by now well known for her active organizing against

the regime's human rights abuses. A former member of the FMD and an active opposition fighter, Gutiérrez sought to add her voice to the group's concerns about government protections and familial necessities and help present the event as a clear challenge to the regime. In many ways, regime officials were not far from the mark in their assessment of the housewives collective. While the members were certainly concerned about household economic issues, their larger efforts were aimed at pointing out the real danger the regime posed to the stability of the nation's families.

The groups of *amas de casas* used the rhetoric of motherhood and family protection to draw attention to the failings of the Balaguer regime.[17] Like similar groups in Chile,[18] the Dominican women's collectives protested the nation's economic problems through the maternal discourse of their roles as familial caretakers. A report presented at the 1975 International Women's Year capstone Seminario Hermanas Mirabal (Mirabal Sisters Seminar) maintains that the groups began in 1971 in the marginal barrios around Santo Domingo "as a tool to gather forces in order to combat the skyrocketing price of staple goods."[19] The high prices and scarcities of the period galvanized women to group together and, according to some scholars, stay together. Moema Viezzer explains that the groups operated for nearly five years, "concentrating their activities in the struggle against scarcities, against the pessimistic conditions of sustenance and education, and against the insecurities of life due to the lack of work."[20] While these groups of women met with mixed success and were not organized solely around issues of maternal concern, their work demonstrates their collective allegiance to issues intimately tied to their roles as mothers and caretakers and the effectiveness of their maternal rhetoric in drawing the attention of the regime.[21] In a similar vein, many women during the first decade of the *doce años* called out the regime's hypocrisy in claiming stability while aggressively targeting political dissidents, and they demanded that Balaguer attend to the palpable destruction of the nation's families.

Widows Organize for Human Rights

Amid the austerity campaigns of the Balaguer regime and the tightening of social control across the nation in the late 1960s, Gladys Gutiérrez chose to confront the regime's abuses head on. Gutiérrez publicly called attention to the July 1969 disappearance of her husband, Henry Segarra Santos,

and organized a group of women to protest the regime's violations of the Dominican home and family. Segarra Santos, leader of the MPD, had gone missing during an educational campaign in Dajabón along the nation's western border. Mobilized by the disappearance and ultimately the murder of her husband while in police custody, Gutiérrez created the Comité de Familiares de Muertos, Presos y Desaparecidos and formed alliances with other human rights groups and opposition parties.[22] By drawing very public and international attention to the regime's denial of rights and devaluation of the Dominican family, Gutiérrez and the organization drew on the power of transnational organizing and solidarity as well as the strength of maternalist rhetoric to help destabilize the Balaguer regime. However, in mobilizing widows in particular, she and fellow committee members also challenged long-standing ideas about single, independent women and their ability to contribute politically while unmoored from the traditional spousal pairing, ultimately serving as a crucial rallying point for female activists.

Gutiérrez began the search for her missing husband through official channels but found the Balaguer regime resistant to any real clarification of his whereabouts. After being given the runaround by various officials, most often with the denial that the man had even been taken into custody, a series of writings on a prison wall were attributed to Segarra Santos. Upon inspection, Gutiérrez declared them to be unequivocally of her husband's hand. The secretary of the presidency offered Gutiérrez a meeting, but she refused the offer claiming to only want to speak with Balaguer directly. She held him wholly responsible for her husband's disappearance and began to organize other women to demand a genuine investigation into her husband's case. In an interview with journalist Ruth Herrera many years later, Gutiérrez recalled her words to Balaguer when he finally conceded her an interview. After the president denied all knowledge of her husband's disappearance, Gutiérrez declared that "starting today, after I pass through that door, you can order me to be detained, disappeared or killed, because I will become the number one enemy of your government. I will be the constant informer of the violation of human rights."[23]

Gladys Gutiérrez complied with her promise and began organizing against the unabated human rights abuses of the regime. Along the way, she gathered many supporters who, like her, were searching for any information about their disappeared loved ones. By the end of September 1969 Gutiérrez had rallied the assistance of the ADPDH and director Martha Martínez and

planned a silent protest of hundreds of Dominican women. Herrera notes that co-organizers included Emma Tavárez Justo, sister of anti-Trujillo activist Manolo Tavárez, and opposition militants and April revolutionaries Consuelo Despradel and Lourdes Contreras.[24] The march was planned for September 23, 1969, coinciding with the opening day of meetings of Latin American finance ministers and bank presidents in Santo Domingo.[25] In addition to significant international contacts, the organizers counted on their deep allegiances within the opposition and the silent and self-sacrificing nature of the protest and its purportedly nonpolitical approach.

In recruiting participants, Gutiérrez and her supporters claimed to have no political aims save the single goal of ending government-sponsored disappearances of male dissidents, a problem they said posed a threat to all Dominican women and families. They published photos and names of the missing activists in various newspapers; the list in the press reached 369 individuals for the years 1966 to 1969.[26] Gutiérrez' call for support, she declared, was "an appeal to all Dominican women to join me in my pain and in my desperation, as one day that pain may be theirs."[27] Co-organizer Martínez declared to the press that women joined their effort because they knew the potential risk applied to anyone: "'We know from experience that people who vanish or are killed for political reasons lead to others ending up the same way,' she said. 'You can't make exceptions of any kind when human rights are concerned.'"[28] Gutiérrez requested that the event not be exploited for political purposes. And while she clearly intended that to mean it would be nonpartisan, it certainly did not indicate that Balaguer and his Partido Reformista should not be made responsible for the acts being committed under his watch. That is, while perhaps not wanting to claim a relation with any particular oppositional party, the march was a rejection of the one in power and an indictment of its lack of protections for Dominican families.

The march began in the early afternoon near the entrance to the colonial city. Parque Independencia, the burial place of the country's founding fathers, served as the focal point; at the appointed time women spontaneously emerged from stores along El Conde, the street that led from the park to the river and the colonial city's end. The women formed *micro-mítines* (microrallies), and the march was held in silence. The police responded swiftly and aggressively. In the only warning, a policeman was reported saying, "I want you to obey me, as we do not want to run down women."[29] Immediately tear gas bombs, which the police claimed were "especially

made for women," were thrown. They arrested more than fifty individuals, including twenty-two women. The women and minors were released that same day, but the men were kept to face the judicial system. Attempting to maintain its professed paternal protections—from not wanting to trample women to fabricating supposedly female-specific tear gas—the Balaguer regime sought to ensure that the march had as little impact as possible but that the women and children participants were shielded from the more directly aggressive tactics of the state.

Event organizers were disappointed albeit not surprised with the police response but generally buoyed by the show of female solidarity around human rights. Organizer, fellow activist, and head of ADPDH Martha Martínez declared that the demonstration was a testament to "the solidarity of women in the struggle for a fundamental right: the right to life."[30] Gutiérrez continued to pressure the government for a full investigation into her husband's case while at the same time began to organize women in situations similar to her own. Despite Balaguer's promise that the investigation into Segarra Santos' death was ongoing, Gutiérrez knew that her options for real change lay outside the bounds of official government action and, for that matter, formally defined politics. She made clear her lack of faith in state political structures and her public disapproval of Balaguer's failure to protect the family in an open letter: "The truth is you have to be very lazy and insensitive to persist in maintaining the anxiety and worry of so many mothers, sisters, girlfriends and wives who have witnessed their loved ones be disappeared, tortured, imprisoned, and even killed."[31] In calling the president lazy, insensitive, and callous to the pain of women, Gutiérrez struck at the heart of Balaguer's promise to bring peace to the nation's mothers, and with such words she drew significant support for the cause of human rights. Her efforts coalesced in the formation of the Comité de Familiares de Muertos, Presos y Desaparecidos, which would make as public as possible the repressive realities of the regime and their effects on their lives.

Due to their lack of faith in the reigning party or prospects for it changing as well as the horrors of the disappearance of loved ones, the CFMPD continued its work into the 1970s. By claiming a connection between maternalism and politics, the women were able to make bold statements that were far more dangerous when made from other platforms. In making demands on the state from their positions as grieving wives, mothers, sisters, and daughters of the persecuted, they could be more forceful about the im-

perative for governmental change from outside the formal political sphere precisely because they drew on Balaguer's promises to women of peace and stability. While men attending the first demonstration were deemed to have acted politically and were kept in jail for their actions, all the women were released, presumably as nonpolitical activists despite their known role in organizing the event. At the same time, the women of the committee began transforming the public image of the widow by becoming highly vocal and political rather than receding into mourning. In making their grief a public concern they entered into the national debate about government, accountability, and the purported democracy professed by Balaguer.

The work of the CFMPD centered on the most grievous cases of familial destruction and utilized international opinion to aid their cause. In a 1971 publication of the Latin American Working Group, Canadian exchange student Margaret Graham reported that the group operating in the capital that year focused most of its energies on imprisoned activists in Graham's estimation because of the international regulations on and assistance for human rights.[32] Graham stated that although every attempt was made by the regime to kill opposition leaders before they reached prison, many ended up in the nation's most notorious detention centers. The women of the CFMPD worked to keep those who survived and went into the prison system in good health. The widow Carmen Mazarra reported that work entailed entire families.[33] The women faced a difficult task given the dismal conditions of the prisons, although their best chances lay in the alliances they might forge with international human rights groups and the threat of bad press for the regime. According to Graham, political dissidents were sent to either La Victoria prison or the military prison within the capital. While conditions in La Victoria were slightly more humane, both institutions offered miserable food, poor ventilation, and clear violations of human rights. Committee members brought money and food to relatives as well as information about loved ones and the current political situation. In some cases they were able to take photos to relay information to human rights groups. While serving as a lifeline for prisoners, they also proved a link between persecuted party members, the Dominican public, and an international audience.

An open letter of protest from twenty Dominican women included in Graham's report attests to these regional and international linkages that the women were making to call attention to the plight of the opposition in the

Dominican Republic during the Balaguer regime. They wrote to report "a violation of human rights and the most elemental norms of law that ha[s] been consistently carried out and supported by the police and judicial authorities."[34] Perpetrated by the regime against their loved ones, all male, the violations they reported were meant "to give evidence of the magnitude of the outrages against what the XX Century demands of democracy in the name of Justice." Their loved ones, they reported, would irrevocably lose their freedom "unless this protest finds sufficient response to stop the evil intention of those who have the future of these persons in their hands." In narrating the events of their relatives' disappearances as well as the rights guaranteed by the Constitution, members demanded attention to justice, democracy, and human rights at the domestic and international levels.

The seven-page letter, placed by the Dominican women "before world public opinion," carefully narrated the social, political, and juridical details of their relatives' cases. Having been arrested for meeting to discuss "the national political situation," six members of the MPD were then detained without charges at the National Police headquarters in putrid cells in a building never meant to serve as a prison. As of the September letter, the men had been held for eight months without formal charges or arrests. In detailing the many constitutional and international abuses committed by the regime in this case, the women writers made clear their knowledge of both the justice system and the political revenge and repression of the regime. As they argued in their careful dissection of the situation, their loved ones had committed no crimes and, even if they had, they had not been judged fairly under the principles of law and justice. They called the arrests and subsequent violations "the product of a shameful revenge, due to the fact that our relatives are in known opposition to the existing regime."

Most importantly, the women called on the solidarity of the world community and the struggles of those like them in the Dominican Republic to help solve this humanitarian crisis. They wrote that their fears were "justified by the confidences that have filtered through the bars of the Police Palace and by the prophetic words of distant relatives about the peculiar treatment that has been applied to them in prison." They pleaded for an international spotlight to be turned on the Balaguer regime "so that the barbarous insensitivity of those murderers be publicly condemned by the true defenders of justice and human brotherhood in all places. Also, so that the organizations and persons to whom we appeal in our cry for sup-

port demand that the Dominican Government grant unconditional freedom to our relatives who have committed no crime."[35] In the midst of their struggles, the committee members also made a direct plea to the UN Commission on Human Rights when they asked in a press release to the Santo Domingo paper *El Nacional* for "an energetic effort to contain terrorism" in the Dominican Republic.[36] They called on the transnational alliances, also a tactic of the women of the right, to conversely bring unfavorable international attention and opinion to the reigning leadership. Each plea cast doubt on the claims made by Balaguer that his government was working to create a stable and democratic transition out of authoritarianism.

The work of the CFMPD and similar collectives during the late 1960s and early 1970s made notable and significant attacks on Balaguer's claims of peace and progress. While the regime continued its repressive tactics, the international pressure applied as a result of the women's vocality made a distinct impression on Balaguer, as he was deeply concerned about world opinion. Moreover, their pleas did reach U.S. ears, which made the inconsistencies of U.S. military and intelligence support to the Dominican government more visible. Like the women of the Trujillo resistance movement, they argued that the regime was much more about the bloody business of familial destruction than it was about bringing peace to Dominican mothers. The women of the committee became key actors in a dangerous public debate about who would define the true nature of the national government as they served as mediators between the regime, the country's persecuted opposition, and international opinion. Finally, seen particularly through the perspective of "las viudas" (the widows), the women of the committee initiated some changes in the social perceptions of widows.[37] Mirna Santos, the widow of the murdered MPD activist Amín Abel Hasbún, asserted that she continued living her life—as a political participant and later again as a wife—because she discounted the social standard that "the widow has no right to rebuild her life."[38] Friend and fellow widow Carmen Mazarra indicated to journalist Herrera that it was in fact her husband, Maximiliano Gómez, who shortly before his own death had written to Santos to say that "the only healthy criteria for respecting the fallen husband or wife is to be faithful to the memory of their ideals and to be prepared to fight against the prejudices of those who see widowhood" as their "singular occupation."[39] Mazarra would also support the sentiment as she maintained her activist activities long past the death of her husband. While the gender relations of the

Dominican Left were far from equalized, the activities of widows and family members of the persecuted helped bring attention to the human rights abuses of the regime through its own discourse and bolstered the perceived strength of women in the opposition, whether married, single, or widowed.

Journalism for Government Accountability

Gladys Gutiérrez and the CFMPD were not alone in their appeals to the government, and the women who joined in various campaigns against the regime found alternative models to protest the lack of political openness. Many women, as became clear in the strength of the committee, were directly affected and enraged by the government's overtly terrorist tactics to eliminate political opposition. For a small cohort of activists, the left-leaning publications of Santo Domingo provided another public arena for political dissent. The journalistic efforts of a number of prominent political activists and former revolutionaries were risky and unconventional. Initially they proffered an only mildly confrontational approach through their focus on motherhood, family, and stability, but their approach became more radical through the early 1970s. Their work was also facilitated by significant advancements of women in education. Amid the tightening of social controls by the Balaguer administration, changing conditions within educational and professional arenas allowed for an increased mobilization among middle- and upper-class women. The movement toward university and professional education for women had begun at the end of the Trujillato and the years that followed but 1966 marked a sharp increase in the enrollment of women at the university level. Slowly but steadily women joined the ranks in careers in medicine, law, politics, and social sciences. The numbers of female teachers increased, and education for women and girls at all levels came closer to equilibrium with that of their male counterparts. These changes propelled women into much more visible places in Dominican society, particularly in the areas of teaching and journalism, and positioned many to make demands on the government and the public at large that would be central to the beginning of the women's movement.

One of the most prominent female journalists and university educators was Ivelisse Prats-Ramírez de Pérez. A professor of education at the Universidad Autónoma de Santo Domingo, she used her standing as a political activist and PRD member to testify to the suffering of mothers and fami-

lies under the Balaguerato. Between 1974 and 1978 she wrote weekly in the newspaper *La Noticia,* often calling attention to the plight of the politically persecuted and exposing the abuses of Balaguer's Partido Reformista.[40] Despite membership in the PRD she avowed her solidarity with the opposition at large, particularly its women. Prats-Ramírez de Pérez made regular reference to the women of the MPD whose husbands and brothers were being imprisoned, disappeared, and killed by regime officials at alarming rates. While she discussed the principles of her own party, particularly in reference to education policy, she was concerned with many issues of interest to Dominican women.

Like the women widowed by the regime, Prats-Ramírez de Pérez sought to demonstrate Balaguer's hypocrisy in claiming peace for troubled mothers. She gave names and faces to the female victims of the regime's terrorism and attended to the maternal pain of these women, but she also discussed the social and gender inequalities of Dominican society more broadly. She was constantly naming the women made widows by the regime's repression and pointing out the atrocities committed against the Dominican family writ large. When she made reference to the death of friend and journalism colleague Orlando Martínez, she focused on the suffering it had caused others; when she discussed the unjust imprisonment of activist Plinio Matos Moquete, she centered on the continual sacrifices made by his mother, Rita. The suffering of these women, Prats-Ramírez de Pérez conveyed to her readers, was the suffering of all Dominican women, who were "at their side, suffering and loving and struggling, and willing to continue beside them," as much as it was also the wound of the Dominican nation.[41] She called on all Dominicans to add their voices to their demands for justice and confrontation of the "brute force" of the regime. She continued to believe, as she wrote in 1976, that Dominican women had the strength to keep fighting for justice.[42]

Prats-Ramírez de Pérez also focused on issues of broader social concern and gave a public voice to the women of the opposition who were not widows. In discussing Women's Day and the upcoming International Women's Year, Prats-Ramírez de Pérez reminded her readers that such recognition was necessary because the group they commemorated were the marginalized, like many other groups in the country's social structure of the time. She argued that while a day focused on women brought forth important discussion, it was ultimately the "ideological superstructure" that needed

fixing. In her writings Prats-Ramírez de Pérez struck at the heart of concerns of women of the Dominican Left who demanded, at least rhetorically, some of the paternal protections promised by Balaguer yet also fought for social equality and revolutionary change for Dominican society despite growing frustration at the lack of transformation in their status as equal partners in that struggle.

Ultimately, Prats-Ramírez de Pérez rejected the Balaguerato's claims of paternal protection. Responding to the regime's rhetoric about widespread female support of the president's leadership style and position as "the candidate of peace," Prats-Ramírez de Pérez questioned her own authenticity as a Dominican woman.[43] She opened her article "¿No eran reformistas?" with a description of the masses of poor women arriving at the gates of the National Palace to receive gifts on Mother's Day, as they did every year, wondering aloud if not lying prostrate to Balaguer and his party somehow made her less of a woman. Her answer, she declared, lay in the September 1969 demonstration led by Gutiérrez protesting the continued human rights abuses of the Balaguer regime.[44] The march, carried out by hundreds of women despite the threat of violence and repression by the government, demanded international attention to the violations of human rights occurring regularly in the Dominican Republic and displayed the nation's women as ideologically diverse and courageous. Accordingly, Prats-Ramírez de Pérez declared, "Dominican women are not all Reformistas or Balagueristas, thanks to God, to Lenin, to Mao, or to the manifesto."[45] Despite the regime's attempts to depict the Dominican woman as its most loyal followers, Prats-Ramírez de Pérez asserted that many women followed alternate, even radical political ideologies.

The availability of multiple paths of political mobilization for Dominican women was fueled by the continually increasing availability of education to middle- and upper-class students. In her investigation into women's education in the Dominican Republic, writer and feminist Ángela Hernández has reported that female enrollment at the university level increased from 6 percent in 1936 to 25 percent in 1960. The increase between 1960 and 1977 was even more significant, bringing women to a nearly equal 43 percent enrollment at the university level.[46] According to Ligia Amada Melo de Cardona, a university and secondary-level science instructor and an expert in pedagogy, the increase in female enrollment had multiple causes.[47] She attributes it to the general increase in women's enrollment in middle and

secondary education, an awakened interest in education among women, changes at the state university leading to expanded career choices, greater access to enrollment, and more widely dispersed extension schools. Melo de Cardona points out that a major factor in the changing demographics in higher education was the university reform movement, or Movimiento Renovador.[48] Although Trujillo himself had changed the name of the national university to the Autonomous University of Santo Domingo (formerly University of Santo Domingo) during the regime, it was not until after his assassination and a massive student uprising that the government granted genuine independence to the state university.[49] The University Autonomy Law granted full administration of the institution to a rector and University Council—comprised of elected faculty and student members—rather than control by the national government.[50] Although structural changes written into the law were slow to take effect, the transformation would further propel the institution into its role as a center for youth resistance.

Student and faculty activism at the Universidad Autónoma de Santo Domingo (UASD) played a major part in political resistance during the Balaguer years, and women were no small percentage of that transformative population. Beginning in the late Trujillato, the Ciudad Universitaria had served as a focal point for youth activism.[51] As evidenced by the activities of women like Minerva Mirabal, Josefina Padilla, and Piky Lora, the relative independence, camaraderie, and intellectual stimulation provided by their university years encouraged their entrance into high-stakes political activism.[52] The end of the dictatorship and the reform movement further made the university a hotbed of political activity, as seen in the activities surrounding the April Revolution. As the country entered the *doce años*, the UASD would become increasingly important as a center of anti-Balaguer politics, propelled by the activism of a highly politicized youth.[53] Ángela Hernández asserts that for years "the centers of gravity for leftist organizing were the university and public schools."[54] The Dominican scholar Clara Báez argues that the changes in women's education and university involvement were not insignificant to the larger social and political context. Since the 1960s, she contends, education helped create "a social movement of women who are breaking with traditional behaviors that confined them to the domestic sphere, demanding a voice and participation in public life on equal terms with men, and threatening to disrupt

the old hierarchical structure in all aspects of social life, specifically in a work world that discriminates."[55] Hernández maintains that the enrollment of hundreds of women in the university and their getting degrees "must have positively influenced their self-perception as subordinate beings."[56] Developing a more positive self-image, however, highlighted the increasing incompatibility of women's advancements and a persistent paternal model of public and private life.

In a series of articles profiling working women during the mid-1960s, several Dominican journalists documented the realities for select members of the female labor force and highlighted some of the rising contradictions among women who had been educated and entered the working world and yet still were expected to uphold and defend their sacred maternal roles. Their conclusions are telling of the somewhat conflicted opinions of women workers yet at the same time a testament to the increasing number of wives and mothers who participated in the working world at a variety of levels. Their questions often illuminated not only what women thought of working but also their opinions on gender equity, the women's movement, and Dominican politics. The articles ranged from individual profiles to group interviews and appeared in the magazines *¡Ahora!* and *¿Que? Revista del Pueblo*, both of which represented the Left in Dominican politics. By the mid-1970s similar columns appeared in the more mainstream *Listín Diario* and indicated a continued conflict between a growing independent female workforce and the demands of Dominican motherhood and family.

For the article entitled simply "Working Women," journalist Amelia de Beevers interviewed a group of female employees at the Royal Bank of Canada in Santo Domingo.[57] After a brief commentary on the strength of Dominican women, de Beevers proceeded with a series of questions targeted at the workers while on their break. The inquiries ranged from women's aspirations to the state of Dominican politics to the compatibility of work and family. At the outset, de Beevers portrayed a group of women in support of women's total independence "because she has demonstrated herself capable of resolving life's problems with the same efficiency and even more responsibility than any man." However, the article also demonstrated that the employees' positions were much more conflicted. Initially, when asked about the dreams and aspirations of "today's woman," the employees responded that they looked forward to total social and political freedom for all women and could envision a woman as president. When questioned about

the compatibility of women's work and home duties, however, interviewees supported the idea of a salary "Plus Familiar" supplement for male heads of household, allowing most women with families to concentrate on the home, thus opening spaces for other male workers and single women in the workplace. This sentiment is expressed in an individual interview conducted by de Beevers' colleague Mary Collins and published in the same paper several months prior.[58] The subject of the article also titled "Working Women," Sonia Altagracia Peralta, was a single woman working as the head of the children's department in a Santo Domingo department store. Although she asserted that she enjoyed the challenges of her work, she planned to continue once married only if her husband and child needed her to. According to Peralta, "Women are made to be the queen of the home."

In contrast to the women working in banks and department stores, an interview with a university-trained lawyer offered Dominican audiences an alternate perspective on women in the working world. In Mary Collins' interview of Concepción Navarrete de Ortíz, the headline asserted that women's work was "compatible with happiness in the home."[59] Navarrete de Ortíz indicated that she was not "exercising her profession" but discussed her job as a teacher at the secondary level. Describing her daily routine, Navarrete de Ortíz expressed her love of caring for her household yet claimed that with enough dedication and organization, a working life was a possible path for all women with children. Still, the young lawyer and teacher was not free of the conflicts expressed by the female bank workers. She, too, indicated that although men liked women who aspired to professional careers, there was always an element among women to want complementarity and a level of protection in their relationships with men.

The women profiled in these articles provide a window into the lives of working women of the Dominican Republic during the Balaguerato. Although conflicted about women's spaces at work and at home, they had clear ideas about politics and express an investment in the political direction of the Dominican nation. A number of new female voices began to filter into national media, including some that questioned the entrenched gender hierarchy of society on all points of the political spectrum.[60] Still, the notion of Dominican women as queens of their households remained entrenched even among women who saw opportunities outside the domestic sphere. In a 1975 *Listín Diario* article likewise titled "Working Women" journalist Susana Morillo affirmed the tension between work and family:

"This is not the first time we have commented on all that housewives can do without needing to abandon their home."[61] Evidenced across multiple media platforms, the attention to women workers demonstrates advancements in various arenas within the labor force, all the while making clear the ongoing challenges—both logistical and ideological—that the dual labors of work and home imposed on Dominican women. As a result, many more vocal opposition activists like Prats-Ramírez de Pérez continued to confront the regime's violations of human rights from a maternal perspective but also to question what all these advancements meant if they were not accompanied by increasing gender equality. By the early 1970s such questions began to coalesce into an embryonic feminist movement.

Constructing a Feminist Consensus

Among the women of the Left who had been involved in the revolutionary movements of the late 1960s, the turn of the decade brought new internal pressures for a change in women's politics as well as, activist Magaly Pineda argued, external influences on attitudes and ideas about the need for a more feminist approach to social inequalities. The creation of groups like the CFMPD and the *comités de amas de casa* helped solidify the strength of women organized together. However, their goals directly targeted only regime change and not larger political transformation. Moreover, while more women were entering into the workforce and the public forum, clear tensions existed regarding women's roles in the public arena and the home. Finally, as sociologist Cornelia Butler Flora argues, while Dominican women during the Balaguer regime "fought the government side by side with their male leftist comrades," many female activists still saw themselves on the margins of social change.[62] Realizing many of these inconsistencies, by the late 1960s and early 1970s a number of women began to shift organizing practices toward more feminist focused goals.

With the demise of the FMD in 1968, Dominican women's activists sought out new avenues to demonstrate their political concerns and shifted toward a more explicitly feminist agenda.[63] The Primer Congreso Revolucionario de Mujeres (First Revolutionary Women's Congress), in August 1968, led to the formation of two distinct women's organizations. The first was the Liga Revolucionario por la Emancipación de la Mujer (LIREMU, Revolutionary League for the Emancipation of Women) while the second

was the Grupo Participación Social de la Mujer (Women's Social Participation Group).[64] LIREMU maintained a strictly Marxist stance, focusing on class revolution above all else. Its members argued that their work contributed to the liberation of the people as a whole while taking the particular oppression of women as a starting point; they called their approach "revolutionary socialism."[65] Conversely, the Grupo Participación Social de la Mujer focused less on strictly class-based concerns and began to expand into different areas of feminist theory. Among its leaders were a number of former revolutionaries like Magaly Pineda as well as younger scholars like Vivian Mota and Martha Olga Garcia. Graham discussed the group's activities in her 1971 report; according to her assessment, the group's overall goal was to study the Dominican woman "in terms of her beliefs and attitudes, her lifestyle, her economic situation, her role in the village and countryside as well as in urban centres."[66] Graham indicated that related projects included the creation of a center of documentation, the study of sexual relations in the Dominican Republic, and networking with movements of women's liberation in other countries.

Other cohorts of women as well began pushing agendas that focused more narrowly on concerns for women, and the problem of reproductive health became a focus of efforts during the early 1970s. Organized in 1966, the Asociación Dominicana Pro-Bienestar de la Familia (Dominican Association for the Well-Being of the Family), known as Profamilia, was a collective that aimed "to promote and educate individuals about the importance of family planning, to create access to contraception, especially among women and men in marginalized urban slums and rural areas, and to raise awareness across the country of the close relationship between population growth and development."[67] The group began its work in two clinics in 1968 in an effort to promote family planning, education, and contraception access, and it supported the government's creation of the Consejo Nacional de Población y Familia (CONAPOFA, National Council of Population and Family).[68] The coordinated efforts of Profamilia and CONAPOFA over the next decade contributed to significant openings for debate and discussion on the role of women, reproduction, and national development both in and out of formal political structures.

CONAPOFA was established by presidential decree in February 1968 with the objective of the "study, investigation, analysis and dissemination of materials relative to the growth, mobility and future of the country's

population."⁶⁹ Through the 1970s it set up clinics in hospitals around the country and expanded its work to community education, family planning rights advocacy, and birth control distribution despite serious opposition from the Catholic Church.⁷⁰ Although they disagreed with the Balaguer regime as a whole, women within opposition parties began to see advantages in coordinating on reproductive issues with women's rights advocates in Partido Reformista circles, as such efforts were beginning to bear more concrete advances. For example, in compiling a report on family planning for the 1975 International Women's Year, Subsecretary of Health Fidelina Thorman de Aguilar called on the assistance of UASD professor and specialist in family law Martha Olga García to compile legislative information relative to women's rights. The final report, a product of collaboration across party lines, would ultimately influence directly the constitutional changes brought about in 1978.

In 1973 the UN Commission on the Status of Women organized a seminar for member states in the Western Hemisphere on the issue of family planning. Similar events were planned for Asia and the Middle East. The event was held in Santo Domingo in May 1973 with attendees representing twenty-three nations. Present also were more than a dozen Dominican representatives of various political affiliations. Included among them was Balaguerista Licelott Marte de Barrios as president of the seminar's executive committee.⁷¹ However, also notable were PRD activist Ivelisse Prats-Ramírez de Pérez and avowed anti-Balagueristas Vivian Mota and Altagracia (Grey) Coiscou Guzmán. In fact, the report submitted on behalf of the Dominican Republic relative to the state of gender and family planning was authored by noted opponents of the regime as well as known collaborators. The interconnected topics of overpopulation, reproduction, and national development proved a space of common ground among women across the political spectrum that would serve as a foundation for discussions of legislative change in the late 1970s. Reflecting on the conference several years later, Mota noted that "family planning programs could be great allies for women in their struggles for vindication."⁷² Still, finding common ground across the political field and beginning the discussion about women's reproduction was only part of how the arena of women's political engagement shifted in the early 1970s.

A collection of writings from the early part of the decade demonstrates the varied yet slowly transforming opinions of women relative to the sit-

uation of the feminine movement in the Dominican Republic toward a more radical feminist stance.[73] Save for a few of the interviewees in one series published by ¿Que? La Revista del Pueblo in 1971–1972, the phrase "women's liberation" was seen as synonymous with Yankee imperialism and yet another exported and imposed ideology divorced from Dominican reality. While all respondents indicated their support for women's advancement and equality in society, many argued for the primacy of revolutionary change and class struggle. LIREMU had perhaps the most scathing critique of the North American feminist movement as it was presented in the Dominican press: "We reject and condemn, as an attempt to vulgarize and make deviant, theories and 'feminist' practices that seek to make a fight against the male sex an objective of the women's movement."[74] Another activist chastised Dominican women who focused on the rights to have or not have children, the right to orgasm, or the passage of one or another laws in their favor while under the "reactionary and traitorous government over which Balaguer presides."[75] However, the very presence of a debate over feminism indicated a subtle shift in their responses toward a more active engagement of gender concerns within the larger struggle. That is, while perhaps earlier it was assumed that restructuring the social and political landscape would automatically eliminate class and gender discrimination, Dominican women of the Left began to realize that they would need to push concurrently for the people's liberation and for their rights as women.

The Dominican press of the Left generally associated the women's movement in the United States with licentiousness and other First World problems, and a number of women used it to decry women's liberation wholesale, but the opening of the debate over gender equality forged a slow path toward a more indigenous construction of feminism. Narrowly viewed, a feminist movement pursued by those seen as radical white women seeking the right to not have children, freedom from marriage, the right to free love and sexual liberation, and legalization of abortion was rejected by Dominican women who sought a more autochthonous vision of women's liberation. While a few of the more radical Dominican women flatly rejected the idea of women's liberation or saw it as a product of the aristocracy, most sought to redirect the debate toward a joint struggle for gender and class change, redefine feminism according to their own visions of emancipation, and integrate women's advancement into the larger movement for social reform.[76] Focusing singularly on women's liberation was akin to placing

it on the margins of the struggle for revolutionary change, a mistake that would only serve to handicap both movements. Instead, the emancipation of the people through radical social, political, and specifically economic change and the return to popular democracy would bring about women's emancipation. Many pointed out that women gaining a level of control over the means of production—a goal for the nation at large—would be a way to decrease the alienation and marginalization of women. Nearly all underscored the need to look at women's liberation from a perspective of the underdeveloped rather than through the feminist dictates of the United States and Europe.[77] Such western understandings, they argued, served merely to distract women from their own distinct double oppression.

Under this locally focused model, rejecting western-style feminism did not indicate a rejection of the rights of women or a struggle for equal gender rights as part of the larger battle to end the Balaguerato. While several deplored what they saw as Balaguer's blatant use of women as pawns to prop up his regime, most still believed that women belonged in politics, the professional world, and high-level leadership posts, as they conveyed their thoughts in a 1975 study of feminism in the Dominican Republic.[78] Female professors at the UASD were especially emphatic about the need for women to become more active in the political and labor arenas, and their students often followed their leads. Professor Ana Sylvia Reynoso argued that "only the entry of women into the world of production equal to men and their resulting financial independence" would bring about liberation. A woman's obligation, according to university employee Elsa Peña, was to "involve herself actively in the general struggle of the people." Student Mirna de Peña contended that "the integration of women into political life is essential for the victorious development of the revolution." A generation of young female students entering the university in the mid-1970s saw an even more radical perspective on the women's liberation movement, perhaps due to their relative removal from the struggles of the 1960s. They argued that women played an important role in society and should not "be subject to what a man says just because he is a man." At twenty and twenty-one years old, these students believed the women's movement to be a call to challenge images of women as victims or objects, to improve themselves, and to create "a good path to the future." According to these young university students, women had to liberate themselves.

The sentiment expressed by the students filtered through the thoughts

of women of the Left as they began to see their own struggles for women's equality being ignored by the radical groups to which they belonged. Sociologist Vivian Mota, in a 1973 ¡Ahora! article titled simply "Women and the Dominican Left," professed that despite all their promises of equality, political organizations ranging from unions to student groups to parties systematically denied women's rights.[79] She declared that "one of the biggest contradictions of the Left" was its inability to admit that, according to Lenin, it was "impossible to incorporate the masses into politics without also incorporating women." She claimed that unlike their Marxist or Engelian approaches, following Lenin would prove the only way to avoid contributing to the oppression of women. Mota argued that women simply were not going to wait for men to hand them their own liberation and that the liberation they sought was not for the inconsequential goals of not having to wear underwear or be exactly the same as men. She exhorted male leaders of the Left to consider the liberation of women as an essential element in the revolutionary struggle and that a failure to "recognize the potential" of women was tantamount to the failure of the revolution.

As Mota's article demonstrates, women of the Left were still highly committed to revolutionary change at the same time that they were becoming extremely exasperated with their male comrades. There was a palpable shift in discourse as the mid-1970s approached. In an attempt to reconcile the seemingly opposing goals of revolutionary change and female equality, Prats-Ramírez de Pérez proposed that the two approaches espoused by her colleagues and compatriots regarding the women's liberation movement were in actuality a dialogue between two related yet distinct struggles. Prats-Ramírez de Pérez argued that on one side was the need for change in socioeconomic structures—human liberation—at the national and international level. Conversely, there was also the need to change stereotypes and establish social and cultural patterns that relegated women to positions of inferiority. For Prats-Ramírez de Pérez, they were interconnected social problems that could not be fought independently. She also pointed out that they were struggles that applied differently to different women and that the idea of one singular "Dominican woman" was a myth. Unlike many of her colleagues, Prats-Ramírez de Pérez offered concrete suggestions to the government. The recommendations were palliatives—by no means solutions to what she called the "capitalist or patriarchal oppression to which Dominican women are subjected"—but rather steps toward an improved system.[80] They

included the creation of day care centers for working mothers and fathers, more opportunities for women's work and advancement, the maintenance of the standard of equal pay for equal work, the equalization of education, and the revision of the job code to provide increased protection for domestic workers. Among the more vocal women of the opposition, Prats-Ramírez de Pérez often presented suggestions for incremental change that could and might actually be implemented by Balaguer's government.

Finding a middle ground between the neglect of their comrades and the need for continued struggle against an oppressive capitalist government proved to be a central issue for women of the Dominican left. Coiscou, a noted author, psychiatrist, and revolutionary, advocated for a real connection with the more radical elements of the U.S. feminist movement; her declarations are testament to the subtle shift in tactics among Dominican feminists.[81] A self-proclaimed feminist activist and participant in the April Revolution, Coiscou had been offered a temporary exile in the postwar period to study medicine abroad. Her return, however, found her no less vocal about the state of gender and class in her native land. She argued that the women of the Dominican Republic needed to be ready to accept the feminist tactics of foreign "radical young white women . . . with a vanguard spirit." Coiscou associated these North American feminist ideals particularly with the organization WITCH, the Women's International Terrorist Conspiracy from Hell, a group that in Coiscou's view encouraged the dual goals of women's liberation and the liberation of North American society as a whole.[82] Rather than reject the U.S. model wholesale, she looked to an example that she considered more appropriately fitted to the Dominican context. Coiscou contended that many Dominican women were simply following the political ideologies of their husbands and compatriots without thinking actively about their own place in society. Instead, she proposed the Movement for the Liberation of Women as a "movement within a movement, in support of a revolution for life, liberty, love, and world peace." She argued that Dominican women were the social group with the "best potential for a vanguard ideology," just as she affirmed her total disbelief that the "men of the petit-bourgeoisie—with their ideology and their party—are going to liberate us."[83] Coiscou maintained the feminist position of the Left that affirmed the need for social revolution as a prerequisite for women's emancipation, and at the same time she argued that more struggle was required of women to accomplish gender equity.

Taken as a whole, the opinions expressed by Dominican women of the opposition surrounding the issues of women's rights and feminism between 1971 and 1975 demonstrate a slow yet undeniable transition. In contrast to their previous solidarity with their male colleagues or their employment of nearly exclusively maternalist techniques to pressure the Balaguer regime for change, the early 1970s showed an increasing attention to issues of gender equality and family planning. Activists employed a more nuanced approach to understanding women's liberation and argued that a movement for women's rights need not emulate a North American model but instead could be shaped to fit a nation in need of drastic socioeconomic and political restructuring. In sum, they sought to maintain their focus on human rights, democratic freedoms, and national development but also construct an ideological position that would allow them to concurrently demand full gender equity.

TRANSITIONING OUT OF THE ACTIVISM of the armed opposition of 1965 proved a difficult challenge for the women of the Left in the Dominican Republic. Aware of the limits of their maternalist reactions to state violence and yet unwilling to give up such powerful weapons, they continued to push the state to attend to the needs of the family. Severely limited in their arenas of protest, they fought to point out the failings of the Balaguerato through opposition party mobilization, various female collectives, human rights campaigns, solidarity, and gradually widening spaces in the media, education, and the labor force. During the second half of the 1960s, women's complaints served to push issues of motherhood and childhood development to the forefront of debates about the future of the Dominican nation. Solidarity with transnational actors around issues of basic human rights served as a platform for many women to protest what they saw as the patriarchal abuses of the Balaguer regime. Particularly through various press outlets, Dominican women demonstrated that the peace and stability promised by the Balaguer campaign had been nothing more than a rhetorical strategy to convince the world of the nation's transition out of dictatorship. By mobilizing around the bloody and violent abuses of the regime, they pointedly illustrated to the world that the worst elements of the Trujillato continued in the Dominican Republic and inflicted serious damage on its families.

Given the trained focus on issues of maternal concern, it is paradoxical that this period also witnessed the emergence of an embryonic feminist movement. A number of factors contributed to this competing narrative in women's political activism. First, there was a substantial increase in the number of publicly and politically active women in the first half of the *doce años* due to advances in education and employment opportunities for women. Second, while many women of the Left had begun organizing in groups and joining the opposition movement, their activities were highly focused on concerns of class and social revolution, and they often felt marginalized by their male companions. This included many of the women widowed by the regime who found it necessary to defend their roles as independent and capable political activists despite their status as widows. Moreover, as the regime began to afford space for discussions of family planning and population control, Dominican women organized, albeit haltingly, around specifically gendered concerns of equality. Finally, international currents propelled by a western-centric feminist movement encouraged a discussion of appropriate and locally focused feminisms among women of the Dominican Left. In addition to demands that ranged from a Cuban-style revolution to a more equitable distribution of power between political parties, women of the opposition began to attend to gender equity as a central part of the larger movement for change.

For many, the initial debate surrounding feminism had much to do with balance: maintaining work and family, creating a political presence and a viable home, and protesting government corruption and social instability. However, by the early 1970s a coalescence of factors including the refusal to address the concerns of gender equity by their male comrades of the Left pushed many women to refocus their priorities and actively promote a feminist agenda. Finding a middle ground between a western, capitalist model and the particular needs of a nation continuing to struggle under authoritarianism proved crucial to their efforts. As they began reformulating an ideology of women's liberation according to the needs of Dominican women, they also accepted certain avenues of cross-partisan collaboration as a means to an end. The activities surrounding the International Women's Year in 1975 would provide a crucial platform for pulling many of these concerns together and leading to a much more coherent feminist movement in the Dominican Republic.

Epilogue

International Women's Year and Dominican
Transnational Feminism under Authoritarianism

IN DECEMBER 1975 A LARGE GROUP of female professors, activists, and politicians gathered at the Universidad Autónoma de Santo Domingo (UASD) to discuss the status of women in Dominican society. Organized by the University Committee for International Women's Year, the seminar was named in honor of the martyred Mirabal sisters and attended by professional women across a wide spectrum of specializations. It served as a capstone for the UN-declared International Women's Year, and the presentations summarized many of the pressing issues Dominican women faced in the final years of the *doce años*. Concerns echoed the marked change in the debate about women's liberation in the Dominican Republic from the decade prior. Questions of gender equity assumed a much more prominent position in the discourse of social change within the political arena, and women began to push for more active attention to the concerns for women's rights. Between 1975 and 1978, the Balaguer regime and women's responses to its politics shifted significantly. As Balaguer transitioned to a more conciliatory approach to opposition, women's political behavior transformed to a more willing acceptance of cross-partisan alliances.[1] The move toward cooperation was a product of several factors. Among Dominican female activists of the Left there was an increasing awareness that their male compatriots in the struggle were consistently failing to consider gender equality to be part of the larger goals of societal change and national development. Coupled with several failed revolutionary attempts across the region and the singularity of the Cuban case, the reduction of violent tactics by the Balaguer regime that drastically limited the efficacy of politi-

cal maternalism, and the influence of international feminist currents that highlighted the ideological flaws of a maternal model even in the Dominican case, female activists' frustrations emboldened them to think more inclusively about the paths to social change. In addition, women within the regime began to see a utility in creating alliances with their opposition counterparts as a means of attaining gender equality. The result was a transition from a relatively bipolar struggle between *balaguerismo* and social revolution to a more expansive discussion of women's global oppression. This realignment brought many women of different political proclivities to a more general consensus on plans of action. The culmination of these ideological shifts can be seen in three major events of the late 1970s: the celebration of International Women's Year in the Dominican Republic, the Seminario Hermanas Mirabal, and the passage of women's equality legislation at the end of Balaguer's tenure in 1978. All three events demonstrate the power of international feminism as a springboard for local action as well as the changing internal dynamics among politically active Dominican women.

The events surrounding the 1975 International Women's Year brought attention to issues of women's liberation globally and in the Dominican Republic. Francesca Miller finds that the dispersal of ideas, the legitimation of feminist concerns, and the international attention raised by the International Women's Year and its world conference in Mexico City were crucial in catalyzing various women's movements across the region.[2] In the Dominican Republic the frustrations of the previous decade only furthered those influences and made the late 1970s fertile ground for the rebirth of a feminist sentiment among a broad spectrum of activists. Following the instructions from the UN's Commission on the Status of Women, Dominican representatives made plans to educate the populace on issues of gender equity and gather data relative to necessary changes in legislation and social policy. In the process, individuals across an array of political backgrounds extended and advanced the conversation about Dominican feminism, further elucidating a model appropriate for the country's particular realities. The capstone seminar, celebrating the ultimate female sacrifice in service to the nation, highlighted the ongoing conflicts of a renewed feminist movement. While the event affirmed a uniquely Dominican vision of feminism with echoes in the debates of the 1920s, its very foundational premise subtly illustrated a continued dialogue of mother-

hood, maternalism, and martyrdom that had undergirded women's activism from the beginning of the century.

As one of the last years of the twelve-year reign of Joaquín Balaguer, events surrounding International Women's Year serve as crucial reminders in understanding the influence of foreign events on the Dominican women's legislative agenda. Particularly during the last three years of the *doce años*, female activists pushed for change in the regime's business-as-usual model of *continuismo* and utilized cross-partisan and transnational alliances for leverage. The result, 1978 legislation expanding rights for women as parents and workers, aligned with a number of the most central and paradoxical concerns of an increasingly engaged and occasionally enraged female political population. The executive order, passed shortly before Balaguer left office, promised equal control for parents under the law as well as reformed worker regulations, but it maintained a focus on women's social roles primarily as mothers and ignored a number of issues pushed by feminist activists such as legalizing therapeutic abortion and closing loopholes in crimes of feminicide.[3]

In a continuation of the many paradoxes of paternalism, a new feminist movement emerged in the late 1970s that was at once attendant to the global circulation of ideals of gender equality and firmly grounded in the legacies of authoritarianism and a maternal style of women's activism. The issues raised by the gathering collective of women focused on some of the same concerns initially raised in the 1920s by women like Abigaíl Mejía and Petronila Angélica Gómez, and yet they were intimately tied with the conflicted legacies of a half century of authoritarianism and transnational activism. On one hand, women active in the movement had gained crucial experience and empowerment working through international networks, fighting for national sovereignty, and collaborating in formal state institutions of governance. On the other, they faced a post-authoritarian Dominican future that continued to favor a model of women's activism that privileged their roles as mothers and caretakers even as it facilitated their entry into the public world of politics. In keeping with the more than fifty years of authoritarianism and women's political activism and the radical currents of change of the mid-century, the modern Dominican feminism that emerged in the 1970s was at once an aspiration to the radical and revolutionary social changes so ubiquitously desired across the region and yet also solidly embedded in the complications of a maternal model of women's activism.

Celebrating the International Woman

Since the turn of the twentieth century Dominican women variously used the networks of transnational activism to achieve advancements in their own territory as well as to establish themselves as politicians, diplomats, and community leaders; 1975 proved to be a crucial year for such activities. The international summits and conferences aimed at addressing the global status of women organized by the IACW and the UN during the mid-1970s, specifically around International Women's Year, created opportunities for Dominican women to network internationally and garner leverage for local concerns.[4] The scholar Margaret Galey asserts that the activities "mobilized a critical mass of women from around the world to formulate strategies and goals to achieve participation as full partners with men in all spheres of decision making and to gain equal access to opportunities offered by the societies."[5] Efforts began in 1972 when the UN Commission on the Status of Women proposed an International Women's Year along the themes of equality, development, and peace and concurrently planned a conference to commemorate the year. The goal of the year was to increase UN-led activities promoting the equality of men and women and to increase women's roles in national and international development projects.[6] Planning for the International Women's Year and its world conference to be held in Mexico City was to be conducted by individual national committees and the central UN commission; both those efforts and the subsequent declaration of the Decade of the Woman, 1975–1985, encouraged women globally to employ the precepts of the program within their own local contexts. Between 1972 and 1974 the United Nations, the commission, the IACW, and local national committees planned for the International Women's Year. The official motto was "Equality, Development, and Peace," and organizers expected member countries to commemorate the event with local activities and attendance at the final conference in Mexico City.

For women in the Dominican Republic, the directives from the organizing committee highlighted some of the ironies of celebrating the rights and privileges granted by a dictatorship while still under the control of a highly authoritarian regime. Balaguer, like Trujillo, desired the international attention women's equality might bring his leadership, and so he eagerly complied with the wishes of the international leaders of the celebration. Given the raft of female politicians with which he surrounded himself, he

did not have to look far for assistance. Subsecretary of Foreign Relations Licelott Marte de Barrios was also the country's delegate to the IACW and the UN and an eager participant in the inter-American politics of women's rights. Marte de Barrios had served loyally under Trujillo and Balaguer, and the president entrusted her to lead the nation's efforts to commemorate the International Women's Year.[7] She delineated what activities would be celebrated and who would conduct them. Despite her alliance with Balaguer's party, her efforts helped make the activities that surrounded the year a springboard for action among women of both sides of the political divide and a step toward a more inclusive construction of political, social, and economic rights for Dominican women. Although Marte de Barrios had long been an avid supporter of Balaguer and his policies, her willingness to create cross-party alliances for goals she deemed essential to the progress of the nation made her an effective conduit to broker compromise between women of differing political positions both through the International Women's Year and into the final years of the Balaguer regime.[8]

According to the memorandum Marte de Barrios sent to the Commission on the Status of Women, the Dominican Republic established a comprehensive plan of action for the execution of the International Women's Year. Following Balaguer's December 1974 declaration of compliance with commission recommendations, Marte de Barrios formally announced government plans for the following year.[9] Celebrations would follow a three-stage process. In the first forty-five days, what Marte de Barrios termed the "awareness-raising stage," the Department of Foreign Relations would promote knowledge of the International Women's Year and distribute its plans for the upcoming year. Various committees, public and private, would assist in drafting a declaration of women's integration, and the period would end with a national survey on the condition of women. In the second stage, which was to last four months, committee members would assist with compiling and processing the collected demographic material. During this "consciousness-raising stage" participants would also assist in conducting a comparative study of women's actual condition in relation to the goals of the UN and IACW declarations. Finally, the year would end with a "crystallization stage" in which the collected data would be used in a series of activities, conferences, and seminars meant to create "a real and effective change in the attitude of women and towards women." Marte de Barrios envisioned this final period as a time to intensify the message in an

amplified publicity campaign through radio, television, motion pictures, magazines, newspapers, and various publicly distributed materials. In sum, the Dominican campaign focused primarily on information gathering, education, and collaborative projects aimed to address existing gender inequalities, particularly those embedded in the country's legal codes.

Through linkages with governmental and nongovernmental agencies, Marte de Barrios swiftly delegated the activities of a nationally organized women's year and gathered a considerable network of support. Starting in November 1974 in anticipation of Balaguer's official declaration, Marte de Barrios solicited aid and financial assistance from officials in the Departments of Labor, Education, Agriculture, and Public Health as well as the attorney general, national lottery, postal service, and national library. She drew on the expertise of academics at the Universidad Nacional Pedro Henríquez Ureña, the Instituto Dominicano de Estudios Aplicados, and the Asociación Pro Educación y Cultura for several national studies and surveys. Marte de Barrios reported garnering assistance from the Office of Community Development, the women governors, and CONAPOFA. She even convinced the president of a tobacco company in Santiago to print ten thousand copies of a commemorative stamp to be distributed throughout the country and at the conference in Mexico City.

By May, Marte de Barrios reported a laudable number of successful activities. The list included a national survey, an evaluation of program activities, the creation of a Centro de Integración Femenina para el Desarrollo (Center for Women in Development), various seminars on women's roles in the economy, the home, and in professional life, the publication and distribution of works by prominent women, declarations of the equality of women, and a regular bulletin on Dominican activities for the International Women's Year.[10] For Marte de Barrios, the integration of women in societal progress and development demanded that Dominicans "overcome various obstacles that arise in today's society and are the result of our traditional cultural condition that has maintained and continues to maintain discrimination against women."[11] Missives from the Dominican Republic in the International Women's Year bulletin produced by the UN's Center for Social Development and Humanitarian Affairs also included activities such as literary and arts fairs spotlighting prominent women, the issuing of the commemorative stamp, and television panel discussions.[12] The report in the bulletin indicated that the year concluded with a gathering of women

"from all levels of society" who met with President Balaguer to present the recommendations and resolutions from the UN World Plan of Action.[13] Reaching across political divides, Marte de Barrios constructed a domestic agenda that, while not revolutionary, did draw on the expertise of a range of politically engaged women and sought to raise the collective consciousness about Dominican women's roles in society. The world conference in Mexico City served as the culmination of those efforts on the international stage.

Scholars and contemporary observers have considered the World Conference of the International Women's Year in Mexico City in June 1975 alternately a success and watershed for the international women's movement while also a contentious debate between the precepts of western feminism and global South human rights.[14] Delegates from more than 130 countries and representatives of even more NGOs of various sizes and origins attended the event. Scholar Devaki Jain argues that three major challenges were proposed by the 1975 conference that would significantly influence the global women's movement. The conference put in place a World Plan of Action that declared the Decade of Women, 1975–1985, and established a goal of women's equal access to resources across the globe. Conference attendees also recommended alterations in collecting national data including gender in order to better map the status of women internationally. Finally, 127 attending member states agreed to implement "national machinery/institutions" for organizing programs for women in development.[15] Despite these generally agreed upon goals, the conference was divided by major cleavages along lines of economic and class status, national sovereignty and global hierarchies, and national feminist agendas.

As a diverse group of Dominican female activists approached the International Women's Year and its culminating conference in Mexico City, women of the country's opposition parties began to address the problems they foresaw in the year's western-centric agenda, both for them and for the rest of the women of the global South. The impact of the efforts of the international community on women in developing nations was, Dominican women noted, a conflicted issue. Despite the Association of University Employees leader Mirna de Peña's displeasure that the International Women's Year had distracted women from the "real struggle," she could not help but admit that it "served as a platform for denouncing the situation of oppression and inequality in which women lived."[16] Prats-Ramírez de Pérez questioned "which woman" was to be celebrated in the Año Internacional de

la Mujer yet at the same time offered concrete suggestions for change that could be followed by the Balaguer regime in keeping with the year's mandates.[17] Ángela Hernández argued at the conclusion of the UN's Decade of Women that the attention of the International Women's Year essentially refocused the imperialist discourse of development and modernization with an eye toward how women's contributions to society "were essential to the progress of the nation." Yet all agreed that the increased focus on women's rights had distinct advantages that included local organizing and activism, education, and government attention. The UN declarations, while handicapped by what Hernández called an "imperialist discourse of development and modernization,"[18] still provided a catalyst for discussion that would engender a more active contemplation among Dominican women about their own specifically gendered marginality.

Dominican commentators were more than aware of these ideological cleavages, and yet they acknowledged the advantages inherent in Dominican participation in the International Women's Year.[19] Women of the opposition had begun more aggressively to advance issues of gender oppression, but class and social change, not to mention the upcoming elections, were still of extreme importance. Many of the concerns expressed by western feminists seemed superfluous to Dominicans and their Latin American counterparts. Commenting on the closure of the International Women's Year, Prats-Ramírez de Pérez pointed out that Dominican women had been very active, albeit perhaps not in the way the UN committee had envisioned. Nonetheless, given the level of oppression and entrenched patterns of discrimination, a single year was entirely insufficient to wipe out an entire unjust social system:

> [I]n the months that have passed since December 1975, the Dominican women who took the lead in this year "as women" have not been idle. . . . The reality is that we are back in our parties, in our unions, in our housewives clubs, in our classrooms, in our factories, in all possible community groups, leaving aside the struggle against man for a struggle with our men . . . for the necessary revolutions for democracy, nationhood, and citizenship.[20]

Prats-Ramírez de Pérez concluded that while perhaps not achieving the desired concrete goals or statistics, the International Women's Year "brought to our side many companions now awakened" to the concerns of gender

equity. For her, the changes were less events to enumerate or list but rather realities to be witnessed in everyday political activity. Magaly Pineda, an established journalist, professor, and feminist, commented on the intersection of the effects of international arena and local influences on changing women's attitudes toward feminism:

> However distorted and/or minimized, news of "crazy" women demanding freedom, equality, and participation in countries all around the world did not fail to reach the ears of Dominican women. The "officialization" of the theme of women through the declaration of International Women's Year extended the radius of influence. There is a broad radio-communications network in our country, as well as an able and generally progressive press corps, both of which saw to it that echoes of International Women's Year reached even the most isolated regions of the country.

Hearing about crazy women demanding freedom, according to a number of Dominican commentators, had a positive impact on the revival of a feminist agenda. Pineda further reflected on the impact of the international arena on women's mobilization and the "extended radius of influence" in the Dominican Republic. She argued that "especially after 1975 women who had begun to learn words like discrimination and sexism began a process of change. . . . And the growing international feminist movement also [had] a vital impact."[21] Whether they agreed with the specifics of the United Nations' worldwide declaration of a year of the woman or its intended goals, the international attention to women's rights created by the 1975 International Women's Year influenced the ways Dominican women were able to promote a domestic agenda of feminism.

In the end, most Dominican activists saw the attention from the year in a favorable light, even if significant change for Dominican women and society lay ahead of them. Like the efforts of Balaguer functionary Marte de Barrios, the International Women's Year was in some ways a form of window dressing covering a much larger problem. Yet for Dominican feminists, the act of simply shining a light on gender inequality was important. What many feminist activists were beginning to realize was that to ignore the regime's engagement with the year as simply another international performance was to miss opportunities to engage in debate about local issues of gender and equity. While Marte de Barrios certainly navigated Balaguer's

desire to paint the nation in a democratic light, she also knew that such opportunities served to open doors for discussion of more substantial areas of women's rights. Much like Josefina Padilla's argument that she felt obligated to seize upon Trujillo's claims of democratic opening in the 1940s even if they were disingenuous, women across the political spectrum saw opportunities amid the contradictions of the late Balaguerato. Many of these issues would be raised in the Dominican International Women's Year conference.

Remembering las Mirabal

Given the condition of the Universidad Autónoma de Santo Domingo in 1975, it was with no small irony that the Dominican seminar of the International Women's Year, the Seminario Hermanas Mirabal, was held in December in the classrooms of that institution. Despite being denied funds by the Balaguer regime consistently since the late 1960s and frequently shut down for student protests, the university became the site for the nationwide conference that would commemorate the yearlong celebrations. As the intellectual center for many of the Dominican women who had become active in the burgeoning feminist movement, the classrooms of the university served as an ideal location for an event that would take on the concerns of gender equity raised by the International Women's Year. The seminar, named after the martyred Mirabal sisters, highlighted the ways in which feminism had come to be a central point of discussion among a significant group of women across partisan divides and the manner in which the topic of gender equity had become a space of previously unseen compromise. However, the seminar also showed the legacies of authoritarianism as women sought to demonstrate their importance to the nation as sacrificing and revolutionary leaders beyond their roles as mothers.

At the inaugural session of the conference, Hugo Tolentino Dipp, university rector, offered an opening statement testifying to the importance of studying the condition of Dominican women and the role of the university in that quest.[22] He focused on the need to see women's oppression as a "double alienation," a product of women's position in both the reproduction of the family and the reproduction of labor. He exhorted conference attendees and particularly presenters not to lose sight of the "even bigger inequalities" embedded in society. However, while the conference attendees were ever aware of these larger looming social woes, gender was the

central concern of the nearly weeklong event. As part of Balaguer's effort to encourage the activities of the International Women's Year, the seminar received official state sanction. Representatives from the Departments of Foreign Relations, Public Health, Agriculture, Education, and Labor were all present, including Marte de Barrios. The United Nations sent a representative to the seminar, as did the private, much-better-funded universities throughout the nation. The event was attended as well by a three-woman delegation from the Federation of Cuban Women. While most participants adhered to Tolentino Dipp's call to give attention to class and larger social change, the assembly of women from such a broad spectrum of political perspectives meeting to discuss exclusively women's issues created an event of unprecedented import.

Event organizers focused the name and the imagery of the conference around the martyred Mirabal sisters, and their mythic presence helped set a tone of nation and sacrifice that would characterize the many presentations and roundtables.[23] In his introductory presentation Carlos Temístocles Roa proclaimed, "There could be no better or more significant model for an event on the condition of Dominican women than the one chosen by the organizers, the inspiring example and sacrifice of women who are true heroines of our people: the Mirabal sisters."[24] Dignitaries seated at the inaugural session held court in front of life-size portraits of the three famous sisters, and portraits of Minerva Mirabal adorned the front of every podium. The families of all three women were honored guests. Not yet twenty years old, Minou Tavárez Mirabal, daughter of the martyred Minerva Mirabal and Manolo Tavárez, offered an opening statement. As she discussed the work of her late mother, she argued for not just a change in immediate conditions but an aspiration to a "higher ideal for society [that] suppresses the injustices and social differences and evades foreign interference of any kind." Especially during the International Women's Year, she contended, the most elevated homage that could be paid to her mother's memory would be to "promote in women a sense of political responsibility, advancing . . . toward the achievement of a sovereign country."[25] Following the tone set at the conference opening with the Mirabal sisters representing women's heroic sacrifice in service to the nation, presenters discussed the importance of gender equity yet set such goals amid larger and more revolutionary visions of change.

Throughout the conference, presenters focused on the need for transfor-

mative change but also on the requirements for creating a truly indigenous and sovereign feminist movement. The presence of the Federation of Cuban Women bolstered the role of women and gender equity in revolutionary change. That is, while the attendance of the Cuban women affirmed the conference's revolutionary status, they also reminded participants that without the full involvement and consideration of women, "a true process of change would not be possible."[26] Such arguments clearly marked Dominican feminism as distinct from any western model, as Prats-Ramírez de Pérez pointed out in her presentation entitled simply "Educational Environment." While citing specific examples in her talk, she concluded her list of main points with the statement that Dominican women had been receiving "a misconstrued idea of liberation based on misled patterns of consumerism, sexual licentiousness, and the copying of foreign practices."[27] Prats-Ramírez de Pérez advocated for wide-scale social change while maintaining a keen attention to issues of gender and women's rights. Although pessimistic about the larger social and cultural context of women's education, she recognized that some of those ideas were changing. She capably placed her argument about women's subjugation in Dominican society within the context of the underdevelopment and dependency of Latin America in such a way as not to undermine the focus of the conference.

Dominican press outlets reinforced the distance from western feminism as articles in *El Caribe*, *Última Hora*, and *Firme* reported that the seminar was somehow not feminist but offered a unique opportunity for women to address issues of inequality. Professors and activists Magaly Pineda, Martha Olga García, and Laura Faxas said that despite their double oppression under a capitalist and imperialist system, Dominican women were a "vast revolutionary potential, much like a sleeping giant about to wake up."[28] Such revolutionary potential, they contend, needed to be channeled into concrete actions for the liberation of society but also through continued discussions of the specific conditions of women's oppression.

Concerns among presenters included women's presence in education, women's civil rights and discriminatory judicial codes, the integration of women into various professional and economic arenas, media and communications, political participation, and social and cultural gender norms. The conclusions painted a dismal picture. On the whole, women were less educated, more underemployed, unfairly stereotyped, and discriminated against in de jure and de facto situations. Women were victims of the op-

pression of underdevelopment but also of a double alienation through class and gender discrimination. A conference attendee declared mildly, "The Dominican woman lives in a social structure that does not benefit her."[29] Still, for some of the participants there were small rays of hope. Professor and dean of the Agriculture and Veterinary Program at the UASD Ana Silvia Reynoso de Abud referenced the Agricultural and Union Training Institute as an organization committed to creating female leadership in the agricultural and labor movements. Education professor Ligia Amada Melo de Cardona cited increased enrollment of women in education at the university level. Among university women, Prats-Ramírez de Pérez observed that a large percentage were "developing new attitudes that dismiss their familial enslavement and the patriarchal role of the Dominican man."[30]

Several conference participants offered concrete suggestions for change in their presentations, particularly in the area of education. Education specialists Zoraida Heredia Vda. Suncar and Erasmo Lara argued for a drastic reworking of the texts used in primary and secondary education, incorporating gender-neutral language, and replacing images of weakness with those depicting women in professional life achieving and asserting themselves. They also suggested parallel improvements around gender policies in the classroom. Prats-Ramírez de Pérez offered numerous concrete suggestions for change in the areas of education, political parties, media, and information dispersal that included the augmentation of university outreach programs in gender education, campaigns to increase women's leadership in political parties and unions, increased sex education for women, and regulation of disparaging images of women in the media. Envisioning the "new woman," scholar Fanny Sánchez de Bonilla argued for several changes that, like those of Prats-Ramírez de Pérez, came both from state-centered incentives and private or party initiatives. They included the greater integration of women into working life, the encouragement of female membership in unions, professional associations and clubs, the stimulation of women's participation in student groups, the organization of women within political parties, encouragement of the reorganization of the FMD, and the launching of an educational campaign relative to the equal rights and opportunities of Dominican women.[31]

While there was certainly cause to be pessimistic about the status of women's rights and presenters offered a plethora of suggestions and indicated significant work still to be done, some concrete changes would begin

as a result of the increased collaboration across party lines in the last years of the Balaguerato as well as women's active encouragement of the creation of a uniquely Dominican feminist movement. The Seminario Hermanas Mirabal served as a local and collaborative platform for awareness and mobilization around women's rights. Although dominated by women of the left of the political spectrum and highly cognizant of the legacies of both maternalism and imperialism, the event was formally sponsored by the regime and an official component of the International Women's Year. Such compromise, contradiction, and opening of dialogue would prove central in moving forward the recommendations of the assessment committee for the year initially called together by Balaguer and Marte de Barrios in 1973.

Courting Compromise

Attendant to the increased attention to women's rights both globally and locally, Balaguer appointed a committee in 1973 to assess the laws of the nation to determine any legislation that was discriminatory on the grounds of gender. In a report filed with the U.N. Council for the International Women's Year, the purpose of the committee was to "draft a report on amendments needed to ensure the complete legal equality, both civil and political, of Dominican women."[32] At particular issue were the many laws protecting women's custody rights. While social and cultural norms demanded Dominican women care for the physical, emotional, and educational upbringing of their children, they were afforded none of the same rights of parentage as their male counterparts. Additionally, laws regarding marital abuse still insulated male abuse. The committee, headed by Marte de Barrios, was comprised of many of the regime's most prominent female lawyers. Still, it took the committee five years to pass the recommended amendments.

One of the steps in the assessment of the state of Dominican legislature relative to women was a report presented at the 1975 Seminario Hermanas Mirabal by lawyer Margarita Tavárez, former revolutionary Piky Lora, sex education specialist Martha Olga García, and UASD philosophy and law professor Flavia García. They raised several important points in their presentation. The most pressing issue was the unequal treatment of married and single women in the constitution. While single women received full rights under the law, married women were subject to the will of their husbands in issues ranging from property to foreign travel. Most importantly,

the rights and responsibilities of parents were assigned solely to fathers, and men were given administrative authority over all goods and resources obtained by the couple. The presenters showed that the law placed women "in a place of absolute dependence on her spouse." While other countries had changed such laws that emanated from the Napoleonic code and severely restricted married women's rights, the Dominican Republic remained tied to these marital norms. The four scholars argued forcefully for the "creation of a new legal status to replace the current markedly paternalistic and in-egalitarian system to ensure greater independence of women, and their better and more active collaboration in the development of family."[33] Their focus on laws encoded in a paternalist system was a clear response to the many purported protections maintained by both the Trujillo and Balaguer governments.

Besides concerns with the Dominican constitution, Tavárez, Lora, García, and García addressed discrimination against women built into the civil and penal codes of the country. In reference to the penal code, their concerns centered on uneven punishments for adultery, the sentencing structure for rape, and laws criminalizing all abortion procedures. They proposed a specific modification relative to abortion, declaring that abortion in cases of medical necessity or rape and incest should be legalized. The legal experts addressed the labor code and its sections specifically directed at women. They argued that although the code initially declared men and women to have equal rights to work, by providing special regulations regarding women workers the law did not legislate equally for men and women. The four presenters contended, "We accept the protection of women, but only as it pertains to mothers," and took issue with each piece of legislation that dealt with a woman's condition outside of the concerns of pregnancy.[34] They suggested state incentives to increase the hiring of women workers and regulations to apply certain protective measures to both male and female workers. Finally, their report addressed legislation making male spouses solely responsible for housing payments, arguing that such a law stripped women of the status of "co-manager of the household."

The conclusions of their "Estudio jurídico de la mujer" fell in line with the goals established by its authors at the outset: to compile all legislation that either benefited or harmed women, to establish a clear picture of the legislative situation of women, and to suggest possibilities for legal modification with the end goal to modernize the structure of women's roles in

society. The recommendations in the report included modifying all legislation restricting the rights of married women, whether relative to property or children, the creation of civil unions as legally protected entities, and the equalizing of all laws pertaining to adultery, particularly the elimination of the loophole that granted immunity to any man who killed his female partner on the grounds of adultery. The authors offered alternatives to the existing labor codes that were either protective of or discriminatory toward women, and they advocated for equalizing the laws relative to home maintenance. Finally, they pleaded for improved prison conditions for women and the development of a more inclusive program of public housing and employment. The suggestions were at once groundbreaking and a familiar echo of a number of ideas first presented by feminists in the 1920s.

The report presented at the Seminario Hermanas Mirabal laid the groundwork for the legal reforms that would be made by Balaguer's modification committee, although not all of the suggestions made by the scholars at the UASD conference would be addressed by the regime's reform committee. Still, by 1978, many of the suggestions made in the report were being argued by Balaguer's commission for legal reform. A report from the Department of Women's Affairs stated that the International Women's Year "prompted demands that were partially satisfied with the 1978 legislation."[35] That executive order, Law 855, was passed on August 22, 1978, barely before Balaguer stepped down from his presidential post. Significantly, it gave mothers and fathers equal control over their children, and it set forth important improvements in labor legislation. While it failed to put in place some of the recommended changes offered at the seminar, it did take significant ideological steps on the path to true equity. These steps, however, were trodden along a road that was still heavily obstructed by the paternal protections enshrined by the politics of authoritarianism.

A series of editorials in *Listín Diario* in June 1975 prior to the World Conference of the International Women's Year illustrates some of the frustrations expressed by women that were central to this rocky path to feminism that had infiltrated a public discussion beyond feminist circles. Educator and guest contributor Altagracia M. Herrera Miniño offered readers in the capital an aggressive response to a debate set off by regular writer Domingo O. Bergés-Bordas, who had declared that he did not believe in the need for a women's liberation movement in the Dominican Republic.[36] In a manner reminiscent of the male voices at the time of the suffrage debate, Bergés-

Bordas argued that Dominican women were not oppressed nor subject to the will of men. Herrera Miniño fired off a response that challenged Bergés-Bordas and his readers to support his spurious claims of equality, given the continued paternal practices of the Dominican state.

At the center of the debate between the two writers were the connected issues of maternal responsibility and women's equity. Herrera Miniño questioned Bergés-Bordas' assumption that while women carried nearly all the responsibility for the duties of the home and child rearing, they still somehow had fundamentally equal rights and privileges. Without disparaging women who worked exclusively in the home, she wondered about the women who were forced to maintain households and labor in the public sector because "what the man earns is not sufficient to maintain his habits of alcoholism, gambling, running around with other women, and at the same time provide sufficient food, clothing, medication and education for his wife and children." For Herrera Miniño, claims of gender equity fundamentally ignored the many everyday struggles Dominican women faced in balancing work and home life and dealing with the rampant problem of male vice, not to mention the larger ideological challenges that lay ahead for the women's movement. She asked whether Bergés-Bordas was even aware of the many battles waged by women of the world "to gain the right to vote and have access to education? Or the arduous path to be able to freely choose the man she wants to marry?"[37] As the list of questions continued, Herrera Miniño transitioned to issues of global import and universal prejudices that still held sway against women. Then she jumped directly to concerns immediate to the Dominican people when she queried why,

> in our country, Mr. B. B. an adult or a married woman who wants to travel must submit written permission from her husband or father to the General Office of Passports? Do you know, Mr. B. B., of similar limitations for men who want to abandon their family and use a trip as an excuse to achieve their ends?[38]

In concluding her list of critiques, she nearly scoffed at his gallant claims that men should honor and protect their wives, mothers, and daughters. To Herrera Miniño, true liberation would only be reached when men stopped protecting "their" women out of masculine pride and began respecting all women for their own inherent humanity.

In the final section of her editorial Herrera Miniño used her dialogue

with Bergés-Bordas to challenge her readers to claim a place in the Dominican women's movement; she engaged well-worn models of women's activism and yet gently espoused a move beyond maternalism. Given the seeming lack of female models in the historical narrative of the Dominican Republic, the author argued for an eye to foreign examples to awaken in a woman "her desire to be useful to her country." She claimed that the real struggle for women was to recognize that their unequal condition was not something created by God but by "ignorant and close-minded men who have used us only to attain their goals." Moreover, Dominican women needed to "realize the crucial role they should play in the public life of society," while Dominican men needed to lose their fear of women who "hold key positions at all levels of the life of the country." She contended that such changes could only improve Dominican society and bring it closer to the life envisioned by a Christian God. While her consummately Christian and nationalistic tone followed the narrative created by women since the turn of the century, her argument to stop relying on a naturalized view of women's differences represented a significant transition to a more egalitarian discourse of feminism that would grow exponentially in the late 1970s and into the 1980s.

The debate between Herrera Miniño and Bergés-Bordas in the pages of a capital daily demonstrates the issues surrounding feminism and women's liberation that had become a much larger part of the public debate about the future of the nation by 1975 and would remain central through the end of the decade and into the next. Venues of debate in these final years ranged from newspapers to international conferences and from party forums to government legislation. The discussion would translate to action as multiple feminist collectives began to gather in the late 1970s and early 1980s around issues of particular urban and rural concern, including the groundbreaking Centro de Investigación para la Acción Femenina.[39] The unfolding of the discourse surrounding women's equality in these middle years of the 1970s speaks to many issues of Dominican women's politicization over the previous fifty years. Despite differences in partisan ideology, Dominican women began to see feminism and women's equality as important issues in the struggle for the nation's progress and their own. They ably tied issues of women's rights as well to larger questions of national progress. They selectively chose from among imported ideologies of feminism and women's liberation to build upon a model that was appropriate to the

Dominican Republic, a nation still struggling under the yoke of authoritarian rule and about to arrive at yet another major political transition. And while it was necessarily incomplete, they began to see many of the problems and contradictions of a model of political advancement built on women's particular and even extraordinary contributions to public life as nurturing mothers and caretakers.

Rethinking Feminism under Dictatorship

The 1978 legislative changes ushered in during the last moments of the *doce años* occurred concurrently with the transition out of the Balaguer regime and into a more representative governmental structure. The confluence of events grounded in a renewed feminist movement speaks to the essential role Dominican women played in the politics of authoritarianism and regime transition during the twentieth century. Ultimately, Dominican women created various pathways to political participation even when encumbered by the paternalistic models established by regimes of authoritarianism. Much has been written about the overtly masculine nature of Dominican politics, yet research has only begun to examine how women actually functioned within this challenging political sphere.[40] While women's activities have been overlooked during these periods because of the roles they played in supporting violent and oppressive regimes, their efforts are no less essential to the historical record for the light they shed on authoritarian rule, political mobilization, and gendered participation. For the women who labored valiantly against the repressive measures of Trujillo and Balaguer, the historical record has been no less unkind. Wrapped into a mythologized vision of women's valiant and self-sacrificing efforts, their work becomes represented by a handful of vaunted martyrs. In both remembering and forgetting authoritarianism, scholars have obscured the paradoxes of paternalism and consequently the contributions of women to the national narrative. Moving beyond one-dimensional or mythologized understandings of political mobilization highlights the essential place women carved out from the rise of Trujillo through the demise of the *doce años*. Unwilling to remain silent on issues of sovereignty, accountability, and citizenship, they contributed actively to shaping the Dominican state with and in spite of dictatorial leaders. Precisely through their own efforts to provide an appropriate and protected place for women in the politics of

authoritarianism, the regimes of Trujillo and Balaguer served to bolster collectives of women seeking expanded influence and ultimately, equality in the public arena.

The *damas trujillistas* and *balagueristas* enacted a performance of politics that mirrored their respective regime's desire to present the Dominican Republic as a modernizing, democratic state. In adopting and in some cases transforming their expected roles as female members of the regimes, they established a precedent for women's participation in Dominican politics. Their efforts, through both regimes, were grounded in a solidly paternal model of governance in which political women served as the nurturing supplement to the protective state. While their work during the Trujillato was limited to their entrance into formal politics and involvement through delineated spaces in the programs of social assistance, they laid the groundwork for a more engaged female population as the nation transitioned into the *doce años* of Balaguer. Over time, the women of the Balaguerato became increasingly savvy at the structure and function of Dominican politics and ultimately changed the nature of female engagement with the state through their focus on the maternal demands of the national family and the imperatives of local need. Significantly, their active engagement with the authoritarian state served to legitimize claims to democracy, anticommunism, and development that buttressed the stability and duration of both regimes.

Performing the politics of maternalism was not only a role played out by regime participants but also a practice of the women of the opposition. Women like resistance fighter Altagracia del Orbe, UCN leader Elisa Zayas Bazán, and widow and human rights activist Gladys Gutiérrez constructed their contributions to the political arena through careful attention to their expected roles as mothers and wives and their understandings of a democratic and just Dominican Republic. Their acts of bearing witness to unjust regimes and assaults on national sovereignty convey the reality that women were finding effective platforms from which to project their vision of female contributions to the political arena. They took on the discourses of the regimes they sought to upend and turned the rhetoric on its head. As their regime colleagues discussed democracy and peace, these women fought to demonstrate that they too believed in these concepts but only saw their reality in genuine regime change. Especially through their discourses of human rights and inter-American solidarity they found international audiences to refute regime claims of stability and peace. Their efforts led to

identifiable shifts in support locally and internationally for authoritarian leadership. Incorporating the women of these highly authoritarian regimes and the women of the resistance as well as their discourses of gendered participation in the same study expands existing understandings of how the politics of consent or opposition developed in the Dominican Republic and how such politics worked to shore up or destabilize long-standing regimes.

The most fundamental questions posed in this study concern the ways scholars understand political participation during periods of limited freedoms, the roles of women in the processes of government transition, and the meaning of female politicization under authoritarian leadership. As a group often marginalized from the national project, Dominican women, mobilized under and through authoritarianism, found multiple avenues to contribute to the politics of the authoritarian state. Certainly, such avenues were severely constricted by the regimes themselves and the dictates of international politics, yet many women created large and small windows to contribute to discourses of national sovereignty, citizenship, and the future of the Dominican state as they understood it. For the Dominican Republic during the twentieth century, these issues continued to have crucial significance. The thirty years of dictatorship of Rafael Trujillo and the twelve years of Balaguer cast a long shadow on the history of the country and women—envisioned generally as mothers, martyrs, and sometimes villains—are particularly marginalized from this already partial political narrative. Understanding women's many paths to politicization demonstrates that their contributions were not negligible but rather crucial to the structure and function of the state. And yet, as the two regimes provided ample space for formal political mobilization through the model of maternalism and women's inherent capabilities as naturalized and nationalized caretakers, the period is also marked by the serious legacies of women's activism channeled through the trope of motherhood.

Maternalism served as one of the most central avenues to politicization for women and established long-lasting legacies of public engagement, but it must not be seen as a static model. For the women of these authoritarian regimes, the roles as mother and caretaker were clearly only one element of their political identities, and their identities were constantly shifting. For women of the Trujillato, their political careers were often more complicated by issues of negotiation with the regime and its conceptions of democracy and anticommunism. The female *balagueristas*, particularly

the women governors, were certainly concerned with their public image as mediators, and yet they focused much more intently on issues of their local communities even when such provincial needs far surpassed their individual positions as caretakers and mothers. For the women of the resistance, during the Trujillato and after it, their activism was often couched within the Dominican state's violations of the national home and family and yet also molded to the needs of the global political moment. As this model of local, national, and transnational engagement shifted and changed, it also gradually exposed the limitations inherent in accepting the parameters of participation structured by a paternal, authoritarian state.

Despite a wide range of approaches to politics, transnational feminism served as a constant source of leverage for women of all partisan allegiances. From Dominican women's first foray into the Inter-American Commission of Women to the staging of the International Women's Day in 1975, opportunities on the international stage facilitated women's transnational engagement and furthered their individual and collective goals. While the intensity of involvement varied over the course of the century depending on the reigning government, the global context, and women's aims, international feminism served as an essential platform for Dominican women. The details of transnational activism among women exposes a richer and more nuanced story of the relationship of the Dominican Republic to the global context of shifting international relations and the ever-threatening hegemony of the United States. From the politics of the Good Neighbor through the developmentalism of the late 1970s Cold War, Dominican women demonstrated that everyday diplomacy cut several ways. Employing the rhetoric of global imperatives often created leverage for and expansion of women's rights and opportunities; pointing to the ways dictatorial leaders and U.S. interventionism were undermining international projects of stability, democracy, autonomy, and human rights provided politically active women with precise tools to mobilize toward regime change. Through the everyday negotiations of transnationalism, female politicians and activists came to better understand the hegemonic nature of imperial designs yet also deploy their discourse in a struggle for local change.

Throughout the thirty-year dictatorship and later twelve years of authoritarian rule, women were fundamental to the politics of Trujillo and Balaguer. Participation at local, national, and international levels allowed women to uphold the status quo as well as push for large-scale change in

the political environment that would eventually result in a democratic transition in 1978. Women's varied involvements in a politics of paternalism, however, also laid the foundations for the development of a feminist movement in the Dominican Republic in the 1970s. Through the sheer expansion of participation and political awareness as well as the practices of leadership, thousands of Dominican women contributed to debates about the future of the nation that by the 1970s would turn to crucial questions of the roles of women in social and political transformation. Not in spite of but in fact because of so many years of authoritarian rule, an indigenous feminism emerged that was at once harkening back to the independent clarion for equality of the early twentieth century and solidly embedded in the paternalist patterns of nearly fifty years of authoritarianism. While there is a certain loss inherent in the end of an autonomous feminist movement in the late 1920s, much like the end of first-wave movements across the hemisphere, the women's organizations, collectives, and actions as well as their challenges to and engagements with the Dominican state across fifty years of authoritarianism were foundational to and exemplary of the style and nature of the feminism that emerged in the second half of the century.

Constructing the narrative of the foundations of late twentieth-century feminism in the Dominican Republic through the many stories of Dominican women demonstrates how and why women became involved in various types of political regimes, the ways dictatorship and authoritarian rule shape women's political participation in specific ways, and the importance of the transnational arena to local understandings of political engagement. Beyond the staid archetypes of women's political involvement and encompassing the multiple links between women and the Dominican state, the democratization of the late 1970s and the growth of feminism in those same years in the Dominican Republic can be seen as intimately connected to the long history of women's involvement in local, state, and national politics from the beginning of the century. As a number of female activists have said, it was necessary to place "un granito de arena," a grain of sand, to start the process of change.[41] Through a better understanding of these many tiny grains of sand we can begin to move the Dominican feminist movement and the heroic acts of individual women into a more complete and complex picture of Latin American women's political mobilization and the nature and function of authoritarianism. The Dominican narrative is similar to others and unique; as in many other places across the region, the emergence

of modern feminism in the 1970s was a complicated blend of ideas from the global North and local realities that reached far back into the twentieth and even nineteenth centuries. Many paternalistic regimes fostered an engaged if traditional female political activism. And as more studies are showing, women at all levels and locations on the political spectrum understood and engaged the transnational arena as a productive space for personal and collective advancement. However, what the story of Dominican female activism across the twentieth century demonstrates is that among the many paradoxes of paternalism, the mobilization of maternalism among women spread across the political spectrum and the hemisphere enabled a steady if slow and heavily burdened process of reenvisioning the nature of the state and the importance of women's equality in that process.

Notes

Introduction: Gendering the History of Dictatorship and Transnational Politics

1. *El Caribe* (Ciudad Trujillo [Santo Domingo]), June 3, 1961, 8–15.
2. "One of Trujillo's Assassins Reported Slain, 3 Seized," *New York Times*, June 3, 1961, 1.
3. *El Caribe* reported that women in San Cristóbal "who cried in despair, pulled at their hair, and tore off their clothes"; June 3, 1961, 1–2. Captions in *El Caribe* and *La Nación* described many women at the funeral events as inconsolable, weak, and unable to contain their grief. One woman even had to be taken away by the Red Cross because she fainted upon seeing Trujillo's body in the casket; *La Nación*, June 2, 1961, 15. Unless otherwise noted, all translations are my own.
4. *Ajusticiamiento* is translated as judgment, execution, or death penalty, although it also directly means "bringing to justice" and is used by Dominicans almost exclusively to refer to the assassination of Trujillo.
5. The family remained in the country until the end of November, during which time they meted out revenge on anyone suspected of being a part of the assassination.
6. Grey Coiscou Guzmán, personal correspondence with the author, July 15, 2004.
7. Sources indicate that this merengue was not written until August, suggesting the malleability, particularly during such a traumatic time, of memory.
8. While most of the activist women considered in this study were phenotypically light-skinned, educated, and of the middle and upper classes, there was certainly a diversity among them, and many would be considered black in a U.S. context. However, they would not have coded themselves as such. In this study I address the class-based and urban-centric discourse with which they engaged as it was precisely their positionality that allowed them the access to state structures that undergirds the narrative of this study. For more on Dominican racial constructs see Ginetta E. B. Candelario, *Black behind the Ears: Dominican Racial Identity from Museums to Beauty Shops* (Durham, NC: Duke University Press, 2007); Silvio Torres-Saillant, "The Tribulations of Blackness: Stages in Dominican Racial Identity," *Callaloo : A Journal of African-American and African Arts and Letters Callaloo* 23, no. 3 (2000): 1086–1111.
9. Maja Horn, *Masculinity after Trujillo: The Politics of Gender in Dominican Literature* (Gainesville: University Press of Florida, 2014), 36.
10. Gerda Lerner, *The Creation of Patriarchy* (New York: Oxford University Press, 1986), 239; Christine Ehrick, "To Serve the Nation: Juvenile Mothers, Paternalism, and State Formation in Uruguay, 1910–1930," *Social Science History* 29, no. 3 (2005): 492.
11. Mary A. Renda, *Taking Haiti: Military Occupation and the Culture of U.S. Imperialism, 1915–1940* (Chapel Hill: University of North Carolina Press, 2001), 15.

12. Lauren Derby, *The Dictator's Seduction: Politics and the Popular Imagination in the Era of Trujillo* (Durham, NC: Duke University Press, 2009), 7. On authoritarian structures of rule in the Dominican Republic see Rosario Espinal, *Autoritarismo y democracia en la política dominicana* (San José, Costa Rica: Centro Interamericano de Asesoría y Promoción Electoral, Instituto Interamericano de Derechos Humanos, 1987), 56–59.

13. Derby, *Dictator's Seduction*, 111.

14. See Victoria González-Rivera, *Before the Revolution: Women's Rights and Right-Wing Politics in Nicaragua, 1821–1979* (University Park: Pennsylvania State University Press, 2011); Victoria González-Rivera and Karen Kampwirth, *Radical Women in Latin America Left and Right* (University Park: Pennsylvania State University Press, 2001); Margaret Power, *Right-Wing Women in Chile: Feminine Power and the Struggle against Allende, 1964–1973* (University Park: Pennsylvania State University Press, 2002). This pattern has also been documented extensively in the case of European fascist regimes as well as within the Ku Klux Klan in the United States; see Victoria De Grazia, *How Fascism Ruled Women: Italy, 1922–1945* (Berkeley: University of California Press, 1992); Claudia Koonz, *Mothers in the Fatherland: Women, the Family, and Nazi Politics* (New York: St. Martin's, 1987); Kathleen M. Blee, *Women of the Klan: Racism and Gender in the 1920s* (Berkeley: University of California Press, 1991).

15. Here I am following scholars Linda Gordon, *Pitied but Not Entitled: Single Mothers and the History of Welfare, 1890–1935* (New York: Free Press, 1994), 55; and Seth Koven and Sonya Michel, *Mothers of a New World: Maternalist Politics and the Origins of Welfare States* (New York: Routledge, 1993), 2–4, 30.

16. The body of scholarship on women, gender, and the Trujillo regime is small but has been growing in recent years. See Lauren Derby, "The Dictator's Seduction: Gender and State Spectacle during the Trujillo Regime," *Callaloo* 23, no. 3 (2000): 1112–1146; Ellen Dubois and Lauren Derby, "The Strange Case of Minerva Bernardino: Pan American and United Nations Women's Right Activist," *Women's Studies International Forum* 32, no. 1 (2009): 43–50; Myrna Herrera Mora, *Mujeres dominicanas, 1930–1961: Antitrujillistas y exiliadas en Puerto Rico* (San Juan: Isla Negra, 2008); Melissa Madera, "'Zones of Scandal' Gender, Public Health, and Social Hygiene in the Dominican Republic, 1916–1961" (PhD diss., State University of New York, Binghamton, 2011); Elizabeth S. Manley, "Intimate Violations: Women and the Ajusticiamiento of Dictator Rafael Trujillo, 1944–1961," *The Americas* 69, no. 1 (2012): 61–94; April J. Mayes, "Why Dominican Feminism Moved to the Right: Class, Colour and Women's Activism in the Dominican Republic, 1880s–1940s," *Gender and History* 20, no. 2 (2008): 349–371; Neici M. Zeller, "The Appearance of All, the Reality of Nothing: Politics and Gender in the Dominican Republic, 1880–1961" (PhD diss., University of Illinois, Chicago, 2010); Neici M. Zeller, *Discursos y espacios femeninos en República Dominicana, 1880–1961* (Santo Domingo: Letra Gráfica, 2012).

17. I am drawing on recent analyses of the Trujillo dictatorship that reexamine the regime from the perspective of informed consent and exchange rather than simply coercion and violence; see particularly Derby, *Dictator's Seduction*, 3–12; Richard Lee Turits, *Foundations of Despotism: Peasants, the Trujillo Regime, and Modernity in Dominican History* (Stanford, CA: Stanford University Press, 2003).

18. For an example of the breadth and depth of these transnational engagements see the document selections in chapter 5 of *Cien años de feminismos dominicanos*, ed. Ginetta E.

B. Candelario, Elizabeth S. Manley, and April J. Mayes (Santo Domingo: Archivo General de la Nación, 2016).

19. Karen Offen argues for a justified use of "transnationalism," even if it might be anachronistic, "because to do so makes these precedents and activists visible and underscores the significance of their initiatives"; "Understanding International Feminisms as 'Transnational'—An Anachronism? May Wright Sewall and the Creation of the International Council of Women, 1889–1904," in *Gender History in a Transnational Perspective: Biographies, Networks, Gender Orders*, ed. Oliver Janz and Daniel Schönpflug (New York: Berghahn Books, 2014), 30.

20. See, for example, Laurent Dubois, *Avengers of the New World: The Story of the Haitian Revolution* (Cambridge: Harvard University Press, 2009); Leon Fink, *Workers across the Americas: The Transnational Turn in Labor History* (New York: Oxford University Press, 2011); Micol Seigel, *Uneven Encounters: Making Race and Nation in Brazil and the United States* (Durham, NC: Duke University Press, 2009); Sandhya Rajendra Shukla and Heidi Tinsman, *Imagining Our Americas: Toward a Transnational Frame* (Durham, NC: Duke University Press, 2007).

21. Shukla and Tinsman, *Imagining Our Americas*, 5.

22. Valerie Sperling, Myra Marx Ferree, and Barbara Risman, "Constructing Global Feminism: Transnational Advocacy Networks and Russian Women's Activism," *Signs* 26, no. 4 (2001): 1155–1186.

23. Offen, "Understanding International Feminisms as 'Transnational.'"

24. Francesca Miller called for a more international perspective on Latin American feminism in the mid-1980s; Miller, "The International Relations of Women of the Americas 1890–1928," *The Americas* 43, no. 2 (1986): 171–182. For responses in other contexts see Christine Ehrick, "Madrinas and Missionaries: Uruguay and the Pan-American Women's Movement," *Gender and History* 10, no. 3 (1998): 406; Donna J. Guy, "The Politics of Pan-American Cooperation: Maternalist Feminism and the Child Rights Movement, 1913–1960," *Gender and History* 10, no. 3 (November 1998): 449–469; Katherine Marie Marino, "La Vanguardia Feminista: Pan-American Feminism and the Rise of International Women's Rights, 1915–1946" (PhD diss., Stanford University, 2013).

25. Seigel, *Uneven Encounters*.

26. Jocelyn Olcott, "Empires of Information: Media Strategies for the 1975 International Women's Year," *Journal of Women's History* 24, no. 4 (Winter 2012): 26.

27. On solidarity in Latin America see Van Gosse, "Unpacking the Vietnam Syndrome: The Coup in Chile and the Rise of Popular Anti-Interventionism," in *The World the Sixties Made: Politics and Culture in Recent America*, ed. Richard R. Moser and Van Gosse (Philadelphia: Temple University Press, 2003), 100–113; James N. Green, *We Cannot Remain Silent: Opposition to the Brazilian Military Dictatorship in the United States* (Durham, NC: Duke University Press, 2010); Margaret Power, "The U.S. Movement in Solidarity with Chile in the 1970s," *Latin American Perspectives* 36, no. 6 (2009): 46–66.

28. Jessica Stites Mor, *Human Rights and Transnational Solidarity in Cold War Latin America* (Madison: University of Wisconsin Press, 2013), 5.

29. Such failures and miscommunications are seen in the papers of U.S. activist Mary L. Elmendorf, 1931–2009, Special and Area Studies Collections, Smathers Libraries, University of Florida (hereafter Elmendorf Papers). For an example of how pan-American feminism was less than successful see Ehrick, "Madrinas and Missionaries."

30. Margaret McFadden, *Golden Cables of Sympathy: The Transatlantic Sources of Nineteenth-Century Feminism* (Lexington: University Press of Kentucky, 1999).

31. The literature on the more informal networks embedded in global interactions has been advanced extensively by work in the American Encounters/Global Interactions series edited by Gilbert M. Joseph and Emily S. Rosenberg. The series, published by Duke University Press, began with Gibert M. Joseph, Catherine LeGrand, and Ricardo Donato Salvatore, *Close Encounters of Empire: Writing the Cultural History of U.S.-Latin American Relations* (Durham, NC: Duke University Press, 1998). Other exemplars of the series are Michel Gobat, *Confronting the American Dream: Nicaragua under U.S. Imperial Rule* (Durham, NC: Duke University Press, 2005); Seigel, *Uneven Encounters*; Heidi Tinsman, *Buying into the Regime: Grapes and Consumption in Cold War Chile and the United States*, 2014.

32. Michel-Rolph Trouillot, *Silencing the Past: Power and the Production of History* (Boston: Beacon, 1995).

33. James Wertsch, "Blank Spots in Collective Memory: A Case Study of Russia," *Annals of the American Academy of Political and Social Science* 617, no. 1 (2008): 58–71.

34. Paloma Aguilar Fernandez and Carsten Humlebaek, "Collective Memory and National Identity in the Spanish Democracy: The Legacies of Francoism and the Civil War," *History and Memory* 14, no. 1 (2002): 121–164.

35. Among the supposed co-conspirators are Trujillo functionaries Isabel Mayer and Minerva Bernardino, who have been excoriated in popular histories; see Wenzell Brown, *Angry Men, Laughing Men: The Caribbean Caldron* (New York: Greenberg, 1947), 150, 170; Robert D. Crassweller, *Trujillo: The Life and Times of a Caribbean Dictator* (New York: Macmillan, 1966), 151; Franklin J. Franco, *La era de Trujillo* (Santo Domingo: Fundación Cultural Dominicana, 1992), 78.

36. María Jesús Pola Zapico, "María Trinidad Sánchez, Madre de la Patria," *El Nacional* (Santo Domingo), March 18, 2014, http://elnacional.com.do/madre-de-la-patria.

37. Lizabeth Paravisini-Gebert, "Women of Hispaniola in the Caribbean Context," in *The Women of Hispaniola: Moving towards Tomorrow: Selected Proceedings of the 1993 Conference*, ed. Daisy Cocco-DeFilippis (Jamaica, NY: York College, 1993), 27.

38. Ibid., 32.

39. Julia Alvarez, *In the Time of the Butterflies* (Chapel Hill, NC: Algonquin Books, 1994); Junot Díaz, *The Brief Wondrous Life of Oscar Wao* (New York: Riverhead Books, 2007); Mario Vargas Llosa, *La Fiesta del Chivo* (Madrid: Alfaguara, 2000).

40. For more on the ways those pushed to the margins have resisted and created alternative narratives of *dominicanidad* see Lorgia García-Peña, *The Borders of Dominicanidad: Race, Nation, and Archives of Contradiction* (Durham, NC: Duke University Press, 2016).

41. Since the end of the *doce años* the historical profession in the Dominican Republic has been dominated by men; furthermore, the process of dealing with a past bedeviled by dictatorship and U.S. aggression has favored a state-dominated political history from which women are excluded. The murdered Mirabal sisters are consistently offered as an antidote to this male-centric narrative.

42. A study conducted in 1993 by the Center for Gender Studies at the National Institute of Technology and Science in the Dominican Republic confirmed the silencing of women and gender in the national narrative. After looking to the major history texts taught at the country's prominent universities, Margarita Paiewonsky has argued that not only did Dominican historians reduce their own history to a "chronology of political and

economic events" but also that by focusing on the social history of power they had reduced the participation of women to a position of virtual insignificance. Although only three texts were analyzed, they collectively comprised the only works used at the college level in the nation's six major universities; references to the Mirabal sisters made up an average of 28 percent of all references to specific female figures in the three texts. The exclusion of women and gender in these texts has much to do with the periodization of Dominican history that generally organizes events in the past around major political battles and categorically denies the experiences of women who operated at the more local level. In all three texts the combined proportion of specific masculine references was 92.2 percent, with only fifty-two distinct female individuals mentioned, reinforcing the point that women appear exclusively in the Dominican narrative as heroes or martyrs; Margarita Paiewonsky, "Imagen de la mujer en los textos de historia dominicana," *Género y Sociedad* 1, no. 1 (May 1993): 30–59.

43. Examples include Ramón Alberto Ferreras, *Historia del feminismo en la República Dominicana (su origen y su proyección social)* (Santo Domingo: Editorial del Nordeste, 1991; Angel Lockward, *La mujer dominicana* (Santo Domingo: Fundación de Estudios Económicos y Políticos, Edicciones Literatura Popular, 1998); Maritza Olivier, *Cinco siglos con la mujer dominicana* (Santo Domingo: Amigo del Hogar, 1975); Yolanda Ricardo, *La resistencia en las Antillas tiene rostro de mujer (transgresiones, emancipaciones)* (Santo Domingo: Academia de Ciencias de la República Dominicana, 2004). One recent study offers an extensive list of pioneering women while also presenting some framing analysis that begins to place such women in a larger historical context; Valentina Peguero, *Mujeres pioneras dominicanas. Datos biográficos y bibliográficos* (Santo Domingo: Búho, 2015).

44. Paiewonsky, "Imagen de la mujer en los textos de historia dominicana," 48–49.

45. Margarita Cordero, *Mujeres de abril* (Santo Domingo: Centro de Investigación para la Acción Femenista, 1985); Ángela Hernández, *Emergencia del silencio: La mujer dominicana en la educación formal* (Santo Domingo: Editora Universitaria, Universidad Autónoma de Santo Domingo, 1986). In addition to her contributions to Cordero's *Mujeres de abril*, Magaly Pineda worked tirelessly through her life to draw attention to the concerns of Dominican feminism and the need to recognize women's roles in building a functional and democratic state; Pineda, "The Spanish-Speaking Caribbean: We Women Aren't Sheep," in *Sisterhood Is Global: The International Women's Movement Anthology*, ed. Robin Morgan (Garden City, NY: Anchor/Doubleday, 1984), 131–134. See also Celsa Albert Batista, *Mujer y esclavitud en Santo Domingo* (Santo Domingo: Ediciones CEDEE, 1993).

46. Daisy Cocco-DeFilippis, "The Politics of Literature: Dominican Women and the Suffrage Movement. Case Study: Delia Weber," in *Winds of Change: The Transforming Voices of Caribbean Women Writers and Scholars*, ed. Adele Newson and Linda Strong-Leek (New York: Peter Lang, 1998), 83–106; Carmen Durán, *Historia e ideología: Mujeres dominicanas, 1880–1950* (Santo Domingo: Archivo General de la Nación, 2010); Herrera Mora, *Mujeres dominicanas, 1930–1961*; María Filomena González Canalda, "Apuntes para el estudio sobre la autonomía de las mujeres en Bayaguana en el siglo XVIII y durante el período del 1822 al 1844," in *Miradas desencadenantes: Hacia una construcción de la autonomía de las mujeres*, ed. Lourdes Contreras (Santo Domingo: Instituto Tecnológico de Santo Domingo, 2014), 219–241; Quisqueya Lora H., "La difícil recuperación del papel de la mujer en la historia dominicana" (Santiago, Dominican Republic: Pontífica Universidad Católica Madre y Maestra, 2013); Teresita Martínez Vergne, "Bourgeois Women in

the Early Twentieth-Century Dominican National Discourse," *New West Indian Guide* 75, no. 1/2 (2001): 65–88.

47. Elizabeth Dore and Maxine Molyneux, preface to *Hidden Histories of Gender and the State in Latin America*, ed. Elizabeth Dore and Maxine Molyneux (Durham, NC: Duke University Press, 2000), xii.

48. Derby, "Dictator's Seduction" (2000), 1113.

49. Writing at the end of the regime, both Robert Crassweller and Jesús de Galíndez dismissed women's involvement. Galíndez, disappeared by the regime in 1956, had just completed his dissertation on Trujillo. It was published posthumously with the help of Russell Fitzgibbon. See Crassweller, *Trujillo*; Jesús de Galíndez, *The Era of Trujillo, Dominican Dictator* (Tucson: University of Arizona Press, 1973).

50. Zeller, *Discursos y espacios femeninos*.

51. April J. Mayes, *The Mulatto Republic: Class, Race, and Dominican National Identity* (Gainesville: University Press of Florida, 2014), 119.

52. Ginetta E. B. Candelario, "Al eco de su voz allende a los mares: La primera etapa en el pensamiento feminista dominicano," in *Miradas desencadenantes: Los estudios de género en la República Dominicana al inicio del tercer milenio*, ed. Ginetta E. B. Candelario (Santo Domingo: Centro de Estudios de Género, INTEC, 2005), 43–49.

53. "Feminismo Balaguerista: A Strategy of the Right," *NACLA's Latin America and Empire Report* 8, no. 4 (April 1974): 28–31; Vivian M. Mota, "Politics and Feminism in the Dominican Republic, 1931–1945 and 1966–1974," in *Women and Change in Latin America*, ed. June C. Nash and Helen Icken Safa (South Hadley, MA: Bergin and Garvey, 1986) 265–278; Shoshana B. Tancer, "La Quisqueyana: The Dominican Woman, 1940–1970," in *Female and Male in Latin America*, ed. Ann M. Pescatello (Pittsburgh, PA: University of Pittsburgh Press, 1973) 209–229.

54. M. Cordero, *Mujeres de abril*; Teresa Espaillat, *Abril en mis recuerdos: Testimonio de una combatiente* (Santo Domingo: Cocolo, 2001); Ruth Herrera, *Las viudas de los doce años* (Santo Domingo: Taller, 1996); Carolina Mainardi Vda. Cuello, *Vivencias* (Santo Domingo: Manatí, 2000); Alfonsina Perozo, *Los Perozo: Su exterminio por la dictadura de Trujillo; Mis vivencias* (Santo Domingo: Centenario, 2002); Ivelisse Prats-Ramírez de Pérez, *Los días difíciles* (Santo Domingo: Méndez y Abreu, 1982); Delta Soto, *Vivencias de una revolucionaria* (Santo Domingo: Editora Universitaria, Universidad Autónoma de Santo Domingo, 2004).

55. See, for example, Crassweller, *Trujillo*; Bernard Diederich, *Trujillo: The Death of the Dictator* (Princeton, NJ: Markus Wiener, 2000); Galíndez, *Era of Trujillo*.

56. Turits, *Foundations of Despotism*, 3–9.

57. Lillian Guerra, "Why Caribbean History Matters," *Perspectives on History* 52, no. 3 (March 2014): 32–33. See also Maja Horn, "Dictates of Dominican Democracy: Conceptualizing Caribbean Political Modernity," *Small Axe* 18, no. 2 (2014): 21.

58. Gilbert M. Joseph and Daniel Nugent, *Everyday Forms of State Formation: Revolution and the Negotiation of Rule in Modern Mexico* (Durham, NC: Duke University Press, 1994).

59. Jeffrey L. Gould, *To Lead as Equals: Rural Protest and Political Consciousness in Chinandega, Nicaragua, 1912–1979* (Chapel Hill: University of North Carolina Press, 1990).

60. Turits, *Foundations of Despotism*.

61. Lauren Hutchinson Derby, "The Magic of Modernity: Dictatorship and Civic Culture in the Dominican Republic, 1916–1962" (PhD diss., University of Chicago, 1998), 23;

Derby, *Dictator's Seduction* (2009), ix. See also Walter Cordero and Neici M. Zeller, "El desfile trujillista: Despotismo y complicidad," in *Homenaje a Emilio Cordero Michel*, eds. Emilio Cordero Michel and José Miguel Abreu Cardet (Santo Domingo: Academia Dominicana de la Historia, 2004): 113–174;

62. Sandra McGee Deutsch, "Gender and Sociopolitical Change in Twentieth-Century Latin America," *Hispanic American Historical Review* 71, no. 2 (May 1991): 259–306; Nicholas Fraser and Marysa Navarro, *Evita* (New York: W. W. Norton, 1996); see also Rebekah E. Pite, *Creating a Common Table in Twentieth-Century Argentina: Doña Petrona, Women, and Food* (Chapel Hill: University of North Carolina Press, 2013).

63. Eric Paul Roorda, *The Dictator Next Door: The Good Neighbor Policy and the Trujillo Regime in the Dominican Republic, 1930–1945* (Durham, NC: Duke University Press, 1998), 1.

64. Gilbert M. Joseph and Daniela Spenser, *In from the Cold: Latin America's New Encounter with the Cold War* (Durham, NC: Duke University Press, 2008).

65. Jadwiga E. Pieper Mooney, *The Politics of Motherhood: Maternity and Women's Rights in Twentieth-Century Chile* (Pittsburgh, PA: University of Pittsburgh Press, 2009), 11.

66. Karen Offen, "Defining Feminism: A Comparative Historical Approach," *Signs* 14, no. 1 (1988): 151.

67. For the latter see Susan K. Besse, *Restructuring Patriarchy: The Modernization of Gender Inequality in Brazil, 1914–1940* (Chapel Hill: University of North Carolina Press, 1996); Nicole L. Pacino, "Creating Madres Campesinas: Revolutionary Motherhood and the Gendered Politics of Nation Building in 1950s Bolivia," *Journal of Women's History* 27, no. 1 (2015): 62–87.

68. Mooney, *Politics of Motherhood*, 4.

69. González-Rivera, *Before the Revolution*; González-Rivera and Kampwirth, *Radical Women in Latin America Left and Right*; Sandra McGee Deutsch, *Las Derechas: The Extreme Right in Argentina, Brazil, and Chile, 1890–1939* (Stanford, CA: Stanford University Press, 1999); Margaret Power, "More than Mere Pawns: Right-Wing Women in Chile," *Journal of Women's History* 16, no. 3 (2004): 138–151; Power, *Right-Wing Women in Chile*.

70. Power, *Right-Wing Women in Chile*.

71. Sandra McGee Deutsch, "Spreading Right-Wing Patriotism, Femininity, and Morality: Women in Argentina, Brazil, and Chile, 1900–1940," in *Radical Women in Latin America Left and Right*, ed. Victoria González and Karen Kampwirth (University Park: Pennsylvania State University Press, 2001), 223–248.

72. Johanna I. Moya Fábregas, "The Cuban Woman's Revolutionary Experience: Patriarchal Culture and the State's Gender Ideology, 1950–1976," *Journal of Women's History* 22, no. 1 (2010): 62.

73. Ibid., 72. See also K. Lynn Stoner, "Militant Heroines and the Consecration of the Patriarchal State: The Glorification of Loyalty, Combat, and National Suicide in the Making of Cuban National Identity," *Cuban Studies* 34, no. 1 (2003): 71–96.

74. Virtudes Alvarez, *Mujeres del 16* (Santo Domingo: Mediabyte, 2005); Miguel Aquino García, *Tres heroínas y un tirano: La historia verídica de las hermanas Mirabal y su asesinato por Rafael Leonidas Trujillo* (Santo Domingo: Ediciones Universidad Interamericana UNICA, 1996); Herrera, *Las viudas de los doce años*; Herrera Mora, *Mujeres dominicanas, 1930–1961*.

75. Manley, "Poner un grano de arena: Gender and Women's Political Participation under Authoritarian Rule in the Dominican Republic, 1928–1978" (PhD diss., Tulane Uni-

versity, 2008); Mayes, "Why Dominican Feminism Moved to the Right"; Zeller, *Discursos y espacios femeninos*; Zeller, "The Appearance of All, the Reality of Nothing"; Neici M. Zeller and Margaret Power, "What Difference Does Gender Make? Women and Conservative Politics in the Dominican Republic and Chile, 1961–1978" (paper presented at the annual conference of the American Historical Association, Chicago, January 5–8, 1995).

76. Mayes, *Mulatto Republic*, 118.

77. Victoria González-Rivera, "Undemocratic Legacies: First-Wave Feminism and the Somocista Women's Movement in Nicaragua, 1920s–1979," *Bulletin of Latin American Research* 33, no. 3 (2014): 260.

78. Elisabeth Friedman, *Unfinished Transitions: Women and the Gendered Development of Democracy in Venezuela, 1936–1996* (University Park: Pennsylvania State University Press, 2000), 15. See also Georgina Waylen, "Women and Democratization: Conceptualizing Gender Relations in Transition Politics," *World Politics* 463 (1994): 327–354.

79. Sonia E. Alvarez, *Engendering Democracy in Brazil: Women's Movements in Transition Politics* (Princeton, NJ: Princeton University Press, 1990).

Chapter 1. Advocating Suffrage and Sovereignty: Pan-American Feminism and the Rise of the Trujillato, 1922–1942

1. Petronila Angélica Gómez, "Ya es hora," *Fémina* (San Pedro de Macorís), July 15, 1922, 1.

2. Lars Schoultz, *Beneath the United States: A History of U.S. Policy toward Latin America* (Cambridge, MA: Harvard University Press, 1998), 290–315; John F. Bratzel, introduction to *Latin America during World War II*, ed. Thomas M. Leonard and John F. Bratzel (Lanham, MD: Rowman and Littlefield, 2007).

3. Roorda, *Dictator Next Door*.

4. Millery Polyné argues that despite a long history of studies of pan-Americanism, the contributions of African American and Afro-Latino populations have been consistently ignored. Women's roles in pan-Americanism have similarly been understudied; *From Douglass to Duvalier: U.S. African Americans, Haiti, and Pan Americanism, 1870–1964* (Gainesville: University Press of Florida, 2010).

5. Miller, "Latin American Feminism and the Transnational Arena," 11.

6. Rafael Leónidas Trujillo Molina, "Opening Address," June 1, 1956, in IACW, *Conference Program for the Eleventh Assembly of the Inter-American Commission of Women* (Ciudad Trujillo [Santo Domingo]: Impresora Dominicana, 1956), 3.

7. Nancy Cott points out that women in the United States during the Progressive Era "could (and did) argue on egalitarian grounds for equal opportunity in education and employment and for equal rights in property, law and political representation, while also maintaining that women would bring special benefits to public life by virtue of their particular interests and capacities"; *The Grounding of Modern Feminism* (New Haven, CT: Yale University Press, 1987), 20.

8. This would fall under Karen Offen's distinction between "relational" and "individualistic" feminism, the former being a focus on women's particular contributions to society "as embodied, female individuals" and emphasizing their "childbearing and/or nurturing capacities"; *European Feminisms, 1700–1950: A Political History* (Stanford, CA: Stanford University Press, 2000), 22.

9. Heureaux's period of rule lasted from 1882 to 1899 and is credited with significant

economic and social modernization for the nation. On the period generally see Emelio Betances, *State and Society in the Dominican Republic* (Boulder, CO: Westview, 1995); Teresita Martínez-Vergne, *Nation and Citizen in the Dominican Republic, 1880–1916* (Chapel Hill: University of North Carolina Press, 2005). On the role of sugar and contested paths to modernity see Turits, *Foundations of Despotism*, 60–67.

10. Lauren Derby argues that Dominican liberalism at this point was "hegemonic" while at the same time highly socially conservative; *Dictator's Seduction* (2009), 15.

11. See Emelio Betances, "Social Classes and the Origin of the Modern State: The Dominican Republic, 1844–1930," *Latin American Perspectives* 22, no. 3 (Summer 1995): 20–40. For more on the influence of Hostos in women's education at the turn of the century see Hernández, *Emergencia del silencio*.

12. Martínez-Vergne, "Bourgeois Women."

13. Ibid., 81.

14. Gertrude M. Yeager, "Women's Roles in Nineteenth-Century Chile: Public Education Records, 1843–1883," *Latin American Research Review* 18, no. 3 (1983): 152. See also Steven Palmer, "Educating Señorita: Teacher Training, Social Mobility, and the Birth of Costa Rican Feminism, 1885–1925," *Hispanic American Historical Review* 78, no. 1 (1998): 45–82.

15. Salomé Ureña de Henríquez' support of Dominican nationhood is most evident in her poetry and prose; see her *Poesías completas* (Ciudad Trujillo: Impresora Dominicana, 1950). For a history of the school see Emilio Rodríguez Demorizi, *Salomé Ureña y el Instituto de Señoritas: Para la historia de la espiritualidad dominicana* (Ciudad Trujillo: Impresora Dominicana, 1960). It is notable that both books were published during the Trujillo period, the latter by one of the regime's leading intellectuals.

16. Martínez-Vergne, *Nation and Citizen*, 106; Zeller, *Discursos y espacios femeninos*, 15–46.

17. Eugenio María de Hostos, *La educación científica de la mujer* (Río Piedras: Editorial de la Universidad de Puerto Rico, 1993); Zeller, *Discursos y espacios femeninos*, 22.

18. Daisy Cocco-DeFilippis, "Los movimientos de sufragio y el ensayo femenino," in *Desde la diáspora: Selección bilingüe de ensayos* (New York: Ediciones Alcance, 2003), 241–243.

19. Zeller, *Discursos y espacios femeninos*, 38. Steven Palmer argues the same for Costa Rica; "Educating Señorita."

20. Betances, *State and Society in the Dominican Republic*, 74; Derby, *Dictator's Seduction*, 18. For more on the gradual militarization of U.S. foreign policy prior to the occupation see Ellen D. Tillman, "Militarizing Dollar Diplomacy in the Early Twentieth-Century Dominican Republic: Centralization and Resistance," *Hispanic American Historical Review* 95, no. 2 (2015): 269–298.

21. Martínez-Vergne, "Bourgeois Women," 65. While Martínez-Vergne refers to this group as a bourgeois intelligentsia, Emelio Betances argues that it was hardly solidified enough for such a title but rather an "embryonic bourgeoisie." Either way, they were clearly motivated by a desire to independently direct the country toward a more developed status for both internal and external consumption; Betances, *State and Society in the Dominican Republic*, 67.

22. On the U.S. occupation see G. Pope Atkins and Larman C. Wilson, *The Dominican Republic and the United States: From Imperialism to Transnationalism* (Athens: University of Georgia Press, 1998), 37–64; Betances, *State and Society in the Dominican Republic*; Bruce J. Calder, *The Impact of Intervention: The Dominican Republic during the U.S. Oc-*

cupation of 1916–1924 (Austin: University of Texas Press, 1984); Lauren Hutchinson Derby, "Magic of Modernity," 26–143; Rebecca Ann Lord, "An 'Imperative Obligation': Public Health and the United States Military Occupation of the Dominican Republic, 1916–1924" (PhD diss., University of Maryland, College Park, 2004); Turits, *Foundations of Despotism*, 71–79.

23. Derby, "Magic of Modernity," 30.

24. Sugar was touted by U.S. officials as the best path to economic solvency, but it was also in U.S. best interests to promote such a direction, which helps explain the diminished power of the Cibao elite as well as the rise of the Santo Domingo coterie; Calder, *Impact of Intervention*, 67–71.

25. Turits, *Foundations of Despotism*, 78.

26. For more on Gómez and San Pedro de Macorís see Mayes, *Mulatto Republic*, 125–128.

27. Club Nosotras was formed in Santo Domingo by Abigaíl Mejía Soliere. The name literally means "our club," with *nosotras* being the feminine first-person plural, "we women."

28. Petronila Angélica Gómez, "La Voz de América. Discutiendo sobre feminismo," *Fémina*, September 15, 1926, 1.

29. Several weeks after the arrival of the U.S. Marines, a group of seventeen women presented a petition to the U.S. delegation, ultimately requesting an alternative to occupation in the name of the Dominican family and national sovereignty. Zeller notes that teacher Ercilia Pepín sent a skirt to a male teacher who had hoisted the U.S. ensign upon arrival of the Marines in Santiago, clearly impugning the recipient's patriotism as well as his masculinity; *Discursos y espacios femeninos*, 52–65. See also Mayes, "Why Dominican Feminism Moved to the Right"; Alan McPherson, "Personal Occupations: Women's Responses to U.S. Military Occupations in Latin America," *Historian* 72, no. 3 (Fall 2010): 568–598; Neici M. Zeller, "'To Live the Modern Life!' Imperialism, Modernization, and the Gender War in the Dominican Republic, 1916–1924" (paper presented at the Tenth Berkshire Conference on the History of Women, Chapel Hill, NC, 1996).

30. Zeller, *Discursos y espacios femeninos*, 65–67.

31. Zeller, "'To Live the Modern Life!'"

32. Linda Kerber and other U.S. historians have used the term "Republican motherhood" to refer specifically to a type of U.S. female identity in the early nineteenth-century United States, but the idea has much wider implications in its reference to women's formative roles in raising citizens and their use of the idea of their role as mothers and educators to create political spaces as we see here; Kerber, *Women of the Republic: Intellect and Ideology in Revolutionary America* (Chapel Hill: University of North Carolina Press, 1980). For example, Sarah Chambers offers an alternative model in her reading of Manuela Sáenz that she calls "republican friendship," which allows for women who did not necessarily fit the model of mother for a variety of reasons; Chambers, "Republican Friendship: Manuela Sáenz Writes Women into the Nation, 1835–1856," *Hispanic American Historical Review* 81, no. 2 (2001): 225–257.

33. Gómez argued that these "beautiful specimens of women, with their love of study and enthusiastic devotion to the country's culture, honor not only people of whom they are daughters, but the Republic, giving an eloquent testimony of what a woman can do when suitably educated to exercise the professions"; "Notas breves," *Fémina*, August 15, 1925, 12.

34. Carmen de Burgos, "Feminismo y Trabajo," *Fémina*, August 1927, 1–2.

35. Chilean poet Gabriela Mistral weighed in on the debate, sending her reply directly to

Fémina and arguing that Burgos and the women of her feminist circle had falsely accused her of being opposed to the working woman. Rather, she intoned, she sought not to reduce women to their maternal roles but rather to channel those skills into appropriate work; Mistral, "Alrededor del feminismo," *Fémina*, October 1927, 1-2, 7.

36. Delia Weber, "Del feminismo: Amamos la discusión con amplitud y exquisitez del arte," *Fémina*, October 1927, 13-14, 17.

37. Carmen G. de Peynado, "El feminismo," *Fémina*, October 1927, 7, 9.

38. The precarious nature of endorsing women's professionalism must be stressed, as is evident by a series of articles published about Dominican lawyer Ana Teresa Paradas. After visiting New York and being interviewed by a local columnist, she said the woman had seriously misrepresented her and made it sound as though she was in full support of the U.S. occupation because of the advancements it offered women in the professional world. In March 1922 Paradas waged a fierce campaign against the article and the backlash it caused; Paradas, "En respuesto de una falsa imputación," *El Siglo* (Santo Domingo), March 22, 1922, reprinted in *Vetilio Alfau Durán en Anales: Escritos y documentos*, ed. Arístides Incháustegui and Blanca Delgado Malagón (Santo Domingo: Banco de Reservas, 1997), 652-653.

39. Zeller, *Discursos y espacios femeninos*, 73. Gómez' work, while groundbreaking in many ways, was not without precedent. Ginetta Candelario has noted that prominent feminist and *normalista* Mercedes Mota attended a conference of the International Council of Women in 1901 and offered a talk before the gathering that was subsequently printed in the local press; Candelario, "El eco de su voz," 45-46.

40. Gabriela Cano, "Elena Arizmendi, una habitación propia en Nueva York, 1916-1938," *Arenal* 18, no. 1 (June 2011): 105.

41. The return of Abigaíl Mejía, educator, prominent socialite, and student of Salomé Ureña, to Santo Domingo from Spain in 1925 marked an important transition in the early feminist movement. Mejía, who had spent several years in Europe receiving education, working for the Dominican government, and witnessing the activities of Spain's feminist groups, moved back to her native country with, by all accounts, a renewed enthusiasm for the Dominican women's movement; Lusitania Martínez, "Abigaíl Mejía y los inicios del movimiento feminista dominicano," in *Política, identidad y pensamiento social en la República Dominicana (siglos XIX y XX)*, ed. Raymundo González, Michiel Baud, and Pedro San Miguel (Santo Domingo: Academia de Ciencias Dominicana, 2000), 137.

42. The Santo Domingo newspaper *Listín Diario* regularly provided summaries of Club Nosotras gatherings; for example, "Un distinguido grupo de damas lanza la iniciativa de crear una nueva Sociedad Cultural," *Listín Diario*, July 26, 1927, 5, 7.

43. Paradas was the first female lawyer to graduate from the University of Santo Domingo; Zeller, *Discursos y espacios femeninos*, 62.

44. "Por qué Santo Domingo no envío delegadas a la conferencia femenina de Baltimore," *Listín Diario*, May 25, 1922, 1.

45. Derby, *Dictator's Seduction*, 27.

46. Calder, *Impact of Intervention*, 88.

47. Zeller, "'To Live the Modern Life!'"; Derby, "Magic of Modernity," 56-57. For similar fears of public women in Brazil see Besse, *Restructuring Patriarchy*.

48. Attempting to create a greater sense of domestic stability and individual civic duty through the home, ruling U.S. forces encouraged marriage and the putative nuclear family and yet also allowed for the recognition of children born out of wedlock, creating some

relief for single mothers; Calder, *Impact of Intervention*, 88–89. As a number of scholars of the occupation point out, U.S. efforts vis-à-vis gender proved, at times, highly contradictory.

49. Derby, Mayes, and Zeller all mention the increased number of women in professional arenas, although the irony is that the move served to dent funding to the normal schools; Derby, "Magic of Modernity," 96; Mayes, "Why Dominican Feminism Moved to the Right," 356–357; Zeller, *Discursos y espacios femeninos*, 58–62. Zeller also indicates that permissions were granted to women under the occupation government to practice medicine and apply for civil service jobs; "'To Live the Modern Life!'"

50. For more on Trujillo and his solidification of control through the National Guard see Crassweller, *Trujillo*; Galíndez, *Era of Trujillo*; Germán E. Ornes, *Trujillo: Little Caesar of the Caribbean* (New York: Thomas Nelson and Sons, 1958).

51. For more on the "Revolution of 1930" see Betances, *State and Society in the Dominican Republic*, 97; Derby, *Dictator's Seduction*, 20; Galíndez, *Era of Trujillo*, 10–15; Frank Moya Pons, *The Dominican Republic: A National History* (Princeton, NJ: Markus Wiener, 1998), chapter 17.

52. Maja Horn argues for the need to understand the Trujillato as a distinct (and gendered) political-social period yet not treat it as a grotesque aberration; *Masculinity after Trujillo*, 15–18.

53. Betances, *State and Society in the Dominican Republic*, 97. For an approach that addresses rural support for the regime in its earliest stages see Turits, *Foundations of Despotism*, 80–97.

54. Derby, *Dictator's Seduction*, 5.

55. Livia Veloz explains that "al calor de esas actividades culturales nació la idea" (the idea of forming the AFD was borne of the excitement of these activities); *Historia del feminismo en la República Dominicana* (Santo Domingo, 1977), 15. However, Neici Zeller notes that it was actually a group of university students who convinced the feminist-leaning members to create the new group; *Discursos y espacios femeninos en República Dominicana, 1880–1961*, 82.

56. Veloz, *Historia del feminismo en la República Dominicana*, 15. A book written by Ercilia Pepín's students states that on February 28, 1932, a Santiago subcommittee of the AFD was formed and the 105 attendees elected Pepín as its honorary president; *Algunas notas biográficas de la insigne patricia y educadora señorita Ercilia Pepín* (Santiago, Dominican Republic: L. H. Cruz, 1932).

57. The initial agenda of the organization was considerably broad, including topics as varied as penal facility reform, alcoholism, and foreign landownership. After its first major conference the platform remained diverse, centering on issues of social welfare with a concentration in women's education and reflecting the organization's dual goals of progress and social welfare; AFD, "Estado actual de la organización y de las labores realizadas por la 'Accion Feminista Dominicana,'" February 1, 1932; 78-M196, Box 31, Folder I98; Doris Stevens Papers, 1884–1983, Schlesinger Library, Radcliffe Institute, Harvard University (hereafter Stevens Papers). The research for this chapter was conducted in 2005; citations reflect the old index rather than the more recent reorganization of the collection.

58. The letterhead appears on Consuelo González Suero to Doris Stevens, November 30, 1931; 78-M196, Box 31, Folder I98; Stevens Papers.

59. Francesca Miller stresses that while Stevens was essential to the IACW's formation,

equally so were the demands of the Latin American women's groups in attendance; *Latin American Women and the Search for Social Justice* (Hanover, NH: University Press of New England, 1991). For more on leader Doris Stevens see Leila J. Rupp, "Feminism and the Sexual Revolution in the Early Twentieth Century: The Case of Doris Stevens," *Feminist Studies* 15, no. 2 (1989): 289–309.

60. Stevens to Gómez, September 29, 1929, 78-M196, Box 36, Folder I346, "Publicity," Stevens Papers.

61. Lcda. Consuelo González Suero and Gladys de los Santos to Inter-American Commission of Women, Santo Domingo, August 14, 1931, 78-M196, Box 31, Folder I98, Stevens Papers.

62. Gómez did not remain silent on the matter, reminding *Fémina* readers of its work since 1922 and referring to Mejía as a "figura antifeminista"; Zeller, *Discursos y espacios femeninos*, 88–89.

63. Consuelo González Suero and Gladys E. de los Santos to Doris Stevens, November 30, 1931 (IACW's translation); A104, Box 10, Folder 27, Stevens Papers.

64. AFD, "Estado actual de la organización," March 29, 1932, Stevens Papers.

65. The importance of Trujillo's 1932 speech at the Ateneo to the women's movement can be seen through its repeated publication. It appears in Carmen Lara Fernández, *Historia del feminismo en la República Dominicana* (Ciudad Trujillo: Arte y Cine, 1952), and María Caridad Nanita, *La mujer dominicana en la era de Trujillo* (Ciudad Trujillo: Impresora Dominicana, 1953). It was replicated in its entirety in *Listín Diario* as well as in *Equal Rights* (June 11, 1932, 152), likely at the request of the AFD; both replications can be found in 78-M196, Box 31, Folder I98, Stevens Papers.

66. Stevens to Mejía, November 12, 1933, 78-M196, Box 31, Folder I98, Stevens Papers.

67. Bernardino had been involved with the AFD but was not the most likely candidate. Neici Zeller notes that Bernardino attended the conference without AFD approval. Given her humble origins and menial job, it is unclear how she procured the funds; Zeller, "The Appearance of All, the Reality of Nothing," 96.

68. *Equal Rights*, Special Pan American Edition, July 7, 1934 (Washington, DC), A-104, Box 3, Folder 33, Stevens Papers.

69. Like Bernardino, Landestoy was a member of the AFD but not one of its most prominent activists; she similarly used the IACW as leverage for greater domestic opportunities. While by no means rich, Landestoy had greater resources than Bernardino and family in the United States. For evidence that they both struggled to find the resources to spend time in Washington with Stevens see the correspondence in 78-M196, Box 31, Folders I98–99, Stevens Papers.

70. See the folder titled "Photos" in 78-M196, Box 23, Stevens Papers. Between 1933 and 1938 Bernardino and Landestoy were frequently present at the Pan American Union offices and seemed to loathe returning to their own country. They waxed nostalgic for their time at the IACW and with their "dearest Doris," and their letters are full of collegial affection.

71. Cited in "Inter American Commission of Women: Documents Concerning Its Creation and Organization," 32, A-104, Box 3, Folder 32, Stevens Papers.

72. Abigaíl Mejía (de Fernández), Directora General, AFD, to Doris Stevens, IACW, May 20, 1932, 78-M196, Box 31, Folder I98, Stevens Papers.

73. Mejía to Stevens, March 8, 1938, A104, Box 10, Folder 27, Stevens Papers.

74. Stevens to Trujillo, April 11, 1934; Stevens to Trujillo, April 13, 1934, 78-M196, Box 29, Folder I9, Stevens Papers.

75. Programa de la "Acción Feminista Dominicana," Santo Domingo, May 14–15, 1932, 78-M196, Box 31, Folder I98, Stevens Papers.

76. In Fernández, *Historia del feminismo en la República Dominicana*, 25.

77. In notes for an unpublished manuscript Stevens indicated that she had brought along a "huge scrapbook of clippings showing her country-wide campaign for the election"; Box 11, Folder 351, Stevens Papers.

78. To my knowledge, no such practice vote was enacted anywhere else in Latin America.

79. Veloz notes that despite the paltry nature of such a sum, they did what they could, as "there was no other option"; *Historia del feminismo en la República Dominicana*, 35.

80. A report to Stevens from the AFD indicates that only 25 women voted against suffrage and that while 632,441 women of legal age did not vote, the number of nonvoting men was similarly high, at 550,704; AFD, "Informe sobre las elcciones femeninas de ensayo," 78-M196, Box 31, Folder I99, and AFD to Stevens, 78-M196, Box 31, Folder I101, Stevens Papers.

81. The letter was written in French, likely to evade regime censorship; Mejía to Stevens, November 19, 1938, 78-M196, Box 31, Folder I101, Stevens Papers. Many thanks to Neici Zeller for helping to translate this letter from Mejía.

82. In a letter following the *voto de ensayo* Landestoy wrote of the collective, "Unfortunately they had so many disagreements amongst themselves that President Trujillo was disappointed in them"; Landestoy to Stevens, October 31, 1934, 78-M196, Box 31, Folder I99, Stevens Papers.

83. Mejía to Stevens, December 30, 1939, 78-M196, Box 31, Folder I101, Stevens Papers.

84. Robin Derby and Richard Turits, "Historias de terror y los terrores de la historia: La masacre haitiana de 1937 en la República Dominicana," *Estudios Sociales* 26, no. 92 (1993): 65–76; Edward Paulino, *Dividing Hispaniola: The Dominican Republic's Border Campaign against Haiti, 1930–1961* (Pittsburgh, PA: University of Pittsburgh Press, 2016).

85. Eric Paul Roorda, "Genocide Next Door: The Good Neighbor Policy, the Trujillo Regime, and the Haitian Massacre of 1937," *Diplomatic History* 20, no. 3 (1996): 301.

86. Eliades Acosta Matos, *La dictadura de Trujillo: Documentos*, vol. 2, book 1 (Santo Domingo: Archivo General de la Nación, 2012), 385.

87. For a version of the speech at Mayer's home see Crassweller, *Trujillo*, 154. Several weeks earlier, provincial officials in Monte Cristi reported to a capital newspaper that a tribute would be held soon in Mayer's honor as a result of Trujillo deciding to rename Villa Demetrio Rodríguez as Villa Isabel in her honor. It is possible this was the reason for the event at her home; "Monte Cristi redirá pronto un homenaje a doña Isabel Mayer," *Listín Diario*, October 5, 1937, 4.

88. "La voz de la mujer dominicana," *Listín Diario*, November 29, 1940, 2.

89. "El voto simbólico de la mujer," *Listín Diario*, May 18, 1938. Earlier newspaper accounts covered meetings and open expressions of support among women calling for Trujillo's reelection, many nearly begging him to accept the nomination; see "Pide la reelección del Honble. Pdte. Trujillo para el periodo 1938–1942 la mujer noroestana," *Listín Diario*, October 9, 1937, 1.

90. "342,458 mujeres votaron por el creador de la paz dominicana," *La Opinión*, May 18, 1938. A note from the AFD to the IACW reports similar statistics; Gladys de los Santos to Stevens, 78-M196, Box 31, Folder I100, Stevens Papers.

91. Sample ballots sent to Stevens from Maria Caridad Nanita León and Maria Luisa Nanita León, 78-M196, Box 31, Folder I100, Stevens Papers.

92. Mejía to Stevens, November 15, 1938, 78-M196, Box 31, Folder I101, Stevens Papers.

93. Mejía forwarded copies of her *Ideario Feminista*, and pediatrician de los Santos sent Stevens an imprint of her book on proper child care; 78-M196, Box 31, Folders I100 and I101, Stevens Papers.

94. Although only briefly, Bernardino did speak out against the dictatorship when she said at a dinner that the government of the Dominican Republic was a dictatorship and that Trujillo refused to grant the vote to women, hence her stay of one year and ten months in the United States; Bernardino speech at the Women's City Club, Washington, DC, June 8, 1937, 78-M196, Box 19, Folder I30, Stevens Papers.

95. Partido Dominicano, Correspondence, Junta Central Directiva, Circular Nos. 10389, 10245, 10348, January 14, 1938, Archivo General de la Nación, Santo Domingo (hereafter AGN).

96. Partido Dominicano, Correspondence, Junta Central Directiva, Circular Nos. 10377–10378, January 14, 1938, AGN; Nanita, *La mujer dominicana en la era de Trujillo*, 12.

97. Stevens noted in a memo for an unpublished book that upon asking U.S. Secretary of State Cordell Hull whether she should accept the invitation, he responded with a question: "Could I take the criticism that might be forthcoming for accepting this invitation, since it was pressure from our government which had prevented President Trujillo from seeking a third term as President?"; "Book Notes," 76-246, Box 11, Folder 351, Stevens Papers.

98. Stevens to Landestoy, October 26, 1938, 78-M196, Box 31, Folder I100, Stevens Papers.

99. Bernardino to Consuelo González Suero, September 7, 1938, 78-M196, Box 31, Folder I103, Stevens Papers.

100. "Encuesta Nacional," *La Nación*, December 4–30, 1940.

101. Milady Félix Miranda married, dropping her maternal last name to adopt her husband's name; Félix de L'Official, "Encuesta Nacional," *La Nación*, December 5, 1940, 9.

102. Mejía, "Encuesta Nacional," *La Nación*, December 11, 1940, 9, 11.

103. Lcdo. Luis Romanace, San Cristóbal, "Encuesta Nacional," *La Nación*, December 4, 1940, 9.

104. Lcda. Fredesvinda Pérez, Azua, "Encuesta Nacional," *La Nación*, December 28, 1940, 9.

105. Rosa Smester, "Encuesta Nacional," *La Nación*, December 18, 1940, 9.

106. *La Nación* listed the following invitees, making clear who was now included in the blessed coterie of activists: Minerva Bernardino (vice president, IACW), Isabel Mayer, Aurora de Nanita, Mercedes Soler Vda. Peynado, Nieves Luisa Trujillo de Castillo, Delia Weber (director, AFD), Julieta Pérez de Medrano, Marina R. de Cruz Ayala, Silveria R. de Rodríguez Demorizi, Floripez Mieses Vda. Carbonell, Celeste Wos y Gil, Cristina Peynado Soler, Carmita Landestoy, Dolores Patiño, Niní P. de Martí, Consuelo Bernardino (Minerva's sister), Eleonora Heredia, Lidia Pichardo, Carmen Lara Fernández, Ana Leonor Marínez Lavandier, Ramonita Martínez Lavandier, and Clementina Henríquez. In addition to the familiar names, many of the women in attendance were siblings or wives of high-level officials, including Trujillo's sister; "El feminismo dominicano ofreció testimonio de gratitude y adhesion al Generalísimo Trujillo en acto solemne celebrado en la Cámara Baja," July 20, 1941, 9.

107. This significant political change was subsumed by the more celebratory issue of suffrage; Zeller, "The Appearance of All, the Reality of Nothing," 127–128.

108. Bernardino to Stevens, May 22, 1942, 78-M196, Box 31, Folder I101, Stevens Papers.

109. Stevens to Grace Jacobs, May 25, 1936, 78-M196, Box 36, Folder I385, Stevens Papers. To my knowledge, Stevens never commented on the Haitian massacre; after her celebrated trip to Santo Domingo she received a harsh telegram from the Dominican Revolutionary Union criticizing her contact with Trujillo and saying the "so-called emancipation of Dominican women would be but a cynical mockery"; August 1938, 78-M196, Box 31, Folder I103, Stevens Papers.

Chapter 2. Defending the Home against the Chaos of Communism: Women, Regime Politics, and the Cold War, 1942–1961

1. Carmen G. Vda. Peynado, "A las mujeres intelectuales de la República Dominicana," *La Opinión*, November 22, 1943, 2, 7. The piece was reprinted during the actual centennial in the bimonthly Ciudad Trujillo newspaper *La Mujer en la Era de Trujillo*, January 15, 1944, 7. *Vda*. is used in place of *Viuda de* in the Dominican Republic to refer to widowed women. For some women, maintaining this convention as part of their names served as a signifier for their husbands' sacrifices in service of the opposition.

2. Nanita, *La mujer dominicana en la era de Trujillo*, 11. Zeller lays out how the term *damas trujillistas* became more prominent as the regime began relying on elite officials' wives beginning in the late 1930s; "The Appearance of All, the Reality of Nothing," 106–162.

3. Some recent studies have sought to bring Cold War history in Latin America "in from the cold," to borrow Joseph and Spenser's 2008 book title, and look beyond the typical narratives of state-directed policy; see Joseph and Spenser's introduction to their edited volume, *In from the Cold*, 16, and other contributions to that collection as well as Mire Koikari, *Pedagogy of Democracy: Feminism and the Cold War in the U.S. Occupation of Japan* (Philadelphia: Temple University Press, 2009); Jadwiga E. Pieper Mooney and Fabio Lanza, eds. *De-Centering Cold War History: Local and Global Change* (New York: Routledge, 2012).

4. Howard Wiarda refers to Perón's corporatism in Argentina as the "prototype," arguing that it combined authoritarianism with an attention to labor and an emphasis on group rights over those of the individual; *Corporatism and Comparative Politics: The Other Great Ism* (Armonk, NY: M. E. Sharpe, 1996), 113–114. Joel Wolfe points to the gendered nature of such a project in the case of Brazil; "From Working Mothers to Housewives: Gender and Brazilian Populism from Getúlio Vargas to Juscelino Kubitschek," in *Gender and Populism in Latin America: Passionate Politics*, ed. Karen Kampwirth (University Park: Pennsylvania State University Press, 2010), 91–109.

5. The historiography of the second half of the regime generally focuses on the resistance movements that began to develop in the mid-1940s with the expedition of Cayo Confites and culminated with the assassination of the Mirabal sisters by Trujillo in 1960; Aquino García, *Tres heroínas y un tirano*; Roberto Cassá, *Los orígenes del Movimiento 14 de Junio* (Santo Domingo: Editora Universitaria, Universidad Autónoma de Santo Domingo, 1999); José Israel Cuello H., *¿Qué era la resistencia antitrujillista interna a la hora de la invasión de Constanza, Maimón y Estero Hondo, el 14 de junio de 1959?* (Santo Domingo: Fundación Testimonio, 1983); José Diego Grullón, *Cayo Confites: La revolución traicionada* (Santo Domingo: Alfa y Omega, 1989).

6. While it would be extremely difficult to track every woman who actively or passively excused herself from an active role in the party, the actions of some serve to demonstrate that not all women facilely folded themselves into Trujillo's version of feminism. For ex-

ample, later resistance activist Carmen Natalia Martínez Bonilla shows up on the rolls of the 1944 Dominican Feminine Congress, and Carmita Landestoy would eventually leave her post as head of the Dominican Party Women's Section for exile in the United States and write a book denouncing the regime.

7. Derby, *Dictator's Seduction* (2009), chapter 4.

8. Regime leaders evidently believed that women's participation should be channeled through a distinct and psuedo-independent group; they created a female branch or auxiliary that would be subservient to the larger party structure but appear autonomous. For an excellent discussion of a women's branch under the regime of Somoza in Nicaragua see chapter 3 of González-Rivera, *Before the Revolution*.

9. Partido Dominicano, Correspondence, Junta Comunal, Restauración, Circular No. 054, February 26, 1942, AGN.

10. Although ultimately still a single-party system, the creation of the Partido Trujillista (PT) on November 15, 1940, served as a shallow demonstration of the dictator's openness to competing political organizations. Given that Trujillo declared women's rights later that same year, it could have been originally intended either as a women's branch or as a space for the reformation of strayed citizens. For more on the formation of the Partido Trujillista see Galíndez, *Era of Trujillo*, 47–50.

11. Not all women were pleased with this arrangement. Given the ubiquity of PD membership among Dominican men, women were confused as to how they could achieve suffrage while being denied what they viewed as their full rights as citizens; see, for example, Adela Ramirez Alvarez to Virgilio Álvarez Pina, June 15, 1942, Partido Dominicano, Correspondence 1942, AGN.

12. Partido Dominicano, Correspondence, Junta Central Directiva, Circular No. 271, June 9, 1942, AGN.

13. Landestoy, despite being denied the opportunity to be the Dominican representative to the IACW, recovered quickly. Upon being tapped as the incoming president of the Sección Femenina, she proclaimed her readiness to head up the group of women eager to join the ranks of the official party. Her selection was both obvious and potentially problematic. Although she was known for her journalism and participation in the IACW, she was never the most prominent member of the feminist cadre.

14. After returning from her work with the IACW, Landestoy began publishing a new magazine in the capital entitled *El Hogar*. The publication, dedicated to Dominican women and their everyday realities as mothers and new citizens, allowed her a space from which to curry favor with the regime and promulgate her ideas on citizenship and maternalism. On several occasions Landestoy wrote to Trujillo to request aid for her magazine. She also published the magazine *Prédica y Acción* after the women's branch began its social assistance work.

15. An allocation was approved in November 1943 to donate a portion of kerosene sales throughout the country to the *desayuno escolar* (school breakfast) programs, with all remaining funds to be spread evenly to other programs in *asistencia social*; Partido Dominicano, Correspondence, November 1943, AGN.

16. "La mujer en acción," *La Mujer en la Era de Trujillo*, November 30, 1942, 4.

17. Zeller, "The Appearance of All, the Reality of Nothing," 145.

18. See Partido Dominicano, Correspondence, July-August-September 1942, AGN.

19. Trujillo renamed the capital in 1936 and changed the names of several provinces, thousands of streets and parks, and the nation's tallest mountain to reflect his and his fam-

ily's names. The capital city's name was restored to Santo Domingo after his assassination, as were names of all the other entities.

20. Morató Vda. Egea, "Progreso de las escuelas de alfabetización," *La Mujer en la Era de Trujillo,* November 15, 1942, 8. Morató Vda. Egea was one of the most vocal proponents outside the Sección Femenina for the involvement of Dominican women in Trujillo's national improvement projects. Her newspaper, *La Mujer en la Era de Trujillo*, appeared bimonthly in Ciudad Trujillo from 1942 to 1952 and showcased the activities of the Sección Femenina and other distinguished *damas trujillistas*.

21. The first edition appeared on May 30, 1943. Reproductions of the front page of each edition during 1943 can be found in Carmita Landestoy, *Mis relaciones con el Presidente Trujillo* (Ciudad Trujillo, 1945).

22. Unsigned to "Grande y Amado Jefe," Partido Dominicano, Correspondence, December 1942, AGN. It should be noted that the initiative for the event came from top party brass who closely monitored all the speeches; Zeller, "The Appearance of All, the Reality of Nothing," 156.

23. While women in each of the sixteen provincial juntas of the women's branch organized for the success of the congress planned for January 1943, the event still maintained a profile distinct from the everyday functions of the Sección Femenina. The commission entrusted to aggregate the public fervor for the congress and plan its every detail consisted of several of the most prominent women in Ciudad Trujillo, including Delia Weber, Maria Teresa Nanita de Espaillat, and Milady Félix de L'Official. For evidence of cooperation by encargadas in the provinces see V. Álvarez Pina to Nidia B. de Paeiwonsky, November 6, 1942, Partido Dominicano, Correspondence, Junta Central Directiva, AGN.

24. "Designadas presidentas de honor," *La Nación,* January 9, 1943, 3, 5.

25. Comisión Nacional Organizadora, "Primer Congreso Femenino Dominicano, Resolución," Partido Dominicano, Correspondence, Primer Congreso Femenino Dominicano, Legajo 515273, AGN. Bernardino distributed the resolution widely across her transnational networks, including to the subsecretary of the Pan American Union; Bernardino to Pedro de Alba, February 12, 1943, Correspondence, Primer Congreso Femenino Dominicano, Legajo 515273, AGN.

26. "Programa del Primer Congreso Femenino Dominicano," Partido Dominicano, Correspondence, Primer Congreso Femenino, Legajo 515273, AGN.

27. For a more extensive discussion on the project of Dominicanization of the borderlands and the 1937 massacre as an act of national consolidation see Paulino, *Dividing Hispaniola*; Richard Lee Turits, "A World Destroyed, a Nation Imposed: The 1937 Haitian Massacre in the Dominican Republic," *Hispanic American Historical Review* 83, no. 3 (2002): 589–635.

28. Octavia S. Vda. Valverde, "Madrinas de lectura par alas escuelas fronterizas," Partido Dominicano, Correspondence, Primer Congreso Femenino, Legajo 515273, AGN.

29. Altagracia Rodríguez de Monclús, "La protección a la maternidad y la infancia," Partido Dominicano, Correspondence, Primer Congreso Femenino, Legajo 515273, AGN. Andrea Morató Vda. Egea increased the vitriol of this discourse in several of her editorials, citing the need to build "a containment wall" to prevent "foreign leaks"; editorial, "Ayuda fronteriza, patriotismo vigilante de Trujillo," *La Mujer en la Era de Trujillo,* January 15, 1944, 2.

30. The president of the party wrote to remind Landestoy that "as a permanent norm of your actions, you must always obtain the most collaboration possible for your activities, in

application of the principles of harmony and understanding to each detail [of your work]." Still, it failed to fill the requirements of a major concern, logistically speaking; Virgilio Álvarez Pina to Carmita Landestoy, November 25, 1943, Partido Dominicano, Correspondence, November 1943, AGN.

31. Luminaries like Senator Isabel Mayer, lawyers Margarita Vda. Peynado and Milady Félix (Miranda) de L'Official, and regular participants Amada Nivar de Pittaluga, Josefa Sánchez de González, and Carmita Landestoy spearheaded the efforts of the committee, and Lucila Sanchez de Álvarez, wife of the president of the Dominican Party, served as treasurer. The group is rather illustrative of the old and new members, with Mayer, Peynado, Landestoy, and Félix de L'Official representing the older cohort of AFD members and the remainder belonging to the more elite club of officials' wives.

32. Attendance at the planning meeting numbered more than two hundred women, and the proposals, a newspaper article indicates, were received "with applause and great demonstrations of support by the important group of distinguished ladies who filled the rooms of the Ateneo"; "Un busto a la Heroína Maria Trinidad Sanchez y el Collar de la Paz al Hon. Presidente Gralsmo. Trujillo Molina," *La Opinión*, November 2, 1943, 1–2.

33. Mayer and Sánchez de González each contributed one hundred Dominican pesos. Ernestina de Roa wrote to *La Opinión* to publicly display her support, noting she could only contribute the "modest" sum of twenty-five; "La señora Ernestina de Roa se adhiere entusiásticamente a la iniciative de imponer el collar de la paz al Generalísimo Trujillo y erigir un busto a María Trinidad Sanchez," *La Opinión*, November 9, 1943. See also Mercedes Tulia S. de Casado to Lucila Sanchez de Álvarez Pina, November 30, 1943, Partido Dominicano, Correspondence, Junta Central Directive (1943, vol. 40), AGN.

34. Larger towns could rely on a more formal fund-raising practice; smaller rural communities depended on local social activities to gather donations. Although generally pleased with local efforts, Landestoy was concerned about the section's programs when she encouraged *encargadas* to redouble their efforts "so that the ten aspects of our labor can be shown through actual deeds in time for the glorious date of the Centennial"; Landestoy to Adolfina R. Mejía de López, September 15, 1943, Partido Dominicano, Correspondence, Junta Central Directiva (1943, vol. 30), AGN.

35. Amada Nivar de Pittaluga, "Dianas del Centenario," *La Opinión*, November 5, 1943, 1–2.

36. María Patín Pichardo de Lamarche, "Una doble glorificación" *La Opinión*, November 6, 1943, 1–2.

37. In the small pantheon of prominent Dominican women Trinidad Sánchez is perhaps the most referenced. My discussions with Neici Zeller on this point have been instrumental in understanding the strategic power of Trinidad Sánchez to the *damas trujillistas*. For a later example see "La mujer al amparo de Trujillo," *La Mujer en la Era de Trujillo*, October 24, 1950, 3.

38. Bernardino, in Unión Panamericana, *Boletín de la Comisión Interamericana de Mujeres* (Washington, DC), February 1944, 76–246, Box 21, Stevens Papers.

39. Landestoy to Presidentas de las Juntas Comunales del Partido Trujillista, November 4, 1943, Partido Dominicano, Correspondence, Oficios (1943, vol. 14), AGN.

40. Bernardino, in Unión Panamericana, *Boletín de la Comisión Interamericana de Mujeres*, February 1944, 76–246, Box 21, Stevens Papers.

41. Juan Ulises García Bonnelly, *Las obras públicas en la era de Trujillo* (Ciudad Trujillo: Impresora Dominicana, 1955), 212–215, 223.

42. "Se repartirá una gran cantidad de trajes y zapatos entre personas necesitadas de esta ciudad el próximo 27 de febrero," *La Nación*, February 2, 1945, 4; and "Partido Dominicano" *La Nación*, February 24, 1945, 3.

43. In García Bonnelly, *Las obras públicas en la era de Trujillo*, 238.

44. Female memorialists during the Trujillato fail to note a distinction between the work undertaken by the *damas trujillistas* before the announcement of the plan and those activities directed by women in the wake of the reorganization, as if to stress their own continuity in the work they felt was theirs. As noted in the magazine *Previsión Social*, they continued to exclusively comprise the committees of Mothers Clubs, Social Workers, School Breakfast, Adult Literacy, School Uniforms, Clothing for the Poor, and Frontier Aid into the 1950s; Carmen Lara Fernández, *Historia del feminismo en la República Dominicana*; Petronila Angélica Gómez, *Contribución para la historia del feminismo dominicano* (Ciudad Trujillo: Librería Dominicana, 1952); Nanita, *La mujer dominicana en la era de Trujillo*.

45. "Se repartirá una gran cantidad de trajes y zapatos entre personas necesitadas de esta ciudad el próximo 27 de febrero," *La Nación*, February 2, 1945, 4.

46. "Celébranse brillantes actos con motivo de natalicio del Generalísimo Trujillo," *La Nación*, October 23, 1945, 1.

47. "Asistencia social en Barahona," *La Nación*, January 15, 1945, 7.

48. The six border provinces were Monte Cristi, Libertador, San Rafael, Independencia, Barahona, and Baoruco.

49. "Lo que necesita Barahona," *La Nación*, February 14, 1945, 7.

50. Trujillo had changed the term of the presidency from four to five years under the same cloak of women's rights as he had eliminated the vice presidency in 1942.

51. Bernardino in "La mujer y la reelección," *La Nación*, September 22, 1945, 5. The reelection cycle generally lasted two years.

52. "Manifestación reeleccionista de la mujer puertoplateña," *La Nación*, January 15, 1945, 7.

53. "Con nuestra idea reeleccionista," *La Nación*, March 14, 1945, 3.

54. "Las mujeres capitaleñas cerraron anoche la campaña reeleccionista que iniciaron en Santiago en el 1945," *La Opinión*, May 10, 1947, 3.

55. The party summarized the event saying that the women were justly grateful for the "peace and tranquility" Trujillo had provided for the Dominican family; Partido Dominicano, Memoria, 1947, Biblioteca Nacional, Santo Domingo.

56. The Second Feminine Congress, held in December 1945, was purportedly a follow-up to the previous year's all-women's convention but instead served as a rallying center for the Trujillo reelection campaign by women in Santiago; "Las damas que dirigirán el movimiento reeleccionista," *La Nación*, September 19, 1945, 3; Ernesto J. Suncar Méndez, "La mujer dominicana en franca actividad política de adhesion a la reeleccción del benefactor de la Patria," *La Nación*, September 21, 1945, 5.

57. Given her prominent political positions, Mayer was clearly favored by the regime. Party correspondence indicates that she was gifted with a Chevrolet Deluxe Sports Sedan in 1940 authorized by Trujillo himself; Derby, "Magic of Modernity," 352.

58. "Nuevas contribuciones para el monumento a la paz de Trujillo," *La Nación*, May 1, 1944, 3.

59. "Damas de esta ciudad que fueron inscritas en la Sección Femenina del Partido Dominicano," *La Nación*, February 11, 1945, 4.

60. Despite an official enrollment sheet that women were required to fill out, many wrote directly to the party to request membership and relied on a consistent script to prove their loyalty despite a lapsed membership.

61. Women still held elected positions and official posts, but most of the female leaders of *asistencia social* were effectively marginalized; Zeller, *Discursos y espacios femeninos*, 147–148.

62. For more on Trujillo's relations with the United States during World War II, particularly the benefits of the Lend-Lease Act for the Dominican Republic see Eric Paul Roorda, "The Dominican Republic: The Axis, the Allies, and the Trujillo Dictatorship," in *Latin America during World War II*, ed. Thomas Leonard and John F. Bratzel (Lanham, MD: Rowman and Littlefield, 2007), 75–91.

63. Ibid., 89–90. See also Crassweller, *Trujillo*, 214–215.

64. Cited in Galíndez, *Era of Trujillo*, 235–236.

65. Jonathan Hartlyn, *The Struggle for Democratic Politics in the Dominican Republic* (Chapel Hill: University of North Carolina Press, 1998), 45. By 1959 Trujillo had even constructed an "anticommunist foreign legion" to combat the supposed threat of communist infiltration.

66. "Address delivered by Señorita Minerva Bernardino, Delegate of the Dominican Republic, at the Plenary Session of the Inter-American Conference on Problems of War and Peace, March 6, 1945," Pan American Union, *Bulletin of the Inter-American Commission of Women* (Washington, DC, September 1945).

67. The UFIA was one of several social and cultural organizations Dominican women joined and used to increase their political and social capital. For example, the cultural collective Abside helped women to pool their resources, demonstrate their allegiance to the regime in a public arena, and improve upon their individual social standing through the second half of the Trujillato.

68. "La reunión celebrada anoche por la UFIA en el Ateneo," *La Nación*, September 2, 1945, 11.

69. Delia Weber, "The Meaning of Civilization and the New Woman," in *Documents of Dissidence: Selected Writings by Dominican Women*, ed. Daisy Cocco-DeFilippis (New York: CUNY Dominican Studies Institute, 2000), 92.

70. "Dominican Republic," Pan American Union, *Bulletin of the Inter American Commission of Women*, November 1948, 76–246, Box 21, Stevens Papers. The organization was incorporated on July 5, 1949, by official decree; *Gaceta Oficial*, vol. 2, book 55 (Ciudad Trujillo, 1949), 321–322.

71. In keeping with official state form, the organization's first act was to make Trujillo's wife, María Martínez de Trujillo, its honorary president, "in view of her interest and her noteworthy contribution to the cultural, political, and social progress of Dominican women"; "Dominican Republic," Pan American Union, *Bulletin of the Inter-American Commission of Women*, November 1948, 76–246, Box 21, Stevens Papers.

72. José Vicente Pepper, "La voz autorizada de la mujer dominicana," *La Nación*, September 12, 1950, 5.

73. "Fué una gran apoteosis reeleccionista la manifestación del Consejo Nacional de Mujeres, en el Teatro Independencia, ayer," *La Nación*, September 10, 1950, 3. The article offered excerpts from each of the sixteen speeches given at the event. Women's activities for reelection were regularly published. The locations for the various events indicated the attempted reach of the organizers; some were held at the elaborate Teatro Nacional, oth-

ers took place at more intimate areas of elite culture like the Ateneo Dominicano, and some were set in more working-class bastions like the Centro Social Obrero or the Club de Juventud.

74. Lydia Pichardo Lapeyretta, "Reelección," *La Nación*, September 9, 1950, 5.

75. Cited in Myrna Santos de Rivera et al., "Participación política, sindical y estudiantil de la mujer," in *Seminario Hermanas Mirabal sobre diagnóstico, evaluación y recomendaciones modificativas de la condición de la mujer dominicana. Colección Historia y Sociedad* 220, no. 27, ed. Universidad Autónoma de Santo Domingo (Santo Domingo, Editorial Gaviota, 1977), 255. The authors indicate that the speech by Álvarez Pina was a direct response to the participation of women in the revolutionary group Juventud Democrática. Unfortunately, there was no reference for the quote from Álvarez Pina.

76. Battle de Paiewonsky, in "Fué una gran apoteosis," *La Nación*, 3.

77. Pichardo Lapeyretta, "Reelección," 5.

78. "Fué una gran apoteosis," *La Nación*, 3.

79. "Entra en vigor la Ley de Emergencia en la República," *La Mujer en la Era de Trujillo*, February 23, 1951, 1.

80. "Trujillista siempre" to Dr. Manuel de Jesús Ramos, July 12, 1950, Secretaría de Estado de Educación, Legajo 2451 (1950), AGN.

81. Thelma Frías de Rodríguez, *Diez razones de mi anticomunismo*, pamphlet (Ciudad Trujillo, 1959). Frías was the daughter of early *Fémina* contributor Consuelo Montalvo de Frías.

82. The women of the regime could not have been completely unaware of the dubious nature of their claims about Dominican democracy and anticommunism. In 1946 one of the standard-bearers of Latin American women's rights and once their hero, Gabriela Mistral, reportedly rejected an invitation from the regime to honor her for her recent Nobel Prize in literature. According to reports, the Chilean poet "said no to homages from tyrannies" although legislation had been passed to establish a Day of the Woman, and she was to be its very first honoree; Enrique Agujar, "30 años de educación dominicana," *El Nacional de ¡Ahora!*, May 24, 1984, 20.

83. The number of subjuntas continued to increase. An article in *La Mujer en la Era de Trujillo* reported twenty-five representative groups across the country in 1952, surpassing the number of provinces at the time.

84. The presence of the CNM would have been expected at symbolic events like the March 6, 1950, honoring of fellow female Trujillista Mercedes Laura Aguiar as the "Símbolo del Magisterio Nacional y Mujer de América"; Aguiar was a thirty-year educator the group had feted a year earlier along with another prominent Dominican teacher. The CNM similarly continued efforts around the time of the centennial celebrations. In October 1950 the group solicited permission to construct a bust honoring national poet and educator Salomé Ureña; Enrique Agujar, "30 años de educación dominicana," *El Nacional de ¡Ahora!*, May 25, 1984, 15; *Colección de leyes, decretos y resoluciones*, vol. 1 (Ciudad Trujillo, 1950), AGN, 5367.

85. Bernardino continued to pressure her colleagues to affirm the UN Commission on the Status of Women resolution on women's nationality even though it brought little real change for Dominican women's equality.

86. Zeller points out that during the 1940s the regime had already begun to solidify its ideology of protection of the Dominican woman and mother; "El régimen de Trujillo y la fuerza laboral femenina en la República Dominicana, 1945–1951," in *La República Do-*

minicana en el umbral del siglo XXI: Cultura, política y cambio social, ed. Ramonina Brea, Rosario Espinal, and Fernando Valerio-Holguín (Santo Domingo: Pontificia Universidad Católica Madre y Maestra, Centro Universitario de Estudios Políticos y Sociales, 1999), 442.

87. For more on the *feria* see Crassweller, *Trujillo*, 293–299; Derby, *Dictator's Seduction*, 109–134.

88. Nanita de Espaillat was joined by a now predictable cast of original AFD members and new Trujillistas including Minerva Bernardino, Celeste Wos y Gil, Amada Nivar de Pittaluga, Mercedes Soler Vda. Peynado, Josefa Sánchez de González, Margarita Peynado, Nelly D. de Carías, Urania Montás, Ernestina Guzmán de Mejía, Sara Paulino de Morera, and Marina Prats Nieto; Inter-American Commission of Women (IACW), *Eleventh Assembly of the Inter-American Commission of Women, Final Act, Ciudad Trujillo, Dominican Republic, June 2–21, 1956* (Washington, DC: Pan American Union, 1956).

89. Trujillo welcomed the distinguished guests to his country, a land of "peace, concord, justice and social progress," and praised the work of the IACW, expressing his constant support and enthusiasm for their efforts and ideals; Rafael Leónidas Trujillo Molina, "Opening Address," in IACW, *Conference Program for the Eleventh Assembly of the Inter-American Commission of Women* (Ciudad Trujillo: Impresora Dominicana, 1956). Delegates extended the "vote of applause and appreciation" to the dictator in their final program; IACW, *Eleventh Assembly of the Inter-American Commission of Women, Final Act*, 19.

90. The Dominican delegates emphasized the many concrete achievements of women in their country. Participants noted that women had occupied positions in the Senate, the Congress, city and provincial governments, and public administration. In 1952 two women were elected as senators and one was elected to Congress. Dominican delegates listed national accomplishments in areas besides politics as well: during the 1954–1955 academic year, girls made up 49 percent of the total school enrollment, the national Plan of Studies and Curriculum established a stringent code of gender equality in education, 763 women were enrolled at the national university for the coming school year, and women worked in the judiciary branch, the diplomatic corps, education, and other fields of public service, holding 40 percent of public employee positions; delegate speeches, IACW, *Conference Program for the Eleventh Assembly*.

91. Julio Cesar Santana, *La mujer dominicana en la "Era de Trujillo"* (San Pedro de Macorís: La Orla, 1956), 14.

92. Teresita Roja de Cantizano, "Elogia a la maternidad," *Almanaque Dominicano. Revista Annual Miscelanica* (Santiago, Dominican Republic), 1957.

93. In the Dominican Republic the term *celestina* often describes an older female figure who procures young girls for the sexual desires of a powerful male; in this case, the accusation refers specifically but not exclusively to Trujillo and implies corroboration in the regime's destructive sexual politics; on Mayer see Crassweller, *Trujillo*, 151; Franco, *La era de Trujillo*, 78. In an article that appeared in *Life* journalist Cornelius Ryan wrote that Trujillo's many mistresses "were once supplied by an old harridan named Isabel Mayer, more widely know as 'La Celestina'"; "Beautiful Murder: Dominican Republic 'Elects' Trujillo President," *Life*, June 2, 1947, 7–9. The *celestina*, namesake figure in a sixteenth-century Spanish play, served as matchmaker to a lovelorn noble; Fernando de Rojas, *La celestina*, trans. Dorothy Sherman Severin (Madrid: Cátedra, 1987). An edition of the play was published in 1938 by Dominican intellectual Pedro Henríquez Ureña, son of Salomé, with his

introduction and notes; Fernando de Rojas, *La celestina: O comedia de Calisto e Melibea* (Buenos Aires: Losada, 1938).

94. Brown, *Angry Men, Laughing Men*, 170.

95. Manolo Tavárez Justo, son of Mayer's first husband and native of Monte Cristi, would soon become a leader of the new youth movement along with his wife, Minerva Mirabal. Reports of the group's initial meetings indicate Mayer's own grandson Guido D'Alessandri was also involved; Galván, *Minerva Mirabal*, 111.

96. Bernardo Vega, *Los Estados Unidos y Trujillo: Los días finales, 1960–61; Colección de documentos del Departamento de Estado, la CIA y los archivos del Palacio Nacional Dominicano* (Santo Domingo: Fundación Cultural Dominicana, 1999), 50.

97. Álvarez Pina to various, January 29, 1960, Partido Dominicano, Correspondence, Junta Central Directiva, AGN; Crassweller, *Trujillo*, 378.

98. Letter and telegram from Isabel Mayer to Secretario de lo Interior y Cultos, Monte Cristi, January 29–30, 1960, Partido Dominicano, Correspondence, Junta Central Directiva, AGN. She also responded publicly to the denunciation in the "Foro público."

Chapter 3. Intimate Violations: Gender, Family, and the *Ajusticiamiento* of Trujillo, 1944–1961

Author's note: A previous version of this chapter appeared in *The Americas* 69, no. 1 (July 2012), 61–94. I am grateful for the journal's permission to include this edited version here.

1. Justino José del Orbe, *Del exilio político dominicano antitrujillista, en Cuba* (Santo Domingo: Taller, 1983), 142–152. Del Orbe chronicles the event through a series of clippings and photographs taken from several Cuban newspapers. *Información* reported that participants included Carmen Negret, Petronila Gómez, Altagracia del Orbe (Justino's wife), Lupe Luciano, Olimpia Vera, Carmen de Lara, María del Rey, Migdalia Díaz, Yolanda Pulido, Ada Daniel, Elsa Zurita, Elena Quintero, Mercedes Quintero, and Saski Prus. *Hoy* added Matilde Daniel and Marta Duque to the list of women.

2. Examples range from U.S. journalistic accounts to Dominican histories and participant memoirs. For the former see Diederich, *Trujillo*; John Bartlow Martin, *Overtaken by Events: The Dominican Crisis from the Fall of Trujillo to the Civil War* (New York: Doubleday, 1966). For historical accounts see Roberto Cassá, *Los orígenes de Movimiento 14 de Junio* (Santo Domingo: Editoria Universitaria, Universidad Autónoma de Santo Domingo 1999); Emilio Cordero Michel, "Las expediciones de junio de 1959," *Estudios Sociales* 25, no. 88 (June 1992): 35–63; Vega, *Los Estados Unidos y Trujillo*. For memoirs see Juan J. Cruz Segura, *Bajo la barbarie: La Juventud Democrática clandestina, 1947–1959; Testimonio de un protagonista* (Santo Domingo: Taller, 1997); Orbe, *Del exilio político dominicano antitrujillista, en Cuba*, although the last-cited does include some evidence of female activism on the part of his wife, Altagracia.

3. Several important exceptions include Mainardi Vda. Cuello, *Vivencias*; Grey Coiscou Guzmán, *Testimonios: La gavilla luminosa* (Santo Domingo: Cocolo, 2002); Grey Coiscou Guzmán, *Testimonios: La simiente convulsa* (Santo Domingo: Cocolo, 2002). Alfonsina Perozo and Delta Soto have also published memoirs that touch on their roles in the resistance movement, Perozo's *Los Perozo* and Soto's *Vivencias de una revolucionaria*. Several authors have published works that discuss the lives of the important female resistance activists Minerva Mirabal and Carmen Natalia Martínez Bonilla.

4. Herrera Mora, *Mujeres dominicanas, 1930–1961.*

5. Hernández, *Emergencia del silencio*, 122–126.

6. Bernardo Vega, *Un interludio de tolerancia: El acuerdo de Trujillo con los comunistas en 1946* (Santo Domingo: Fundación Cultural Dominicana, 1987), 5–7.

7. In Coiscou Guzmán, *Testimonios: La gavilla luminosa*, 4.

8. Cassá, *Los orígenes de Movimiento 14 de Junio*, 78.

9. Josefina Padilla, personal correspondence with the author, October 2004.

10. This period roughly coincides with female suffrage and the regime's larger international show of democracy and transparency.

11. For more on the origins of what Richard Turits calls a "brief wave of liberal idealism" see his *Foundations of Despotism*, 236.

12. Padilla, personal correspondence. Among others were Gilda Pérez, Brunilda Soñé (head of her group in La Vega), Sobeya Mercedes Almonte, Edna Moore, Leila Pantaleón, Dinorah Echevarria, and Ligia Echevarria.

13. Homes and local communities were essential to the movement in both phases and provided a platform for female participation. Ligia Echevarria Hernández and her sister Dinorah became involved in the movement through the activities of their brother Vinicio. According to memorialist Juan J. Cruz Segura, the home of the Echevarrias served as a sort of "center of the diffusion of revolutionary ideas"; *Bajo la barbarie*, 29. Josefina Padilla and her sister Silvia as well as Carmen Natalia Martínez Bonilla and her sister Carmen Julia also lived in homes of opposition activities. In addition, women who hailed from the same hometown often found that ties of friendship drew them into the movement. Violetica Martínez, Ruth Fernández, and Lourdes Pichardo, all from the small but affluent town of Moca, formed a cell of the Juventud Democrática with Federico Pichardo; Mu-Kien A. Sang, *Yo soy Minerva! Confesiones más allá de la vida y la muerte* (Santo Domingo: Amigo del Hogar, 2003), 53. Male friends and girls schools provided links for activism for women like Gilda Pérez y Pérez, Brunilda Soñe Pérez, Tomasina Cabral, Dulce Tejada, and Emma Rodríguez; Fundación de los Héroes de Constanza, Maimón y Estero Hondo, *Memorias de la lucha contra la tiranía* (Santo Domingo: Fundación de los Héroes de Constanza, Maimón y Estero Hondo, 1983), 38, 48.

14. Many activists have praised the work of Josefina Padilla and Carmen Natalia Martínez Bonilla. In discussing an early Juventud Democrática meeting Virgilio Díaz Grullón mentions Martínez Bonilla's constant work, adding that it "was not possible to imagine what we would have done without her" or without her permanent example of commitment, values, and self-denial. Activist Juan Bautista Ducoudray Mansfield attests that "while the JD was legal, there was one person who played an important role, from 1946 to 1947, and that person was Carmen Natalia Martínez Bonilla"; in Coiscou Guzmán, *Testimonios: La gavilla luminosa*, 106–107. Díaz Grullón called Martínez Bonilla "el alma presente" of the Juventud Democrática and argues that she was in the "center of it all," offering her enthusiasm, constant work, and "fe en el futuro democrático de nuestro pueblo" (faith in the democratic future of our nation); in Lusitania Martínez, "Carmen Natalia Martínez: Feminista," *Ambar 7: Revista de Mujeres* 3, no. 6/7 (November 1991): 32.

15. Martínez Bonilla's extensive life work is honored in the memoirs of many participants of the resistance, including Cruz Segura, *Bajo la barbarie*. A selection of her letters is reproduced in Ángela Hernández, *Pensantes* (Santo Domingo: Ediciones Calíope, 2004), 111–118. There is also a short article about her life and literary work in Sherezada (Chiqui) Vicioso, *Algo que decir: Ensayos sobre literatura femenina, 1981–1997* (Santo Domingo:

Búho, 1998), 43–50. Following the end of the regime, Martínez Bonilla became involved with the Inter-American Commission of Women and served as the organization's president, adding to her reputation as an accomplished member of the left concerned with the rights of women.

16. Cited in Herrera Mora, *Mujeres dominicanas, 1930–1961*, 77.

17. Ibid., 78.

18. Ibid., 80.

19. The transition had much to do with international pressures and the rise of a Cold War mentality that would support a brutal dictator rather than risk the possibility of communism; Roorda, *Dictator Next Door*, 230–231.

20. Exile groups published reports of the actions of the Dominican government widely; Boxes 34, 37, 38, 43, and 61, Frances R. Grant Papers, 1897–1986, Special Collections and University Archives, Rutgers University Libraries (hereafter Grant Papers).

21. Carmen Natalia Martínez, "Coraje y dignidad," in Hernández, *Pensantes*, 112. All of the letters, minus the final one to the Mexican embassy, can be found in the compilation *Pensantes*, 111–118. The final letter, signed by the entire family, is in Herrera Mora, *Mujeres dominicanas, 1930–1961*, 218–221.

22. Martínez, "Coraje y dignidad," in Hernández, *Pensantes*, 114. During this time all passports were held by the Dominican government, and individuals and families had to request them for travel.

23. Martínez, "Coraje y dignidad," in Hernández, *Pensantes*, 118.

24. Virgilio Álvarez Pina, "Partido Dominicano: Advertencia," *La Nación*, October 19, 1946, 1, cited in Herrera Mora, *Mujeres dominicanas, 1930–1961*, 81–82.

25. The group would later change its name to the Frente Unido de Liberación Dominicano (United Dominican Liberation Front).

26. "Voces femeninas," *Quisqueya Libre*, September 1944, 4.

27. Ibid., 7.

28. "La voz del Frente unido de Liberación," *Quisqueya Libre*, July–August 1945, 6.

29. "Trujillo es repudiado también por las mujeres," *Quisqueya Libre*, January–February 1936, 3.

30. Orbe, *Del exilio político dominicano antitrujillista, en Cuba*.

31. Centro de Investigación para la Acción Femenina (CIPAF), "*Quehaceres:* We Were Ready to Go," *Connexions* 36 (1991), 19–20; original in English.

32. Del Orbe, *Del exilio político dominicano antitrujillista, en Cuba*, 65–75.

33. Ibid., 132. Original article circa March 1960.

34. Carolina Mainardi Reyna (later Mainardi Vda. Cuello), who joined the Partido Revolucionario Dominicano (PRD) with her husband when it formed in Puerto Rico in 1942, recalled picketing the Dominican consulate in 1958 on the fourth anniversary of the galvanizing disappearance of Jesús de Galíndez, a former regime official turned vocal opponent in exile who was kidnapped while living in New York City. For more on his disappearance see Manley, "The Galíndez Case in the Dominican Republic," *Latin American History: Oxford Research Encyclopedias,* forthcoming. Known for her oratorical skills, Maricusa Ornes was invited often by the Vanguardia Revolucionaria Dominicana (VRD) to be the voice of its weekly radio program in the capital.

35. Herrera Mora, *Mujeres dominicanas, 1930–1961*, 224.

36. Carmen Natalia Martínez Bonilla, "La democracia está en peligro inminente," *Boletín* (San Juan), June–July 1950, 1. Martínez Bonilla and Carolina Mainardi served as ad-

ministrator or editor during the run of another paper, *Exilio*, the monthly publication of the Frente Undido Dominicano (FUD). Martínez Bonilla also served as the secretary of public relations for the Unión Patriótica Dominicana (UPD) at various points. Altagracia del Orbe was similarly involved in writing campaigns in Cuba; Orbe, *Del exilio político dominicano antitrujillista, en Cuba*; Herrera Mora, *Mujeres dominicanas, 1930–1961*.

37. Reprinted in Herrera Mora, *Mujeres dominicanas, 1930–1961*, 248.

38. Orbe, *Del exilio político dominicano antitrujillista, en Cuba*, 47. Word of the movement reached Trujillo in time for him to mobilize a counterattack, and the expeditionaries never received the support they thought they might in the countryside. One boat had to turn back, but nearly all the men who headed out from Cuba were killed outright or arrested and then killed.

39. Ibid., 145–152.

40. Cited in ibid., 93–94.

41. Justino del Orbe mentions briefly the Congreso Latinoamericano de Mujeres that was held October 9–12, 1959, and he includes a letter signed by attendees. Although he gives little background on the event, the appeal to "hermanas de América Latina" written by event attendees and reproduced in his book was signed by several active female Dominican exiles, including Altagracia del Orbe; *Del exilio político dominicano antitrujillista, en Cuba*, 94–96, 153–154.

42. Unsigned to Frances Grant, March 17, 1959, Box 43, Folder 27, Grant Papers. The writer identified herself as the wife of Movimiento de Liberación Dominicano leader Alfonso Canto.

43. "8 Trujillo Foes Reported Killed," *New York Times*, January 31, 1960.

44. Carmita Landestoy, *¡Yo también acuso!* (New York: Azteca Press, 1946).

45. Ibid., 120.

46. Orbe, *Del exilio político dominicano antitrujillista, en Cuba*, 93–94, 111–112.

47. Ibid., 112, 132.

48. Herrera Mora, *Mujeres dominicanas, 1930–1961*, 244.

49. Orbe, *Del exilio político dominicano antitrujillista, en Cuba*, 148.

50. Irma Hernández Santana, an exile in New York and member of the Movimiento de Liberación Dominicana (MLD), was sent by fellow activist-exile Alfonso Canto to conduct research back in the Dominican Republic. Clearly, the more visible and active male exiles would have been quickly jailed for such actions, while women were up to that time better protected from imprisonment and torture. At a time when the various exile groups were attempting to coordinate their activities with each other, such diligences could often be completed only by women; Cassá, *Los orígenes de Movimiento 14 de Junio*, 130; Herrera Mora, *Mujeres dominicanas, 1930–1961*, 107.

51. Some women were hamstrung by their previous involvement in the resistance. Josefina Padilla returned to the university after her year of house arrest only because of a family friend's intervention, and Padilla was forced to sign an agreement promising total abstention from political activities; Padilla, personal correspondence with the author, October 2004.

52. On Minerva Mirabal and the history of the much-mythologized *mariposas* (butterflies), as the sisters were called, see Aquino García, *Tres heroínas y un tirano*; Roberto Cassá, *Minerva Mirabal: La revolucionaria* (Santo Domingo: Tobogan, 2000); Ferreras, *Las Mirabal*; Galván, *Minerva Mirabal*; Violeta Martínez, *Homenaje a las hermanas Mirabal.* (Santo Domingo: Quinta Edición, 2001); Sang, *¡Yo soy Minerva!*

53. Still, many memorialists have chosen to attribute her position in the opposition to her sin of sexually rejecting the dictator. According to many accounts, Mirabal attended a ball held by Trujillo in his native town of San Cristóbal in 1949 at which the young woman rejected his advances. Historian Alcibíades Cruz González contends that "Trujillo always remembered the party at San Cristóbal at the Boriqua Ranch, as well as Minerva's opposition to the regime." González expresses a widely held belief that her opposition to the regime took second place in Trujillo's mind to the much bigger sin of rejection. True or not, the attribution of Trujillo's rage to sexual rejection ignores the entire sociopolitical environment in which Mirabal and her sisters became politically active; Alcibíades Cruz González, *Las heroínas de Salcedo en un ojo de agua* (Santo Domingo: Impresos Cobe, 1997), 150.

54. They included Brunilda Soñé, Violeta Martínez Bosch, and Emma Rodríguez. William Galván argues that it was particularly the friendship between Mirabal, Martínez, and Rodríguez in 1944 that galvanized the women's political engagement; *Minerva Mirabal*, 107.

55. Ibid., 160. Galván identifies Soñé, Martínez, and Rodríguez as the others arrested.

56. In July 1951, Mirabal and her mother were confined to the Hotel Presidente in Santo Domingo while the girls' father, Enrique Mirabal, was imprisoned nearby. Although the regime shortly released him as well as Minerva and her mother, the confinement was meant to terrorize the entire family into compliance. Nonetheless, the following fall Minerva Mirabal convinced her family to allow her to enroll at the Universidad de Santo Domingo.

57. The most prominent member of the group was a young priest named Daniel Cruz. Roberto Cassá reports that the group included several nuns; *Los orígenes de Movimiento 14 de Junio*, 113–121. While the hierarchy actively supported the regime until its very last year, more research needs to be conducted on the potentially important roles of laymen and laywomen as well as other grassroots religious groups in the resistance movement. As has been pointed out in other Latin American cases, regime support from church hierarchy does not necessarily rule out the possibility of lay activism.

58. In Galván, *Minerva Mirabal*, 246.

59. Cassá, *Los orígenes de Movimiento 14 de Junio*, 172. Cassá reports that in addition to Morales, members included Aída Arzeno, Ana Valverde Vda. Leroux, Argentina Capobianco, Italia Villalón, Elena Abréu, and Carmen Jane Bogaert de Heinsen.

60. Turits, *Foundations of Despotism*, 252.

61. Ibid. Turits argues that "the insurgents' quixotic gesture was nonetheless effective. It inspired the urban resistance and fueled the cycle of intensifying state terror and growing opposition that would create fertile terrain for a coup and lead to the collapse of the regime." One participant, Rafael Valera Benítez, declares in his 1984 memoir, that the invasion "had the effect of moving the consciousness of the entire nation and provoking a psychological impact that shocked the entire world, impelling a torrent of organizing in opposition to Trujillo"; *Complot develado* (Santo Domingo: Fundación Testimonio, 1984), 19.

62. Tomasina Cabral, "Testimonio de Sina Cabral," in *Memorias de la lucha contra la tiranía*, Fundación de los Héroes de Constanza, Maimón y Estero Hondo (Santo Domingo: Fundación de los Héroes de Constanza, Maimón y Estero Hondo, 1983), 195.

63. Vega, *Los Estados Unidos y Trujillo*, 42.

64. Cassá, *Los orígenes de Movimiento 14 de Junio*, 241.

65. Ibid., 127.

66. The massive wave of arrests began on January 17, 1960. Former secret police agent Clodoveo Ortiz González offered his version of the arrests in a report he submitted to U.S. Ambassador John Bartlow Martin. In it Ortiz states that some 350 individuals were imprisoned, including five women. Other reports have indicated higher numbers as well as more females arrested; Vega, *Los Estados Unidos y Trujillo*, 42–44. As before, the exile community publicized these numbers widely.

67. They included Tomasina Cabral, Fe Violeta Ortega, Dulce Tejada, Miriam Morales, Asela Morel, and Minerva's sister María Teresa.

68. Asela Morel, "Testimonio de la Dra. Asela Morel," in *Memorias de la lucha contra la tiranía*, ed. Fundación de los Héroes de Constanza, Maimón y Estero Hondo (Santo Domingo: Fundación de los Héroes de Constanza, Maimón y Estero Hondo, 1983), 188.

69. Cabral, "Testimonio de Sina Cabral," 197.

70. Cabral details the entire incident in "Testimonio de Sina Cabral," 197. Cabral's description of the torture was likely softened in her own retelling. While he does not identify her by name, fellow inmate Rafael Valera Benítez offers a significantly more chilling narrative of the actions taken against "una compañera del clandestinaje," with details of the entire macabre scene; Valera Benítez, *Complot develado*, 36–40. Recently she gave an interview to a national paper, *Listín Diario*, to remind present and future generations of the ruthless and dangerous dictatorship; in Wendy Santana, "No le di ni una sola lágrima a la tiranía," *Listín Diario*, May 10, 2010, http://www.listindiario.com/la-republica/2010/05/10/141402/no-le-di-ni-una-sola-lagrima-a-la-tirania.

71. Morel, "Testimonio de la Dra. Asela Morel," 189.

72. U.S. Embassy documents reportedly include descriptions of the torture of Tomasina Cabral and Asela Morel forwarded to the OAS as part of its investigation of human rights abuses; Vega, *Los Estados Unidos y Trujillo*, 114.

73. In a recollection of the trial, Tomasina Cabral describes a strong sense of solidarity: "For the first time in our lives, we were witness to something that had not been seen in many years. The public who witnessed the trials sang the national anthem and practically pushed the armed guards, of whom there were many. The pressure was so intense that they stopped the provision of food from our families that had previously been negotiated between the district attorney and the guards"; Cabral, "Testimonio de Sina Cabral," 198.

74. Cassá, *Los orígenes de Movimiento 14 de Junio*, 260–270; Vega, *Los Estados Unidos y Trujillo*, 55–58. The letter is reproduced in its entirety in Valera Benítez, *Complot develado*, 156–160.

75. Turits argues for the importance of the pastoral letter throughout the countryside, although undoubtedly it was extremely important in urban areas as well. He writes that among peasants, the pastoral letter "presented an open repudiation of official discourse by an alternative source of authority, thus exposing the limitations of the regime's hegemony"; *Foundations of Despotism*, 256.

76. Valera Benítez, *Complot develado*, 43.

77. Vega, *Los Estados Unidos y Trujillo*, 63–65.

78. Ibid., 54, 110.

79. For more on the Movimiento Popular Dominicano, its members' return from exile in June 1960, and its publication *Libertad* see Cassá, *Los orígenes de Movimiento 14 de Junio*, 293–316.

80. Both articles are quoted in Sánchez de Rubio's correspondence but not attached.

She cites *Libertad,* August 1, 1960, 4, for the first but gives no additional information on the second; Dra. Dulce Ma. Sánchez de Rubio to Secretario de Estado de Interior y Cultos, Interior y Policía, Legajo 5204, AGN.

81. Galván reports that Trujillo made this statement during a visit to Villa Tapia, a town close to the women's hometown of Salcedo; *Minerva Mirabal,* 317. Bernard Diederich makes a similar assertion; *Trujillo,* 69. Court records from the subsequent trial of the Mirabal assassins indicate that the statement was made at the home of José Quezada on November 2, 1960; Valera Benítez, *Complot develado,* 126.

82. Turits, *Foundations of Despotism,* 257.

83. *El Caribe,* April 23, 1961; cited in Vega, *Los Estados Unidos y Trujillo,* 610–611. Cassá also makes reference to the presence of prostitutes in the church in La Vega; *Los orígenes de Movimiento 14 de Junio,* 283.

84. "Wives of 3 Foes of Trujillo Dead," *New York Times,* November 30, 1960, 5.

85. "100 Here Protest 3 Dominican Deaths," *New York Times,* December 4, 1960, 50.

86. Valera Benítez, *Complot develado,* 139–143.

87. Ibid., 9. Journalist Bernard Diederich expresses a similar conclusion, that the "cowardly killing of three beautiful women in such a manner had greater effect on Dominicans than most of Trujillo's other crimes. It did something to their machismo. They could never forgive Trujillo this crime. More than Trujillo's fight with the Church or the United States, or the fact that he was being isolated by the world as a political leper, the Mirabals' murder tempered the resolution of the conspirators plotting his end"; Diederich, *Trujillo,* 71–72.

88. Address of Carmen Natalia Martínez at the "Salute to the Dominican People and Its Women," January 26, 1963, Box 43, Folder 21, Grant Papers.

Chapter 4. Neither Russia nor the United States: Women and the Search for Legitimate Democracy, 1961–1965

1. Journalistic and firsthand accounts of this period abound, yet there is a relative dearth of scholarly examination of this fascinating and tumultuous time. Moreover, the academic studies that do address the period employ a top-down approach that reifies the extremely masculinized understanding of these years. For the former see Dan Kurzman, *Santo Domingo: Revolt of the Damned* (New York: Putnam, 1965); Martin, *Overtaken by Events*; Tad Szulc, *Dominican Diary* (New York: Delacorte, 1965). For more in-depth analysis from a perspective of foreign policy see Atkins and Wilson, *The Dominican Republic and the United States*; Piero Gleijeses, *The Dominican Crisis: The 1965 Constitutionalist Revolt and American Intervention* (Baltimore, MD: Johns Hopkins University Press, 1978); Michael J. Kryzanek, "The Dominican Intervention Revisited: An Attitudinal and Operational Analysis," in *United States Policy in Latin America: A Quarter Century of Crisis and Challenge, 1961–1986,* ed. John D. Martz (Lincoln: University of Nebraska Press, 1988), 135–156; Abraham F. Lowenthal, *The Dominican Intervention* (Baltimore, MD: Johns Hopkins University Press, 1995).

2. In Arthur M. Schlesinger, *A Thousand Days: John F. Kennedy in the White House* (Boston: Houghton Mifflin, 1965), 769. See also Stephen G. Rabe, *The Most Dangerous Area in the World: John F. Kennedy Confronts Communist Revolution in Latin America* (Chapel Hill: University of North Carolina Press, 1999), 41.

3. See Koikari, *Pedagogy of Democracy*

4. Russell Crandall, *Gunboat Democracy: U.S. Interventions in the Dominican Republic,*

Grenada, and Panama (Lanham, MD: Rowman and Littlefield, 2006), 22, 69; Gleijeses, *Dominican Crisis*, 258.

5. The 1984 anthology by Robin Morgan demonstrates the global circulation of feminist ideas of greater gender equality beginning in the early 1960s; *Sisterhood Is Global: The International Women's Movement Anthology* (Garden City, NY: Anchor/Doubleday, 1984).

6. For general trends of an increasing female presence in revolutionary struggles during the twentieth century and the need to look at such social movements with a feminist lens see Karen Kampwirth, *Women and Guerrilla Movements: Nicaragua, El Salvador, Chiapas, Cuba* (University Park: Pennsylvania State University Press, 2002); Margaret Randall and Lynda Yanz, *Sandino's Daughters: Testimonies of Nicaraguan Women in Struggle* (Vancouver, Canada: New Star Books, 1981); Timothy P. Wickham-Crowley, *Guerrillas and Revolution in Latin America: A Comparative Study of Insurgents and Regimes since 1956* (Princeton, NJ: Princeton University Press, 1991).

7. Jane Jaquette first posited the relation between guerrilla activity and feminism in 1973, and the connection has since been elaborated by several scholars, including Karen Kampwirth and Rosario Montoya; Jane Jaquette, "Women in Revolutionary Movements in Latin America," *Journal of Marriage and Family* 35, no. 2 (May 1, 1973): 344–54; Karen Kampwirth, *Feminism and the Legacy of Revolution: Nicaragua, El Salvador, Chiapas* (Athens: Ohio University Press, 2004); Rosario Montoya, *Gendered Scenarios of Revolution: Making New Men and New Women in Nicaragua, 1975–2000* (Tucson: University of Arizona Press, 2012).

8. Atkins and Wilson, *The Dominican Republic and the United States*, 120–128.

9. Ibid., 99–128.

10. Moya Pons, *Dominican Republic*, 381–390.

11. Martin, *Overtaken by Events*, 83.

12. Tony Raful, *Movimiento 14 de Junio: Historias y documentos*, 5th ed. (Santo Domingo: Búho, 2013), 221–223.

13. "Damas de Santiago aplauden protesta de mons. Pérez Sánchez en el Senado," *Unión Cívica* (Santo Domingo), September 2, 1961, 2, 6. On the death of the young men on Calle Espaillat see Martin, *Overtaken by Events*, 82.

14. "Prominentes damas de esta capital dirigen mensaje a los obispos, *Unión Cívica*, August 26, 1961, 7–8.

15. After the pastoral letter of January 25, 1960, the Church received intense pressure from the regime to rescind its criticisms. As a result, the Church offered an apology and silenced its critiques in the last months of the Trujillato, although it did not concede to Trujillo's desire to be conferred with the title "Benefactor de la Iglesia."

16. Martin, *Overtaken by Events*, 74–76. Translation in original.

17. In addition to *Unión Cívica*, the publications from groups like 1J4 and even the national paper *El Caribe* provided space for women to reach broader audiences with their concerns.

18. "¿Donde está mi esposo?" *Unión Cívica*, September 23, 1961, 2–3.

19. Ibid.

20. These were the four largest and most significant parties in the elections of 1962, although there were others.

21. Elisa de Zayas Bazán, "La mujer dominicana no debe permanecer indiferente en este grave momento para la patria," *Unión Cívica*, September 27, 1961, 5

22. Paid advertisements, *El Caribe*, September 29–30, 1962, 7, 18.

23. "Unión Cívica inicia campaña pre electoral," *El Caribe*, October 1, 1962, 9.

24. Ibid. The mention of women as the greatest moral and political force came from Fabiola Catrain de Pérez, the party's secretary of feminine affairs.

25. Unlike some of the other women active during this period, Padilla had remained relatively uninvolved in the final years of the regime due to her earlier activism. Her husband was imprisoned and eventually killed mere months before the *ajusticiamiento*, after which she returned to politics.

26. "PRSC recaba la unidad de fuerzas democráticas," *El Caribe*, September 14, 1962, 10. The PRSC women's section was called the Frente Femenino.

27. Thelma Frías to Secretary Tabaré Alvarez Peyrera, Secretaría de Estado de Interior y Policía, July 4, 1962, Legajo 5504, SEIP, AGN.

28. "Importante," *El 1J4* (Santo Domingo), January 3, 1962, 10.

29. Fidelio Despradel, *Abril: Historia gráfica de la Guerra de Abril* (Santo Domingo: Secretaría de Estado de Cultura de la República Dominicana, 2005), 225.

30. "El 14 lanza consigna no votar en diciembre," *El Caribe*, November 26, 1962, 22. It was at this meeting in Santiago on the second anniversary of the sisters' murder that the 1J4 decided to abstain from elections due to flaws in the process.

31. Lora Iglesias joined the 1J4 while attending the Universidad de Santo Domingo, from which she graduated in 1962 at the age of twenty-two with a doctorate in law. Lora included among her female companions former resistance fighters and new faces such as Asela Morel, Aura de Manzano, Paula Tineo, Milagros Prats, Magda Mejía-Ricart, Tomasina Cabral, and Grey Coiscou; Carmen Josefina Lora Iglesias, *Piky Lora, relato de una guerrillera* (Santo Domingo: Manatí, 1983).

32. This is particularly true in the photographic archives of the 1J4, where pictures of leader Manolo Tavárez Justo frequently show him surrounded by women; for example see Raful, *Movimiento 14 de Junio*, 231, 291.

33. "Apoya medida para derogar Ley Emergencia," *El Caribe*, September 8, 1962, 1. Other women mentioned in the protests are Tomasina Cabral, Grey Coiscou, Jeannette Miller, Colombina Vda. Ducoudray, and Mariana Jiménez de Alvarez.

34. "Piden permitan regreso a exiliados antitrujillistas," *El Caribe*, September 23, 1962, 1, 8.

35. Julio C. Bodden, "Conocen causa contra asesinos de las hermanas Mirabal," *El Caribe*, June 28, 1962, 16.

36. Julio C. Bodden, "Continúa juicio contra acusados de muerte de las Mirabal," *El Caribe*, June 29, 1962, 16.

37. In Raful, *Movimiento 14 de Junio*, 136–137.

38. Leoncio Pieter, "El proceso Mirabal," *El Caribe*, July 4, 1962, 4.

39. Betances, *State and Society in the Dominican Republic*, 114.

40. For more on the Bosch presidency see Hartlyn, *Struggle for Democratic Politics in the Dominican Republic*, 60–97; Martin, *Overtaken by Events*, 343–584.

41. The celebration of the fiftieth anniversary of the 1963 Constitution in 2013 is a testament to its lasting impression; Dominican Republic, Ministerio de la Mujer, *50 años de la constitución 1963–2013* (Santo Domingo: Ministerio de la Mujer, 2013).

42. Following the *ajusticiamiento* the Church cleaved closely to the most conservative parties, particularly the UCN. While beyond the scope of this study, the relations between the Church and the regimes of Trujillo and Balaguer are an important area of research yet to be fully fleshed out. For a collection of primary documents concerning the Church and Trujillo as well as a general history of the Dominican Catholic Church see José Luis Sáez, *La sumisión bien pagada: La Iglesia dominicana bajo la era de Trujillo, 1930–1961* (Santo

Domingo: Archivo General de la Nación, 2008); José Luis Sáez, *Cinco siglos de Iglesia dominicana* (Santo Domingo: Amigo del Hogar, 1987).

43. Raful, *Movimiento 14 de Junio*, 312.

44. Ana Silvia R. de Columna, "Vanguardia femenina," *¡Ahora!*, September 12, 1964, 62. The scholar Clara Baéz argues that "in the 1960s women emerged as new political subjects"; in "Informe sobre la situación social de la mujer en el context histórico de las transformaciones económicas, demográficas y culturales de la República Dominicana a partir de la década de 1960," *Ciencia y Sociedad* 13, no. 1 (March 1988): 37.

45. *Mujeres dominicanas*, published by the Secretaría de Estado de la Mujer (SEM), states that the FMD was formed on October 14, 1961, while a display at the Museo de la Resistencia Dominicana gives the date as June 13, 1961. "Federación de Mujeres Dominicanas," (1961), Placard, Museo de la Resistencia Dominicana, Santo Domingo. The SEM publication indicates that the first leadership group was formed by Ligia Echavarría de Sánchez, María Elena Muñoz, Aída Cartagena Portalatín, Ana Silvia Reynoso, Soucy de Pellerano, Xiomara Saladín Defilló, and Bernardita Jorge; SEM, *Mujeres dominicanas*, 95.

46. Hernández, *Emergencia del silencio*, 148.

47. Moema Viezzer, *As mulheres da República Dominicana. Se alguém quiser saber* (São Paulo: Global, 1982), 80.

48. The SEM publication lists several activities of the FMD (without documentation), among them calls for the resignation of Balaguer, involvement in a national strike in 1961, demands for free return of exiled Dominicans, the growth of the organization to include a provincial committee in Santiago, organized activities and assistance for the poor, a public march after the *golpe de estado* overthrowing Juan Bosch, public condemnation of the new government, and an organized march protesting the presence of U.S. Marines in Santo Domingo; *Mujeres dominicanas*, 98–101.

49. "Federación Dominicana de Mujeres," *El 1J4*, January 3, 1962, 10.

50. Ibid.

51. "Aviso," *El 1J4*, December 30, 1961, 5. Like the parties' female auxiliary groups, the FMD also engaged in more traditional, hands-on development activities, including the creation of schools for domestic workers; advertisement, *El Caribe*, July 3, 1962, 2. FMD members also sought international linkages for leverage; "Entregan flores a delegada," *El Caribe*, August 1, 1962, 16.

52. "Aviso," *El 1J4*, December 30, 1961, 5.

53. The presumption of communist leanings likely stemmed from the FMD's similarity and/or connections to Cuba's Federación de Mujeres Cubanas (FMC), of which the FMD leaders were aware. Magaly Pineda indicated to me that the FMC provided assistance and support for FMD's efforts. For U.S. assertions of communism see Ambassador John Bartlow Martin's report on activity in the Dominican Republic in May 1962, Box 423, Record Group 59, U.S. National Archives (USNA II), College Park, MD.

54. "Federación de Mujeres Dominicanas," in Ángela Hernández and Orlando Inoa, eds. *La mujer en la historia dominicana* (Santo Domingo: Secretaría de Estado de la Mujer, 2009), 230.

55. "Comunicado" (1963), placard, Museo de la Resistencia Dominicana, Santo Domingo.

56. Gladys de los Santos to Frances R. Grant, 1961–1966, Box 43, Folder 24, Grant Papers. APFD members also contributed to campaigns led by IACW president Carmen Natalia Martínez Bonilla.

57. APFD to Doctor José A. Mora, May 30, 1965, Box 43, Folder 24, Grant Papers. APFD

leadership copied the letter to embassies of multiple Latin American countries, the U.S. ambassador, and the head of the Inter-American Peace Force.

58. Hartlyn, *Struggle for Democratic Politics in the Dominican Republic*, 87–88; Moya Pons, *Dominican Republic*, 383–385.

59. As part of the Frente Juan de Dios Ventura Simó, Piky Lora joined twenty-four young men in the mountains of Bonao in late November. By early December many of the group had been captured by the military, and Lora led the remaining group toward refuge. When they encountered the opposition, the men hid while Lora concocted a story about going to meet a lover and was sent on her way. After taking refuge in a local home, she received word that all members of her group had been killed or captured. Lora, *Relato de una guerrillera*.

60. Bernardino's angry letter to Adlai Stevenson demonstrates again her political savvy as she attempted to salvage what was left of her international reputation; Bernardino to Stevenson, May 8, 1962, Secretaría de Estado de Relaciones Exteriores, AGN.

61. Martínez Bonilla was appointed February 15, 1962; *News Bulletin of the Inter-American Commission of Women* (Pan American Union, Washington, DC), January–April 1962, no. 19, 1.

62. Inter-American Commission of Women, *Libro de oro* (Washington, DC: Inter-American Commission of Women, Organization of American States, 1980), 35, Box 3, Folder 17, Inter-American Commission of Women Records, Sophia Smith Collection, Smith College (hereafter IACW Papers).

63. *News Bulletin of the Inter-American Commission of Women*, September–December 1963, no. 24, vii. See also Sherezada (Chiqui) Vicioso, "De la soledad al compromiso," *Ambar 7: Revista de Mujeres* 3, no. 6–7 (November 1991), 13. The IACW program aimed to train hundreds of women in public leadership and voluntary service in the hopes of, as Martínez Bonilla argued, healing the "wounds that this poor old world has received through-out the centuries." See also Comisión Interamericana de Mujeres and Curso Regional del Programa Interamericano de Adiestramiento para Mujeres Dirigentes, "Informe y evaluación del primer curso regional del programa Interamericano de adiestramiento para mujeres dirigentes" (Washington, DC: Organization of American States, 1967).

64. Carmen Natalia Martínez Bonilla, editorial, *News Bulletin of the Inter-American Commission of Women*, no. 24 (September–December 1963): 5.

65. Inter-American Commission of Women, *Report Presented to the Seventeenth Session of the U.N. Commission on the Status of Women, New York City, March 11–29, 1963* (Washington, DC: Pan American Union, 1963), Box 1, Folder 6, IACW Papers.

66. "Activities of the National Committees on Cooperation with the Inter-American Commission of Women," *News Bulletin of the Inter-American Commission of Women*, no. 20 (May–August 1962): 3. Among the women in the group were former national vice presidential candidate Josefina Padilla de Sánchez, Martha Martínez de Suárez as president, Clara T. de Reid, Selenia de Cabral, and Sibila López Renha.

67. Ibid. It is unclear whether Martínez Bonilla was referring to Gladys de los Santos' APFD or the Comité Pro-Derechos Humanos led by Martha Martínez de los Suárez.

68. In the early 1940s Grant actively corresponded with Minerva Bernardino but by 1946 had come to see the country (and its feminist representative) as rapacious and undemocratic. She had been particularly moved to action against the regime by the disappearance of her friend and colleague Jesús de Galíndez; see particularly the folders "Minerva Bernardino" and "Jesús de Galíndez," Grant Papers.

69. It appears they initially met when Grant first visited the country in November 1962 to be awarded the prestigious medal of honor Duarte, Sánchez y Mella for her efforts to protect Dominican civil and political liberties. De los Santos managed to secure a joint meeting with the Comité Pro-Derechos Humanos, perhaps through its leader Martha Martínez de Suárez, to honor Grant during her visit; "Otorgan condecoración a dama norteamericana," *El Caribe*, November 24, 1962, 2; "Designa señorita Grant socia honor asociación," *El Caribe*, November 28, 1962, 18. All correspondence can be found in Box 43, Folder 24, Grant Papers.

70. Gladys de los Santos to Frances Grant, October 1, 1963, Box 43, Folder 24, Grant Papers. In the letter she writes that the group that had taken over the government after the coup—including her brother Emilio—had successfully managed to save the country from "falling into the hands of Russia."

71. While her specific reasons are unknown, it was likely that the lack of real support from the inter-American community during and after the April Revolution and the problems surrounding the subsequent government had much to do with her becoming disillusioned with the system.

72. For a detailed account of one U.S. diplomat's perspective on the events see Martin, *Overtaken by Events*, 637–723.

73. M. Cordero, *Mujeres de abril*. For a detailed analysis of the book's testimonial style see Wanda Rivera-Rivera, "Revolution Interrupted: The 'Women of April' and the Utopia of National Liberation," in *The Utopian Impulse in Latin America*, ed. Kim Beauchesne and Alessandra Santos (New York: Palgrave Macmillan, 2011), 145–71.

74. M. Cordero, *Mujeres de abril*. I would add that there also needs to be a more thorough analysis of how women's involvement affected the outcome of the revolution itself.

75. In Despradel, *Abril*, 225.

76. Sagrada Bujosa, Brunilda Amaral, Conchita Martínez, Teresa Espaillat, and Piky Lora served as instructors and group leaders due to their prior experiences.

77. In M. Cordero, *Mujeres de abril*, 70, 71, 72.

78. Ibid., 25.

79. In Despradel, *Abril*, 225.

80. In M. Cordero, *Mujeres de abril*, 26.

81. Ibid., 73.

82. Ibid., 30.

83. Ibid., 27.

84. Ibid., 26, 27.

85. In Despradel, *Abril*, 226.

86. Ibid.; M. Cordero, *Mujeres de abril*, 119.

87. Quisqueya Rivas de Liz and Vincenta Lamourth to Mary Cannon, Series 2, Box 2, Elmendorf Papers.

Chapter 5. First to Liberate Women's Lib: Negotiating the Politics of Mediation during Balaguer's *Doce Años*, 1966–1978

1. René Fortunato, dir., *La herencia del tirano*, film (Santo Domingo: Videocine Palau, 1998).

2. Mary L. Elmendorf, "Women Governors of the Dominican Republic," unpublished manuscript, 1967, Series 2, Box 1, Folder 9, Elmendorf Papers.

3. Hartlyn, *Struggle for Democratic Politics in the Dominican Republic*, 15.

4. For an insightful discussion of this type of populist clientelism and its creation of local networks in the case of Argentina see Javier Auyero, *Poor People's Politics: Peronist Survival Networks and the Legacy of Evita* (Durham, NC: Duke University Press, 2001).

5. Koikari, *Pedagogy of Democracy*, 5.

6. Christian Krohn-Hansen, "Masculinity and the Political among Dominicans: 'The Dominican Tigre,'" in *Machos, Mistresses, Madonnas: Contesting the Power of Latin American Gender Imagery*, ed. Marit Melhuus and Kristi Anne Stølen (London: Verso, 1996), 108–133.

7. Rabe, *Most Dangerous Area in the World*, 15.

8. Grants for programs run by the IACW and the League of Women Voters Overseas Education Fund (OEF) were abundant during this period; examples can be found in the Overseas Education Fund Archives, Special Collections, Hornbake Library, University of Maryland Libraries (hereafter OEF Archives), as well as reports from the IACW.

9. Overseas Education Fund, "Contract between the U.S. and the Overseas Education Fund of the League of Women Voters," 1, Box 13, OEF Archives.

10. Wendy A. Pojmann, *Italian Women and International Cold War Politics, 1944–1968* (New York: Fordham University Press, 2013), 2.

11. The classic works on *continuismo* are Russell H. Fitzgibbon, "Continuismo: The Search for Political Longevity," in *Caudillos: Dictators in Spanish America*, ed. Hugh M. Hamill (University of Oklahoma Press, 1992), 210–17; Eric R. Wolf and Edward C. Hansen, "Caudillo Politics: A Structural Analysis," *Comparative Studies in Society and History* 9 (1967): 168–179.

12. Atkins and Wilson, *The Dominican Republic and the United States*, 143; Hartlyn, *Struggle for Democratic Politics in the Dominican Republic*, appendix A.

13. Atkins and Wilson, *The Dominican Republic and the United States*, 150–170.

14. By the early 1970s the GDP had grown rapidly and significantly. Construction investments alone rose from $80 million in 1969 to $265 million in 1977 and constituted between 29 and 44 percent of all public expenditures. They most often flowed directly from the office of the president and were commonly handed out without a competitive bidding process; Hartlyn, *Struggle for Democratic Politics in the Dominican Republic*, 102; Moya Pons, *Dominican Republic*, 400.

15. Susan Sleater, "The Role of Educated Women in Dominican Society," 11, unpublished manuscript, Series 2, Box 2, Folder 12, Elmendorf Papers.

16. For more on Balaguer's appeals to the feminine desire for peace, see Zeller and Power, "What Difference Does Gender Make?"

17. Partido Reformista, *Estatutos del Partido Reformista*, Santo Domingo, n.d. (1966?).

18. Joaquín Balaguer, "Un partido de extracción popular," in his *La marcha hacia el Capitolio* (Mexico City: Fuentes Impresores, 1973), 321–326.

19. Several articles make reference to the appointments but essentially dismiss their significance; Mota, "Politics and Feminism in the Dominican Republic," 272; Tancer, "La Quisqueyana," 222.

20. *Listín Diario* and *El Caribe*, July 1966. Articles in both dailies covered inauguration activities in Santo Domingo, background features on individual governors in key provinces, and provincial capital celebrations of the new officials.

21. "Ejecutivo juramenta gobernadoras," *Listín Diario*, July 7, 1966, 1, 4.

22. "The Land Columbus Loved Welcomes Tourists and Investors: Dominican Republic," advertisement, *New York Times*, October 3, 1971. Howard Wiarda and Michael Kry-

zanek note that Balaguer employed this publicity tactic on several occasions to highlight regime successes for "foreign consumption"; "Dominican Dictatorship Revisited: The Caudillo Tradition and the Regimes of Trujillo and Balaguer," *Revista/Review Interamericana* 7 (1982): 428n27.

23. All correspondence from the female governors can be found in the files of the Secretaría de Estado del Interior y Policía, 1966–1978 (hereafter SEIP), AGN. The volume of materials for each provincial governor varied markedly, but each official produced some level of correspondence every year of the twelve-year regime.

24. In "Ejecutivo juramenta gobernadoras," *Listín Diario*, July 7, 1966, 4.

25. Ley No. 2661 de fecha 31 de diciembre de 1950, sobre las atribuciones y deberes de los gobernadores civiles de las Provincias, G.O. no. 7237, copy sent to the governor of Pedernales on her request, Legajo 1274, Expediente (hereafter Exp.) 3–18/16, SEIP, AGN. In their role as proponents of provincial progress and moral order, the governors were also expected to be vigilant for the development of "cults and savage practices contrary to morality and good custom."

26. In keeping with the visible gender inequities of the time, the women governors earned a salary significantly lower than that of their male predecessors. They received a monthly salary of three hundred and thirty Dominican pesos in comparison with the four hundred given to male governors in 1963. This salary would remain constant through their tenures in 1970 and in 1974, although salaries for other provincial employees would rise approximately 17 percent during that same period; Legajo 1984, Exp. 1–21, 1974, SEIP, AGN.

27. Continued and insistent requests for cars, office supplies, and paid staff members were the most common of appeals that appeared throughout their missives to the capital. Some unabashedly enumerated their everyday struggles to accomplish the work of the party given their limited resources, particularly considering the austerity measures put in place by Balaguer from 1966 to 1969. Others sent pleading messages directly to the president when urgent necessities arose.

28. Elmendorf, "Women Governors of the Dominican Republic," 1967, Series 2, Box 1, Folder 9, Elmendorf Papers. Elmendorf served as a consultant to Latin America for several large U.S. nonprofits including CARE in Mexico; her particular interest was the role of women in development.

29. Ibid, 3.

30. Ibid, 4.

31. Ibid, 21. Another wrote to Elmendorf that she thought it was her role to aid Dominican women in preparing for life and defending themselves.

32. "Balaguer declara la mujer es útil en vida política," *Listín Diario*, September 25, 1969. For full text of the speech see Balaguer, "Respaldo de la mujer cibaeña," in his *La marcha hacia el Capitolio*, 359–362.

33. "Gobernadoras prometan política de cordialidad y entendimiento," *El Caribe*, July 7, 1966, 11.

34. Ana Valentina Roa de Moreta, "Memoria anual," 1967, Legajo 883, Exp. 1–58/9, SEIP, AGN. The provincial annual reports were often grouped together in the same *legajo* as is the case here with La Estrelleta and La Romana.

35. Telegram from Italia Leopoldina Pion de Gómez to Secretario de Estado de Interior y Policía, Santo Domingo, November 22, 1967, Legajo 1019, Exp. 1–62, SEIP, AGN.

36. Juana Castellanos Vargas, Gobernadora Provincial, to Secretario de Estado de Interior y Policía, Legajo 1784, Exp. 3–18/6, SEIP, AGN.

37. Virginia Pérez de Florencia, "Memoria anual," 1967, Legajo 883, Exp. 1-58/12, SEIP, AGN.

38. In many cases the governors also suggested the construction of alternative, vocational-style schools including sewing centers, artisan schools, cane-cutting schools, and night literacy centers for adults. See, for example, Altagracia Acosta de Bezi, Gobernadora Provincial, to Doctor Joaquín Balaguer, Presidente Constitucional de la República, March 24, 1971, Samaná, Legajo 1672, Exp. 3-18/20, SEIP, AGN.

39. Roa de Moreta, "Memoria Anual," 1967, SEIP, AGN.

40. Initially established in 1947 as the Carrie Chapman Catt Memorial Fund, the OEF became the new name and immediately received a $42,000 grant from the Stern Family Fund to conduct two years of planning for Latin American programs; OEF, "Curso Dominicano de Capitación Cívico-Social," Box 246, OEF Archives.

41. The initial contract between the U.S. government and the League of Women Voters' Overseas Education Fund specifically funded the league's newly established leadership institute for Latin American women but also provided the fiscal and ideological support necessary for continued expansion into the region; OEF, "Guidelines," Box 13, OEF Archives.

42. Caroline Ware, "Civic Action Groups in Latin America," 1968, Series 2, Box 1, Folder 17, Elmendorf Papers.

43. Ibid, 9. Ware argued that modernization in Latin American societies called "for the development of 'intermediate organizations' which can provide the instruments of social and political participation and can give a new texture to public life."

44. A spring 1969 report noted that women who participated in the previous year's seminar were "already evidence of a 'multiplier effect'"; OEF, "Dominican Republic Training Program Final Report," June 22, 1969, Box 246, OEF Archives.

45. "Crisis Action Is Not Their Forte," unidentified newspaper and date, Box 203, OEF Archives.

46. League representatives emphasized that "under no circumstances" was the OEF to become "involved in partisan, political matters, nor [would] it ever attempt to influence political action"; OEF, "The Overseas Education Fund of the League of Women Voters: The Aims and Nature of our Program," October 1964, Box 13, OEF Archives.

47. OEF, "Aims and Nature," Box 13, OEF Archives.

48. Thomas Scanlon, "Overseas Education Fund in Latin America: A Benchmark Study of a Title IX Activity," (1971), 91, Series 2, Accession 2, Box 2, Folder 14, Elmendorf Papers.

49. Elmendorf, "Women Governors of the Dominican Republic," 4, Elmendorf Papers.

50. OEF, "Translation of Report from Iluminada A. de Perella, Santiago, Dominican Republic," March 4, 1970, 3, 75-38, Box 2, Folder 56, Lucille Heming Koshland Papers, 1947-1974, Schlesinger Library, Radcliffe Institute, Harvard University (hereafter Koshland Papers). Most of the participant data come from three major courses: a 1968 seminar for the new female governors, a coinciding course for provincial volunteers, and a nationwide course held in June 1969. Participant responses from OEF international programs reflected similar concerns and have been included here; OEF, Una Cross, project director, "A Progress Report on the Civic Education Project of the Overseas Education Fund of the League of Women Voters in the Dominican Republic," January 23–March 5, 1969, Series 2, Box 1, Folder 18, Elmendorf Papers; OEF, "The Role of Women in the Process of Development: A Civic Education Project in the Dominican Republic. A Report of the National Seminars and the Four Regional Seminars," April 25, 1968, 1, Series 2, Box 1, Folder 18,

Elmendorf Papers; "Dominican Republic Training Program Final Report," June 22, 1969, Box 246, OEF Archives.

51. In OEF, "Role of Women in the Process of Development," Elmendorf Papers.

52. OEF, "Dominican Republic Training Program Final Report," June 22, 1969, Box 246, OEF Archives.

53. For example, of the newly installed governor of the province of Pedernales, Virginia Moquete de Pérez, national party functionaries wrote in 1970 that in addition to having the necessary moral qualifications, the candidate was "a genuine, esteemed and distinguished daughter of the region as well as a loyal party member and fervent admirer of [Balaguer's] exemplary politics"; telegram from Antonio Bello, President of PR, Pedernales, to Enrique Pérez y Pérez, Secretario de Estado del Interior y Policía, September 7, 1970, Legajo 1516, SEIP, AGN.

54. Pérez de Florencia, "Memoria Anual," 1967, SEIP, AGN.

55. An example of a friendly letter is Dilania Pelletier de Moquete to Joaquín Balaguer, November 6, 1973, Legajo 1911, Exp. 3-18/1, SEIP, AGN.

56. Aida Ivonne Rivas de Peña to Secretario de Estado de Interior y Policia, Neyba, October 1, 1973, Legajo 1911, Exp. 3-18/18; SEIP, AGN.

57. The governors expressed frustration with a lack of response from the government relatively frequently and often sardonically; see, for example, the letters from the governor of Moca about the conditions of her car in 1968 in Legajo 1058, Exp. 1-47, SEIP, AGN.

58. Correspondence of Virginia Moquete de Pérez, Governor of Pedernales, 1972-1973, Legajo 1785, Exp. 3-18/16, and Legajo 1911, Exp. 3-18/16, SEIP, AGN.

59. Ana Valentina Roa de Moreta, Gobernadora Provincial, to Hon. Señor Presidente de la República, Joaquín Balaguer, June 6, 1969, Elias Piña, Legajo 1286, Exp. 3-18/7, SEIP, AGN. The subsequent investigation declared the event a plot to "disrupt the tranquility of the province" but failed to depict it as a viable threat to the governor personally. Nonetheless, Roa de Moreta was shaken by the incident and worried that her particular defense of provincial campesinos and the Partido Reformista provoked such a dangerous level of political intrigue and violence.

60. Ana Valentina Roa de Moreta, Gobernadora Provincial, to Secretario de Estado del Interior y Policía, September 5, 1972, Elias Piña, Legajo 1784, Exp. 3-18/7, SEIP, AGN.

61. Ana Valentina Roa de Moreta, Gobernadora Provincial, to Excelentísimo Señor Presidente de la República, Doctor Joaquín Balaguer, July 25, 1972, Elias Piña, Legajo 1784, Exp. 3-18/7, SEIP, AGN.

62. Lilian Luciano Vda. Alonzo, Gobernadora Provincial, to Secretario de Estado del Interior y Policía, September 1, 1969, Nagua, Legajo 1274, Exp. 3-18/15, SEIP, AGN.

63. Ana Amelia de Saladin, Gobernadora Provincial to Secretario de Estado de Interior y Policía, Dajabon, July 18, 1972, Legajo 1784, Exp. 3-18/4, SEIP, AGN.

64. Onofre Medina, José A. Jiménez, Aquiles Pérez, Luis Heredia Medrano, Manuel Peña González, and Francisco Méndez M. to Joaquín Balaguer, December 1, 1969, Pedernales, Legajo 1274, Exp. 3-18/16, SEIP, AGN.

65. Alejandrina Domenche de Mañe, Gobernadora Provincial, to Francisco Augusto Lara, Vice-Presidente de la República, February 10, 1969, Mao, Legajo 1275, Exp. 3-18/27, SEIP, AGN.

66. Memorandum from Dr. Pablo Ramsay Solano H., Subsecretary, to Secretary SEIP, September 16, 1970, Legajo 1451, Exp. 1-20, SEIP, AGN.

67. *Intercambio*, July 1968, 2, Box 2, Folder 57, Koshland Papers.

68. Mercedes Leger to Secretario de Estado de Interior y Policia, San Cristóbal, January 18, 1970, Legajo 1517, Exp. 3-18/21, SEIP, AGN.

69. In *Intercambio*, July 1968, Koshland Papers.

70. Pérez de Florencia, "Memoria anual," 1967, SEIP, AGN.

71. Though not an exhaustive list, several examples demonstrate the governors' upward mobility. The governor of Independencia served a four-year term as a senator before returning to her post; the governor of La Vega became the *síndica municipal* for the prominent capital city of her province; the much-maligned Governor Roa de Moreta of Elias Piña province, who was physically assaulted during her tenure, went on to become a congressional representative and later president of the Asociación de Agriculturas y Ganaderos in 1976.

Chapter 6. *Sangre sin Revolución*: The Gendered Politics of Opposition through the *Doce Años*

1. The period of the *doce años* has been generally neglected by scholars, Dominican and other. For exceptions see Roberto Cassá, *Los doce años: Contrarrevolución y desarrollismo* (Santo Domingo: Alfa y Omega, 1986); Michael J. Kryzanek, "Diversion, Subversion, and Repression: The Strategies of Anti-Opposition Politics in Balaguer's Dominican Republic," *Caribbean Studies* 17, no. 1/2 (1977): 83-103; Ana S. Q. Liberato, *Joaquín Balaguer, Memory, and Diaspora: The Lasting Political Legacies of an American Protégé* (Lanham, MD: Lexington Books, 2013); Wiarda and Kryzanek, "Dominican Dictatorship Revisited."

2. Scholars and memorialists have asserted, mostly without solid statistics, that the Balaguer regime was more violent than the Trujillato in terms of yearly deaths and disappearances, excluding the Haitian massacre. For a widely circulated account see René Fortunato's film *La violencia del poder* (Santo Domingo: Videocine Palau, 2003).

3. Steven Gregory, *The Devil behind the Mirror: Globalization and Politics in the Dominican Republic* (Berkeley: University of California Press, 2014); Jesse Hoffnung-Garskof, *A Tale of Two Cities: Santo Domingo and New York after 1950* (Princeton, NJ: Princeton University Press, 2008).

4. Hoffnung-Garskof, *Tale of Two Cities*, 45.

5. Franklin J. Franco, *Historia de la UASD y de los estudios superiores* (Santo Domingo: Editora Universitaria, Universidad Autónoma de Santo Domingo, 2007); Hernández, *Emergencia del silencio*.

6. Juan Bosch led the exile to Puerto Rico after he failed to win the presidency in 1966; Jorge Duany, "Dominican Migration to Puerto Rico," *Centro Journal* 17 (2005): 247. For a discussion of Balaguer's response to the opposition parties see Kryzanek, "Diversion, Subversion, and Repression."

7. While the Marxist-led MPD would be the most persecuted of the groups, the list of oppositional political affiliations also included the Partido Socialista Popular (PSP), the Partido Quisqueyano Demócrata (PQD), and the Unión Cívica Nacional (UCN).

8. Proctor Lippincott, "Concerning a Recent Visit to the Dominican Republic," *NACLA Newsletter* 1, no. 2 (March 1967), 3, NACLA Archive of Latin Americana, Smathers Library, University of Florida.

9. Norman Thomas to Roger Baldwin, March 14, 1967, Box 61, Folder 4, Grant Papers.

10. According to a report provided to North American Congress on Latin America, the group was "no more than a manifestation of the decay of the system and its regime and the

illegality within its own laws." The report indicated that the "Anti-Communist and Anti-Terrorist Front of Reformist Youth" group was comprised of former left-wing militant youth blackmailed by the regime and forced to choose either torture and imprisonment or money, freedom, and arms. Balaguer attributed the activity to the breakdown of the MPD and "a phenomenon of juvenile delinquency among fanatical leftist groups," but there is evidence the regime supported the paramilitary collective; Latin American Working Group, *La Banda: An Episode of Terror* (Toronto: Latin American Working Group, 1971); Isis Duarte and José A. Pérez, "Consideraciones en torno a la política represiva y asistencial del estado dominicano, 1966–1978," *Realidad Contemporanea* 11, no. 10–11 (1979): 59–77.

11. Secretario Administrativo de la Presidencia to Secretario de Estado de Interior y Policía, January 26, 1968, Legajo 1095, Exp. 3–16, SEIP, AGN.

12. "Sugiere a la mujer activar el cambio," *Listín Diario,* September 6, 1969, 15.

13. Jefe de la Policía Nacional to Balaguer, April 1, 1967, Legajo 969, Exp. 4–36, SEIP, AGN. In the same memo the chief of police reported dramatically on a woman who had made such an injurious comment about President Balaguer that he could not even write it down.

14. Ana Ramona Valerio, Presidenta Provincial de la Rama Femenina del PRD, to Secretaría de Asuntos Femeninos del PRD, March 6, 1967, Legajo 969, Exp. 4–36, SEIP, AGN.

15. Enrique Pérez y Pérez to Excelentísimo Señor Presidente de la República, August 31, 1972, Legajo 1682, Exp. 3–38, SEIP, AGN.

16. Ibid. Pérez y Pérez had been loudly condemned by the national press for his failure to respond to the terrorist tactics of La Banda in 1971; Latin American Working Group, *La Banda*. According to Jonathan Hartlyn, Pérez y Pérez represented one of two major groups within the military, the other being led by General Neit Rafael Sijas. Balaguer attempted to retain power over the military "by shifting them from one position to another over his twelve years in power"; *Struggle for Democratic Politics in the Dominican Republic*, 109–110.

17. Minimal attention has been paid to these groups despite their clear influence and their connections to other Latin American women's groups like those in Chile. For references to the groups in the Dominican Republic see the UASD publication *Seminario Hermanas Mirabal*; Dominican Republic, SEM, *Mujeres dominicanas*; Tancer, "La Quisqueyana"; Moema Viezzer, *As mulheres da República Dominicana.*

18. For mobilization of women through housewives clubs in Chile in the late 1940s through mid-1960s see Power, *Right-Wing Women in Chile*, 60.

19. Santos de Rivera et al., "Participación política, sindical y estudantil de la mujer," in *Seminario Hermanas Mirabal*, 259.

20. Viezzer, *As mulheres da República Dominicana*, 81–82.

21. Engineer Marcelo Jorge Pérez argued in his paper that it was the militancy of one group of *amas de casa* in the Santo Domingo barrio of Los Prados calling attention to the unequal distribution of blackouts that essentially resulted in the announcement a fairer system in October 1975 by the federal government; "Servicios de energía eléctrica," in *Seminario Hermanas Mirabal*, 310.

22. Gutiérrez initially mobilized around the Trujillo resistance as a member of the 1J4 and later joined the MPD. At some point after her husband's disappearance she went into exile in Paris for a time but returned in 1974 and became extremely active in the women's rights movement and the Partido de Liberación Dominicano (PLD), eventually leading the government's first official ministry of women's affairs in 1979. She served in multiple

national government posts until her death in 2015. Despite the conditions surrounding her husband's death, she seems to never have used *viuda* in her name; many of the other widows of the *doce años* made the same choice.

23. Herrera, *Las viudas de los doce años*, 18.

24. Ibid.

25. R. J. Maidenberg, "Quiet March in Santo Domingo for a Change," *New York Times*, September 27, 1969, 6.

26. Herrera, *Las viudas de los doce años*, 19.

27. "Grupo de mujeres hará manifestación," *Listín Diario*, September 18, 1969, 8.

28. In Maidenberg, "Quiet March," *New York Times*, September 27, 1969, 6.

29. In "La policía impide marcha de mujeres," *Listín Diario*, September 24, 1969, 4.

30. In ibid.

31. In "Esposa de Segarra se dirige Balaguer," *Listín Diario*, October 25, 1969, 5.

32. Margaret Graham, *The Pajarito Project, Dominican Republic 1971* (Toronto: Latin American Working Group, 1971).

33. Herrera, *Las viudas de los doce años*, 50.

34. Graham, *Pajarito Project*. Translations in original. While the letter was clearly intended for multiple international groups, the copy included in Graham's report did not indicate precisely where it was sent.

35. Ibid.

36. In Latin American Working Group, *La Banda*, 7.

37. In her book *Las viudas de los doce años,* Ruth Herrera has transcribed interviews with five women who were widowed by the Balaguer regime: Gladys Gutiérrez, Mirna Santos, Carmen Mazarra, Elsa Peña, and Sagrada Bujosa. While indicating that most women similarly widowed became active in the CFMPD, her focus was more on the men's murders.

38. Santos is cited in Herrera, *Las viudas de los doce años,* 33. The 2015 film *339 Amín Abel Hasbún: Memoria de un crimen*, directed by Etzel Báez offers a fresh perspective on the murder of activist Amín Abel Hasbún in 1970, often considered the most notorious of all of Balaguer's political assassinations in no small part because he was shot in his home in front of his pregnant wife and young child.

39. In Herrera, *Las viudas de los doce años*, 53.

40. Born in the early 1930s, Prats-Ramírez de Pérez lived through nearly the entirety of the Trujillato. After receiving her degree in education from the UASD in 1964 she began teaching. She was a prominent member of the PRD, served on its executive committee, and became the party president in 1979. She also continued her work in education, serving as the first director of the Department of Pedagogy at the UASD in 1967 as well as dean and vice dean of the School of Humanities from 1968 to 1972.

41. Prats-Ramírez de Pérez, "No eran reformistas?" in her *Los días difíciles*, 177.

42. Prats-Ramírez de Pérez, "Todos los años serán nuestros años," in her *Los días difíciles*, 139–142.

43. Ibid., 141.

44. Prats-Ramírez de Pérez, "No eran reformistas?" in her *Los días difíciles*, 175. For a visual depiction of these Mother's Day gatherings see Fortunato's film *La violencia del poder*.

45. Ibid., 177. Perhaps not coincidentally, the next day at a reelection homage, Balaguer declared that involving women in politics was "not only useful but necessary"; *Listín Diario*, September 25, 1969, 1.

46. Cited in Lucero Quiroga, "Feminización Universitaria en la República Dominicana: 1977–2002," in *Miradas desencadenantes: Los estudios de género*, ed. Candelario, 54.

47. Ligia Amada Melo de Cardona, "Participación de la mujer en la educación sistemática en la República Dominicana," *Colección UASD Crítica* 238, no. 19 (1977): 11–12.

48. The university reform movement in the Dominican Republic was similar to movements across Latin America that began after World War I but had a much later start due to the strong arm of the Trujillato.

49. Franco, *Historia de la UASD y de los estudios superiores*, 227–235.

50. Atkins and Wilson, *The Dominican Republic and the United States*, 91, 144–146.

51. Trujillo had built up the area surrounding the university as part of a larger program of urban renewal; Ornes, *Trujillo: Little Caesar of the Caribbean*, 178–181.

52. While in most cases women lived with families or in boarding houses during their university years, the relative autonomy of life in such a new setting still afforded a newfound independence.

53. The UASD and the Ciudad Universitaria were sources of aggravation for the regime. Historian Frank Moya Pons argues that Balaguer "yielded the control of the state university to the revolutionary groups to keep them busy and under observation," but it was not an easy exchange of power; *Dominican Republic*, 395. On many occasions the government closed the university and enforced the closure with military force due to upswings in political violence. In one case, the UASD was closed for two weeks during the second Balaguer term; Ian Bell, *The Dominican Republic* (Boulder: Westview Press, 1981), 100. Most opposition groups on the left had student subsidiaries, and those groups were often the strongest arm of the party. By 1977, the president had "yet to break the hold of the PRD and the left at the Autonomous University of Santo Domingo"; Kryzanek, "Diversion, Subversion, and Repression," 95. Balaguer consistently denied the UASD their proper share (5 percent) of the national budget while offering generous subsidies to private and more conservative schools, which merely fueled the animosity between the regime and the state university's already politicized student body; Bell, *Dominican Republic*, 173–174.

54. Hernández, *Emergencia del silencio*, 154.

55. Clara Báez, *La subordinación social de la mujer dominicana en cifras* (Santo Domingo: Dir. General de Promoción de la Mujer, 1981), 43.

56. Hernández, *Emergencia del silencio*, 159.

57. Amelia de Beevers, "Mujeres que trabajan," *¡Ahora!* December 19, 1964, 68–69. The author does not identify the positions of the interviewees, but they were likely all bank tellers.

58. Mary Collins, "Mujeres que trabajan: Sonia Altagracia Peralta," *¡Ahora!* August 10, 1964, 79.

59. Mary Collins, "Sí es compatible el trabajo de la mujer con las felicidades del hogar," *¡Ahora!* May 30, 1964, 69.

60. In the early 1970s feminist activist and educator Magaly Pineda began contributing to *Listín Diario* under the pseudonym Leonor Tejada, similarly raising issues of gender equity and social transformation.

61. Susana Morillo, "Mujeres que trabajan," *Listín Diario*, July 14, 1975, 6A.

62. Cornelia Butler Flora, "Socialist Feminism in Latin America," *Women and Politics* 4, no. 1 (1984): 86.

63. Gladys Gutiérrez argues that partisan fissures were the major reason for the organization's breakdown; in Herrera, *Las viudas de los doce años*, 11.

64. Ferreras, *Historia del feminismo en la República Dominicana*, 212.

65. "Por un verdadero movimiento liberador de la mujer," *Que? La Revista del Pueblo* 2, no. 20 (June 1972): 38–46.

66. Graham, *Pajarito Project*, 9.

67. "Historia," *Profamilia*, n.d., http://www.profamilia.org.do/pageview.aspx?ArticleID=2.

68. One of the group's clinics, Clínica Evangelina Rodríguez, was named for one of the earliest Dominican feminists and the first advocate for women's reproductive health in the country; Antonio Zaglul, *Despreciada en la vida y olvidada en la muerte: Biografía de Evangelina Rodríguez, la primera médica dominicana* (Santo Domingo: Taller, 1980).

69. Decreto no. 2091, CONAPOFA, February 14, 1968, at http://conapofa.gov.do/transparencia/doc/base_legal/.

70. Vivian M. Mota, "Algunas consideraciones sobre la iglesia católica, la mujer y la planificación familiar," *Estudios Sociales* 6, no. 3 (September 1973): 117–142.

71. Licelott Marte de Barrios came of age during the Trujillato and received her law degree in 1958, working briefly for the regime before leaving to study at the Sorbonne. She entered political life in 1966 and served in several prominent positions during the *doce años*. For the seminar see United Nations, Department of Economic and Social Affairs, *Regional Seminar on the Status of Women and Family Planning for Countries of the Western Hemisphere, Santo Domingo, Dominican Republic, 9-22 May 1973* (New York: United Nations, 1974).

72. Mota, "Algunas consideraciones sobre la iglesia Católica, la mujer y la planificación familiar," 134.

73. Examples from the series can be seen in *¿Que? La Revista del Pueblo* 1 and 2, nos. 11, 12, and 20 (1971–1972).

74. LIREMU, "Movimiento de la Mujer Por Un Verdadero Liberador," *¿Que? La Revista del Pueblo* 2, no. 20 (June 1972): 38–46.

75. Ferreras, *Historia del feminismo en la República Dominicana*, 212.

76. LIREMU, "Movimiento de la mujer por un verdadero liberador," *¿Que? La Revista del Pueblo* 2, no. 20 (June 1972): 38–46; "Picadillos," *¿Que? La Revista del Pueblo* 3, no. 32 (December 1973): 34. Women much later still decried the imperialism of western feminism. In Ramón Ferreras' 1991 *Historia del feminismo en la República Dominicana*, Nelly Nirsi Matos López, at the time a twenty-year-old engineering student, considered the women's liberation movement in the Dominican Republic to be "represented by a small group of aristocratic 'ladies' who really are not doing anything for what should be called 'Dominican feminism' in the country; what they do is blah conferences, trips abroad (for what?), lectures, etc. etc." (202). Carmen Mazara, widow of activist Maximiliano Gómez and a member of the MPD, emphatically stated, "I do not believe in women's liberation. I believe in the liberation of society" (214).

77. In Ferreras, *Historia del feminismo en la República Dominicana*, 206, 210.

78. Ibid., 202–212.

79. Vivian Mota, "La mujer y la izquierda dominicana," *¡Ahora!*, January 1, 1973, 66–67.

80. Ferreras, *Historia del feminismo en la República Dominicana*, 207–210.

81. Altagracia Coiscou Guzmán, "La liberación de la mujer," *¿Que? La Revista del Pueblo* 1, no. 12 (October 1971): 38–42.

82. Ibid, 39. Coiscou's association with the Women's International Terrorist Conspiracy from Hell (WITCH) merits further research; one of the most prominent members of the

organization, Robin Morgan, would later include a Dominican feminist tract, "The Spanish Speaking Caribbean" by Magaly Pineda, in the 1984 anthology *Sisterhood Is Global*.

83. Coiscou Guzmán, "La liberación de la mujer," 40.

Epilogue: International Women's Year and Dominican Transnational Feminism under Authoritarianism

1. Hartlyn, *Struggle for Democratic Politics in the Dominican Republic*, 111.
2. Miller, *Latin American Women and the Search for Social Justice*, 202–203.
3. Forty years later, Dominican feminist collectives continue to fight these issues.
4. The UN Economic and Social Council created a subcommission on the status of women as a subsidiary to the Commission on Human Rights in 1946, and Minerva Bernardino helped draft the original subcommission charter. That same year, with the assistance of Eleanor Roosevelt, the group was elevated to the status of full commission, the UN Commission on the Status of Women. The IACW was initially the only non-UN intergovernmental organization to observe sessions of the commission, although attendance by NGOs was common; Margaret E. Galey, "Women Find a Place," in *Women, Politics, and the United Nations*, ed. Anne Winslow (Westport, CT: Greenwood, 1995), 11–27.
5. Margaret E. Galey, "Forerunners in Women's Quest for Partnership," in *Women, Politics, and the United Nations*, ed. Anne Winslow (Westport, CT: Greenwood, 1995), 1.
6. Devaki Jain, *Women, Development, and the UN: A Sixty-Year Quest for Equality and Justice* (Bloomington: Indiana University Press, 2005), 67.
7. Cándido Gerón, *Diccionario político dominicano: 1821–2000* (Santo Domingo: De Colores, 2001), 357.
8. Ramonina Brea and Isis Duarte, *Entre la calle y la casa: las mujeres dominicanas y la cultura política a finales del siglo XX* (Santo Domingo: Profamilia, Búho, 1999), 139.
9. Licelott Marte de Barrios, "Esquema de la campaña de promoción y difusión para el Año Internacional de la Mujer, 1975," Secretaría de Estado de Relaciones Exteriores, AGN.
10. Licelott Marte de Barrios, "Aide Memoire," May 3, 1975, Santo Domingo, Secretaría de Estado de Relaciones Exteriores, AGN.
11. In Ferreras, *Historia del feminismo en la República Dominicana*, 199.
12. "Dominican Republic," *IWY Bulletin*, March 1975, 15, IACW Papers.
13. "Dominican Republic," *IWY Bulletin*, February 1976, 7, IACW Papers.
14. For more on the tensions of the event as alternately a watershed and a cacophony of voices see Jocelyn Olcott, "Cold War Conflicts and Cheap Cabaret: Sexual Politics at the 1975 United Nations International Women's Year Conference," *Gender and History* 22, no. 3 (November 2010): 733–754.
15. Jain, *Women, Development, and the UN*, 69–71.
16. In Ferreras, *Historia del feminismo en la República Dominicana*, 211. Interestingly, Mirna de Peña had argued at the Seminario Hermanas Mirabal that the "so-called International Women's Year" was nothing more than a vehicle of bourgeois women run by opportunists and ignorant of the real needs of working women. Clearly within the course of the year her opinion weathered some changes; Peña, "Participación de la mujer en el movimiento syndical," in *Seminario Hermanas Mirabal*, 271.
17. In Ferreras, *Historia del feminism en la República Dominicana*, 208–209.
18. Hernández, *Emergencia del silencio*, 151.
19. Dominican appointees to the world conference of the International Women's Year in

Mexico City included many of Balaguer's most prominent female officials. Representing the government in a formal capacity were Licelott Marte de Barrios, subsecretary of foreign affairs and representative to the IACW, as the head of the delegation; Fidelina Thorman de Aquilar, subsecretary of the Department of Public Health and Social Assistance; Quisqueya Damirón, Dominican consul in New York; and Amparo Vittini, director of the Women's Division of the Department of Agriculture. Antonia Ramírez served in her capacity as professor at the Universidad Nacional Pedro Henríquez Ureña, while Fior Solis de Méndez, Minerva Bretón, Inova Marte, Clara Leyla Alfonso, and Carmen Brusiloff represented the disciplines of psychiatry, economics, law, and journalism, respectively. However, more than just attending the June conference, the delegates were responsible for regular meetings and seminars at national and regional levels with governors, legislators, and local officials throughout the year.

20. Prats-Ramírez de Pérez, "Todos los años serán nuestros años," in her *Los días difíciles*, 142.

21. Pineda, "Spanish Speaking Caribbean," 133. Pineda was born in Santo Domingo in 1943 but exiled in 1960 to Puerto Rico, where she remained until 1965. She was involved in the April Revolution and helped form the Federation of Dominican Women. After the civil war she became a professor at the UASD and continued to work on feminist issues through journalism and educational projects. In 1980 she cofounded the Centro de Investigación para la Acción Femenina (CIPAF, Center of Investigation for Women's Action), perhaps the most important feminist collective in the Dominican Republic.

22. "Discurso pronunciado por el Dr. Hugo Tolentino Dipp," in *Seminario Hermanas Mirabal*, 20–24.

23. Included in the list of presenters were journalist and feminist Magaly Pineda, former vice presidential candidate Josefina Padilla, Association of University Employees leader Myrna de Peña, journalist and PRD member Ivelisse Prats-Ramírez de Pérez, and UASD professors Isis Duarte, Ana Silvia Reynoso, and Martha Olga García. Many were former members of the Federación de Mujeres Dominicanas, most were active in their respective political parties, and all were distinguished individuals in their fields. Of the thirty planned presentations, only six were from men; Universidad Autónoma de Santo Domingo, *Seminario Hermanas Mirabal*.

24. Carlos Temístocles Roa, "Introducción," in *Seminario Hermanas Mirabal*, 5–6.

25. "Palabras pronunciadas por la señorita Minerva Josefina Tavárez Mirabal," in *Seminario Hermanas Mirabal*, 29–30. Minerva Josefina (Minou) Tavárez Mirabal, daughter of Minerva Mirabal de Tavárez and Manuel Aurelio Tavárez Justo, was born August 31, 1956; Galván, *Minerva Mirabal*, 228.

26. "Delegación cubana considera desde 1959 comenzó en su país revalorización de la mujer," *Última Hora*, December 10, 1975, 3.

27. Prats-Ramírez de Pérez, "Educación ambiental," in *Seminario Hermanas Mirabal*, 183.

28. Magaly Pineda, Martha Olga García, and Laura Faxas, "Mujer, mito y realidad," in *Seminario Hermanas Mirabal*, 148.

29. Francisco A. de Moya Espinal, "República Dominicana: Trabajo femenino, educación y discriminación," in *Seminario Hermanas Mirabal*, 50.

30. Prats-Ramírez de Pérez, "Educación ambiental," in *Seminario Hermanas Mirabal*, 176–177.

31. Zoraida Heredia Vda. Suncar and Erasmo Lara, "Textos escolares y condiciona-

mientos sexuales," in *Seminario Hermanas Mirabal*, 193–204; Prats-Ramírez de Pérez, "Educación ambiental," in *Seminario Hermanas Mirabal*; Fanny Sánchez de Bonilla, "La mujer dominicana y su grado de participación en el proceso politico actual," in *Seminario Hermanas Mirabal*, 232–240.

32. "Dominican Republic," *International Women's News* 69, no. 5 (1974): 30.

33. Margarita Tavárez, Flavia García, Carmen Josefina Lora, and Martha Olga García, "Estudio jurídico de la mujer, modificaciones legales, profundidad y extension," in *Seminario Hermanas Mirabal*, 212.

34. Ibid., 223–224,

35. SEM, *Mujeres Dominicanas*, 140.

36. Altagracia M. Herrera Miniño, "¿Necesitan las mujeres liberación?" *Listín Diario*, June 6, 1975, 7, and June 7, 1975, 7.

37. Ibid., June 6, 1975, 7.

38. Ibid., June 7, 1975, 7.

39. For its current agenda see the CIPAF website, http://www.cipaf.org.do/index.php.

40. See Lipe Collado, *El tíguere dominicano* (Santo Domingo: El Mundo, 1992); Derby, "Dictator's Seduction" (2000); Krohn-Hansen, "Masculinity and the Political among Dominicans."

41. M. Cordero, *Mujeres de abril*, 30.

Bibliography

Archives

Archivo General de la Nación, Santo Domingo (AGN)
 Partido Dominicano, Correspondence, 1942–1960
 Secretaría de Estado de Educación, 1950
 Secretaría de Estado de Interior y Policía, 1942–1978
 Secretaría de Estado de Relaciones Exteriores, 1930–1978
 Secretaría de Estado de Salud Pública y Asistencia Social, 1959–1978
Biblioteca Nacional, Santo Domingo (BN)
 Memorias del Partido Dominicano, 1944–1948
Elmendorf, Mary L., Papers, 1931–2009. Special and Area Studies Collections, Smathers Library, University of Florida.
Grant, Frances R., Papers, 1897–1986. Special Collections and University Archives, Rutgers University Libraries.
Inter-American Commission of Women Records. Sophia Smith Collection, Smith College.
Koshland, Lucile Heming, Papers, 1947–1974. Harvard University, Radcliffe Institute, Schlesinger Library.
League of Women Voters, Overseas Education Fund Archives. Special Collections, Hornbake Library, University of Maryland Libraries.
North American Congress on Latin America (NACLA), Archive of Latin Americana. Special and Area Studies Collections, Smathers Library, University of Florida.
Stevens, Doris, Papers, 1884–1983. Harvard University, Radcliffe Institute, Schlesinger Library.
Thomas, Norman, Papers, 1904–1967. Manuscripts and Archives Division, New York Public Library.
U.S. Department of State, General Records, Record Group 59. U.S. National Archives (USNA II), College Park, MD.

Published Sources

Acosta Matos, Eliades. *La dictadura de Trujillo: Documentos.* Vol. 2, book 1. Santo Domingo: Archivo General de la Nación, 2012.
Aguilar Fernandez, Paloma, and Carsten Humlebaek. "Collective Memory and National

Identity in the Spanish Democracy: The Legacies of Francoism and the Civil War." *History and Memory* 14, no. 1 (2002): 121–164.
Albert Batista, Celsa. *Mujer y esclavitud en Santo Domingo*. Santo Domingo: Ediciones CEDEE, 1993.
Algunas notas biográficas de la insigne patricia y educadora señorita Ercilia Pepín. Santiago, Dominican Republic: L. H. Cruz, 1932.
Alvarez, Julia. *In the Time of the Butterflies*. Chapel Hill, NC: Algonquin Books, 1994.
Alvarez, Sonia E. *Engendering Democracy in Brazil: Women's Movements in Transition Politics*. Princeton, NJ: Princeton University Press, 1990.
Alvarez, Sonia E., and Elisabeth Jay Friedman. "Encountering Latin American and Caribbean Feminisms." *Signs* 28, no. 2 (2003): 537–579.
Álvarez, Virtudes. *Mujeres del 16*. Santo Domingo: Mediabyte, 2005.
Aquino García, Miguel. *Tres heroínas y un tirano: La historia verídica de las hermanas Mirabal y su asesinato por Rafael Leonidas Trujillo*. Santo Domingo: Ediciones Universidad Interamericana UNICA, 1996.
Arregui, Marivi. "Trayectoria del feminismo en la República Dominicana." *Ciencia y Sociedad* 13, no. 1 (March 1988): 9–18.
Atkins, G. Pope, and Larman C. Wilson. *The Dominican Republic and the United States: From Imperialism to Transnationalism*. Athens: University of Georgia Press, 1998.
Auyero, Javier. *Poor People's Politics: Peronist Survival Networks and the Legacy of Evita*. Durham, NC: Duke University Press, 2000.
Bacchetta, Paola, and Margaret Power. *Right-Wing Women: From Conservatives to Extremists around the World*. New York: Routledge, 2002.
Báez, Clara. "Informe sobre la situación social de la mujer en el contexto histórico de las transformaciones económicas, demográficas y culturales de la República Dominicana a partir de la década de 1960." *Ciencia y Sociedad* 13, no. 1 (March 1988): 19–42.
———. *La subordinación social de la mujer dominicana en cifras*. Santo Domingo: Dirección General de Promoción de la Mujer, 1981.
Báez, Etzel, dir. *339 Amín Abel Hasbún: Memoria de un crimen*. Film. Etzel Báez Filme, 2014.
Báez Díaz, Tomás. *Trilogía: La mujer aborigen, la mujer en la colonia y la mujer dominicana*. Santo Domingo: De Colores, 1998.
Balaguer, Joaquín. *La marcha hacia el Capitolio*. Mexico City: Fuentes Impresores, 1973.
Bell, Ian. *The Dominican Republic*. Boulder, CO: Westview, 1981.
Benerias, Lourdes, and Gita Sen. "Disigualdades de clase y género y el rol de la mujer en el desarrollo económico: Implicaciones teóricas y practicas." In *Sociedad, subordinación y feminismo*, edited by Magdalena León. Bogotá: Asociación Colombiana para el Estudio de la Población, 1982.
Bernardino, Minerva. *Lucha, agonía y esperanza trayectoria triunfal de mi vida*. Santo Domingo: Corripio, 1993.
———. *Minerva Bernardino, su lucha por los derechos de la mujer*. Santo Domingo, 1976.
Besse, Susan K. *Restructuring Patriarchy: The Modernization of Gender Inequality in Brazil, 1914–1940*. Chapel Hill: University of North Carolina Press, 1996.
Betances, Emelio. "Social Classes and the Origin of the Modern State: The Dominican Republic, 1844–1930." *Latin American Perspectives* 22, no. 3 (July 1995): 20–40.
———. *State and Society in the Dominican Republic*. Boulder, CO: Westview, 1995.
Blee, Kathleen M. *Women of the Klan: Racism and Gender in the 1920s*. Berkeley: University of California Press, 1991.

Blee, Kathleen M., and Sandra McGee Deutsch. *Women of the Right: Comparisons and Interplay across Borders.* University Park: Pennsylvania State University Press, 2012.

Borgwardt, Elizabeth. *A New Deal for the World: America's Vision for Human Rights.* Cambridge, MA: Harvard University Press, 2005.

Bosch, Juan. *The Unfinished Experiment: Democracy in the Dominican Republic.* New York: Praeger, 1965.

Bouvard, Marguerite Guzman. *Revolutionizing Motherhood: The Mothers of the Plaza de Mayo.* Wilmington, DE: Scholarly Resources, 1994.

Boyd, Carolyn. "The Politics of History and Memory in Democratic Spain." *Annals of the American Academy of Political and Social Science* 617, no. 1 (2008): 133–148.

Bratzel, John F. Introduction to *Latin America during World War II*, edited by Thomas M. Leonard and John F. Bratzel, 1–16. Lanham, MD: Rowman and Littlefield, 2007.

Brea, Ramonina, and Isis Duarte. *Entre la calle y la casa: Las mujeres dominicanas y la cultura política a finales del siglo XX.* Santo Domingo: Profamilia, Búho, 1999.

Brea, Ramonina, Rosario Espinal, and Fernando Valerio-Holguín, eds. *La República Dominicana en el umbral del siglo XXI: Cultura, política y cambio social.* Santo Domingo: Pontificia Universidad Católica Madre y Maestra, Centro Universitario de Estudios Políticos y Sociales, 1999.

Brown, Wenzell. *Angry Men, Laughing Men: The Caribbean Caldron.* New York: Greenberg, 1947.

Bustamante, Gregorio R. *Una satrapía en el Caribe.* Guatemala City: Ediciones del Caribe, 1949.

Cabral, Tomasina. "Testimonio de Sina Cabral." In *Memorias de la lucha contra la tiranía*, Fundación de los Héroes de Constanza, Maimón y Estero Hondo, 195–202. Santo Domingo: Fundación de los Héroes de Constanza, Maimón y Estero Hondo, 1983.

Calder, Bruce. *The Impact of Intervention: The Dominican Republic during the U.S. Occupation of 1916–1924.* Austin: University of Texas Press, 1984.

Campbell, Caroline Jane. "Women and Men in French Authoritarianism: Gender in the Croix de Feu and Parti Social Francais, 1927–1945." PhD diss., University of Iowa, 2009.

Candelario, Ginetta E. B. *Black behind the Ears: Dominican Racial Identity from Museums to Beauty Shops.* Durham, NC: Duke University Press, 2007.

———. "El eco de su voz allende a los mares: La primera etapa en el pensamiento feminista dominicano." In *Miradas desencadenantes: Los estudios de género*, edited by Candelario, 43–49.

———, ed. *Miradas desencadenantes: Los estudios de género en la República Dominicana al inicio del tercer milenio.* Santo Domingo: Centro de Estudios de Género, Instituto Tecnológico de Santo Domingo, 2005.

Candelario, Ginetta E. B., Elizabeth S. Manley, and April J. Mayes, eds. *Cien años de feminismos dominicanos.* Santo Domingo: Archivo General de la Nación, 2016.

Cano, Gabriela. "Elena Arizmendi, una habitación propia en Nueva York, 1916–1938." *Arenal* 18, no. 1 (June 2011): 85–114.

Carlson, Marifran. *Feminismo! The Woman's Movement in Argentina from Its Beginnings to Eva Perón.* Chicago: Academy Chicago, 1988.

Cassá, Roberto. *Capitalismo y dictadura.* Santo Domingo: Editora Universitaria, Universidad Autónoma de Santo Domingo, 1982.

———. *Los doce años: Contrarrevolución y desarrollismo.* Santo Domingo: Alfa y Omega, 1986.

———. *Minerva Mirabal: La revolucionaria.* Santo Domingo: Tobogan, 2000.

———. *Los orígenes del Movimiento 14 de Junio.* Santo Domingo: Editora Universitaria, Universidad Autónoma de Sango Domingo, 1999.

Cassá, Roberto, and Fred Murphy. "Recent Popular Movements in the Dominican Republic." *Latin American Perspectives* 22, no. 3 (July 1995): 80–93.

Chambers, Sarah C. "Republican Friendship: Manuela Sáenz Writes Women into the Nation, 1835–1856." *Hispanic American Historical Review* 81, no. 2 (2001): 225–257.

Chaney, Elsa. *Supermadre: Women in Politics in Latin America.* Austin: University of Texas Press, 1979.

Chehabi, H. E., and Juan J. Linz. *Sultanistic Regimes.* Baltimore, MD: Johns Hopkins University Press, 1998.

Chester, Eric Thomas. *Rag-Tags, Scum, Riff-Raff, and Commies: The U.S. Intervention in the Dominican Republic, 1965–1966.* New York: Monthly Review, 2001.

Clark, A. Kim. *Gender, State, and Medicine in Highland Ecuador: Modernizing Women, Modernizing the State, 1895–1950.* Pittsburgh, PA: University of Pittsburgh Press, 2012.

Cocco-DeFilippis, Daisy. *Desde la diáspora: Selección bilingüe de ensayos.* New York: Ediciones Alcance, 2003.

———, ed. *Documents of Dissidence: Selected Writings of Dominican Women.* New York: CUNY Dominican Studies Institute, 2000.

———. "The Politics of Literature: Dominican Women and the Suffrage Movement. Case Study: Delia Weber." In *Winds of Change: The Transforming Voices of Caribbean Women Writers and Scholars,* edited by Adele Newson and Linda Strong-Leek, 83–106. New York: Peter Lang, 1998.

Coiscou Guzmán, Grey. *Testimonios: La gavilla luminosa.* Santo Domingo: Cocolo, 2002.

———. *Testimonios: La simiente convulsa.* Santo Domingo: Cocolo, 2002.

Collado, Lipe. *El tíguere dominicano.* Santo Domingo: El Mundo, 1992.

Contreras, Dario. *Mensaje a la mujer dominicana.* Ciudad Trujillo: La Nación, 1942.

Cordero, Margarita. *Mujeres de abril.* Santo Domingo: Centro de Investigación para la Acción Feminista, 1985.

———. "Mujer y política." *Ciencia y Sociedad* 13, no. 1 (March 1988): 43–53.

Cordero, Walter. *Actitudes de los directores de los medios de comunicación de masas frente a la planificación familiar.* Santo Domingo: Consejo Nacional de Población y Familia, 1976.

Cordero, Walter, and Neici M. Zeller. "El desfile trujillista: Despotismo y complicidad." In *Homenaje a Emilio Cordero Michel,* edited by Emilio Cordero Michel and José Miguel Abreu Cardet, 113–174. Santo Domingo: Academia Dominicana de la Historia, 2004.

Cordero Michel, Emilio. "Las expediciones de junio de 1959." *Estudios Sociales* 25, no. 88 (June 1992): 35–63.

Cott, Nancy F. *The Grounding of Modern Feminism.* New Haven, CT: Yale University Press, 1987.

Crandall, Russell. *Gunboat Democracy: U.S. Interventions in the Dominican Republic, Grenada, and Panama.* Lanham, MD: Rowman and Littlefield, 2006.

Craske, Nikki, and Maxine Molyneux, eds. *Gender and the Politics of Rights and Democracy in Latin America.* New York: Palgrave, 2002.

Crassweller, Robert D. *Trujillo: The Life and Times of a Caribbean Dictator.* New York: Macmillan, 1966.

Cruz González, Alcibíades. *Las heroínas de Salcedo en un ojo de agua*. Santo Domingo: Impresos Cobe, 1997.

Cruz Infante, José Abigaíl. *Hombre y mujeres de Trujillo: Isabel Mayer*. Santo Domingo: Argos, 2013.

Cruz Segura, Juan J. *Bajo la barbarie: La Juventud Democrática clandestina, 1947–1959: Testimonio de un protagonista*. Santo Domingo: Taller, 1997.

Cuello H., José Israel. *¿Qué era la resistencia antitrujillista interna a la hora de la invasión de Constanza, Maimón y Estero Hondo, el 14 de junio de 1959?* Santo Domingo: Fundación Testimonio, 1983.

De Grazia, Victoria. *How Fascism Ruled Women: Italy, 1922–1945*. Berkeley: University of California Press, 1992.

del Orbe, Justino José. *Del exilio político dominicano antitrujillista, en Cuba*. Santo Domingo: Taller, 1983.

Derby, Lauren. "The Dictator's Seduction: Gender and State Spectacle during the Trujillo Regime." *Callaloo* 23, no. 3 (2000): 1112–1146.

———. *The Dictator's Seduction: Politics and the Popular Imagination in the Era of Trujillo*. Durham, NC: Duke University Press, 2009.

Derby, Lauren Hutchinson. "The Magic of Modernity: Dictatorship and Civic Culture in the Dominican Republic, 1916–1962." PhD diss., University of Chicago, 1998.

Derby, Robin, and Richard Turits. "Historias de terror y los terrores de la historia: La masacre haitiana de 1937 en la República Dominicana." *Estudios Sociales* 26, no. 92 (1993): 65–76.

Despradel, Fidelio. *Abril: Historia gráfica de la Guerra de Abril*. Santo Domingo: Secretaría de Estado de Cultura de la República Dominicana, 2005.

Deutsch, Sandra McGee. "Gender and Sociopolitical Change in Twentieth-Century Latin America." *Hispanic American Historical Review* 71, no. 2 (May 1991): 259–306.

———. *Las Derechas: The Extreme Right in Argentina, Brazil, and Chile, 1890–1939*. Stanford, CA: Stanford University Press, 1999.

———. "Spreading Right-Wing Patriotism, Femininity, and Morality: Women in Argentina, Brazil, and Chile, 1900–1940." In *Radical Women in Latin America Left and Right*, edited by Victoria González and Karen Kampwirth, 223–248. University Park: Pennsylvania State University Press, 2001.

Díaz, Junot. *The Brief Wondrous Life of Oscar Wao*. New York: Riverhead Books, 2007.

Diederich, Bernard. *Trujillo: The Death of the Dictator*. Princeton NJ: Markus Wiener, 2000.

Dominican Republic, Ministerio de la Mujer. *50 años de la constitución, 1963–2013*. Santo Domingo: Ministerio de la Mujer, 2013.

Dominican Republic, Museo Nacional de Historia y Geografía. *Mujeres sobresalientes en la historia dominicana*. Santo Domingo: Dirección de Información, Publicidad y Prensa de la Presidencia, 1983.

Dominican Republic, Secretaría de Estado de la Mujer. *Mujeres dominicanas: De la sombra a la luz*. Santo Domingo: Secretaría de Estado de la Mujer, 2000.

Dore, Elizabeth, and Maxine Molyneux, eds. *Hidden Histories of Gender and the State in Latin America*. Durham, NC: Duke University Press, 2000.

———. Preface to *Hidden Histories of Gender and the State in Latin America*, edited by Dore and Molyneux, ix–xiii.

Draper, Theodore. *The Dominican Revolt: A Case Study in American Policy*. New York: Commentary, 1968.

Duarte, Isis, and José A. Pérez. "Consideraciones en torno a la política represiva y asistencial del estado dominicano, 1966–1978." *Realidad Contemporanea* 11, no. 10–11 (1979): 59–77.

Dubois, Ellen, and Lauren Derby. "The Strange Case of Minerva Bernardino: Pan American and United Nations Women's Right Activist." *Women's Studies International Forum* 32, no. 1 (2009): 43–50.

Duany, Jorge. "Dominican Migration to Puerto Rico." *Centro Journal* 17 (2005): 242–268.

Dubois, Laurent. *Avengers of the New World: The Story of the Haitian Revolution*. Cambridge, MA: Harvard University Press, 2009.

Durán, Carmen. *Historia e ideología: Mujeres dominicanas, 1880–1950*. Santo Domingo: Archivo General de la Nación, 2010.

Ehrick, Christine. "Madrinas and Missionaries: Uruguay and the Pan-American Women's Movement." *Gender and History* 10, no. 3 (1998): 406–424.

———. "To Serve the Nation: Juvenile Mothers, Paternalism, and State Formation in Uruguay, 1910–1930." *Social Science History* 29, no. 3 (2005): 489–518.

Escobar, Arturo. *The Making of Social Movements in Latin America: Identity, Strategy, and Democracy*. Boulder, CO: Westview, 1992.

Espaillat, Teresa. *Abril en mis recuerdos: Testimonio de una combatiente*. Santo Domingo: Cocolo, 2001.

Espinal, Rosario. *Autoritarismo y democracia en la política dominicana*. San José, Costa Rica: Centro Interamericano de Asesoría y Promoción Electoral, Instituto Interamericano de Derechos Humanos, 1987.

———. "Between Authoritarianism and Crisis-Prone Democracy: The Dominican Republic after Trujillo." In *Society and Politics in the Caribbean*, edited by Colin Clarke, 145–165. New York: St. Martin's, 1991.

Fábregas, Johanna I. Moya. "The Cuban Woman's Revolutionary Experience: Patriarchal Culture and the State's Gender Ideology, 1950–1976." *Journal of Women's History* 22, no. 1 (2010): 61–84.

Fernández, Carmen Lara. *Historia del Feminismo en la República Dominicana*. Ciudad Trujillo: Arte y Cine, 1952.

Ferreras, Ramón Alberto. *Historia del feminismo en la República Dominicana (su origen y su proyección social)*. Santo Domingo: Editorial del Nordeste, 1991.

———. *Las Mirabal*. Santo Domingo: Editorial del Nordeste, 1982.

Fink, Leon. *Workers across the Americas: The Transnational Turn in Labor History*. New York: Oxford University Press, 2011.

Fitzgibbon, Russell H. "Continuismo: The Search for Political Longevity." In *Caudillos: Dictators in Spanish America*, edited by Hugh M. Hamill, 210–217. Norman: University of Oklahoma Press, 1992.

Flora, Cornelia Butler. "Socialist Feminism in Latin America." *Women and Politics* 4, no. 1 (1984): 69–93.

Fortunato, René, dir. *La herencia del tirano*. Film. Santo Domingo: Videocine Palau, 1998.

———, dir. *La violencia del poder*. Film. Santo Domingo: Videocine Palau, 2003.

Foweraker, Joe. *Theorizing Social Movements*. London: Pluto, 1995.

Franco, Franklin J. *La era de Trujillo*. Santo Domingo: Fundación Cultural Dominicana, 1992.

———. *Historia de la UASD y de los estudios superiores*. Santo Domingo: Editora Universitaria, Universidad Autónoma de Sango Domingo, 2007.

———. *Historia del pueblo dominicano*. Santo Domingo: Sociedad Editorial Dominicana, 2002.

———. *El juicio a los asesinos de las hermanas Mirabal*. Santo Domingo: Comisión Permanente de Efemérides Patrias, 2011.

Fraser, Nicholas, and Marysa Navarro. *Evita*. New York: W. W. Norton, 1996.

French, Jan Hoffman. "A Tale of Two Priests and Two Struggles: Liberation Theology from Dictatorship to Democracy in the Brazilian Northeast." *The Americas* 63, no. 3 (2007): 409–443.

Frías de Rodríquez, Thelma. *Diez razones de mi anticomunismo*. Pamphlet. Ciudad Trujillo, 1959.

Friedman, Elisabeth. *Unfinished Transitions: Women and the Gendered Development of Democracy in Venezuela, 1936–1996*. University Park: Pennsylvania State University Press, 2000.

Fundación de los Héroes de Constanza, Maimón y Estero Hondo. *Memorias de la lucha contra la tiranía*. Santo Domingo: Fundación de los Héroes de Constanza, Maimón y Estero Hondo, 1983.

Galey, Margaret E. "Forerunners in Women's Quest for Partnership." In *Women, Politics, and the United Nations*, edited by Anne Winslow, 1–10. Westport, CT: Greenwood, 1995.

———. "Women Find a Place." In *Women, Politics, and the United Nations*, edited by Anne Winslow, 11–27. Westport, CT: Greenwood, 1995.

Galíndez, Jesús de. *The Era of Trujillo, Dominican Dictator*. Tucson: University of Arizona Press, 1973.

Galván, William. *Minerva Mirabal: Historia de una heroína*. Santo Domingo: Editora Universitaria, Universidad Autónoma de Santo Domingo, 1982.

García Bonnelly, Juan Ulises. *Las obras públicas en la era de Trujillo*. Ciudad Trujillo: Impresora Dominicana, 1955.

García-Peña, Lorgia. *The Borders of Dominicanidad: Race, Nation, and Archives of Contradiction*. Durham, NC: Duke University Press, 2016.

Gentry, Caron E. "Twisted Maternalism." *International Feminist Journal of Politics* 11, no. 2 (June 2009): 235–252.

Gerón, Cándido. *Diccionario político dominicano: 1821–2000*. Santo Domingo: De Colores, 2001.

Gleijeses, Piero. *The Dominican Crisis: The 1965 Constitutionalist Revolt and American Intervention*. Baltimore, MD: Johns Hopkins University Press, 1978.

Gobat, Michel. *Confronting the American Dream: Nicaragua under U.S. Imperial Rule*. Durham, NC: Duke University Press, 2005.

Gómez, Petronila Angélica. *Contribución para la historia del feminismo dominicano*. Ciudad Trujillo: Librería Dominicana, 1952.

Gómez Sánchez, Fiume Bienvenida. *Minerva, Patria y María Teresa: Heroínas y mártires*. Santo Domingo: Cocolo, Consejo Nacional de Educación Superior, 1999.

González Canalda, María Filomena. "Apuntes para el estudio sobre la autonomía de las mujeres en Bayaguana en el siglo XVIII y durante el período del 1822 al 1844." In *Miradas desencadenantes: Hacia una construcción de la autonomía de las mujeres*, edited by Lourdes Contreras, 219–241. Santo Domingo: Instituto Tecnológico de Santo Domingo, 2014.

Gonzalez-Perez, Margaret. "Guerrilleras in Latin America: Domestic and International Roles." *Journal of Peace Research* 43, no. 3 (2006): 313–329.

González-Rivera, Victoria. *Before the Revolution: Women's Rights and Right-Wing Politics in Nicaragua, 1821–1979*. University Park: Pennsylvania State University Press, 2011.

———. "Undemocratic Legacies: First-Wave Feminism and the Somocista Women's Movement in Nicaragua, 1920s–1979." *Bulletin of Latin American Research* 33, no. 3 (2014): 259–273.

González-Rivera, Victoria, and Karen Kampwirth. *Radical Women in Latin America Left and Right*. University Park: Pennsylvania State University Press, 2001.

Gordon, Linda. *Pitied but Not Entitled: Single Mothers and the History of Welfare, 1890–1935*. New York: Free Press, 1994.

Gosse, Van. "Unpacking the Vietnam Syndrome: The Coup in Chile and the Rise of Popular Anti-Interventionism." In *The World the Sixties Made: Politics and Culture in Recent America*, edited by Richard R. Moser and Van Gosse, 100–113. Philadelphia: Temple University Press, 2003.

Gould, Jeffrey L. *To Lead as Equals: Rural Protest and Political Consciousness in Chinandega, Nicaragua, 1912–1979*. Chapel Hill: University of North Carolina Press, 1990.

Graham, Margaret. *The Pajarito Project, Dominican Republic 1971*. Toronto: Latin American Working Group, 1971.

Green, James N. *We Cannot Remain Silent: Opposition to the Brazilian Military Dictatorship in the United States*. Durham, NC: Duke University Press, 2010.

Gregory, Steven. *The Devil behind the Mirror: Globalization and Politics in the Dominican Republic*. Berkeley: University of California Press, 2014.

Grullón, José Diego. *Cayo Confites: La revolución traicionada*. Santo Domingo: Alfa y Omega, 1989.

Guerra, Lillian. *The Myth of José Martí: Conflicting Nationalisms in Early Twentieth-Century Cuba*. Chapel Hill: University of North Carolina Press, 2005.

———. "Why Caribbean History Matters." *Perspectives on History* 52, no. 3 (March 2014): 32–33.

Guy, Donna J. "The Politics of Pan-American Cooperation: Maternalist Feminism and the Child Rights Movement, 1913–1960." *Gender and History* 10, no. 3 (November 1998): 449–469.

Hahner, June Edith. *Emancipating the Female Sex: The Struggle for Women's Rights in Brazil, 1850–1940*. Durham, NC: Duke University Press, 1990.

Hartlyn, Jonathan. *The Struggle for Democratic Politics in the Dominican Republic*. Chapel Hill: University of North Carolina Press, 1998.

Heredia Vda. Suncar, Zoraida, and Erasmo Lara. "Textos escolares y condicionamientos sexuales." In *Seminario Hermanas Mirabal*, edited by Universidad Autónoma de Santo Domingo, 193–204.

Hernández, Ángela. *Emergencia del silencio: La mujer dominicana en la educación formal*. Santo Domingo: Editora Universitaria, Universidad Autónoma de Santo Domingo, 1986.

———. *Pensantes*. Santo Domingo: Ediciones Calíope, 2004.

Hernández, Ángela, and Orlando Inoa, eds. *La mujer en la historia dominicana*. Santo Domingo: Secretaría de Estado de la Mujer, 2009.

Herrera, Ruth. *Las viudas de los doce años*. Santo Domingo: Taller, 1996.

Herrera Bornia, Orestes. *Previsión social en la República Dominicana*. Ciudad Trujillo: Arte y Cine, 1952.

Herrera Mora, Myrna. *Mujeres dominicanas, 1930–1961: Antitrujillistas y exiliadas en Puerto Rico.* San Juan: Isla Negra, 2008.
Hoffnung-Garskof, Jesse. *A Tale of Two Cities: Santo Domingo and New York after 1950.* Princeton, NJ: Princeton University Press, 2008.
Horn, Maja. "Dictates of Dominican Democracy: Conceptualizing Caribbean Political Modernity." *Small Axe* 18, no. 2 (2014): 18–35.
———. *Masculinity after Trujillo: The Politics of Gender in Dominican Literature.* Gainesville: University Press of Florida, 2014.
Hostos, Eugenio María de. *La educación científica de la mujer.* Río Piedras: Editorial de la Universidad de Puerto Rico, 1993.
Hutchison, Elizabeth Q. *Labors Appropriate to Their Sex: Gender, Labor, and Politics in Urban Chile, 1900–1930.* Durham, NC: Duke University Press, 2001.
Institute for the Comparative Study of Political Systems (U.S.). *Dominican Republic Election Factbook, June 1, 1966.* Washington, DC: Institute for the Comparative Study of Political Systems, 1966.
Inter-American Commission of Women (IACW). *Conference Program for the Eleventh Assembly of the Inter-American Commission of Women.* Ciudad Trujillo: Impresora Dominicana, 1956.
———. *Eleventh Assembly of the Inter-American Commission of Women, Final Act, Ciudad Trujillo, Dominican Republic, June 2–21, 1956.* Washington, DC: Pan American Union, 1956.
———. *Informe y evaluación del primer curso regional del programa interamericano de adiestramiento para mujeres dirigentes.* Washington, DC: Organization of American States, 1967.
———. *Informe del seminario sobre medios de comunicación y su influencia en la imagen de la mujer.* Washington, DC: Organization of American States, 1980.
———. *Libro de oro.* Washington, DC: Organization of American States, 1980.
———. *Report Presented to the Seventeenth Session of the U.N. Commission on the Status of Women, New York City, March 11–29, 1963.* Washington, DC: Pan American Union, 1963.
Jain, Devaki. *Women, Development, and the UN: A Sixty-Year Quest for Equality and Justice.* Bloomington: Indiana University Press, 2005.
Janz, Oliver, and Daniel Schönpflug. *Gender History in a Transnational Perspective: Networks, Biographies, Gender Orders.* New York: Berghahn Books, 2014.
Jaquette, Jane S. "Women in Revolutionary Movements in Latin America." *Journal of Marriage and Family* 35, no. 2 (May 1, 1973): 344–354.
Johnston, Hank. *Latin American Social Movements: Globalization, Democratization, and Transnational Networks.* Lanham, MD: Rowman and Littlefield, 2006.
Joseph, Gibert M., Catherine LeGrand, and Ricardo Donato Salvatore. *Close Encounters of Empire: Writing the Cultural History of U.S.–Latin American Relations.* Durham, NC: Duke University Press, 1998.
Joseph, Gilbert M., and Daniel Nugent. *Everyday Forms of State Formation: Revolution and the Negotiation of Rule in Modern Mexico.* Durham, NC: Duke University Press, 1994.
Joseph, Gilbert M., and Daniela Spenser. *In from the Cold: Latin America's New Encounter with the Cold War.* Durham, NC: Duke University Press, 2008.
Kampwirth, Karen. *Feminism and the Legacy of Revolution: Nicaragua, El Salvador, Chiapas.* Athens: Ohio University Press, 2004.

———, ed. *Gender and Populism in Latin America: Passionate Politics*. University Park: Pennsylvania State University Press, 2010.

———. *Women and Guerrilla Movements: Nicaragua, El Salvador, Chiapas, Cuba*. University Park: Pennsylvania State University Press, 2002.

Kaplan, Caren, Norma Alarcón, and Minoo Moallem. *Between Woman and Nation: Nationalisms, Transnational Feminisms, and the State*. Durham, NC: Duke University Press, 1999.

Karttunen, Frances E. *Between Worlds: Interpreters, Guides, and Survivors*. New Brunswick, NJ: Rutgers University Press, 1994.

Kashani-Sabet, Firoozeh. *Conceiving Citizens: Women and the Politics of Motherhood in Iran*. New York: Oxford University Press, 2011.

Keith, LeeAnna Yarborough. "The Imperial Mind and U.S. Intervention in the Dominican Republic, 1961–1966." PhD diss., University of Connecticut, 2000.

Kerber, Linda K. *Women of the Republic: Intellect and Ideology in Revolutionary America*. Chapel Hill: University of North Carolina Press, 1980.

Klein, Marian van der. *Maternalism Reconsidered: Motherhood, Welfare, and Social Policy in the Twentieth Century*. New York: Berghahn Books, 2012.

Klubock, Thomas Miller. "Writing the History of Women and Gender in Twentieth-Century Chile." *Hispanic American Historical Review* 81, no. 3/4 (August 2001): 493–518.

Knight, Franklin W., and Teresita Martínez Vergne. *Contemporary Caribbean Cultures and Societies in a Global Context*. Chapel Hill: University of North Carolina Press, 2005.

Koikari, Mire. *Pedagogy of Democracy: Feminism and the Cold War in the U.S. Occupation of Japan*. Philadelphia: Temple University Press, 2009.

Koonz, Claudia. *Mothers in the Fatherland: Women, the Family, and Nazi Politics*. New York: St. Martin's, 1987.

Koven, Seth, and Sonya Michel. *Mothers of a New World: Maternalist Politics and the Origins of Welfare States*. New York: Routledge, 1993.

Krohn-Hansen, Christian. "Masculinity and the Political among Dominicans: 'The Dominican Tigre.'" In *Machos, Mistresses, Madonnas: Contesting the Power of Latin American Gender Imagery*, edited by Marit Melhuus and Kristi Anne Stølen, 108–133. London: Verso, 1996.

———. *Political Authoritarianism in the Dominican Republic*. New York: Palgrave Macmillan, 2009.

Kryzanek, Michael J. "Diversion, Subversion, and Repression: The Strategies of Anti-Opposition Politics in Balaguer's Dominican Republic." *Caribbean Studies* 17, no. 1/2 (1977): 83–103.

———. "The Dominican Intervention Revisited: An Attitudinal and Operational Analysis." In *United States Policy in Latin America: A Quarter Century of Crisis and Challenge, 1961–1986*, edited by John D Martz, 135–56. Lincoln: University of Nebraska Press, 1988.

———. "The 1978 Election in the Dominican Republic: Opposition Politics, Intervention, and the Carter Administration." *Caribbean Studies* 19, no. 1/2 (July 1979): 51–73.

———. "Political Party Decline and the Failure of Liberal Democracy: The PRD in Dominican Politics." *Journal of Latin American Studies* 9, no. 1 (1977): 115–143.

———. "Political Party Opposition in Latin America: The PRD, Joaquin Balaguer, and Politics in the Dominican Republic, 1966–1973." PhD diss., University of Massachusetts, 1975.

Kryzanek, Michael J., and Howard J. Wiarda. *The Politics of External Influence in the Dominican Republic*. New York: Praeger, 1988.
Kurzman, Dan. *Santo Domingo: Revolt of the Damned*. New York: Putnam, 1965.
Landestoy, Carmita. *Mis relaciones con el presidente Trujillo*. Ciudad Trujillo, 1945.
———. *¡Yo también acuso!* New York: Azteca Press, 1946.
Latin American Working Group. *La Banda: An Episode of Terror*. Toronto: Latin American Working Group, 1971.
Lavrin, Asunción. *Women, Feminism, and Social Change in Argentina, Chile, and Uruguay, 1890–1940*. Lincoln: University of Nebraska Press, 1995.
Legrand, Catherine. "Informal Resistance on a Dominican Sugar Plantation during the Trujillo Dictatorship." *Hispanic American Historical Review* 75, no. 4 (1995): 555–596.
Leonard, Thomas M., and John F. Bratzel. *Latin America during World War II*. Lanham, MD: Rowman and Littlefield, 2007.
Lerner, Gerda. *The Creation of Patriarchy*. New York: Oxford University Press, 1986.
Liberato, Ana S. Q. *Joaquín Balaguer, Memory, and Diaspora: The Lasting Political Legacies of an American Protégé*. Lanham, MD: Lexington Books, 2013.
Linz, Juan J. *Totalitarian and Authoritarian Regimes*. Boulder, CO: Lynne Rienner, 2000.
Lockward, Angel. *La mujer dominicana*. Santo Domingo: Fundación de Estudios Económicos y Políticos, Ediciones Literatura Popular, 1998.
Lora H., Quisqueya. "La difícil recuperación del papel de la mujer en la historia dominicana." Paper. Santiago, Dominican Republic: Pontífica Universidad Católica Madre y Maestra, 2013.
Lora Iglesias, Carmen Josefina. *Piky Lora, relato de una guerrillera*. Santo Domingo: Manatí, 1983.
Lord, Rebecca Ann. "An 'Imperative Obligation': Public Health and the United States Military Occupation of the Dominican Republic, 1916–1924." PhD diss., University of Maryland, College Park, 2004.
Lowenthal, Abraham F. *The Dominican Intervention*. Baltimore, MD: Johns Hopkins University Press, 1995.
Lozano, Wilfredo. *El reformismo dependiente*. Santo Domingo: Ediciones de Taller, 1985.
Madera, Melissa. "'Zones of Scandal': Gender, Public Health, and Social Hygiene in the Dominican Republic, 1916–1961." PhD diss., State University of New York, Binghamton, 2011.
Mainardi Vda. Cuello, Carolina. *Vivencias*. Santo Domingo: Manatí, 2000.
Malek, R. Michael. "Rafael Leónidas Trujillo Molina: The Rise of a Caribbean Dictator." PhD diss., University of California, Santa Barbara, 1971.
Manley, Elizabeth S. "Intimate Violations: Women and the Ajusticiamiento of Dictator Rafael Trujillo, 1944–1961." *The Americas* 69, no. 1 (2012): 61–94.
———. "Poner un Grano de Arena: Gender and Women's Political Participation under Authoritarian Rule in the Dominican Republic, 1928–1978." PhD diss., Tulane University, 2008.
Marino, Katherine Marie. "La Vanguardia Feminista: Pan-American Feminism and the Rise of International Women's Rights, 1915–1946." PhD diss., Stanford University, 2013.
Martin, John Bartlow. *Overtaken by Events: The Dominican Crisis from the Fall of Trujillo to the Civil War*. New York: Doubleday, 1966.
Martínez, Lusitania. "Abigaíl Mejía y los inicios del movimiento feminista dominicano." In *Política, identidad y pensamiento social en la República Dominicana (siglos XIX y XX)*,

edited by Raymundo González, Michiel Baud, and Pedro San Miguel, 131–152. Santo Domingo: Academia de Ciencias Dominicana, 2000.

———. "Carmen Natalia Martínez: Feminista." *Ambar 7: Revista de Mujeres* 3, no. 6/7 (November 1991): 16–29.

Martínez, Violeta. *Homenaje a las hermanas Mirabal.* Santo Domingo: Quinta Edición, 2001.

Martínez-Vergne, Teresita. "Bourgeois Women in the Early Twentieth-Century Dominican National Discourse." *New West Indian Guide* 75, no. 1/2 (2001): 65–88.

———. *Nation and Citizen in the Dominican Republic, 1880–1916.* Chapel Hill: University of North Carolina Press, 2005.

Mayes, April J. *The Mulatto Republic: Class, Race, and Dominican National Identity.* Gainesville: University Press of Florida, 2014.

———. "Why Dominican Feminism Moved to the Right: Class, Colour, and Women's Activism in the Dominican Republic, 1880s–1940s." *Gender and History* 20, no. 2 (2008): 349–371.

McFadden, Margaret. *Golden Cables of Sympathy: The Transatlantic Sources of Nineteenth-Century Feminism.* Lexington: University Press of Kentucky, 1999.

McPherson, Alan. "Personal Occupations: Women's Responses to U.S. Military Occupations in Latin America." *Historian* 72, no. 3 (Fall 2010): 568–598.

Mejía Soliere, Abigaíl. *Ideario feminista y algún apunte sobre el feminismo en la República Dominicana.* Santo Domingo: R. A. Gómez, 1939.

Melhuus, Marit, and Kristi Anne Stølen, eds. *Machos, Mistresses, Madonnas: Contesting the Power of Latin American Gender Imagery.* New York: Verso, 1996.

Melo de Cardona, Ligia Amada. "Participación de la mujer en la educación sistemática en la República Dominicana." *Colección UASD Crítica* 238, no. 19 (1977): 5–15.

Miller, Francesca. "Feminisms and Transnationalism." *Gender and History* 10, no. 3 (1998): 569–580.

———. "The International Relations of Women of the Americas 1890–1928." *The Americas* 43, no. 2 (1986): 171–182.

———. "Latin American Feminism and the Transnational Arena." In *Women, Culture, and Politics in Latin America*, edited by Emilie L. Bergmann, 10–26. Berkeley: University of California Press, 1990.

———. *Latin American Women and the Search for Social Justice.* Hanover, NH: University Press of New England, 1991.

Miolán, Angel. *El Perredé desde mi ángulo.* Santo Domingo: Letras de Quisqueya, 1984.

Mirabal, Dedé. *Vivas en su jardín: La verdadera historia de las hermanas Mirabal y su lucha por la libertad.* New York: Vintage Español, 2009.

Moghadam, Valentine M. *Globalizing Women: Transnational Feminist Networks.* Baltimore, MD: Johns Hopkins University Press, 2005.

Molyneux, Maxine. "Twentieth-Century State Formation in Latin America." In *Hidden Histories of Gender and the State in Latin America*, edited by Elizabeth Dore and Maxine Molyneux, 33–82. Durham, NC: Duke University Press, 2000.

Montoya, Rosario. *Gendered Scenarios of Revolution: Making New Men and New Women in Nicaragua, 1975–2000.* Tucson: University of Arizona Press, 2012.

Montoya, Rosario, Leslie Jo Frazier, and Janise Hurtig. *Gender's Place: Feminist Anthropologies of Latin America.* New York: Palgrave Macmillan, 2002.

Mooney, Jadwiga E. Pieper. *The Politics of Motherhood: Maternity and Women's Rights in Twentieth-Century Chile.* Pittsburgh, PA: University of Pittsburgh Press, 2009.

Mooney, Jadwiga E. Pieper, and Fabio Lanza. *De-Centering Cold War History: Local and Global Change.* New York: Routledge, 2012.

Morel, Asela. "Testimonio de la Dra. Asela Morel." In *Memorias de la lucha contra la tiranía,* edited by Fundación de los Héroes de Constanza, Maimón y Estero Hondo, 187–190. Santo Domingo: Fundación de los Héroes de Constanza, Maimón y Estero Hondo, 1983.

Morgan, Robin, ed. *Sisterhood Is Global: The International Women's Movement Anthology.* Garden City, NY: Anchor/Doubleday, 1984.

Mota, Vivian M. "Algunas consideraciones sobre la iglesia católica, la mujer y la planificación familiar." *Estudios Sociales* 6, no. 3 (September 1973): 117–142.

———. "Politics and Feminism in the Dominican Republic, 1931–1945 and 1966–1974." In *Women and Change in Latin America,* edited by June C. Nash and Helen Icken Safa, 265–278. South Hadley, MA: Bergin and Garvey, 1986.

Moya Espinal, Francisco A. "República Dominicana: Trabajo femenino, educacion y discriminacion." In *Seminario Hermanas Mirabal,* edited by Universidad Autónoma de Santo Domingo, 49–57.

Moya Pons, Frank. *The Dominican Republic: A National History.* Princeton, NJ: Markus Wiener, 1998.

Nanita, María Caridad. *La mujer dominicana en la era de Trujillo.* Ciudad Trujillo: Impresora Dominicana, 1953.

Nash, June C., and Helen Icken Safa, eds. *Women and Change in Latin America.* South Hadley, MA: Bergin and Garvey, 1986.

Newson, Adele S, and Linda Strong-Leek, eds. *Winds of Change: The Transforming Voices of Caribbean Women Writers and Scholars.* New York: Peter Lang, 1998.

Offen, Karen. "Defining Feminism: A Comparative Historical Approach." *Signs* 14, no. 1 (1988): 119–157.

———. *European Feminisms, 1700–1950: A Political History.* Stanford, CA: Stanford University Press, 2000.

———. "Understanding International Feminisms as 'Transnational'—An Anachronism? May Wright Sewall and the Creation of the International Council of Women, 1889–1904." In *Gender History in a Transnational Perspective: Biographies, Networks, Gender Orders,* edited by Oliver Janz and Daniel Schönpflug, 25–45.

Olcott, Jocelyn. "Cold War Conflicts and Cheap Cabaret: Sexual Politics at the 1975 United Nations International Women's Year Conference." *Gender and History* 22, no. 3 (November 2010): 733–754.

———. "Empires of Information: Media Strategies for the 1975 International Women's Year." *Journal of Women's History* 24, no. 4 (Winter 2012): 24–48.

———. *Revolutionary Women in Postrevolutionary Mexico.* Durham, NC: Duke University Press, 2005.

Olivier, Maritza. *Cinco siglos con la mujer dominicana.* Santo Domingo: Amigo del Hogar, 1975.

Ornes, Germán E. *Trujillo: Little Caesar of the Caribbean.* New York: Thomas Nelson and Sons, 1958.

Pacino, Nicole L. "Creating Madres Campesinas: Revolutionary Motherhood and the Gen-

dered Politics of Nation Building in 1950s Bolivia." *Journal of Women's History* 27, no. 1 (2015): 62–87.

Paiewonsky, Margarita. "Imagen de la mujer en los textos de historia dominicana." *Género y Sociedad* 1, no. 1 (May 1993): 30–59.

Palmer, Bruce. *Intervention in the Caribbean: The Dominican Crisis of 1965.* Lexington: University Press of Kentucky, 1989.

Palmer, Steven. "Educating Señorita: Teacher Training, Social Mobility, and the Birth of Costa Rican Feminism, 1885–1925." *Hispanic American Historical Review* 78, no. 1 (1998): 45–82.

Paravisini-Gebert, Lizabeth. "Women of Hispaniola in the Caribbean Context." In *The Women of Hispaniola: Moving towards Tomorrow; Selected Proceedings of the 1993 Conference*, edited by Daisy Cocco-DeFilippis, 27–32. Jamaica, NY: York College, 1993.

Paulino, Edward. "Anti-Haitianism, Historical Memory, and the Potential for Genocidal Violence in the Dominican Republic." *Genocide Studies and Prevention* 1, no. 3 (2006): 265–288.

———. *Dividing Hispaniola: The Dominican Republic's Border Campaign against Haiti, 1930–1961.* Pittsburgh, PA: University of Pittsburgh Press, 2016.

Peguero, Valentina. *The Militarization of Culture in the Dominican Republic, from the Captains General to General Trujillo.* Lincoln: University of Nebraska Press, 2004.

———. *Mujeres pioneras dominicanas. Datos biográficos y bibliográficos.* Santo Domingo: Búho, 2015.

———. "Participación de la mujer en la historia dominicana." *Eme Eme: Estudios Dominicanos* 10, no. 58 (1982): 21–49.

Peña, Mirna de. "Participación de la mujer en el movimiento syndical," In *Seminario Hermanas Mirabal*, edited by Universidad Autónoma de Santo Domingo, 265–271.

Pérez, Marcelo Jorge. "Servicios de energía eléctrica." In *Seminario Hermanas Mirabal*, edited by Universidad Autónoma de Santo Domingo, 303–310.

Perozo, Alfonsina. *Los Perozo: Su exterminio por la dictadura de Trujillo: Mis vivencias.* Santo Domingo: Centenario, 2002.

Pescatello, Ann M. *Female and Male in Latin America: Essays.* Pittsburgh, PA: University of Pittsburgh Press, 1973.

Pimentel, Thimo. *Identify, Identify!!!* Santo Domingo: Fundación Igneri, 2010.

Pineda, Magaly. "The Spanish-Speaking Caribbean: We Women Aren't Sheep." In *Sisterhood Is Global: The International Women's Movement Anthology*, edited by Robin Morgan, 131–134.

Pineda, Magaly, Martha Olga García, and Laura Faxas. "Mujer, mito y realidad." In *Seminario Hermanas Mirabal*, edited by Universidad Autónoma de Santo Domingo, 137–154.

Pite, Rebekah E. *Creating a Common Table in Twentieth-Century Argentina: Doña Petrona, Women, and Food.* Chapel Hill: University of North Carolina Press, 2013.

Pojmann, Wendy A. *Italian Women and International Cold War Politics, 1944–1968.* New York: Fordham University Press, 2013.

Polyné, Millery. *From Douglass to Duvalier: U.S. African Americans, Haiti, and Pan Americanism, 1870–1964.* Gainesville: University Press of Florida, 2010.

Power, Margaret. "More than Mere Pawns: Right-Wing Women in Chile." *Journal of Women's History* 16, no. 3 (2004): 138–151.

———. *Right-Wing Women in Chile: Feminine Power and the Struggle against Allende, 1964–1973.* University Park: Pennsylvania State University Press, 2002.

———. "The U.S. Movement in Solidarity with Chile in the 1970s." *Latin American Perspectives* 36, no. 6 (2009): 46–66.
Prats-Ramírez de Pérez, Ivelisse. "Educación Ambiental." In *Seminario Hermanas Mirabal*, edited by Universidad Autónoma de Santo Domingo, 171–185.
———. *Los días difíciles*. Santo Domingo: Méndez y Abreu, 1982.
Quiroga, Lucero. "Feminización universitaria en la República Dominicana: 1977–2002." In *Miradas desencadenantes: Los estudios de género*, edited by Candelario, 51–65.
Rabe, Stephen G. *The Most Dangerous Area in the World: John F. Kennedy Confronts Communist Revolution in Latin America*. Chapel Hill: University of North Carolina Press, 1999.
Raful, Tony. *Movimiento 14 de Junio: Historia y documentos*. 5th ed. Santo Domingo: Editora Búho, 2013.
Randall, Margaret, and Lynda Yanz. *Sandino's Daughters: Testimonies of Nicaraguan Women in Struggle*. Vancouver, Canada: New Star Books, 1981.
Renda, Mary A. *Taking Haiti: Military Occupation and the Culture of U.S. Imperialism, 1915–1940*. Chapel Hill: University of North Carolina Press, 2001.
Ricardo, Yolanda. *Magisterio y creación: Los Henríquez Ureña*. Santo Domingo: Academia de Ciencias Dominicana, 2003.
———. *La resistencia en las Antillas tiene rostro de mujer (transgresiones, emancipaciones)*. Santo Domingo: Academia de Ciencias de la República Dominicana, 2004.
Rivera-Rivera, Wanda. "Revolution Interrupted: The 'Women of April' and the Utopia of National Liberation." In *The Utopian Impulse in Latin America*, edited by Kim Beauchesne and Alessandra Santos, 145–171. New York: Palgrave Macmillan, 2011.
Roa, Carlos Temístocles. Introduction to *Seminario Hermanas Mirabal*, edited by Universidad Autónoma de Santo Domingo, 5–6.
Robinson, Nancy P. "Origins of the International Day for the Elimination of Violence against Women: The Caribbean Contribution." *Caribbean Studies* 34, no. 2 (2006): 141–161.
Rodríguez Demorizi, Emilio. *Salomé Ureña y el Instituto de Señoritas: Para la historia de la espiritualidad dominicana*. Ciudad Trujillo: Impresora Dominicana, 1960.
Rojas, Fernando de. *La Celestina*. Translated by Dorothy Sherman Severin. Madrid: Cátedra, 1987.
———. *La Celestina: O comedia de Calisto e Melibea*. Buenos Aires: Losada, 1938.
Roorda, Eric Paul. *The Dictator Next Door: The Good Neighbor Policy and the Trujillo Regime in the Dominican Republic, 1930–1945*. Durham, NC: Duke University Press, 1998.
———. "The Dominican Republic: The Axis, the Allies, and the Trujillo Dictatorship." In *Latin America during World War II*, edited by Thomas Leonard and John F. Bratzel, 75–91. Lanham, MD: Rowman and Littlefield, 2007.
———. "Genocide Next Door: The Good Neighbor Policy, the Trujillo Regime, and the Haitian Massacre of 1937." *Diplomatic History* 20, no. 3 (1996): 301–319.
Rosemblatt, Karin Alejandra. *Gendered Compromises: Political Cultures and the State in Chile, 1920–1950*. Chapel Hill: University of North Carolina Press, 2000.
Rupp, Leila J. "Constructing Internationalism: The Case of Transnational Women's Organizations, 1888–1945." *American Historical Review* 99, no. 5 (1994): 1571–1600.
———. "Feminism and the Sexual Revolution in the Early Twentieth Century: The Case of Doris Stevens." *Feminist Studies* 15, no. 2 (1989): 289–309.
Rupp, Leila J., and Verta Taylor. "Forging Feminist Identity in an International Movement:

A Collective Identity Approach to Twentieth-Century Feminism." *Signs* 24, no. 2 (January 1, 1999): 363–386.

Sáez, José Luis. *Cinco siglos de Iglesia dominicana*. Santo Domingo: Amigo del Hogar, 1987.

———. *La sumisión bien pagada: La Iglesia dominicana bajo la era de Trujillo, 1930–1961*. Santo Domingo: Archivo General de la Nación, 2008.

Sanchez de Bonilla, Fanny. "La mujer dominicana y su grado de participación en el proceso politico actual." In *Seminario Hermanas Mirabal*, edited by Universidad Autónoma de Santo Domingo, 232–240.

Sang, Mu-Kien A. *¡Yo soy Minerva! Confesiones más allá de la vida y la muerte*. Santo Domingo: Amigo del Hogar, 2003.

San Miguel, Pedro L. *The Imagined Island History, Identity, and Utopia in Hispaniola*. Chapel Hill: University of North Carolina Press, 2005.

———. "An Island in the Mirror: The Dominican Republic and Haiti." In *The Caribbean : A History of the Region and Its Peoples*, edited by Stephan Palmié and Francisco A Scarano, 553–570. Chicago: University of Chicago Press, 2011.

San Miguel, Pedro L., and Phillip Berryman. "Peasant Resistance to State Demands in the Cibao during the U.S. Occupation." *Latin American Perspectives* 22, no. 3 (July 1995): 41–62.

Santana, Julio Cesar. *La mujer dominicana en la "Era de Trujillo."* San Pedro de Macorís, Dominican Republic: La Orla, 1956.

Santos de Rivera, Myrna, Olga Luciano, Teresa Fulgencio, Carmen Pérez, Alcira Minaya-Imac Sánchez Padilla, and Victoria Altagracia Paulino. "Participación política, sindical y estudiantil de la mujer." In *Seminario Hermanas*, edited by Universidad Autónoma de Santo Domingo, 249–264.

Schlesinger, Arthur M. *A Thousand Days: John F. Kennedy in the White House*. Boston: Houghton Mifflin, 1965.

Schoultz, Lars. *Beneath the United States: A History of U.S. Policy toward Latin America*. Cambridge, MA: Harvard University Press, 1998.

Scott, Joan Wallach. *Gender and the Politics of History*. New York: Columbia University Press, 1999.

Seigel, Micol. *Uneven Encounters: Making Race and Nation in Brazil and the United States*. Durham, NC: Duke University Press, 2009.

Shukla, Sandhya Rajendra, and Heidi Tinsman. *Imagining Our Americas: Toward a Transnational Frame*. Durham, NC: Duke University Press, 2007.

Slater, Jerome. *Intervention and Negotiation: The United States and the Dominican Revolution*. New York: Harper and Row, 1970.

Soto, Delta. *Vivencias de una revolucionaria*. Santo Domingo: Editora Universitaria, Universidad Autónoma de Santo Domingo, 2004.

Sperling, Valerie, Myra Marx Ferree, and Barbara Risman. "Constructing Global Feminism: Transnational Advocacy Networks and Russian Women's Activism." *Signs* 26, no. 4 (2001): 1155–1186.

Stengre, Carmen. *Mujeres dominicanas (semblanzas)*. Santiago, Dominican Republic: El Diario, 1943.

Sternbach, Nancy Saporta. "Feminisms in Latin America: From Bogotá to San Bernardo." *Signs* 17, no. 2 (1992): 393–434.

Stites Mor, Jessica. *Human Rights and Transnational Solidarity in Cold War Latin America*. Madison: University of Wisconsin Press, 2013.

Stokes, Susan. *Cultures in Conflict Social Movements and the State in Peru*. Berkeley: University of California Press, 1995.

Stoner, K. Lynn. "Militant Heroines and the Consecration of the Patriarchal State: The Glorification of Loyalty, Combat, and National Suicide in the Making of Cuban National Identity." *Cuban Studies* 34, no. 1 (2003): 71–96.

Stuhler, Barbara. *For the Public Record a Documentary History of the League of Women Voters*. Westport, CT: Greenwood, 2000.

Szulc, Tad. *Dominican Diary*. New York: Delacorte, 1965.

Tancer, Shoshana B. "La Quisqueyana: The Dominican Woman, 1940–1970." In *Female and Male in Latin America*, edited by Ann M. Pescatello, 209–229. Pittsburgh, PA: University of Pittsburgh Press, 1973.

Tavárez, Margarita, Flavia García, Carmen Josefina Lora, and Martha Olga García. "Estudio jurídico de la mujer, modificaciones legales, profundidad y extension," in *Seminario Hermanas Mirabal*, edited by Universidad Autónoma de Santo Domingo, 207–224.

Tavárez Mirabal, Minerva Josefina. "Palabras pronunciadas por la señorita Minerva Josefina Tavárez Mirabal." In *Seminario Hermanas Mirabal*, edited by Universidad Autónoma de Santo Domingo, 29–30.

Taylor, Diana. "Performing Gender: Las Madres de La Plaza de Mayo." In *Negotiating Performance: Gender, Sexuality, and Theatricality in Latin/o America*, edited by Diana Taylor and Juan Villegas Morales, 275–305. Durham, NC: Duke University Press, 1995.

Thorman de Aguilar, Fidelina. *La situación de la mujer en República Dominicana*. Santo Domingo: Instituto Dominicano de Estudios Aplicados, 1975.

Tillman, Ellen D. "Militarizing Dollar Diplomacy in the Early Twentieth-Century Dominican Republic: Centralization and Resistance." *Hispanic American Historical Review* 95, no. 2 (2015): 269–298.

Tinsman, Heidi. *Buying into the Regime: Grapes and Consumption in Cold War Chile and the United States*. Durham, NC: Duke University Press, 2014.

———. "Reviving Feminist Materialism: Gender and Neoliberalism in Pinochet's Chile." *Signs* 26, no. 1 (2000): 145–188.

Tolentino Dipp, Hugo. "Discurso pronunciado por el Dr. Hugo Tolentino Dipp." In *Seminario Hermanas Mirabal*, edited by Universidad Autónoma de Santo Domingo, 20–24.

Torres-Saillant, Silvio. "The Tribulations of Blackness: Stages in Dominican Racial Identity." *Callaloo : A Journal of African-American and African Arts and Letters* 23, no. 3 (2000): 1086–1111.

Townsend, Camilla. *Malintzin's Choices: An Indian Woman in the Conquest of Mexico*. Albuquerque: University of New Mexico Press, 2006.

Trouillot, Michel-Rolph. *Silencing the Past: Power and the Production of History*. Boston: Beacon, 1995.

Trujillo, Flor de Oro, Laura Bergquist, and Bernardo Vega. *Trujillo en la intimidad según su hija Flor*. Santo Domingo: Fundación Cultural Dominicana, 2009.

Trujillo Molina, Rafael Leónidas. "Opening Address," June 1, 1956. In *Conference Program for the Eleventh Assembly of the Inter-American Commission of Women*, IACW, 3–6. Ciudad Trujillo: Impresora Dominicana, 1956.

Turits, Richard Lee. *Foundations of Despotism: Peasants, the Trujillo Regime, and Modernity in Dominican History*. Stanford, CA: Stanford University Press, 2003.

———. "A World Destroyed, a Nation Imposed: The 1937 Haitian Massacre in the Dominican Republic." *Hispanic American Historical Review* 83, no. 3 (2002): 589–635.

United Nations, Department of Economic and Social Affairs. *Regional Seminar on the Status of Women and Family Planning for Countries of the Western Hemisphere, Santo Domingo, Dominican Republic, 9-22 May 1973.* New York: United Nations, 1974.

Universidad Autónoma de Santo Domingo (UASD). *Seminario Hermanas Mirabal sobre diagnóstico evaluación y recomendaciones modificativas de la condición de la mujer dominicana.* Colección Historia y Sociedad 220, no. 27 (Santo Domingo, Editorial Gaviota, 1977).

Ureña de Henríquez, Salomé. *Poesías completas.* Ciudad Trujillo: Impresora Dominicana, 1950.

Valera Benítez, Rafael. *Complot develado.* Santo Domingo: Fundación Testimonio, 1984.

Vargas Llosa, Mario. *La Fiesta del Chivo.* Madrid: Alfaguara, 2000.

Vega, Bernardo. *Los Estados Unidos y Trujillo: Los días finales, 1960-1961: Colección de documentos del Departamento de Estado, la CIA y los archivos del Palacio Nacional Dominicano.* Santo Domingo: Fundación Cultural Dominicana, 1999.

———. *Un interludio de tolerancia: El acuerdo de Trujillo con los comunistas en 1946.* Santo Domingo: Fundación Cultural Dominicana, 1987.

———. *Unos desafectos y otros en desgracia: Sufrimientos bajo la dictadura de Trujillo.* Santo Domingo: Fundación Cultural Dominicana, 1986.

Veloz, Livia. *Historia del feminismo en la República Dominicana.* Santo Domingo, 1977.

Vicioso, Sherezada. *Algo que decir: Ensayos sobre literatura femenina, 1981-1997.* Santo Domingo: Búho, 1998.

———. "De la soledad al compromiso." *Ambar 7: Revista de Mujeres* 3, no. 6-7 (November 1991): 7-13.

Vicioso, Sherezada, and Salomé Ureña de Henríquez. *Salomé Ureña de Henríquez (1850-1897): A cien años de un magisterio.* Santo Domingo: Comisión Permanente de la Feria Nacional del Libro, 1997.

Viezzer, Moema. *As mulheres da República Dominicana. Se alguém quiser saber.* São Paulo: Global, 1982.

Ware, Caroline. "Women as Citizens." *Américas,* December 1967, 26-28.

Waylen, Georgina. "Women and Democratization: Conceptualizing Gender Relations in Transition Politics." *World Politics* 463 (1994): 327-354.

Weber, Delia. "The Meaning of Civilization and the New Woman." In *Documents of Dissidence: Selected Writings by Dominican Women,* edited by Cocco-DeFilippis, 90-94.

Weiner, Lynn Y. "Maternalism as a Paradigm: Defining the Issues." *Journal of Women's History* 5, no. 2 (1993): 96-98.

Wells, Allen. *Tropical Zion: General Trujillo, FDR, and the Jews of Sosua.* Durham, NC: Duke University Press, 2009.

Wertsch, James. "Blank Spots in Collective Memory: A Case Study of Russia." *Annals of the American Academy of Political and Social Science* 617, no. 1 (2008): 58-71.

Wiarda, Howard J. *Corporatism and Comparative Politics: The Other Great Ism.* Armonk, NY: M. E. Sharpe, 1996.

———. *Dictatorship and Development: The Methods of Control in Trujillo's Dominican Republic.* Gainesville: University of Florida Press, 1968.

———. "The United States and the Dominican Republic: Intervention, Dependency, and Tyrannicide." *Journal of Interamerican Studies and World Affairs* 22, no. 2 (1980): 247-260.

Wiarda, Howard J., and Michael J. Kryzanek. "Dominican Dictatorship Revisited: The

Caudillo Tradition and the Regimes of Trujillo and Balaguer." *Revista/Review Interamericana* 7 (1982): 417–435.

Wickham-Crowley, Timothy P. *Guerrillas and Revolution in Latin America: A Comparative Study of Insurgents and Regimes since 1956*. Princeton, NJ: Princeton University Press, 1991.

Winslow, Anne. *Women, Politics, and the United Nations*. Westport, CT: Greenwood, 1995.

Wolf, Eric R., and Edward C. Hansen. "Caudillo Politics: A Structural Analysis." *Comparative Studies in Society and History* 9 (1967): 168–179.

Wolfe, Joel. "From Working Mothers to Housewives: Gender and Brazilian Populism from Getúlio Vargas to Juscelino Kubitschek." In *Gender and Populism in Latin America: Passionate Politics*, edited by Karen Kampwirth, 91–109. University Park: Pennsylvania State University Press, 2010.

Wright, Micah. "'A Self-Respecting Mulatto': Race, Prostitution, and Rape in the Dominican Republic under U.S. Occupation, 1916-1924." Paper presented at the annual conference of the Latin American Studies Association, San Juan, Puerto Rico, May 2015.

Yeager, Gertrude M. "Religion, Gender Ideology, and the Training of Female Public Elementary School Teachers in Nineteenth Century Chile." *The Americas* 62, no. 2 (2005): 209–243.

———. "Women's Roles in Nineteenth-Century Chile: Public Education Records, 1843–1883." *Latin American Research Review* 18, no. 3 (1983): 149–156.

Young, Louise Merwin, and Ralph A. Young. *In the Public Interest: The League of Women Voters, 1920–1970*. New York: Greenwood, 1989.

Zaglul, Antonio. *Despreciada en la vida y olvidada en la muerte: Biografía de Evangelina Rodríguez, la primera médica dominicana*. Santo Domingo: Taller, 1980.

Zeller, Neici M. "The Appearance of All, the Reality of Nothing: Politics and Gender in the Dominican Republic, 1880–1961." PhD diss., University of Illinois, Chicago, 2010.

———. *Discursos y espacios femeninos en República Dominicana, 1880–1961*. Santo Domingo: Letra Gráfica, 2012.

———. "El régimen de Trujillo y la fuerza laboral femenina en la República Dominicana, 1945–1951." In *La República Dominicana en el umbral del siglo XXI: Cultura, política y cambio social*, edited by Ramonina Brea, Rosario Espinal, and Fernando Valerio-Holguín, 429–444.

———. "'To Live the Modern Life!' Imperialism, Modernization, and the Gender War in the Dominican Republic, 1916–1924," Paper presented at the Tenth Berkshire Conference for the History of Women, Chapel Hill, NC, June, 1996.

Zeller, Neici M., and Margaret Power. "What Difference Does Gender Make? Women and Conservative Politics in the Dominican Republic and Chile, 1961–1978." Paper presented at the annual conference of the American Historical Association, Chicago, January 5–8, 1995.

Index

Page numbers in *italics* refer to illustrations.

Acción Católica, 77
Acción Clero Cultural, 112, 270n57
Acción Feminista Dominicana (AFD), 24, 40–52, *41*, 55–57, 73, 130, 254n55–57, 255n67,69
Acosta de Bezi, Altagracia, *179*, 280n38
¡*Ahora!*, 208, 215
ajusticiamiento (assassination) of Trujillo, 1–2, 7, 19, 93–94, 121, 124–26, 130, 140, 154, 161, 194, 207, 243n4, 274n25; celebrations of, 2, 260; media coverage of, 1–2
Allende, Salvador (Chile), 21
Alliance for Progress, 160
Altagracia, La, 171
Álvarez, Julia, 14
Álvarez, Sonia, 23
Álvarez Pina, Virgilio, 76, 86, 101
Amaral, Brunilda, 151
amas de casas (housewives), 191, 196–97, 210, 283nn17,21
Amiama, Mercedes, 37
anticommunism, 5, 18, 24–25, 63, 64, 82, 85, 87, 89, 92, 119, 126, 193, 238, 239, 264n82
April Revolution, 16, 123, 135, *138–39*, 140, 142, 143, 147–55, *152*, *153*, 190, 193, 195, 199, 207, 216, 277n71, 288n21
Arache, Olga, 87
Arizmendi, Elena, 36
asistencia social, 62–63, 66, 67, 68–69, 71, 75–78, 80–81, 85, 88–89, 141, 146, 259n15, 263n61
Asociación Dominicana Pro-Bienestar de la Familia (Profamilia), 211
Asociación Dominicana Pro-Derechos Humanos (ADPDH), 193–94, 198n200, 278n67, 277n69
Asociación Patriótica Femenina Dominicana (APFD), 137, 141, 145, 275n56, 276n67
assassinations, political, 32, 93, 113, 118–19, 193, 258n5, 284n38
Ateneo Dominicano, 42, 76, 255n65, 261n32, 264n73
Atlantic world, 9
authoritarian(ism), 2–5, 6, 8, 10, 11, 12–13, 16, 18, 19, 21–23, 26–28, 30, 44, 64, 70, 82, 94, 116, 155, 157, 158, 160–61, 194, 203, 218, 219, 221, 222, 228, 234, 237–39, 240–41, 244n12, 258n4
ayuda fronteriza, 71, 77

Balaguer, Joaquín, 2–3, 7, 10–12, 16, 23, 27, 122, 155, 156, *161*, 193, 221, 240; *Balaguerato*, 4, 8, 13, 22, 26, 160, 176, 178, 188–89, 196, 205, 206, 209, 214, 217, 228, 232, 238; *balaguerista*, 7, 26, 157, 159–60, 165, 167, 183, 185, 186, 188–89, 190–91, 212, 238, 239; *doce años* (see *doce años*)
Balaguer de Vallejo, Emma, 159, *161*
Balcácer de Estrella, Lilia, *178*, 196
Banda, La, 194, 283nn10,16
Barahona, 77–78, 262n48
Battle de Paiewonsky, Nidia, 86
Bergés-Bordas, Domingo O., 234–36
Bernardino, Consuelo, 56, 257n106
Bernardino, Minerva, 43–44, 52, *53*, 56, 70, 83, 89, 143, 160, 246n35, 257nn94,106, 265n88, 276nn60,68; relations with Doris Stevens, 40, 43–44, 47, 49, 50, 52–53, 57; United Nations involvement, 84, 143, 287n4; work with IACW, 43–44, 46, 48, 50–52, 57, 74, 78, 83, 84–85, 88, 143, 255nn67,70
Betances, Emilio, 39, 251n21

Index 311

Boletín, 105
Bosch, Juan, 122, 123, 125, 133, 135–36, 142, 146, 147, 162–63, 274n40, 275n48, 282n6; overthrow of, 123, 135, 137, 140, 142, 147

Cabral, Tomasina, 113, 114–15, 132, 267n13 271nn67,70,72,73, 274nn31,33
Cabral de Macarrulla, Gloria, 118
Cáceres, Ramón, 32, 33
Calder, Bruce, 37
campesino/a, 1, 184, 281n59
Candelario, Ginetta, 15, 253n39
Caribbean, 17, 30, 38, 50, 93, 107, 110, 116, 151, 163
Caribe, El, 91, 118, 133, 134, 230, 243n3, 273n17, 278n20
Casa de Caoba, 119
Cassá, Roberto, 114, 270n57
Castro, Fidel, 107–8, 113, 122
Catholic Church, 115–16, 117, 118, 127, 136, 142, 212, 270n57, 272nn83,87, 273n15, 274n42
14 de Junio, Movimiento (Clandestino), 107, 110, 113–14, 125, 126, 129, 131–32, 135–37, 142, 193, 274nn30, 32; Asociación Femenina de, 129, 131
Cavallo Vda. Ramírez, Ana, 77
centennial, 61, 72–74, 78, 97, 258n1, 264n84
Centro de Investigación para la Acción Femenina (CIPAF), 236, 288n21
Cestero, Tulio M., 46
child rearing, child care, childbearing, 7, 56, 68, 76–77, 117, 173, 232, 235, 257, 250
children, concern for, 6, 7, 47, 56, 64, 68, 77, 86, 93, 95–96, 104, 107, 108, 119, 128, 135, 141, 164, 172, 195, 232, 235
Christian, 72, 92, 99, 101, 131, 141, 236
Cibao, 34, 252n24
citizenship, 3, 5, 16, 17, 25, 32, 33–34, 48, 52, 55, 57, 63, 64, 67, 78, 83, 85, 129, 160, 177, 226, 237, 239, 259; female citizens, 3–5, 16, 21, 55–57, 128, 195
Clemente Travieso, Carmen, 103
clientelism, 157–58, 162, 167, 180–81, 188–89, 278n4
Club Nosotras, 34–36, 40, 252n27, 253n42
Coiscou Guzmán, Grey, 2, 96, 212, 216, 286n82
Cold War, 5, 9, 10–11, 18–19, 60, 61–64, 71, 121–23, 147, 158–60, 171, 187, 188, 240, 258n3, 268n19
Colegio La Salle, 99

Colegio Santa Teresita, 99
Collins, Mary, 209
Comité Central Feminista Dominicana, 36
Comité de Familiares de Muertos, Presos y Desaparecidos (CFMPD), 191, 198, 200
Comité Dominicana de Cooperación Internacional (Committee of International Cooperation), 54, 84
Comité Puertorriqueño Pro Democracia Dominicana (CPPDD), 105
communism, 19, 61, 63, 72, 83, 86–88, 121, 122, 131, 135, 143, 159–60, 193, 268n19, 275n53; collectives, 131, 195; threats to Dominican Republic, 195, 203, 241
conciliation, 125, 166, 169, 176–77, 184, 186, 187, 189; female governors as vehicles of, 161, 164–65, 167
Consejo de Estado, 125, 129, 133, 141, 146
Consejo Nacional de Mujeres (CNM), 84–85, 263n73, 264n84
Consejo Nacional de Población y Familia (CONAPOFA), 211
Constanza, Maimón y Estero Hondo, 107, 113, 136; Fundación de, 133; revolutionary expedition of, 107
constitutional reform, 53, 55, 65–66, 212
constitutional uprising of 1965. *See* April Revolution
Constitution of 1963, 122, 136, 152, 274
continuismo, 7, 18–19, 27, 221, 278n11; definition of, 162; practices under Balaguer, 161
Contreras, Lourdes, 199
Contreras de Puig, Luisa Olivetta, 145
Cordero, Margarita, 15, 147–48, 151
corporatism, 63–64, 68, 72, 74, 86, 258n4
Cruzada de Amor (Crusade of Love), 157, 159, 164
Cuarenta, La, 114, 118, 128, 134
Cuba, 17, 21, 42, 102, 103–4, 106–7, 112–13, 122, 142, 146, 150, 163, 218; Havana, 40, 43, 93, 102, 107; *mambisas*, 21–22; newspapers, 93, 102–3, 266n1; revolution, 21–22, 93, 107, 113, 121–22, 127, 142, 218, 219

damas trujillistas, 20, 24, 62–64, 66, 68–72, 73–77, 79–80, 85–92, 238, 258n2, 260n20, 261n37, 262n44
de Beevers, Amelia, 208–9
de Burgos, Carmen, 35–36, 253n35
de Cestero, Alicia G., 37
de Columna, Ana Silvia R., 137

del Orbe, Altagracia, 103–4, 106, 238, 266n1, 269n36
de los Santos, Gladys, 44, 46, 52, 137, 141, 145–46, 276n67, 277n70
democracy, 5, 8, 18, 19, 23, 26, 34, 46, 61, 63, 98, 102, 105, 110, 120–22, 129, 132, 141–42, 143, 145, 146, 149, 154, 158, 171, 175, 179, 195, 202, 214, 240; democratization, 23, 25, 28, 31, 59, 121–24, 130, 137, 143, 145–47, 157, 158–59, 173–74, 176, 179, 241; discourse of, 19, 24, 47, 74, 78, 80, 82–83, 85–87, 97, 101, 122, 137, 146, 155, 174, 178, 190–91, 238; as façade, 43, 57, 58, 60, 69–71, 92, 102, 110, 112, 119, 127, 128, 170, 239, 264n82; performing/theater, 5, 8, 18, 19, 26, 30, 31, 44, 50–52, 55, 70, 74–75, 92, 117, 172, 173, 188, 201
Department of Education, 87, 162, 224, 229
Department of Foreign Relations, 89, 100, 162, 223, 229, 288n19
Department of Housing, 76, 100
Department of Labor, 76, 100, 224, 229
Department of Public Health and Social Assistance, 224, 229, 288n19
Derby, Lauren, 6, 15, 17, 34, 37, 39, 251n10, 254n49
desayuno escolar, 66–67, 71, 259n15
Despradel, Consuelo, 199
Destrujillización, 140
Deutsch, Sandra McGee, 21
Díaz, Junot, 14
dictators, dictatorship, 1–9, 12–19, 21–25, 28, 29–32, 39, 40, 43, 46, 48, 50, 54, 56–60, 63–65, 68–70, 77, 78, 82, 87, 91, 93–97, 101, 102, 104–5, 107–9, 112, 115, 117, 118, 121–22, 124–26, 128–29, 132–36, 140, 141, 143–45, 147, 154–55, 157–58, 162–63, 166, 174, 207, 217, 222, 237, 239–41, 244n17, 246n41, 257n94, 259n10, 265n89, 268n19, 270n53, 271n70
doce años (1966–1978), 7–8, 16, 18, 21–22, 26–28, 154, 156–58, 165–67, 170, 188, 190–91, 197, 207, 218, 219, 221, 237–39, 246n41, 282n1, 284n22, 286n71
Domenche de Mañe, Alejandrina, 185
Dominican family, 2, 3, 8, 27, 32, 43, 51, 56, 61–65, 75–77, 79, 86, 89, 92, 93, 96, 104, 119, 130–31, 133, 135, 138, 140, 158, 164, 165, 181, 190, 195–97, 198, 205, 208, 238, 240, 252n29, 262n55; healing/restoration of, 3, 4, 6, 86, 95, 121, 122, 124–27, 129, 133, 138, 141, 155, 191; morality, 62, 63, 64, 72, 83, 94–96, 99, 101, 131
dominicanidad, 14, 68, 70, 74, 246n40
dominicanize, 71; borders/borderlands, 51, 70–71, 260n27
Dore, Elizabeth, 15

education, 20, 29, 32–34, 38, 40, 47, 58–59, 67–70, 75–77, 87, 97, 100–102, 111, 117, 131, 143, 151, 163, 168, 172–73, 175–76, 182, 186, 189, 190–92, 194, 204–7, 211–12, 216, 217–18, 220, 224, 226, 230–32, 235, 251n11, 254n57, 265n90
Elmendorf, Mary, 169–70, 176–77, 245n29
encargadas, 67, 71, 77, 80, 260n23, 261n34
encounters, uneven, 10
Equal Rights, 44, 47, 255n65
Espaillat, Teresa, 132, 150–53, 277n76
Estrelleta, La, 173, 279n34

Fabregas, Johanna Moya, 21
family planning, 192, 211–12, 217–18
Farland, Joseph, 116
fascism, 18, 70, 98, 244n14
father, 1, 2, 5–6, 31, 61, 92, 99, 124, 128, 157, 158, 187, 199, 216, 233, 234, 235, 270n56; Balaguer as, 7, 16, 17, 157–58, 187; Trujillo as (*see* Trujillo Molina, Rafael Leónidas: father-like)
Faxas, Laura, 230
Federación de Mujeres Dominicanas (FMD), 19, 137–41, *138–39*, 154, 155, 194–95, 197, 210, 231, 275nn45,48,51,53, 288nn21,23
Federation of Cuban Women, 145, 229, 230, 275n53
Félix (Miranda) de L'Official, Milady, 43–44, 52, 55, 84, 257n101
Fémina, 20, 29, 34–36, 40–41, 45, 61, 264n81
feminism, 3, 20, 23, 46, 58, 62, 64, 101, 139–40, 144, 192, 210–17, 218, 227, 228, 230–32, 234–37, 241–42, 247n45, 250n8, 253n41, 273nn6,7; conservative, 3, 7, 21–23, 47; early 20th-century, 20, 23, 34–37, 59, 191, 234, 241; global, 27, 155, 273n5; maternalist, 40; Pan-American, 3, 29, 46, 214, 245n29; second-wave, 22–23, 27–28, 123–24, 137, 145; transnational, 4, 9–12, 16, 30–31, 39, 44–45, 58–59, 84, 124, 219–21, 240, 245n24; western models of, 3, 166, 214, 218, 225–26, 230, 288n76

feministas balagueristas, 7
feministas trujillistas, 7, 51, 58, 59–60, 62, 64
Feria de la Paz y Confraternidad del Mundo Libre, 89, 265n87
Fernández, Carmen Lara, 56, 257n106
Ferree, Myra Marx, 10
Flora, Cornelia Butler, 210
Flores, Eulalia, 195
foreign relations, 9, 12, 19, 89
Franco dictatorship, 12
"freno suave" (smooth brake), 31, 56, 59
Frías de Rodríguez, Thelma, 87–88, 131, 136, 264n81
Friedman, Elisabeth, 23
Fuentes de Peña, Argentina, 185–86

Galey, Margaret, 222
Galíndez, Jesús María de, *106*, 248n49, 268n34, 276n68
García, Flavia, 232–34
García, Martha Olga, 211, 212, 230, 232–34, 288n23
García Godoy, Hector, 154
gender: equity, 23, 26–27, 123–24, 143, 145–50, 153–55, 156, 177, 191, 203–5, 208, 213–14, 216–18, 219–21, 226–27, 228, 230, 235, 273n5, 285n60; expectations, 3, 20–21, 159, 186–87; ideals of participation, 4–6, 15, 21–23, 25–27, 34, 37, 95, 97, 101, 107, 111, 115, 119–20, 124, 150, 156, 160, 166, 175, 184, 186–87, 193, 227, 231, 237, 239; politics, 110, 136, 175, 189, 230–31, 239, 244n16, 246n42
gente de primera (elite), 24, 32–35, 37–38, 252n24, 264n73
Gómez, Maximiliano, 203, 286n76
Gómez, Petronila Angélica, 20, 29, 34, 36, 40–41, 44–45, 52, 221, 252nn26,33, 253n39, 255n62
González-Rivera, Victoria, 22
González Suero, Consuelo, 44, 52, 54, 84
Good Neighbor policy, 18, 30, 50, 240
Gould, Jeffrey, 17
governors (women) of Balaguer, 7–8, 26, 157, 159, 165–77, *178*, *179*, 180–89, 190, 224, 240, 279nn23,25,26, 280n38, 281nn53,57,59, 282n71; challenges to leadership, 26, 159, 160, 168, 170, 180, 182–85, 186, 187–88; inauguration, 166, 185, 278n20
Graham, Margaret, 201, 211, 284n34

Grant, Frances R., 108, 145–46, 276n68, 277n69
Grupo Participación Social de la Mujer, 211
guerrilleras, 147
Gutiérrez (de Segarra), Gladys, 191, 196–97, 198, 200, 204, 238, 284n37, 285n63; political activism, 191, 204, 206, 238, 283n22; search for husband Henry Segarra Santos, 196–99
Guzmán, Antonio, 27
Guzmán, Leandro, 112–13
Guzmán Gonnell, Rita Violeta, 96

Haiti, 5, 13, 72, 77
Haitian Revolution, 9
Hartlyn, Jonathan, 83, 158, 283n16
Hasbún, Amín Abel, 203, 284n37
Henríquez, Clementina, 56, 257n106
Heredia Vda. Suncar, Zoraida, 231
Hernández, Angela, 15, 138, 206, 207–8, 226
Herrera, Ruth, 198–99, 203, 284n37
Herrera Miniño, Altagracia M., 234–36
Herrera Mora, Myrna, 94
Heureaux, Ulises, 32, 250n9
Heureaux de César, Graciela, 103
hispanidad, 15
historiography, 8, 12–16, 22, 94, 246n42, 258n5
Hoffnung-Garskof, Jesse, 192
Horn, Maja, 5, 254n52
Hostos, Eugenio María de, 32–33, 251n11
human rights, 11–12, 90, 97, 116, 127–29, 141, 145, 190–210, 217, 225, 238, 240, 271n72, 287n4

industrialization, 163, 171, 184
Instituto de Señoritas, 33, 251n15
Instituto Tecnológico de Santo Domingo (INTEC), 15; Center for Gender Studies, 15, 246n42
inter-American, 4, 18, 26–27, 52, 121, 143–45, 153, 154, 223, 238; audiences, 27, 95; community, 24, 125, 277n71; peace force, 153, 276n57; relations, 3–4, 9, 18
Inter-American Association for Democracy and Freedom (IADF), 123, 146
Inter-American Commission of Women/ Comisión Interamericano de Mujeres (IACW/CIM), 9–10, 30, 40, 42, 43–47, 70, 83, 89–90, 123, 240, 268n15; 1956 Conference, Ciudad Trujillo, 89–90, 265n89

Inter-American Conference on Problems of War and Peace (1945), 83
Inter-American Training Courses for Women Leaders, 143
International Institute for Political Education, 131
International Women's Year (IWY), 27, 197, 205, 212, 218, 219–29, 232, 234; Dominican celebrations of, 220, 222, 223, 228, 287nn16,19; World Conference, Mexico City, 220, 222, 225, 287n14
International Youth Congress, 97

Jain, Devaki, 225
journalism, 20, 29, 41, 53, 68, 102–3, 204–5, 208–10, 259nn13,14, 288n21
Junta Patriótica de Damas, 35
Juventud Democrática, 97–99, 111–12, 264n75, 267nn13,14
Juventud Revolucionaria, 96–97

Kennedy, John F., 122, 160
Koikari, Mire, 158–59
Kunhart, Bolívar, 97

labor laws, legislation, 75, 88, 103, 233–35, 264n86
Lamourth Lugo, Vincenta, 144, 154
Landestoy, Carmita, 40, 44, 45, 47, 50, 52, 53, 56–57, 66, 68, 255nn69,70, 256n82, 259n13, 261n31; exile of, 105, 108–9, 259n6; head of Sección Femenina, 66, 71, 73–75, 260n30, 261n34; publications of, 67, 108, 259n14, 260n21; resistance activism, 108–9, 259n6; ¡Yo También Acuso!, 108–9
Lara, Erasmo, 231
League of Women Voters (LWV), 10, 26, 37, 123, 154, 160, 174–75, 278n8, 280nn41,46; Overseas Education Fund (OEF), 154, 160, 174–80, 187, 278n8, 280nn40,41,50
Leger, Mercedes, 187
Liga de Mujeres Ibéricas e Hispano Americanas, 35–36
Liga Revolucionario por la Emancipación de la Mujer (LIREMU), 210–11, 213, 286n76
Listín Diario, 37, 51, 165, 208, 209, 234, 253n42, 255n65, 271n70, 285n60
literacy schools, 66, 67–68, 76, 80, 186, 262n44, 280n38

Lora Iglesias, Carmen Josefina "Piky," 132, 142, 147, 150–51, 207, 232–33, 274n31, 276n59, 277n76

Magna Apotheosis, 52, 263n73
Mainardi Vda. Cuello, Carolina, 105, 266n3, 268nn34,36
Marte de Barrios, Licelott, 212, 223–25, 227–29, 232, 286n71, 288n19
Martí, José, 9
Martin, John Bartlow (U.S. ambassador), 127–28, 271n66, 275n53
Martínez, Martha, 198, 200, 276nn66,67,69, 277n72
Martínez, Orlando, 205
Martínez Bonilla, Carmen Natalia, 97–98, 119, 143–45, 155, 259n6, 266n3, 267nn13,14,15; exile, 100–102, 105, 143, 259n6, 268n36; family struggles, 98, 100–101, 268n21; president, Inter-American Commission of Women, 144, 146–47, 268n15, 275n56, 276nn61,63,67
Martínez de Trujillo, María, 263n71
Martínez-Vergne, Teresa, 32–33, 251n21
martyr, women as, 13, 25, 41, 74, 93–94, 111, 132, 140, 191, 219, 221, 228–29, 237, 239, 247n42
masculinity, 6, 15, 31, 37–39, 58–59, 252n29; crisis of, 37–39, 58; in political arena, 5, 14, 24, 59, 142, 159, 170, 173, 175, 188, 237
Massacre, 1937 Haitian, 50–51, 258n109, 260n27, 282n2
"Mataron el chivo," 2
Matas de Farfán, Las, 71
maternalism, 3, 8, 20–21, 24, 25, 27–28, 101, 117, 130, 132, 155, 160, 188–89, 191, 192, 220–21, 232, 236, 238, 239, 242, 259n14; definition of, 6, 244n15; discourse, 3, 6, 20, 25, 90, 93, 110, 124, 191, 197–98, 200, 236, 239; in politics, 4, 6–7, 16, 20–21, 24–28, 92, 108, 121, 123, 132, 139, 156, 157–58, 160, 166–67, 173, 183, 186–87, 188–89, 191, 192, 238
Mayer, Isabel, 51, 56, 73, 79–80, 91–92, 246n35, 256n87, 257n106, 261nn31,32, 262n57, 265n93, 266n95
Mayes, April, 15, 22, 254n49
Mazarra, Carmen, 201, 203, 284n37
McFadden, Margaret, 11
McGregor, Julieta P. de, 37

Mejía (de Soliere), Abigaíl, 36, 44, 46–47, 48–52, *49*, 55, 221, 252n27, 253n41, 255n62, 257n93
Melo de Cardona, Ligia Amada, 206–7, 231
Mercado, Luis, 108
Military Intelligence Service, 134
Miller, Francesca, 220, 245n24, 254n59
Mirabal, María Teresa, 94, 111, 112, 134
Mirabal, Minerva, 94, 111–14, 134, 207, 229, 266nn95,3, 269n52, 270nn53,54,55, 288n25
Mirabal, Patria, 94, 111, 134
Mirabal sisters, 14, 25, 93–94, 111, 117–20, 122, 132–34, 148, 219, 228–29, 246n41, 247n42, 258n5, 269n52, 272nn81,87
Mirabal trial, 122, 133, 134–35; accused, 122, 133, 134, 155; media coverage of, 122, 133, 135, 155
Moca, 267n13, 281n57
modernity, 5, 24, 37, 89, 251n9; modernizing state, 192; modern woman, 30, 56
Molyneux, Maxine, 15
Monte Cristi, 51, 79, 91, 112, 196, 256n87, 262n48, 266n95
Montevideo, 43–44, 46, 48, 55
Mooney, Jadwiga Pieper, 19, 21
Morales, Miriam, 113, 270n59, 271n67
Morality, 25, 63, 65, 72, 94, 99, 101, 102, 110, 119–20, 121, 131, 133, 186, 279n25
Morató Vda. Egea, Andrea, 68, 87, 260nn20,29
Morel, Asela, 114, 271nn67,72, 274n31
Moreno, Alfonso, 131
Morillo, Susana, 209–10
Mota, Vivian, 211–12, 215
Mujer en la Era de Trujillo, La, 67–68, 80, 87, 258n1, 260nn20,29, 264n83

Nación, La, 54, 69, 78–79, 101, 133, 243n3, 257n106
Nacional, El, 203
Nagua, 184
Nanita, María Caridad, 52, 256n91
Nanita de Espaillat, Maria Teresa, 89, 260n23, 265n88
National Guard, Dominican, 38, 254n90
National Palace, Dominican, 1, 126, 133, 135, 147, 166, 206
National Police, Dominican, 195, 196, 202, 283n13
Navarrete de Ortíz, Concepción, 209

networks: building of, 9, 19, 48, 157, 160, 171, 174, 188, 224, 278n4; of feminism, 10–11, 26, 28, 33, 54, 174, 188; transnational, 4, 11–13, 28, 42, 83, 102, 145–46, 221, 222, 260n25
New York, 35, 102, 105–9, *106*, *109*, 118, 253n38, 268n34, 269n50, 288n19
New York Times, 1, 108, 118, 166
Nivar de Pittaluga, Amada, 73, 84–86, 88, 261n31, 265n88
Normalistas, 32–33, 58, 253n39
North America, 10–11, 37, 59, 107–8, 154, 213, 216–17

occupation, 37, 72; U.S. (1916–1924), 7, 20, 22, 23–24, 29, 32–38, 39, 59, 251nn20,22, 253nn38,48, 254n49; U.S. Marine Corps (1965), 18, 19, 22, 25, 123, *139*, 147–54, 161, 175, 191, 275n48
Offen, Karen, 10, 20, 245n19, 250n8
Olcott, Jocelyn, 11
Organization of American States (OAS), 91, 93, 116, 118, 125, 128, 141, 143, 162, 271n72
Oviedo, Cándida, 151

Padilla, Josefina, 96–98, 101–2, 130–31, 207, 228, 267nn13,14, 269n51, 274n25, 276n66, 288n23
pan-American, 10, 24, 36–37, 40, 68, 245n29, 250n4; relations, 30, 59
Pan American Conference of Women (1922), 36–37
Pan American Union (PAU), 43–44, 46, 105, 255n70, 260n25
Pan-American Women's Association, 108, 123
Paradas, Ana Teresa, 36–37, 253nn38,43
paradox, 5, 32, 218, 221; of paternalism, 4, 7, 28, 157, 221, 237, 242; a strange, 108
Paravisini-Gebert, Lizabeth, 13
Partido Dominicana (PD), 24, 39, 62, 65–67, 71, 76, 80, *81*, 91, 101, 105
Partido Reformista (PR), 162–64, 181, 182, 184, 189, 190, 199, 205, 212, 281n59
Partido Revolucionario Dominicano (PRD), 27, 105, 125, 129, 131, 135–36, 162, 163, 168, 193, 196, 204–5, 212, 268n34, 284n40, 285n53, 288n23
Partido Revolucionario Social Cristiano (PRSC), 125, 129, 131, 135, 193, 195, 274n26; Christian Revolution, 129, 131

Partido Socialista Popular (PSP), 96, 104, 282n7
Partido Trujillista (PT), 65–66, 259n10
paternalism, 5, 8, 11, 17, 23, 221, 237, 241–42; of Balaguer, 7, 157–58; definitions of, 28, 68; of Trujillo, 6–7, 16, 22
Patria Nueva, 39, 57, 59, 92, 120
patriarchy, 2, 143–44, 155
patriotism, 12, 73, 252n29; feminine, 21, 75
Pedernales, 184, 279n25, 281n53
Peña, Mirna de, 214, 225, 287n16, 288n23
Pepín, Ercilia, 37, 252n29, 254n56
Perella, Illuminada A. de, 177
Pérez y Pérez, Enrique, 196, 283n16
Perón, Juan (Argentina), 17, 63, 258n4; Evita, 18; Peronism, 18
Peynado, Carmen G. Vda., 36, 61
Pichardo Lapeyretta, Lydia, 86, 257n106
Pineda, Magaly, 15, 191, 210, 211, 227, 230, 247n45, 275n53, 285n60, 288nn21,23
Pion de Gómez, Italia Leopoldina, 171
Plan de Asistencia y Mejoramiento Social, 66–67, 75–77, 85. See also *asistencia social*
Pola, Susi, 13
politicization, of women, 15, 30, 65, 236, 239
Power, Margaret, 21
Prats-Ramírez de Pérez, Ivelisse, 191, 204, 206, 212, 215–16, 225–27, 230–31, 284n40, 288n23
Prédica y Acción, 68, 259n14
Primer Congreso Femenino Dominicano, 66, 69–71, 260n25
Primer Congreso Revolucionario de Mujeres, 210
progress, national ideals of, 4, 8, 18, 26, 31–33, 38, 42–47, 50, 56, 57, 59, 62, 65, 67–69, 75, 78–79, 85–86, 89, 106, 157, 159, 165–66, 170–74, 181, 188, 190–93, 203, 223, 226, 236, 254n57, 265n89
Progressive Era, 250n7
prostitutes, prostitution, 35, 117–18, 141, 183, 185–86, 192, 272n25
protest, public. *See* resistance: public protests by women
Puerto Plata, 113
Puerto Rico, 42, 99–100, 102, 105–6, 143, 162, 268n34, 282n6, 288n21

Quisqueya Libre, 102–3

Reformismo, 164
resistance: activism, 22, 83, 94–96, 98, 101, 103–5, 110, 112, 125, 129, 151, 155, 193, 196, 207, 238, 259n6, 266n3, 274n31; *antitrujillista*, 95, 104, 109, 111, 113, 133, 143, 193, 199; exile, 25, 95, 102–10, *106*, *109*, 116, 125, 258n6, 268n34, 269nn41,50; movement, 3, 8, 16, 25–26, 35, 93–95, 97–98, 101–2, 103, 107, 111, 113–16, 117, 120, 132, 135, 136, 147–48, 203, 239–40, 258n5, 266n3, 267n15, 269n51, 270nn57,61, 283n22; public protests by women, 29, 35, 95, 96, 98, 99, 102, 105, *106*, 107–8, *109*, 132, 133, *139*, *148*, 154, 192, 195–97, 198–99, 200, 201–2, 206, 274n33, 275n48; revolutionary, 8, 21–22, 94–96, 110, 111–12, 115, 130, 132, 142, 147–54, 194, 196, 206, 210–11, 213–16, 221, 229–30, 264n75, 267n13, 273n6
"Revolution of 1930," 38–39, 254n51
revolution without blood (revolución sin sangre), 190, 193
Reynoso de Abud, Ana Silvia, 214, 231, 275n45, 288n23
Ricart, Angela, 133
Risman, Barbara, 10
Rivas de Liz, Quisqueya Altagracia, 144, 154–55
Roa de Moreta, Ana Valentina, 183, 281n59, 282n71
Rodríguez, Evangelina, 268n68
Roja de Cantizano, Teresita, 90
Romana, La, 172, 174, 181, 187–88, 195, 279n26
Roorda, Eric Paul, 18, 50, 82
Roosevelt, Franklin D., 50

Salcedo, 112, 272n81
Samaná, *179*
Sánchez de Bonilla, Fanny, 231
Sánchez de González, Josefa, 73, 77, 80, 88, 261nn31,33, 265n88
Sánchez de Rubio, Dulce María, 116, 271n80
San Cristóbal, 1, 71, 119, 187, 243n3, 270n53
San Juan de la Maguana, 185
San Pedro de Macorís, 29, 34, 36, 78, 84, 86, 87, 168, 252n26
Santana, Julio Cesar, 90
Santiago, 51, 70, 79, 91, 96–97, 116, 127, 136, 177, *178*, 196, 224, 252n29, 254n56, 262n56, 274n30, 275n48

Santo Domingo/Ciudad Trujillo, 1, 9, 34, 36, 40–41, 52, 68, 79, 81, 89, 105, 107, 110–11, 127, 134, 136, 140, 192, 196–97, 199, 201, 204, 208–9, 212, 252nn24,27, 253nn41,42, 258n109, 260n19, 270n56; Ciudad Nueva, 147; Conde, 2, 199; Gazcue, 162; National Pantheon, 132; Parque Colón, 78, 79; Parque Independencia, 199; Puerta del Conde, *138–39*

Santos, Mirna, 203, 284nn37,38

Sección (Rama) Femenina, del Partido Dominicano, 24, 62, 64–72, 75–78, *81*, 88, 259n14, 260nn20, 23

Seigel, Micol, 10

Semana Patriótica, 35

Seminario Hermanas Mirabal, 197, 220, 228–32, 234, 287n16, 288n23

Shukla, Shandhya, 9

Simó Delgado, Dulce María, 128–29

Smester, Rosa, 56

Soler Vda. Peynado, Mercedes, 72, 257n106, 265n88

solidarity, 4–5, 9, 11–12, 26, 36–37, 44, 82, 102–4, 107, 110, 121, 145, 147, 151, 154, 190–91, 193, 198, 200, 202, 205, 217, 238, 245n27, 271n73

Somoza regime (Nicaragua), 17, 259n8

sovereignty, 3, 5, 7–9, 11, 16, 23, 26, 29–30, 34–39, 55, 58–59, 61, 121–24, 147, 149, 151, 154, 159, 193, 221, 225, 229–30, 237–39, 252n29

Sparling, Valerie, 10

stability, 11–12, 18–19, 37, 40, 47, 61–64, 73, 75, 82, 87, 89, 95, 110, 119–20, 123–24, 126–27, 140, 143–45, 147, 156, 158–59, 163–64, 174, 178, 182, 188, 191, 197, 201, 204, 217, 238–40, 253n48; international discourses of, 47, 64, 110, 120, 240; regime, 11, 73, 89, 90, 97, 143, 156, 163, 174, 197, 217, 238

Stevens, Doris, 41–52, *53*, 57, 254n59, 255nn69,70, 256nn77,80, 257nn93,97, 258n109; as chairwoman of IACW, 40, 43, 44, 52; visit to Ciudad Trujillo, 52–54

Stites Mor, Jessica, 11

suffrage, 6, 21, 24, 34, 37–38, 40, 49, 52–58, 64, 69, 80, 83, 90, 91, 257n107; granting of, 21, 24, 31, 48, 56, 57, 80, 267; struggle for, 34, 47, 48, 52, 83, 234; test vote, 48–50, 256nn79,80

Tavárez, Margarita, 232–33

Tavárez Justo, Emma, 132, 137

Tavárez Justo, Manolo, 112–13, 132, 199, 229, 266n95, 274n32

Tavárez Mirabal, Minerva (Minou), 229, 288n25

Tejada, Dulce, 114, 267n13, 271n67

Thomas, Norman, 193

Thorman de Aguilar, Fidelina, 212, 288n19

Tinsman, Heidi, 9

Tolentino Dipp, Hugo, 228

transnational: activism, 3–4, 8–9, 11–13, 19, 27–28, 30, 35, 59, 83, 86, 123, 127–28, 137, 141, 143, 145, 147, 154, 160, 188, 198, 203, 217, 221, 240–42, 244n18; feminism (*see* feminism: transnational)

Trinidad Sánchez, María, 22, 73, 74–75, 140, 261n37

Triumvirato, 135, 137, 142

Trouillot, Michel-Rolph, 12

Trujillato: bureaucracy of, 3, 6, 17, 39, 65, 75, 80; legacy of, 22, 64, 133, 136, 165–66, 192; regime, 1, 12, 13–15, 16, 17–18, 29, 31, 39, 47, 50, 59, 62–63, 80, 82, 92–93, 95, 98, 101, 103, 115, 117–18, 244nn16,17; regime officials, 8, 20, 46, 54, 62, 63, 65–67, 76–77, 82, 85, 87, 90, 92, 100–101, 112–16, 127, 257n105, 258n2, 261n31; torture under, 98, 114–15, 118, 122, 124, 128

trujillista, 51, 62, 67, 74, 87, 88, 120, 137, 141, 264n84, 265n88. See also *damas trujillistas*; *feministas trujillistas*; resistance: *anti-trujillista*

Trujillo, Ramfis, 121, 124

Trujilloist, 22

Trujillo Molina, Rafael Leónidas, 1, 3, 38; Benefactor de La Patria, 52; Benefactor of Women's Rights, 46, 51, 89; death and funeral of, 1–2, 25, 93, 119, 121, 243n3; Father of the New Fatherland (Padre de la Patria Nueva), 2, 6, 51, 52, 89, 92, 120; father-like, 1–2, 5–7, 17, 31, 92; family of, 2, 25, 121–22, 124, 142, 162, 163, 257n106, 263n71; Generalísimo, 1, 51, 62, 79; Jackal of the Caribbean, 93, 107, 110; rise to power, 29, 38–39, 162 (*see also* "Revolution of 1930"). See also Trujillato: regime

Turits, Richard, 17, 34, 113, 244n17, 267n11, 270n61, 271n75

Unión Cívica, 126, 128, 273n17
Unión Cívica Nacional (UCN), 125–26, 129–31, 135, 136, 142, 153–54, 238, 274n42, 282n7
Unión Democrática Anti-Nazista Dominicana (Dominican Anti-Nazi Democratic Union), 102
Unión Femenina Ibero-Americano (UFIA), 83–84, 263n67
Unión Nacionalista Dominicana, 35
Unión Patriótica Dominicana (UPD), 106–7, 269n36
United Nations (UN), 84, 89, 141, 143, 203, 212, 219–20, 222–27, 229; Commission on Human Rights, 203, 287n4; Commission on the Status of Women, 212, 220, 222, 223, 264n85, 287n4; Council for International Women's Year, 222, 232
United States: imperialism, 5, 7, 9–12, 16, 18–19, 25, 30, 32–35, 37, 38, 97, 116, 122–25, 146, 148, 163, 213, 240, 253n48; occupation of Dominican Republic (*see* occupation)
Universidad de Santo Domingo/Universidad Autónoma de Santo Domingo (USD/UASD), 96, 111–12, 125, 130, 132, 192, 207–8, 212, 214, 219, 228, 234, 269n51, 270n56, 274n31, 284n40, 285nn48,52,53, 288nn21,23
Ureña de Henríquez, Salomé, 33, 37, 56, 251n15, 253n41, 264n84, 265n93

Valera Benítez, Rafael, 119, 270n61, 271n70
Valverde, Octavia S. Vda, 70–71
Vanguardia Revolucionaria Dominicana (VRD), 268n34
Vargas, Aniana, 151
Vargas, Getulio (Brazil), 63
Vargas Llosa, Mario, 14
Vega, La, 97, 111, 117, 267n12, 272n83, 282n71
Veloz, Livia, 48, 254n55, 272n83
Venezuela, 23, 102–3
Victoria, La, 114, 201
Viezzer, Moema, 139, 197
voto de ensayo. See suffrage: test vote

Ware, Caroline, 280n43
Weber, Delia, 35–36, 49, 56, 84, 257n106, 260n23
Wertsch, James, 12
western, 30, 34, 60, 63, 67, 192, 212, 214, 218, 225; models of feminism (*see* feminism: western models of)
widow (viuda), 61, 129, 167, 192, 203, 258, 286; organizing for human rights, 72, 197–98, 218, 238, 284; social perceptions of, 201, 203–4, 221
women: of April Revolution, 16, 123, 138–39, 143, 147–55, 153, 190–92, 195, 199, 216, 277n74, 288n21; as educators, 7, 31, 42, 64–65, 67, 69, 77, 87, 90, 130, 146, 167–68, 171, 172–73, 178, 204, 252n32; as moral guardians, 31, 42, 46, 59, 60, 62–64, 72, 82–83, 94, 101, 130, 131, 157, 165, 170, 180, 274n24; of Trujillato, 6, 7, 8, 13, 15, 16, 18–19, 20–22, 24, 29–64, 74, 79, 81, 82, 84, 89, 92, 101, 103, 105–6, 110, 118, 122, 126, 128, 129, 131, 132, 133, 135, 155, 159, 207, 238, 239, 240, 262nn44,57, 263nn60,61,73, 264n82 (see also *damas trujillistas; feministas trujillistas*)
Women's International League of Peace and Freedom, 108, 123
Women's International Terrorist Conspiracy from Hell (WITCH), 216, 286n82
women's liberation, 4, 166–67, 174, 192, 211, 213–18, 219–20, 230, 234–36, 286n76. *See also* feminism
World War I, 32, 285n48
World War II, 19, 24, 63, 73, 82–83, 96–97, 110, 263n62
Woss y Gil, Celeste, 56, 257n106, 265n88
youth, 97, 118, 172–73; activism, 91, 97–98, 116, 207, 266n95, 283n10; programs, 131, 173

Zayas Bazán, Elisa de, 129–30, 238
Zeller, Neici, 15, 33, 88, 252n29, 254n49, 255n67, 256n81, 258n2, 261n37, 264n86

ELIZABETH MANLEY is Kellogg Endowed Associate Professor of History at Xavier University of Louisiana.

www.ingramcontent.com/pod-product-compliance
Lightning Source LLC
LaVergne TN
LVHW090940041225
826914LV00026B/145